MOXIE

**IRA RESNICK
AND RAISSA BRETAÑA**

FOREWORD BY JANE FONDA

THE DARING WOMEN
OF CLASSIC HOLLYWOOD

Abbeville Press

New York London

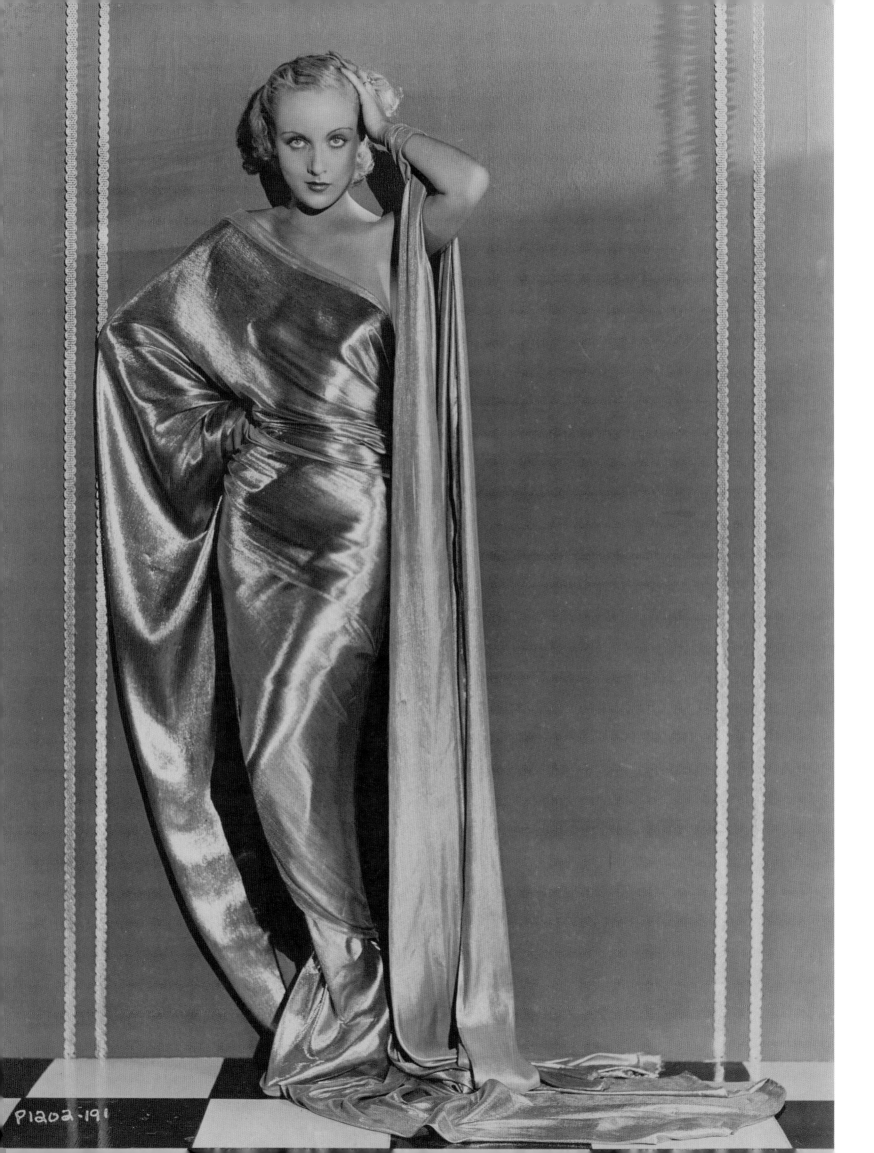

P1202-191

CONTENTS

FOREWORD

BY JANE FONDA

elcome to *Moxie*—a celebration of fifteen powerful women who challenged the male powerbrokers of Hollywood. Whether confronting racial stereotypes, sexual conventions, or outright misogyny, they found ways to resist and outwit the attempts to confine them. They had moxie!

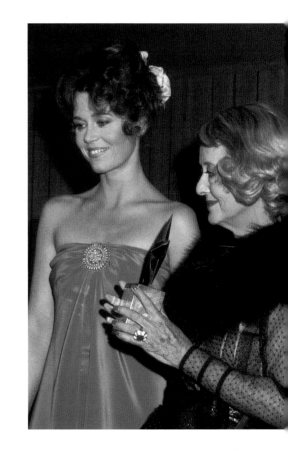

Look at Anna May Wong, born in 1905, who fought for decades to escape the bitter prejudice against Chinese Americans. Laws against miscegenation meant that she could not appear on-screen opposite a white male lead as a romantic interest. She ultimately moved to Europe where she found more opportunities to play characters worthy of her talent, including opposite Laurence Olivier. When she finally returned to the United States, she was rejected for the lead role in *The Good Earth*, which hurt her deeply. But she avenged herself as the first Asian American actress to star in a television series: *The Gallery of Madame Liu-Tsong* (1951).

Bette Davis, born in 1908, refused to be categorized as a sexual temptress and sought unglamorous roles that would showcase her acting, most famously in *Of Human Bondage* for which she insisted on doing her own makeup. At Warner Brothers, she refused to appear in movies she thought beneath her, and like Wong, sought projects abroad—only to be sued by the studio for breach of contract. She lost at trial, but the case shamed the studio into giving her more money and more control over her scripts so that she could play the complicated roles she craved. Her tenacity paid off: she was nominated for ten Academy Awards for Best Actress and won twice.

Barbara Stanwyck, orphaned at age four, dropped out of school at fourteen in order to get out of the foster system and live on her own. Throughout her career she relied on her New York street smarts, navigating from early jobs as a showgirl to success on Broadway to a succession of starring roles in Hollywood movies—including *The Lady Eve* with my father Henry Fonda—that emblazoned her feisty independence.

Ida Lupino was perhaps the most independent of them all. Born into an acting family in London in 1918, she was beckoned to Hollywood by Paramount Pictures when she was just fifteen. Marketed as a "baby vamp" and photographed repeatedly in come-hither poses that bordered on pedophilia, she rebelled. She fought for the leading role in William Wellman's *The Light That Failed* and became a sensation. In the quest for more autonomy, she moved to Warner Brothers where she continued to be pigeonholed as a femme fatale. So in 1947 she made the gutsy decision to freelance—a rare move for a successful performer at the time—and acted in movies for Fox and RKO. But Lupino wanted to control the pictures she made and that meant writing, producing, and directing. With husband Collier Young, she formed The Filmakers, Inc. and issued a full-page "Declaration of Independents" in *Variety*, stating the goal of making realistic movies about important social issues.

These are just a few of the women in this book who have inspired my efforts to make my work in the movies matter. Their moxie inspires me, and I hope will inspire you.

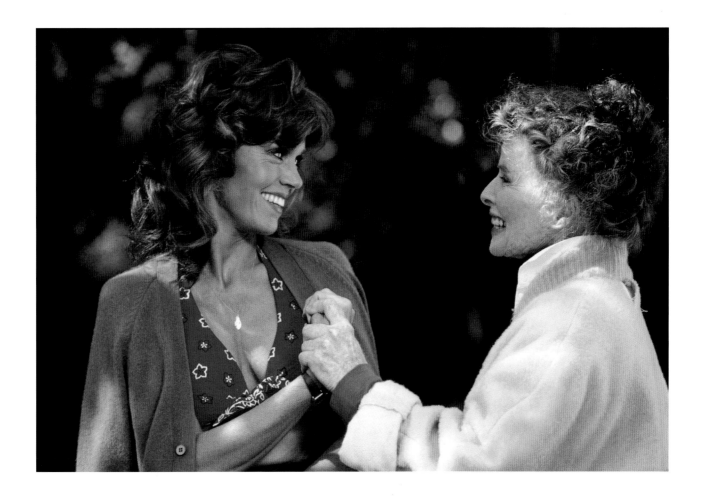

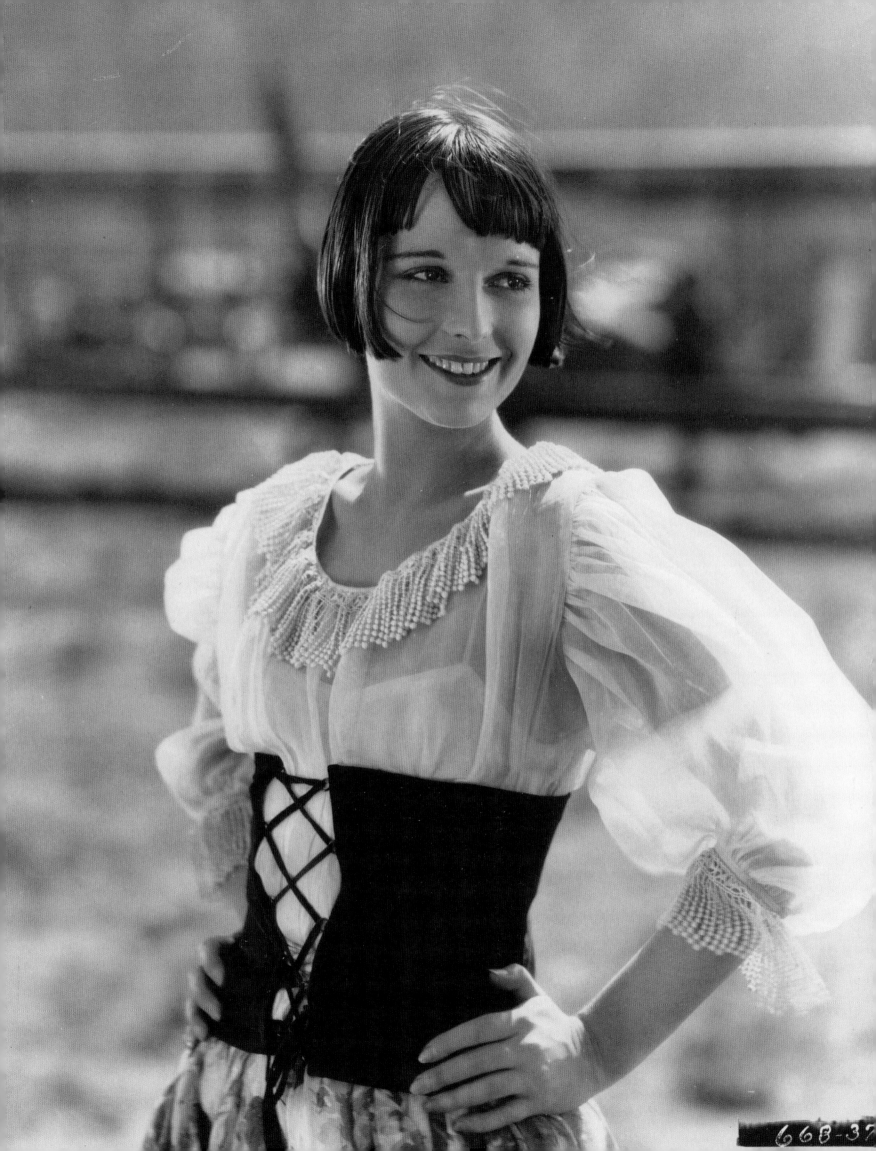

INTRODUCTION

BY IRA RESNICK

As a lifelong movie lover, I have naturally developed an affinity for certain genres, time periods, and directors—but, above all, it is the stars with whom I have always felt the most connected. My favorite performers tend to be those who command attention, the ones who can reach out and really grab you. When it comes to actresses in particular, I have found myself most captivated by the daring women who shaped the movie industry during Hollywood's golden age. Of course, there are many who were notable for their talent or beauty—but it is those that had *moxie* that I continue to be astonished by.

So what exactly is *moxie*? You could call it boldness or courage or determination … but also nerve, spirit, or strength of character. However manifested, it was an absolute necessity for those trying to make it in Hollywood during the heyday of the studio system—a period from the 1920s to the 1950s when a small number of companies dominated the production and distribution of films in the United States. There were the "Big Five": Metro-Goldwyn-Mayer (MGM), Paramount Pictures, Warner Brothers, RKO, and 20th Century Fox. Those in control—studio executives, producers, and directors—were exclusively men, and they determined the fates of the performers under contract. It was a time when signing with a major studio was essential to having any sense of job security and the promise of a career; however, it also meant relinquishing oneself to the demands of an often repressive system. After all, the studios were factories and movie stars were their best-selling product. Mere mortals went in—were given a new name, a full makeover, and a manufactured personality—and out came the gods and goddesses of the silver screen fabricated from tinsel and celluloid and newspaper headlines, ready to

Promotional photo of Louise Brooks for *Now We're in the Air* (1927)

go to market. This system made it difficult for women, especially, to have any sense of control—so it was all the more impressive that this group of actresses managed to forge such successful careers without sacrificing their identities. Some drew upon their fortitude and perseverance; others relied on industry know-how; and still others simply had a lot of guts. They fought battles where there was no history to live by—they were, in fact, writing it themselves.

Each of the fifteen women profiled in this book left her unique mark on film history. Of them, some shared similar qualities or used similar tactics, while others had similar experiences on their journeys to stardom. You have the trailblazers

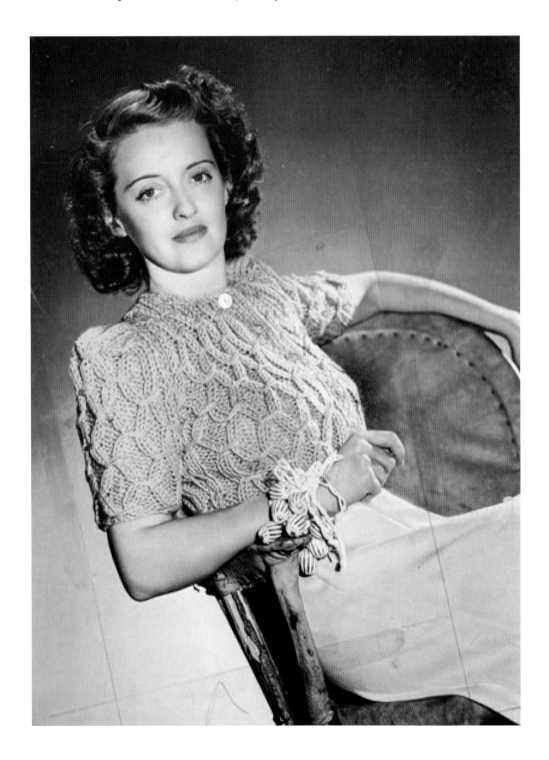

Studio portrait of Bette Davis for Warner Brothers, c. 1940

Carole Lombard in a promotional photo for *Twentieth Century*, 1934

who paved the way for women in the industry—Lillian Gish as a pioneering silent film actress, Anna May Wong as the first Chinese American movie star, and Ida Lupino as a groundbreaking filmmaker. There were the glamour goddesses of the 1930s, who understood the art of image-making and used it to their advantage— the incomparable Marlene Dietrich, the luminous Carole Lombard, and the fashionable Kay Francis. Then came the sassy seductresses of the 1940s—Veronica Lake and Gloria Grahame—who were empowered by their sensuality. You had industry mavens like Claudette Colbert and Myrna Loy, who knew the ins and outs of the business and used their professional savvy to negotiate lucrative contracts. And then there were the independent spirits, who refused to play by Hollywood's rules—the rebellious Louise Brooks and the headstrong Katharine Hepburn. Finally, there were the great artists who transcended genres and sustained lasting careers—Bette Davis, Barbara Stanwyck, and Lauren Bacall.

Each one was legendary in her own right and is given a chapter to illustrate her unique brand of moxie. You will learn of the ways they fought against the studio system and found their power. This is by no means meant to be an exhaustive survey of every great actress in Hollywood during this period—that amount of

moxie simply could not be contained in a single volume! Still, we have managed to squeeze in a few more deserving leading ladies, who are featured in the final chapter.

The stunning images that make up this book are a small selection from my collection of movie art, which I began compiling in 1970. Because this assemblage is the product of my life as a cinephile and avid collector, its holdings naturally represent my personal preferences. It felt like an impossible task to choose only about 200 images from thousands for this project—I really do love them all! Together with my coauthor Raissa Bretaña, we curated a lineup that exemplifies the magnificence of Hollywood as it evolved during the first half of the twentieth century. The images featured are limited to the years 1915 to 1955—a period that saw the rise and fall of the studio system and encapsulates the golden age of classic cinema. Included is a variety of film-related imagery, such as the following:

Studio portraits—used to promote contracted performers, especially early in their careers. Whether they were selling glamour or charisma or sex appeal, these photographs were taken by an in-house photographer at the behest of a studio's publicity department and used to craft each actor's star persona.

Promotional photographs—utilized as publicity tools for specific films and featuring a performer in full character costume, often accompanied by costars.

Film stills—provided snapshots of memorable moments which could also be used to promote a new release.

Lobby cards—smaller versions of movie posters printed on cardstock intended for display in theater lobbies in order to entice audiences. They often came in sets of eight—one main "title card" and seven "scene cards"—and featured various images of the cast.

You may have seen some of the films represented in this book, and some images you will likely recognize; however, many are being published here for the first time. This publication is for my fellow movie lovers and for those who share my admiration for these women that have become enduring icons of classic cinema. I hope in reading it, you will come to appreciate them not just for their work on film, but also their bravery, their brilliance, and their awe-inspiring moxie.

Behind-the-scenes photo of
director Ida Lupino on the set
of *Outrage* (1950)

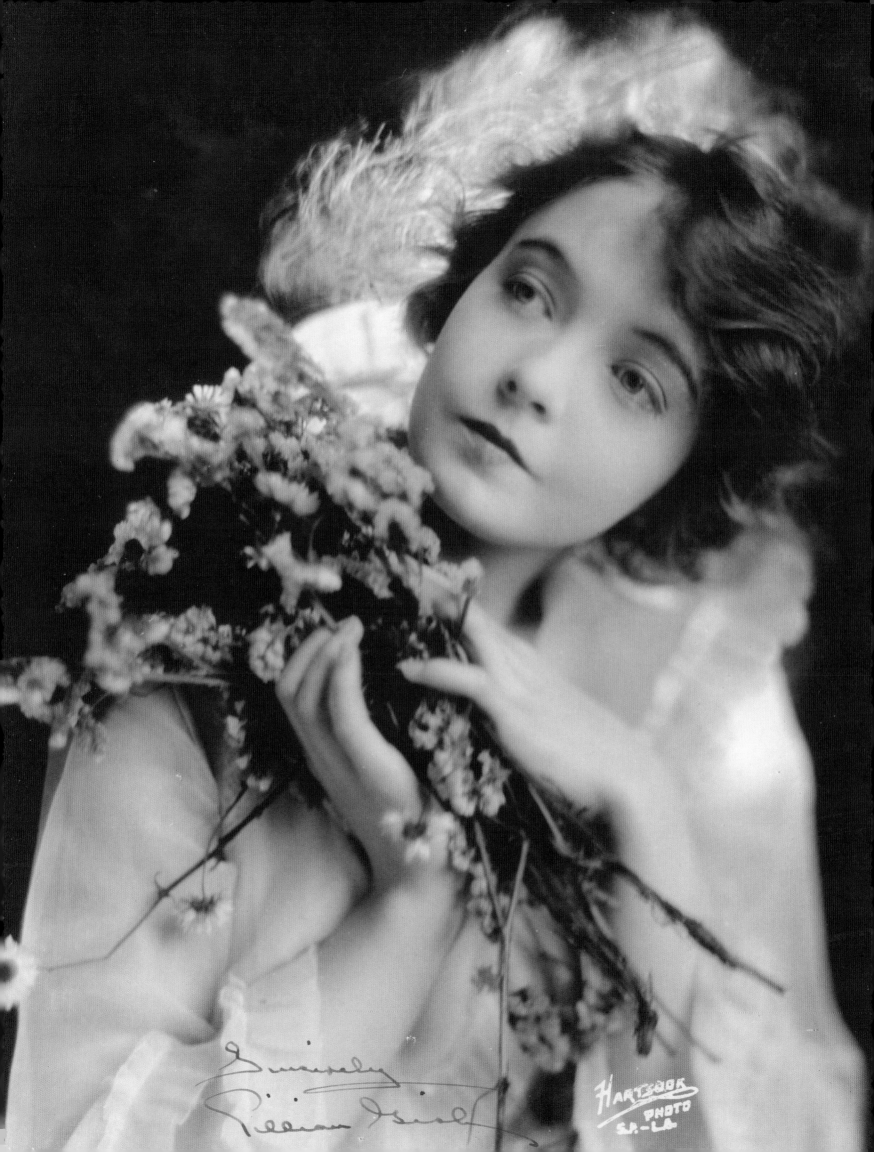

Sincerely
Lillian Gish

LILLIAN GISH

Heralded as "The First Lady of American Cinema," Lillian Gish was a true pioneer of the motion picture industry who, along with her frequent collaborator D. W. Griffith, made some of the most seminal films in the earliest days of cinema. An innovator in her own right, she developed a naturalistic style of acting suited to the silver screen that ultimately forged a new creative path for thespians and legitimized film within the entertainment landscape of the early twentieth century. Her delicate beauty captured the innocence of the era, while her soulful disposition and impassioned portrayals made her the fundamental silent screen heroine. With each performance, Gish artfully balanced fragility and strength. She was accustomed to hard work and so dedicated to filmmaking that she obsessively suffered for her craft. It was with this fervent conviction that she established herself as a leader in the art form.

This undated signed portrait captures the daintiness of Lillian Gish's cherubic face, inquisitive eyes, and cupid's bow lips. With a face framed by soft wisps of hair, she is the quintessential ingénue.

Lillian Diana Gish was born in Springfield, Ohio, on October 14, 1893. It was an auspicious year, given that it also marks the birth of film with the first public demonstration of the Kinetoscope—a poetic alignment that amplifies her status as an originator in the field. After her father abandoned the family, she maintained a lifelong closeness with her sister Dorothy and her mother Mary, an actress who introduced her daughters to the theater when they were quite young. Gish made her stage debut in 1902 and performed alongside her mother and sister in touring companies for the next few years. The Gish family was in and out of New York City, where they shared quarters with a woman named Charlotte Smith, whose

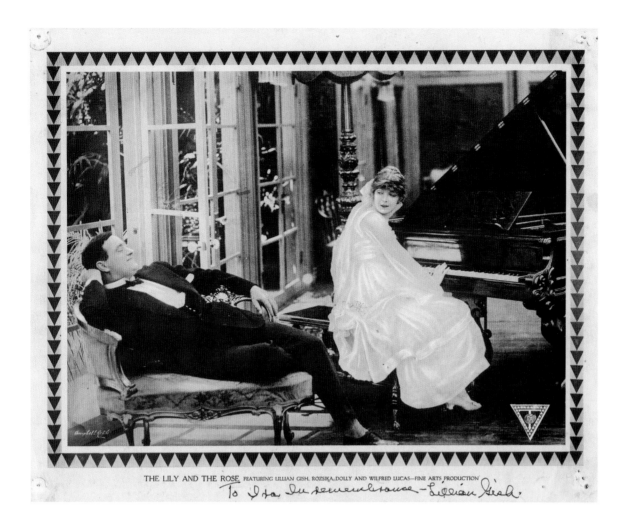

THE LILY AND THE ROSE. FEATURING LILLIAN GISH, ROZSIKA DOLLY AND WILFRED LUCAS—FINE ARTS PRODUCTION

To Ira In remembrance—Lillian Gish.

daughter Gladys was also an aspiring actress. In 1905, Gish beat her out for a role as a dancer in a Broadway production starring the great Sarah Bernhardt. Years later, the Gish sisters recognized Gladys Smith in a film and sought her out at the Biograph Company's studio in Manhattan. There, they discovered that she had changed her name to Mary Pickford—a name that would soon become synonymous with Hollywood royalty. Pickford introduced Lillian and Dorothy to one of the studio's rising directors, D. W. Griffith, and they were immediately brought into the Biograph fold.

In the dedication of her memoir, *The Movies, Mr. Griffith, and Me*, Gish pays tribute to the director "who taught me it was more fun to work than to play." After making her screen debut alongside her sister Dorothy in D. W. Griffith's *An Unseen Enemy* (1912), Miss Lillian—as he called her—began regularly appearing in his films. For the next ten years, she would work almost exclusively with Griffith, from his short one-reels to his hours-long epics. She starred in his landmark Civil War epic *Birth of a Nation* (1915), a commercially successful, yet highly controversial film that sparked outrage due to its deeply problematic depictions of African Americans. She played a smaller role in his next venture, *Intolerance* (1916)—which was similarly colossal in scale, but failed to replicate the same performance at the box office. Other notable collaborations during this period include *The*

This signed lobby card for *The Lily and the Rose* (1915, Triangle Film Corporation, dir. Paul Powell) is inscribed to Ira Resnick. Although there was a different director at the helm, D. W. Griffith still wrote and produced the film in which Gish starred as a southern girl who falls for a rich, handsome football player.

Mothering Heart (1913), *True Heart Susie* (1919), and *Broken Blossoms* (1919), for all of which she took on the archetypal tragic heroine. The partnership between Gish and Griffith would go on to become one of the most famed and influential in the history of cinema. In the dozens of films they made together, they established fundamental industry practices through their shared vision. Both actress and director saw filmmaking as a higher art form and strove to expand its possibilities by pushing it technically and creatively.

Gish took delight in the universal language of silent film and experimented with performance techniques in front of Griffith's camera. She developed a subtle acting style that was a revolution in the silent era, a period dominated by inartful pantomime and exaggerated physicality. From her emotionally intuitive approach came the trademark features of her oeuvre—wistful gazes, placid gestures, and contemplative stillness. She was the queen of the close-up, and her facial expressions emitted such a vivid presence that she was able to create a sense of shared intimacy with the viewer. Still, she wanted to do more. In an interview with *Motion Picture Magazine*, she expressed interest in directing "for the purely selfish reason . . . to help me with my work on the screen. I wanted to get the other angle; see the thing from the other side." *Remodeling Her Husband* (1920), now considered lost, was the first and only film Gish directed. She wrote the story and brought in celebrated writer Dorothy Parker to pen the intertitles. With her sister Dorothy in

Gish is hauntingly beautiful in this portrait by MGM studio photographer Ruth Harriet Louise, taken c. 1925. The image is gently blurred, similar to the manner in which her films were shot. Cinematographer Hendrick Sarto invented the "Lillian Gish lens"—now called a soft-focus lens—to emphasize the actress's ethereal beauty.

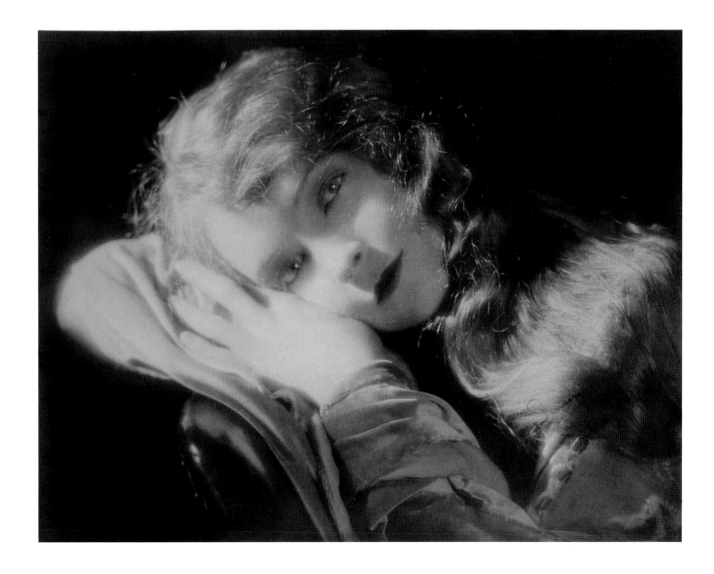

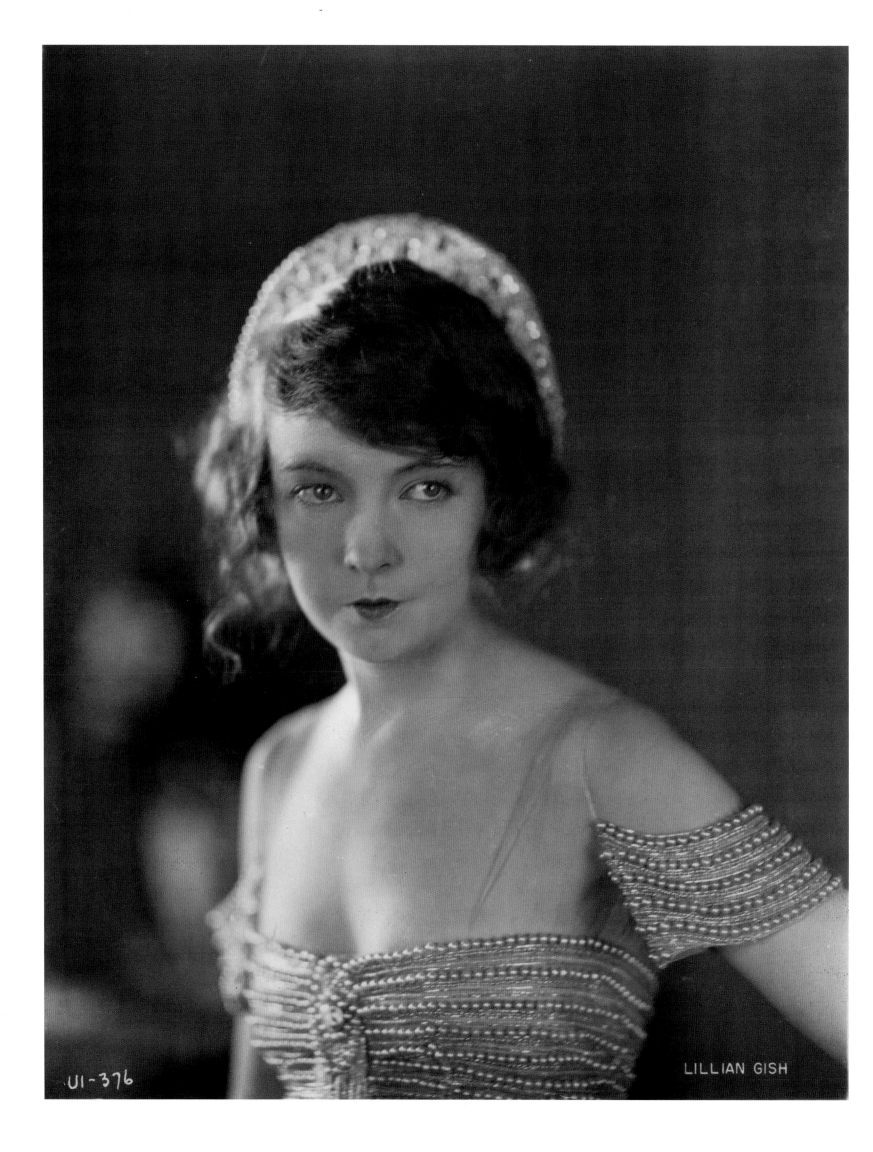

UI-376

LILLIAN GISH

Griffith strove to make timeless films, and so instructed that his heroines be dressed in a classic way. For the ball scene in *Way Down East* (1920, United Artists, dir. D. W. Griffith), Gish wore the Henri Bendel dress seen in this publicity photo, "cut on classic Greek lines." As she describes it in her memoir: "It wasn't in style then, and wouldn't be in style now, but it has never been out of style."

In *Way Down East*, Gish plays a poor country girl sent to call on her rich relatives in the city for financial assistance. This lobby card depicts a scene in which she is dressed by an aunt to attend a society ball, where she falls for a wealthy womanizer who tricks her into a fake marriage.

the leading role and a nearly all-female production team save for the cameraman, Gish produced a successful movie that earned ten times what it cost to make. Nevertheless, the experience confirmed her preference for the other side of the camera.

Gish was a dedicated actor who took great pride in performing her own stunts. Perhaps her most dangerous undertaking was the climactic scene in *Way Down East* (1920), where she lies unconscious on an ice floe floating perilously toward a waterfall. They filmed the sequence amid a harsh blizzard, and it was Gish's idea to have her hair and hand trail in the river's icy waters for dramatic effect. She justified this choice, saying, "Those of us who worked with Mr. Griffith were completely committed to the picture we were making. No sacrifice was too great to get the film right, to get it accurate, true, and perfect." She nearly froze to death and suffered permanent nerve damage in her fingers—but that was of little consequence to her. Her level of dedication may have bordered on masochistic, but she later wrote, "It was a delicious scene, one of my really favorites." It remains one of her most cited performances and perfectly aligns with her overall persona— one that, despite visible weakness, is characterized by a palpable inner strength. The following year, Gish starred alongside her sister in the French Revolution melodrama *Orphans of the Storm* (1921). It would be her last collaboration with Griffith, and incidentally, his last financially successful film.

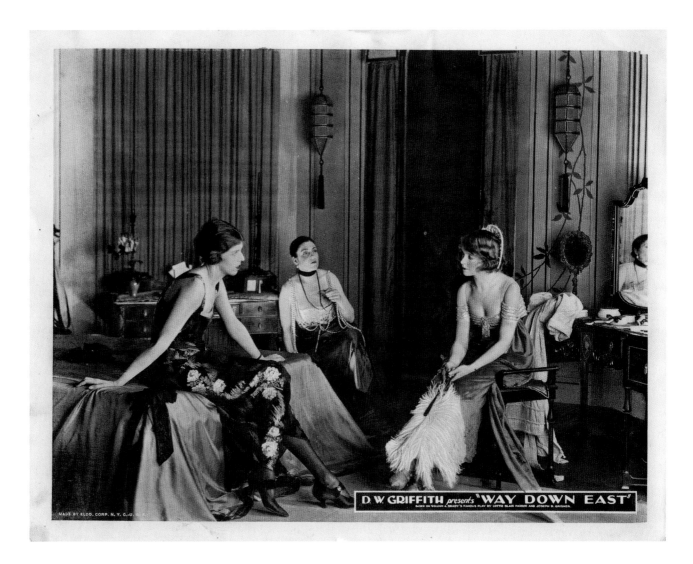

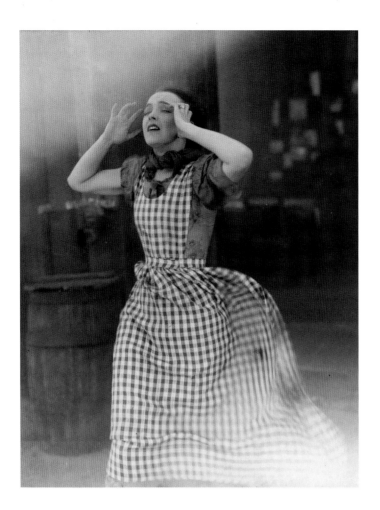

The release of *The Wind* (1928, Metro-Goldwyn-Mayer, dir. Victor Seastrom) coincided with the arrival of "talkies," and it would be one of the last films put out by the studio without audible dialogue. It featured synchronized sound, which included a musical score and sound effects; yet, it is considered one of the greatest films to come out of the silent era.

A lobby card and publicity photo for *The Wind*, which was Gish's favorite film she made at MGM. She plays an emotionally fragile young woman who relocates to Texas and is slowly driven mad by the incessant wind.

A publicity photo for *Orphans of the Storm* (1921, United Artists, dir. Griffith). Set in eighteenth-century Paris, it follows two orphaned young sisters played by Lillian and Dorothy Gish as they navigate the turmoil of the French Revolution.

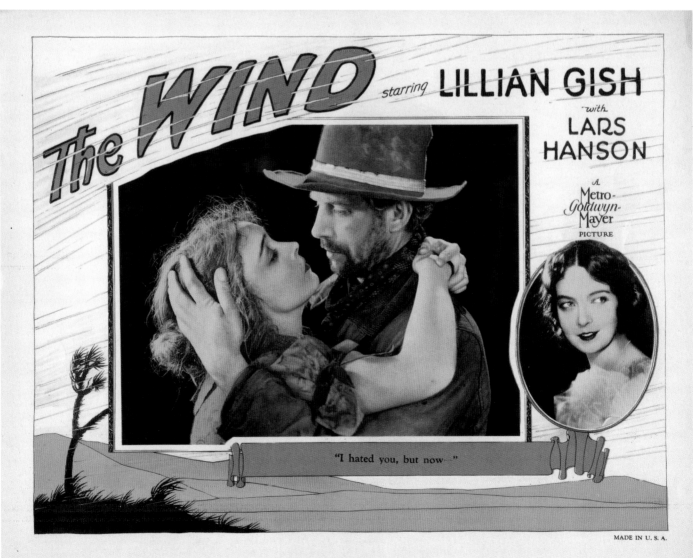

03-240

Mia from "Orphans of the Storm" - With every good wish always. Lillian Gish.

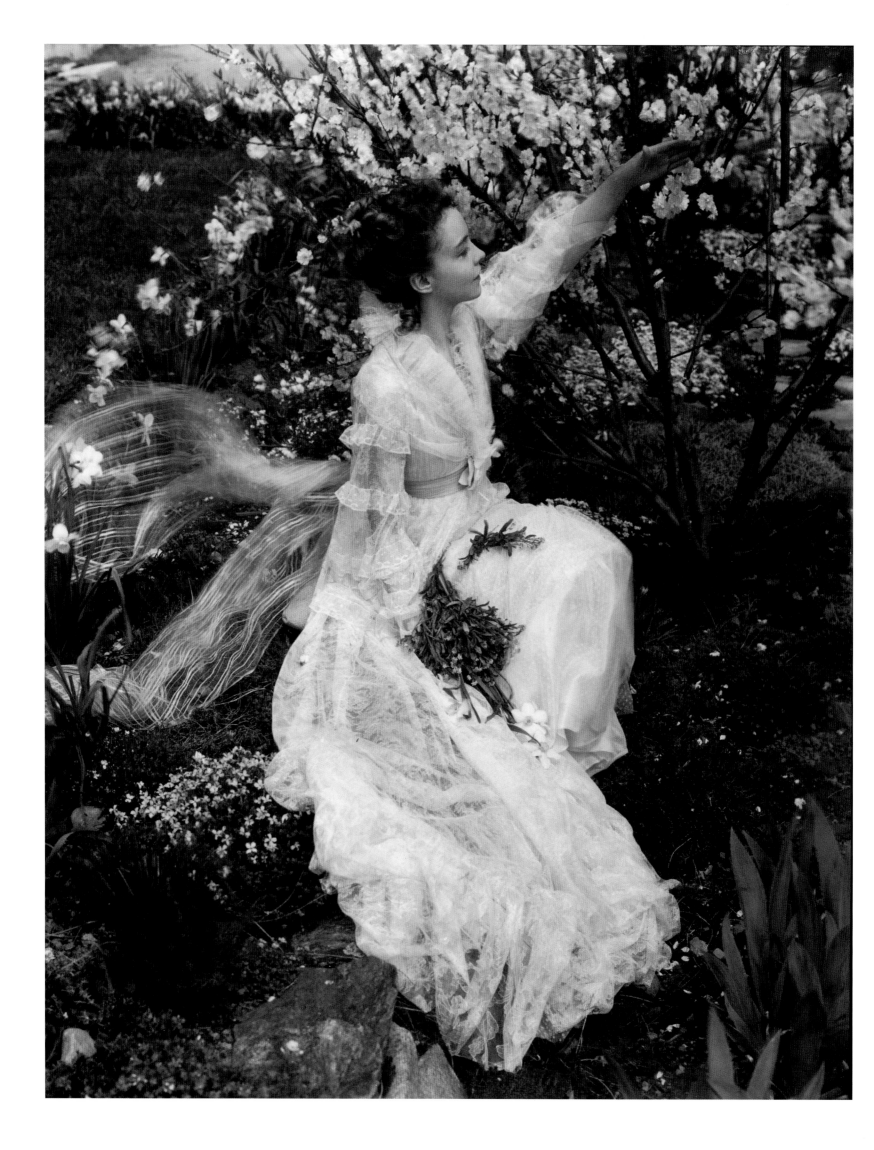

In 1925, Gish accepted a lucrative contract with Metro-Goldwyn-Mayer that allowed her creative input in the production of her films—a power few other women had at the time. Wanting to take on serious fare, she gravitated toward adaptations of classic literature with *La Bohème* (1926) and *The Scarlet Letter* (1926). However, the most significant film she made at MGM was *The Wind* (1928), adapted from the 1925 novel of the same name. It was the one over which Gish had the most creative control and is now recognized as a masterpiece of the silent era.

As the 1920s came to a close and cinema changed with the arrival of sound, Gish returned to the Broadway stage, where she would have success for the rest of her career. Of her profession she said, "Acting is the most exacting work in the world. It takes all one's energy, absorbs ambition, and is intolerant of age." And yet, she continued to make intermittent film appearances in her later years, with noteworthy performances in *The Night of the Hunter* (1955), *The Unforgiven* (1960), and her final film, *The Whales of August* (1987). Because so many of her early films were lost, she became a lifelong advocate for film preservation and was instrumental in the acquisition of Griffith's work by MoMA. Her own legacy is preserved in those nitrate reels—herself immortalized as a pioneer of the film industry.

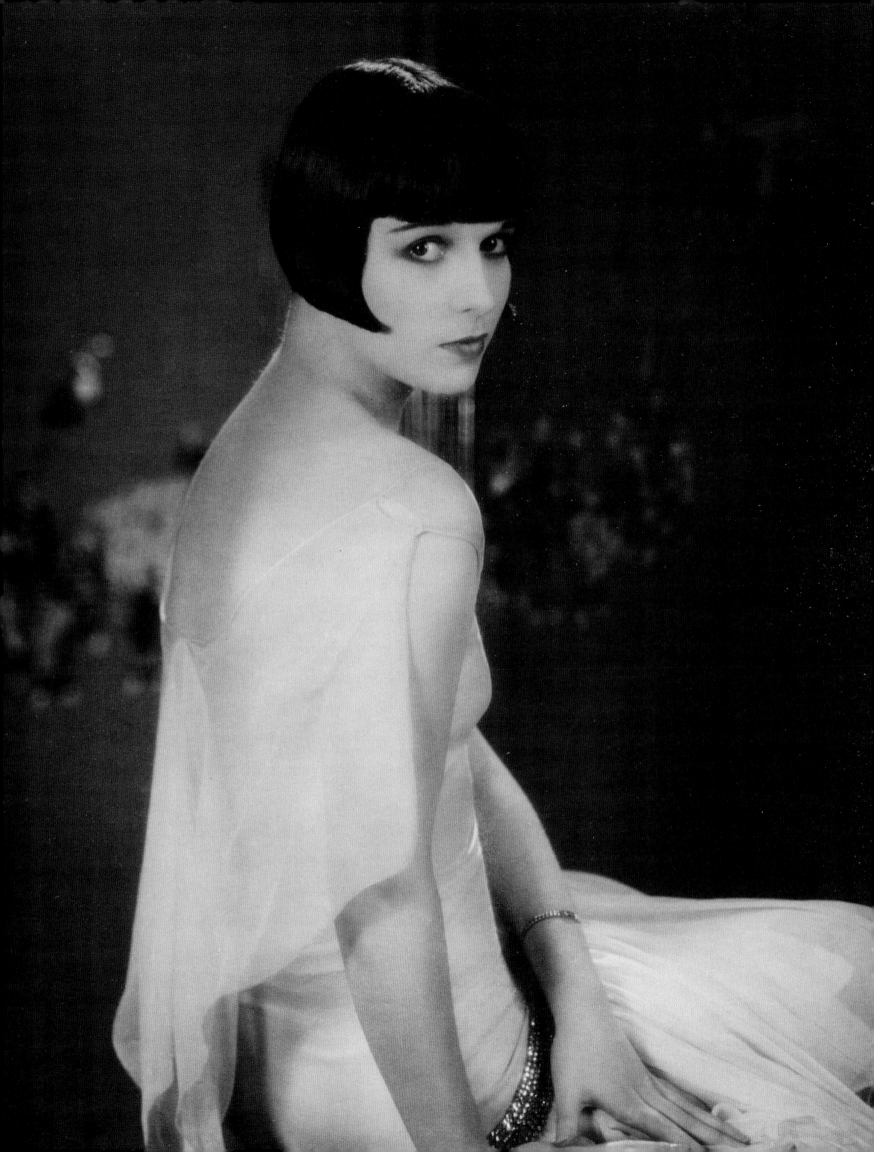

LOUISE BROOKS

1906–1985

Few women could claim to be as decade-defining as Louise Brooks was to the Roaring Twenties. With her jet-black bobbed hair and devil-may-care attitude, she epitomized the flapper both on-screen and off by wholly embodying the freedom and decadence that colored the era. She was the most modern of the moderns and enjoyed a sexually liberated lifestyle that became central to her cinematic persona. In each of her films, she effortlessly merged her own identity with that of her character, which resulted in a dramatic style so artfully natural it appeared as though she were not acting at all. Even as she rose to fame, she retained an air of insouciance—beneath which she concealed an immutable distaste for Hollywood and its politics. In refusing to bow to the demands of the studios, she proved herself too rebellious to fit into the system and ultimately withdrew from the film industry. Nevertheless, she endures as an incontestable icon of the silent era.

Mary Louise Brooks was born on November 14, 1906, in Cherryvale, Kansas, to a mother who was heavily invested in her cultural education. Raised in a musical household echoing with the sounds of Debussy and Ravel, Louise developed a talent for dance and began her professional career at fifteen. When she moved to New York City in 1922, she seized the opportunity to reinvent herself, acknowledging that "if I was to create my dream woman, I had to get rid of my Kansas accent, to learn the etiquette of the social elite, and to learn to dress beautifully." She joined the prestigious Denishawn Dance Company and performed alongside other notable dancers while on tour from 1922 to 1924. During this period, she

This portrait was taken by Alexander Binder at his Berlin studio in 1928—the year Louise Brooks left Hollywood. It was in Germany that she would make her two most influential films and reach the zenith of her career.

claimed, "I learned to act from watching Martha Graham dance." After being fired from the company by founder Ruth St. Denis for her haughtiness, Brooks quickly found work as a chorus girl in the Broadway revue *George White's Scandals*. She would move on to the better-known *Ziegfeld Follies* as a seminude dancer in 1925, through which she attracted the attention of studio producers. Before the end of the year, she had contract offers from both Metro-Goldwyn-Mayer and Paramount Pictures.

Brooks signed a five-year contract with Paramount and had her screen debut as a moll in *The Street of Forgotten Men* (1925). She made quick work of establishing her acting career, appearing in six full-length pictures within her first year at the studio. In 1926, she secured substantial roles in *The American Venus* (1926), *Just*

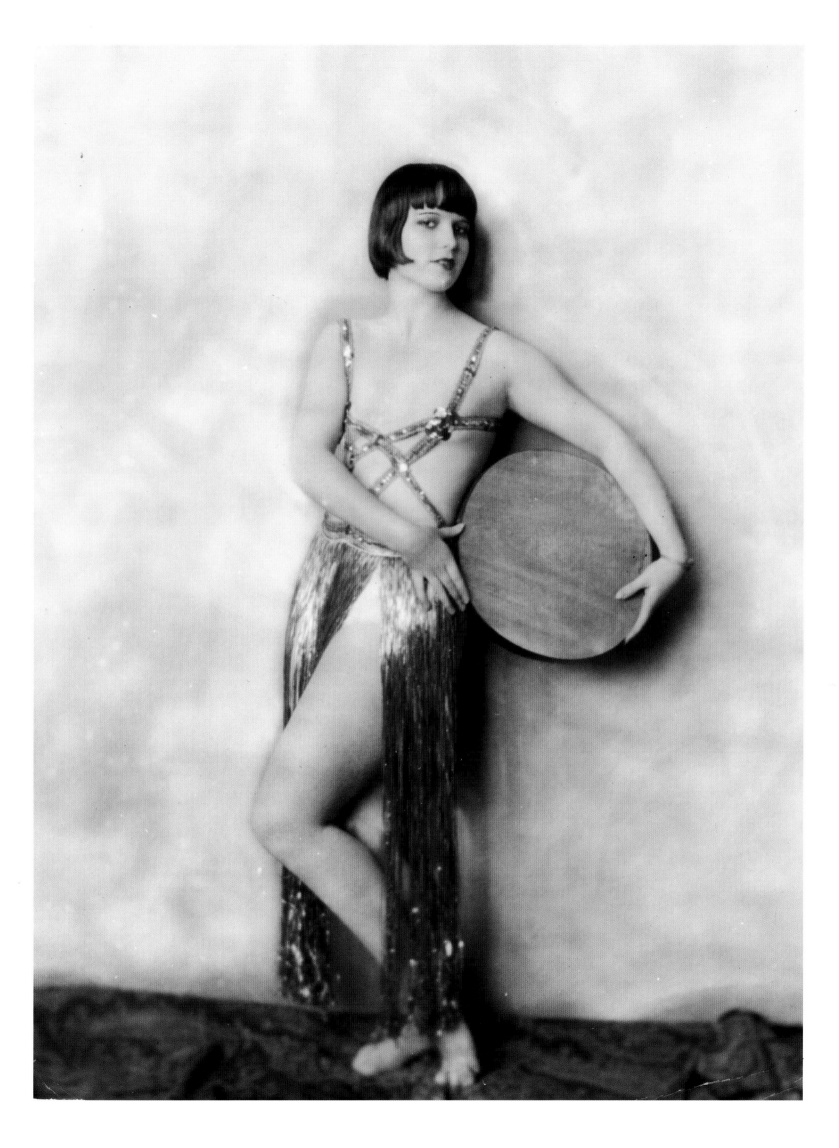

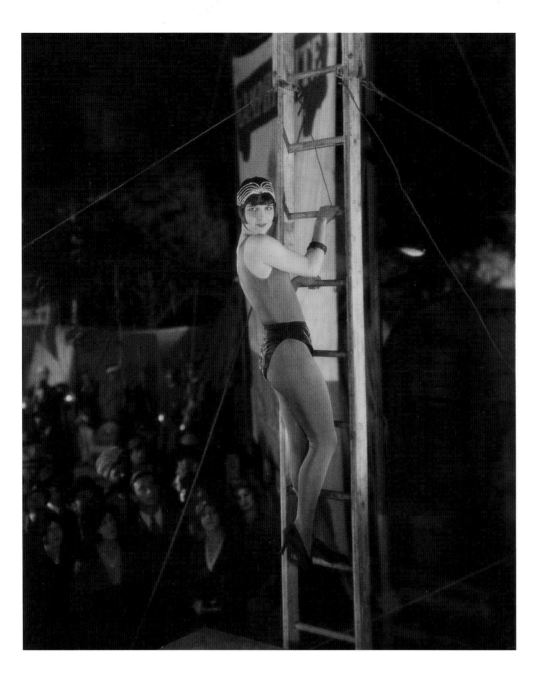

LEFT

Brooks plays the sideshow siren Mam'selle Godiva in *A Girl in Every Port* (1928, Fox Film Corporation, dir. Howard Hawks). In one particularly memorable scene captured in this promotional photo, she performs a high dive into a shallow tank of water.

BELOW

Brooks takes her perch in this lobby card for *The Canary Murder Case* (1929, Paramount Pictures, dir. Malcolm St. Clair). In the pre-Code mystery, she plays a conniving showgirl known as "The Canary" who is killed after a failed blackmail attempt.

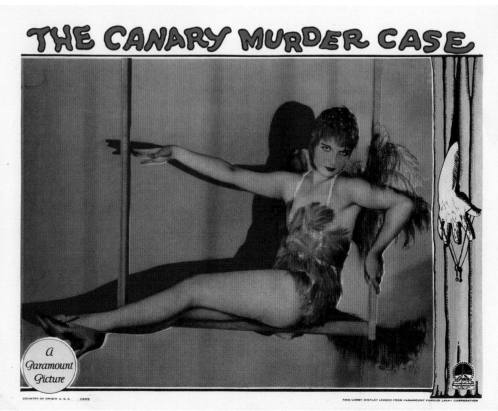

In this studio portrait from the height of her tenure at Paramount Pictures c. 1927 (possibly by Richee), Brooks is clad in a gold lamé gown emblematic of the glamorous trappings of Hollywood that she would soon abandon for the decadence of Berlin.

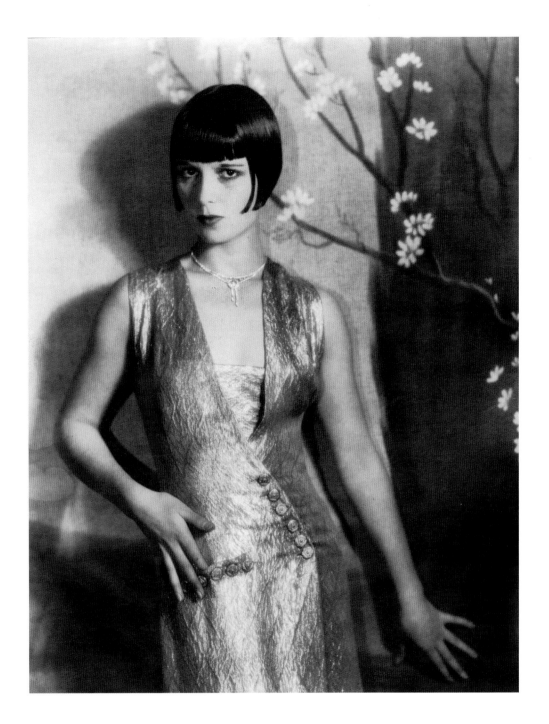

Another Blonde (1926), and *It's the Old Army Game* (1926). She solidified her flapper persona the following year in the films *Rolled Stockings* (1927) and *Evening Clothes* (1927), both now lost. Brooks was loaned out to the Fox Film Corporation for Howard Hawks's *A Girl in Every Port* (1928), in which she played a mysterious vamp who comes between two sailor friends. The film's success would change the course of her career and earn her a fan following. Next came another loan-out to Fox for the adventuresome *Beggars of Life* (1928). In what is considered her best performance in an American film, she played a nameless girl who goes on the run after killing her lecherous stepfather. Brooks spends much of the film riding the rails with a gang of hoboes while disguised as a boy. That she looked so at home in men's clothing instigated questions surrounding her sexual ambiguity—and though she repeatedly voiced her preference for men, she did not discourage rumors of bisexuality.

LOUISE BROOKS

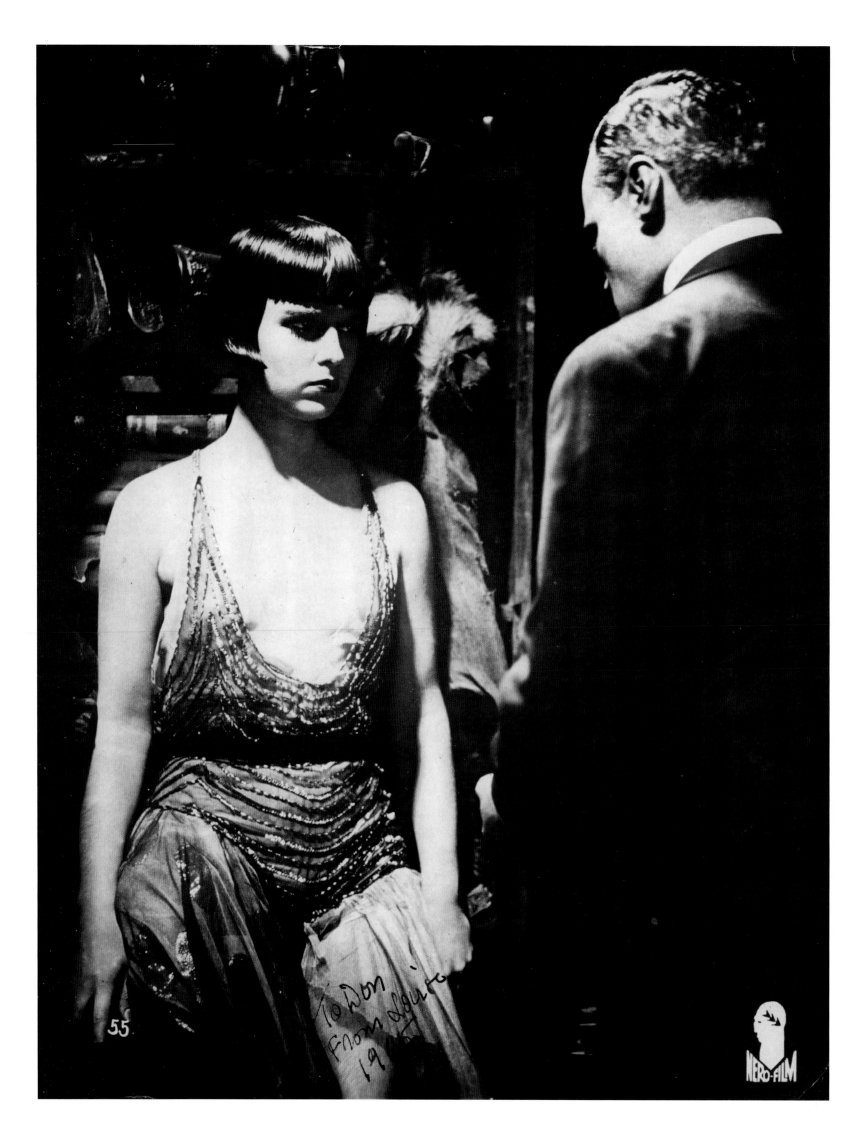

Emboldened by the success of her last few films, Brooks went to Paramount studio executive B. P. Schulberg for a raise. When he denied it, she responded with an obstinate refusal to work. It was a negotiating tactic that would be more commonly employed by high-profile actresses in the following decade, but this rebellious act was certainly ahead of its time. Her frustration with the industry was nearing its boiling point—and just as her star was rising in Hollywood, Brooks brazenly decided to take her leave. She had been beckoned to Berlin by the prominent Austrian director G. W. Pabst, and on the final day of shooting *The Canary Murder Case* (1929), she took off for Europe. The industry-shaking arrival of sound necessitated reshoots in order to release *Canary* as a talkie, but Brooks couldn't be bothered. Even when Paramount offered $10,000 for her to return, she stubbornly refused. Outraged by her impudence, the studio hired another actress to dub Brooks's lines, publicly blamed the vocal swap on her inadequate speaking voice, and effectively blacklisted her. Still, her bold departure ultimately proved to be her most beneficial career decision.

When Brooks landed in Germany in 1928, she was thrust into the exuberance and unabashed hedonism of the Weimar Republic—an environment in which she would flourish. She recalled that pivotal moment: "In Hollywood, I was a pretty flibbertigibbet. . . . In Berlin, I stepped onto the station platform to meet Pabst and became an actress. I would be treated by him with a kind of decency and respect unknown to me in Hollywood."

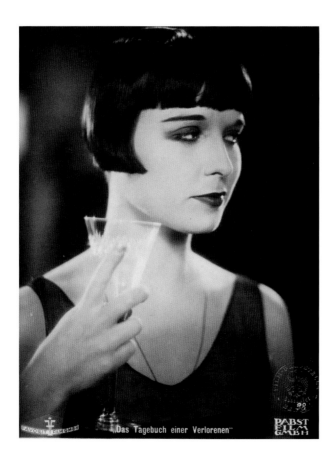

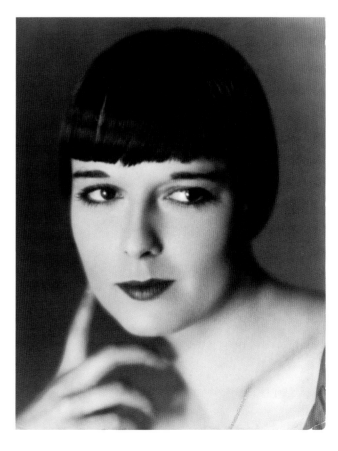

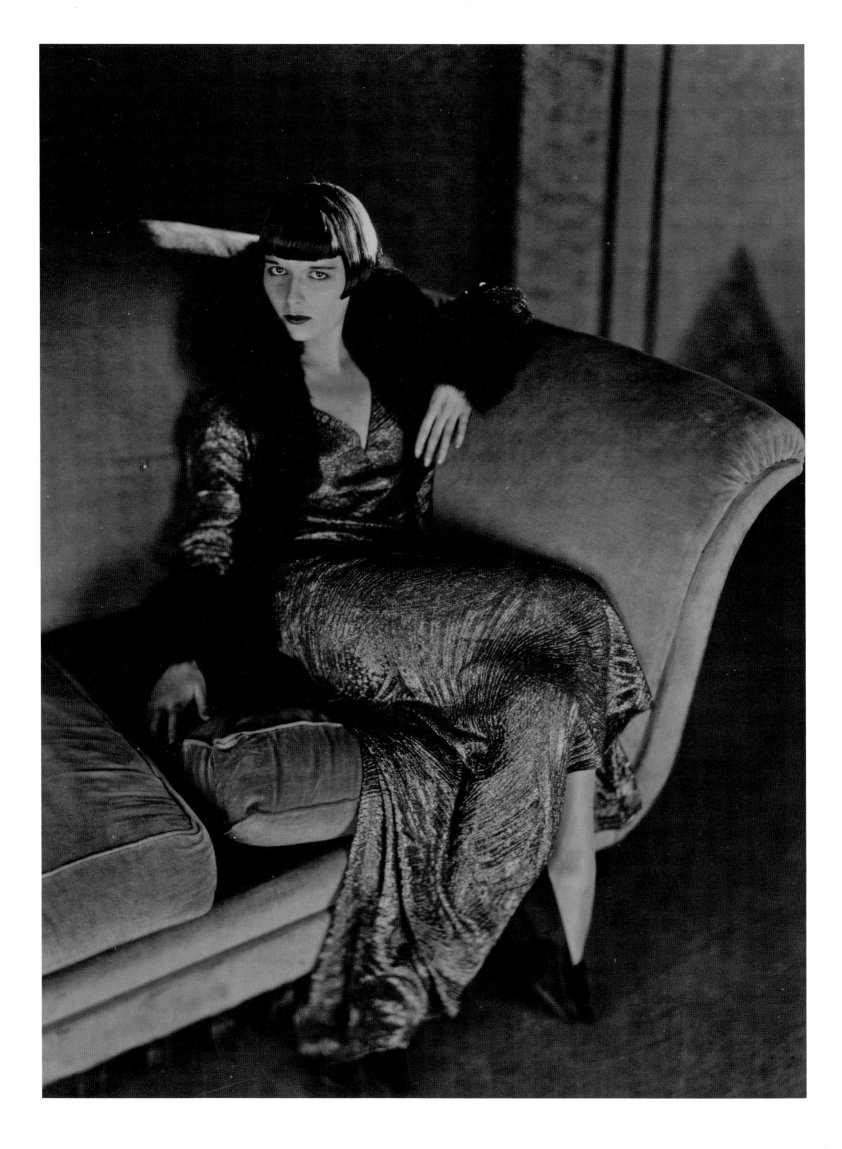

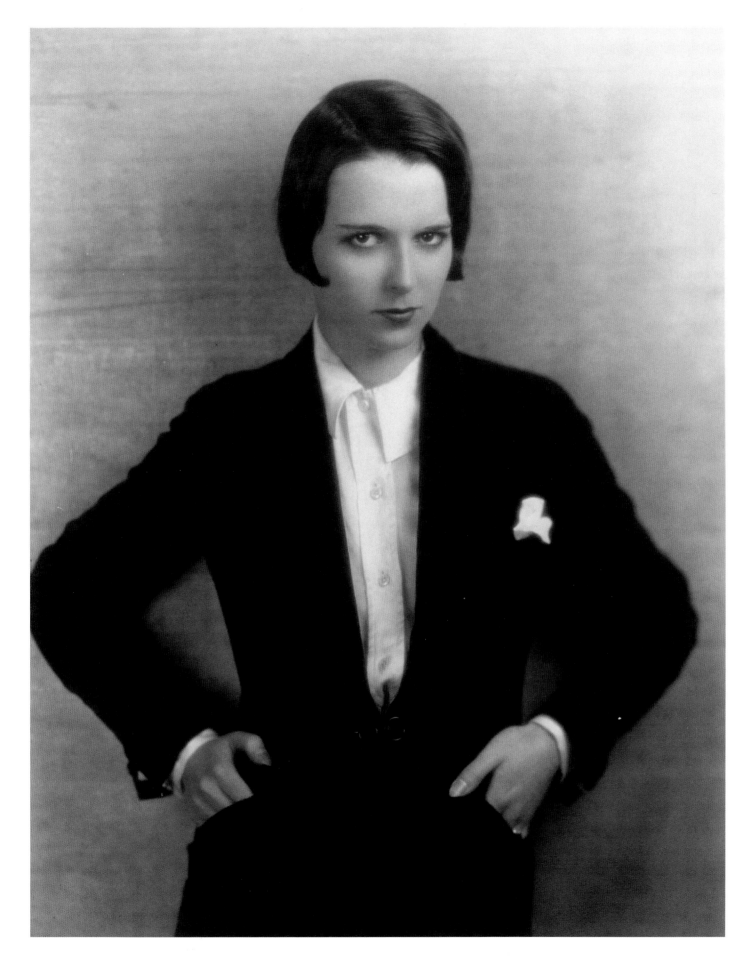

OPPOSITE

In this promotional photo for *Prix de Beauté,*
Brooks is gowned to the apex of sophistication
by Parisian couturier Jean Patou for her role as a
beautiful typist whose life changes upon winning
the "Miss Europe" beauty pageant.

ABOVE

In this Paramount studio portrait taken by Richee c. 1927,
Brooks has perfected the garçonne look—an androgynous
style adopted by fashionable women in the 1920s. The ease
with which she wore masculine attire fueled rumors about her
sexuality, which she took pleasure in perpetuating by admit-
ting to lesbian dalliances.

Brooks found her career-defining role in *Pandora's Box* (1929)—a lurid melodrama that chronicles the downward spiral of a wanton woman whose sexual fervor proves destructive to herself and everyone she encounters. The film was based on two well-known plays by Frank Wedekind, and German audiences responded with indignation that an American actress was cast in the lead role of Lulu. Pabst had searched for his leading lady for months before he saw Brooks in *A Girl in Every Port* and decided that she was the one. Of his instinctive choice, Brooks later said, "It was clever of Pabst to know even before he met me that I possessed the tramp essence of Lulu." The beauty of her performance, however, was the nuance that Brooks brought to that tramp role. From what could have been a one-note exhibition of sexual depravity came the captivating paradoxical display of innocence and promiscuity. Brooks brought the same duality to her second film with Pabst, *Diary of a Lost Girl* (1929)—another sordid story of naivety that devolves into prostitution. Both movies were heavily censored due their frank portrayals of sex, but nevertheless succeeded in turning Brooks into an international celebrity. The French drama *Prix de Beauté* (1930) would be her last European film—and her first talkie. However, because she did not speak the language, all of her dialogue and singing were dubbed.

BELOW
This 1928 photograph of Brooks taken by Edward Steichen was published in the January 1929 issue of *Vanity Fair*. Her contemplative gaze captures her natural proclivity for aloneness.

OPPOSITE
Brooks is impeccably stylish in this 1928 promotional photograph for Paramount Pictures taken by Richee. She wears a fringed evening dress similar to "the Louise Brooks evening gown" designed by Sally Milgrim that appeared in a 1926 print ad. Brooks admitted to having difficulty with dressing fashionably at the beginning of her career, but would become the epitome of chic in her studio days.

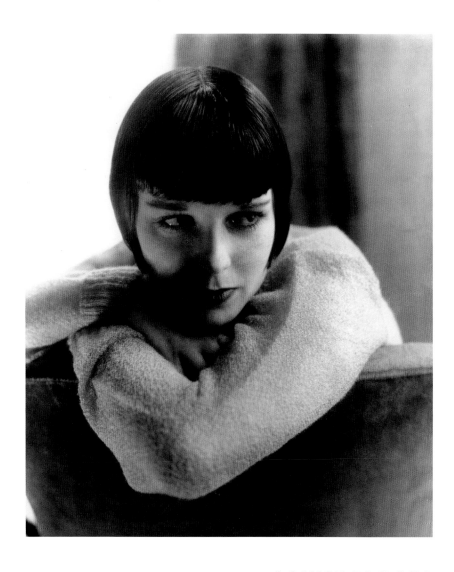

LOUISE BROOKS

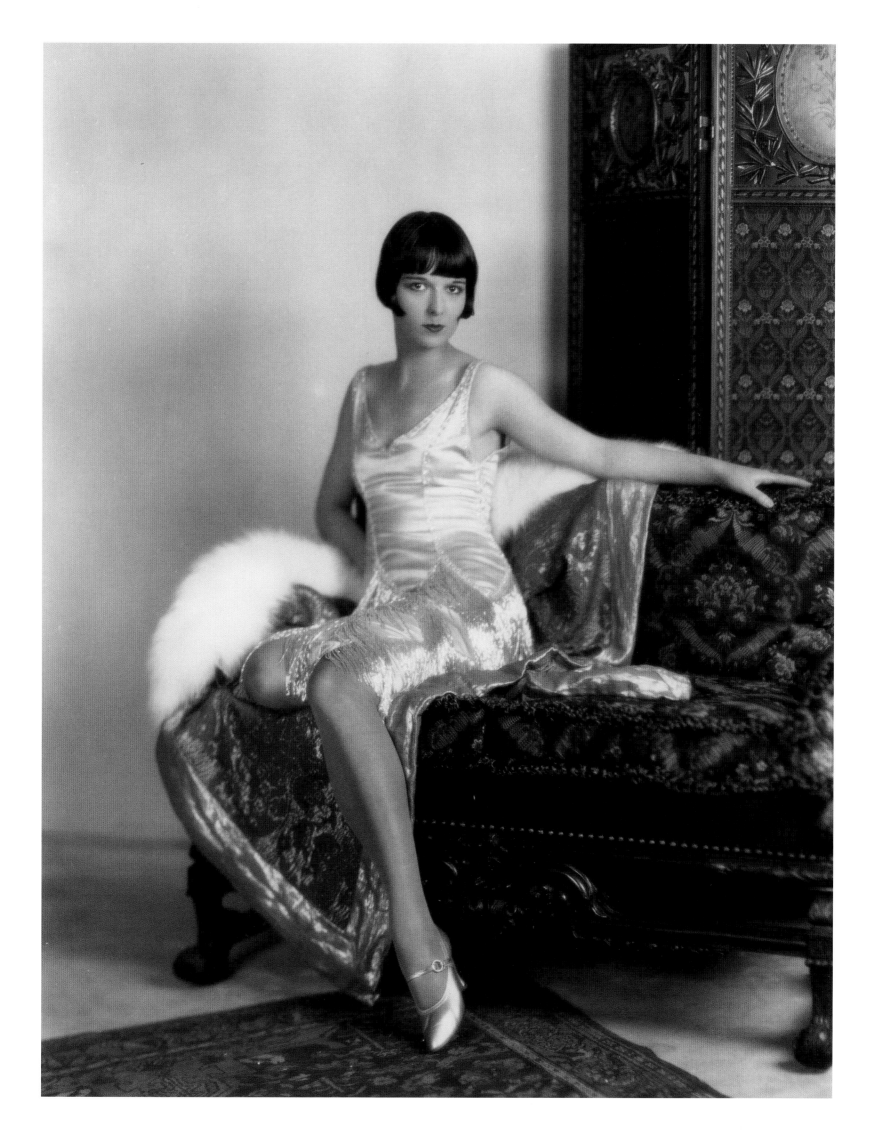

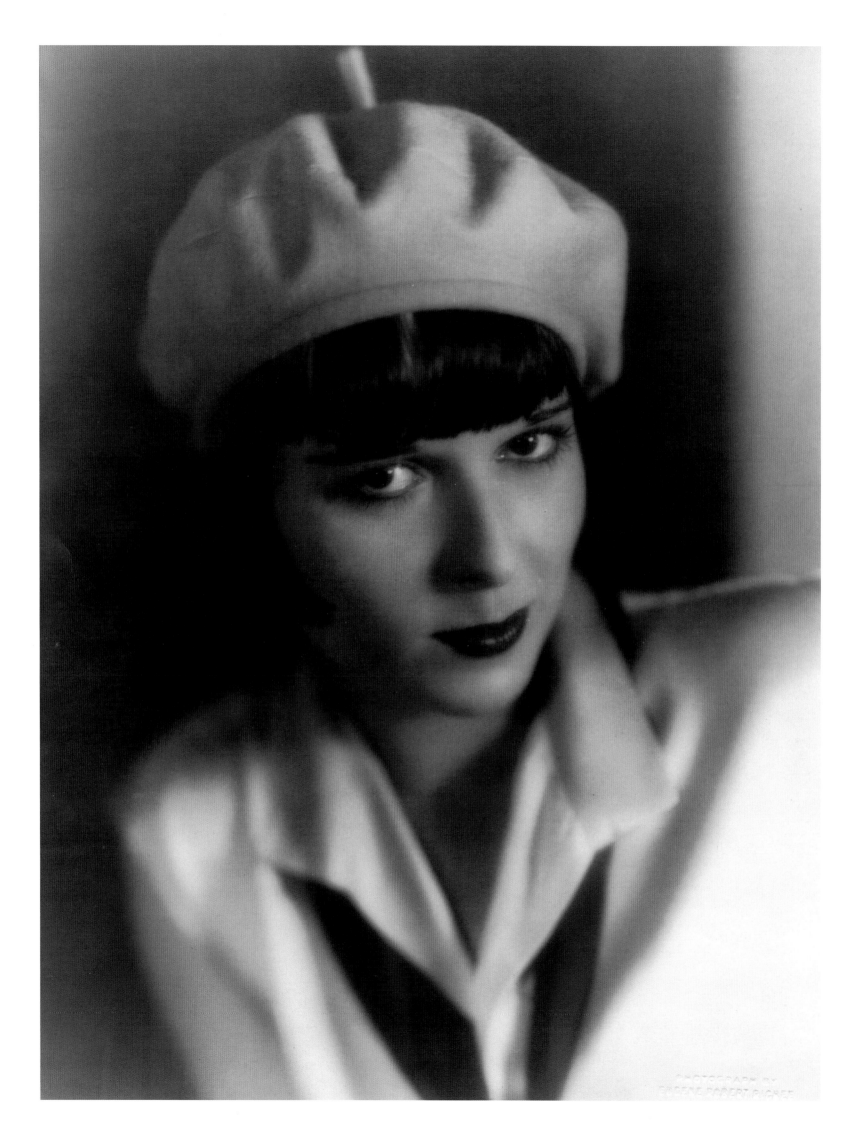

In this undated Paramount Pictures studio portrait by Richee, Brooks possesses an air of Parisian chic. Of her continental deportment, G. W. Pabst said, "Louise has a European soul.... She belongs to Europe and the Europeans." Even the angular quality of her famous haircut lent itself to the graphic style lines of the German Expressionist aesthetic.

In this 1927 photograph by Richee for Paramount Pictures, Brooks wears a softer variation of her signature hairstyle, baring a forehead that some believed was "too high" to be photographed. In an even more dramatic departure from her trademark bob, Brooks wore a riotously curly hairstyle in *Evening Clothes* (1927).

This undated portrait by Richee, handcolored by Claire Van Scoy, is a rare depiction of the actress who was almost exclusively seen through black-and-white films and photographs. A few seconds of Technicolor film that survive from a screen test for *The American Venus* (1926) are the only color film footage of Brooks during her heyday known to exist.

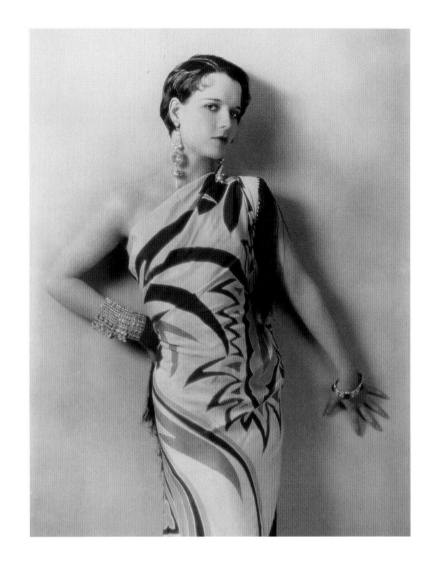

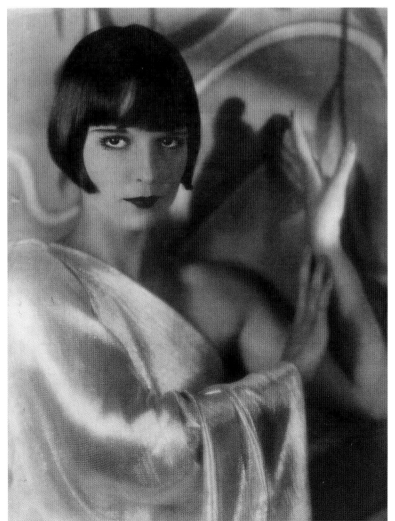

Having achieved stardom in Europe, Brooks was summoned back to Hollywood with the promise of a contract with Columbia Pictures. Upon her return, she faced unwanted advances from studio head Harry Cohn, which she firmly rebuffed. The Columbia offer was withdrawn, but Brooks managed to get cast in two mainstream films—*God's Gift to Women* (1931) at Warner Brothers and *It Pays to Advertise* (1931) at Paramount. When she turned down the female lead in *The Public Enemy* (1931) and the coveted role went instead to Jean Harlow, her acting career suffered a downturn from which it would never recover. She played bit parts throughout the 1930s and made her final film appearance in the Western *Overland Stage Riders* (1938) starring John Wayne. By that point, her discontent with Hollywood had escalated into bitter hatred. Even when her career was on the ascent, she harbored the persistent desire to walk away from it: "Someday, I thought, I would run away from Hollywood forever. Not just the temporary running away I did after making

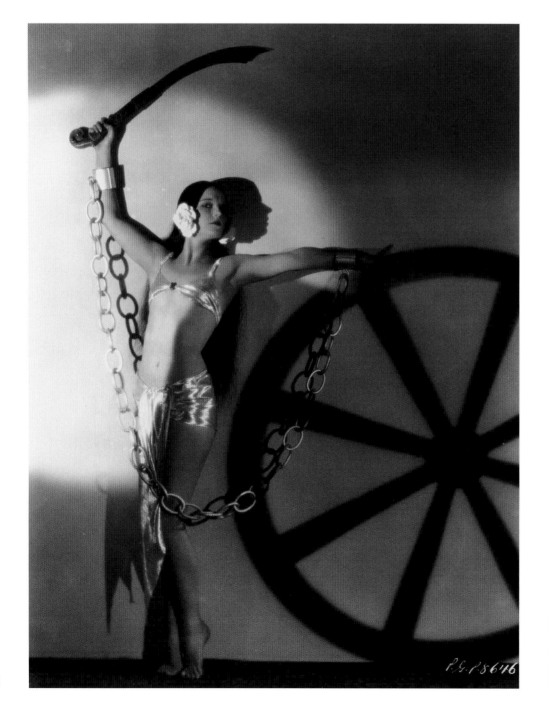

Long-haired and bikini-clad, Brooks is nearly unrecognizable in this stylized image from a promotional photo shoot with George Hommel from about 1928.

Brooks poses with a pair of pearl and silver inlaid pistols from Paramount's valuable collection of firearms in this undated, dangerous-looking promotional photograph.

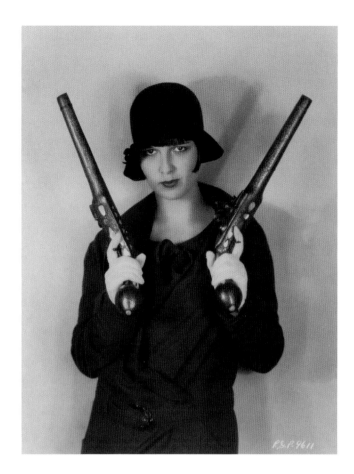

each of my films—but forever." She left for good in 1940. After an unsuccessful attempt to open a dance studio in her native Kansas, Brooks returned to New York City where she endured financial hardship.

When Brooks's films were rediscovered by French film buffs in the 1950s, her popularity was revitalized. Central to this revival was her prominent feature in the exhibition *60 Years of Cinema* at the Musée d'Art Moderne—which spurred film archivist and exhibition organizer Henri Langlois to proclaim, "There is no Garbo! There is no Dietrich! There is only Louise Brooks!" In 1957, Langlois organized a retrospective of her work attended by Brooks at the Cinémathèque Française, which he founded. She received another resurgence of fame in 1979, when an extensive profile on her life and career written by Kenneth Tynan was published in the *New Yorker*, entitled "The Girl in the Black Helmet."

Louise Brooks had a second career as a writer, penning articles for specialist film magazines and eventually compiling a series of essays into a substitutive memoir published in 1982 called *Lulu in Hollywood*. Narrated with disarming acuity and devoid of self-pity, her autobiographical writings brought piercing insight to her turbulent relationship with the film industry. In one passage, she confesses to being "born a loner, who was temporarily deflected from the hermit's path by a career in the theatre and films." In the end, it was her staunch individualism that led to her remarkable legacy. And though her name may have disappeared from Hollywood for a time, her image remains eternal.

LOUISE BROOKS

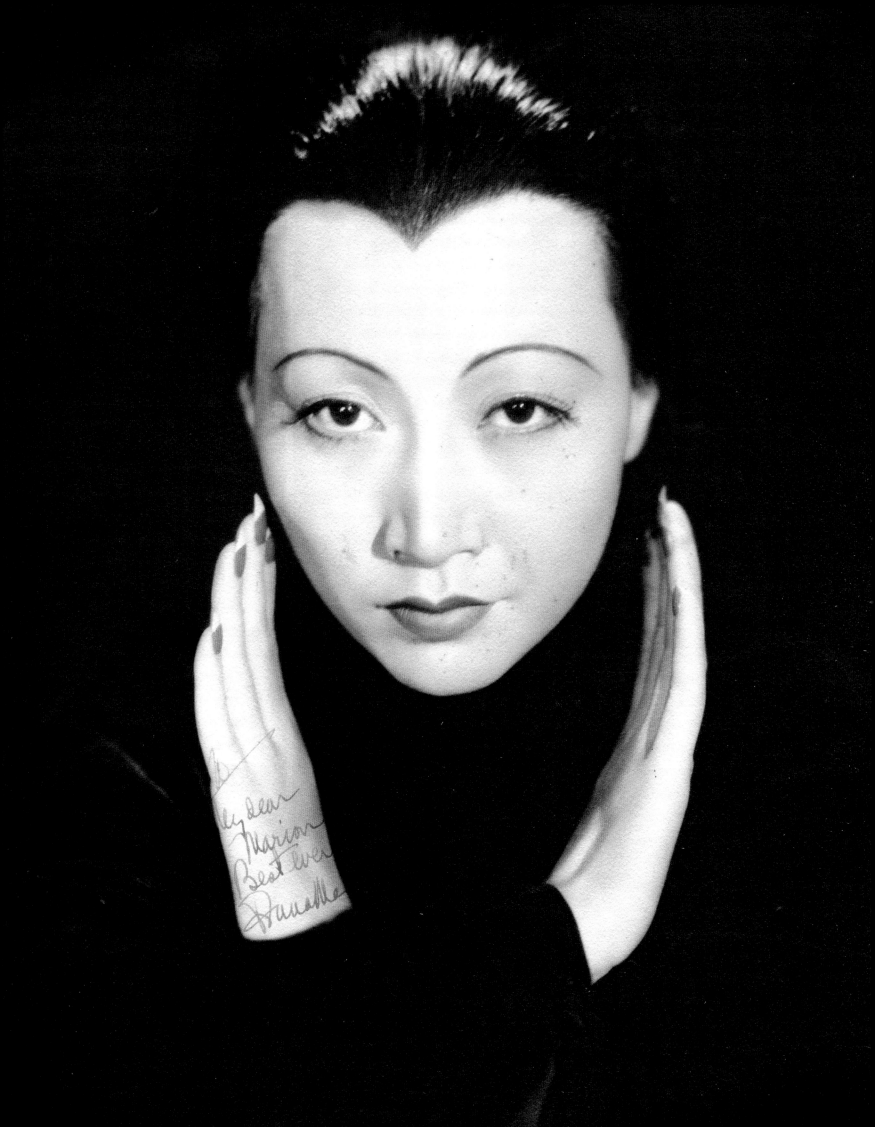

ANNA MAY WONG

It was with unwavering courage and relentless ambition that Anna May Wong forged a path to becoming the first Chinese American film star. She rose to fame during the dawn of the studio era and was internationally renowned for her entrancing on-screen presence, virtuosic acting ability, and impeccable style. However, hers was an ascent that proved more arduous than those of her white Hollywood counterparts, impeded by racial discrimination and restrictive legislation. The prevailing stereotypes of Asian women predominantly limited Wong to two stock characters—either the tragic, submissive "Butterfly" or the mysterious, domineering "Dragon Lady." Still, she delivered each performance with an astonishing display of grace and dignity, even in the most thankless of roles. That her career was so compromised by racial politics makes her success all the more awe-inspiring. A true trailblazer with courageous spirit, Wong achieved a remarkable feat that changed the narrative for marginalized women in the movie industry.

This c. 1930s autographed photo addressed to actress Marion Davies is a testament to Anna May Wong's position among the Hollywood elite. For fans, she commonly used the sign-off "Orientally yours"—perhaps as a wry acknowledgment of the racial typecasting that largely defined her film career and public persona.

Born on January 3, 1905, in Los Angeles, Wong Liu Tsong was the daughter of a laundryman, and became captivated by cinema at a young age. Using her lunch money and tips collected from laundry deliveries, she made a habit of sneaking out of school to go to the movies. Her family strongly disapproved of her fascination with film, yet she set her sights on becoming an actress and began using the anglicized stage name "Anna May Wong" by the age of eleven. It was at this time that the moviemaking industry moved west to Hollywood, and nearby neighborhoods like Chinatown became popular shooting locations. This gave the deter-

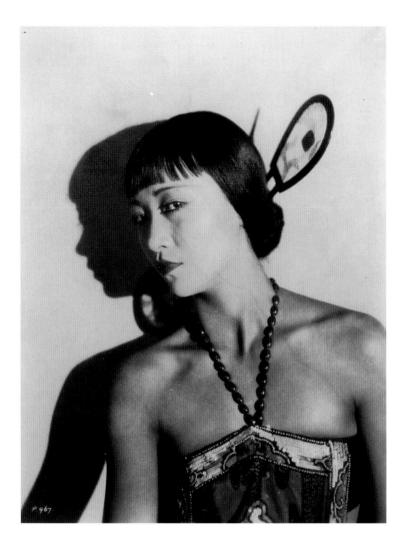

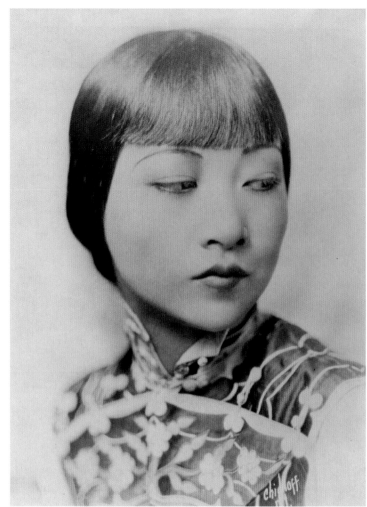

mined little Anna May ample opportunity to hang around film sets and insist that filmmakers give her a part. Her big moment finally came in 1919, when she made her screen debut as an uncredited extra in *The Red Lantern*.

Wong landed her breakout role in *The Toll of the Sea* (1922)—a variation on the *Madame Butterfly* story and the first feature film made using two-strip Technicolor. At just seventeen years old and in her first starring role, she astonished audiences and critics with her heartbreaking, nuanced performance. She played Lotus Flower, a young Chinese woman who falls in love with a visiting American man, only to be later abandoned for a new American wife. Lotus Flower's tragic death is implied at the end of the film—an outcome that would cement Wong's destiny to undertake similarly ill-fated characters throughout her career. However, she took on an entirely different type in her next big film, *The Thief of Bagdad* (1924), starring the swashbuckling Douglas Fairbanks. She makes a memorable appearance as a devious Mongol slave girl, scantily clad in a revealing two-piece ensemble. It is a costume that Wong would wear many versions of in subsequent films that saw her cast as the sexualized "other"—much to the consternation of her family. Still, she persisted in her quest for movie stardom.

ABOVE LEFT
A publicity photo for *The Thief of Bagdad* (1924, United Artists, dir. Raoul Walsh). Although she only appears briefly on-screen, Wong's scene-stealing turn in this film proved pivotal in her rise to stardom.

ABOVE RIGHT
Even in the early days of her career, Wong had already mastered the art of the portrait, as can be seen in this 1925 photograph by Irving Chidnoff. She would go on to shoot with some of the most celebrated photographers of her time.

Wong's initial success was followed by a series of marginal roles in which she was conscripted to play any character deemed exotic by white standards. These parts were not limited to generic portrayals of women from "the Orient," but also included Native American characters in *Peter Pan* (1924) and *The Desert's Toll* (1926). Exasperated by this repressive typecasting, Wong decided to leave Hollywood and pursue film roles in Europe. When her friends and relatives voiced their concerns about the move, she held firm to her resolve: "I considered all they said. Many of them advised against such a difficult and uncertain venture. Then I made up my mind—I would go."

A lobby card for *The Chinese Parrot* (1927, Universal Pictures, dir. Paul Leni). Wong was constantly exoticized and relegated to roles of foreign seductresses and provocative dancers in films such as this one.

In Europe, Wong found the prevailing attitudes toward her race much more favorable. She quickly learned to speak German and French and began working with filmmakers who sought to showcase her talent for acting in films such as *Piccadilly* (1929) and *Pavement Butterfly* (1929). The same year in London, she made her stage debut alongside a young Laurence Olivier in *The Circle of Chalk*. Although

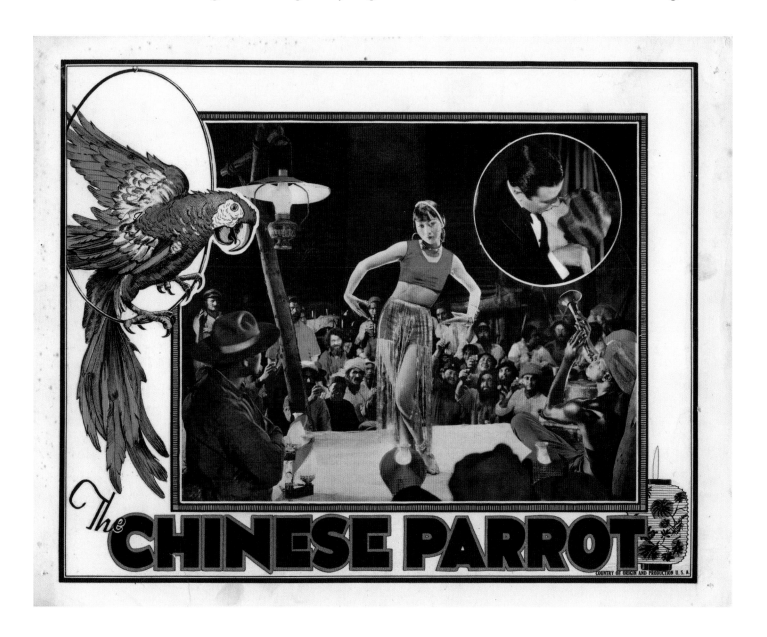

reviews praised her for her beauty, she was criticized for her "squeaky" Californian accent. Ever the industrious professional, she trained in elocution at Cambridge University and took up the fashionable Transatlantic accent. This put her in an advantageous position upon her return to North America, when talkies were taking off and studios were eager to offer contracts to well-spoken stars.

Wong signed a contract with Paramount Pictures and returned to Hollywood in 1931. Despite being a third-generation Californian and an internationally recognized movie star, she was still required to apply for reentry to the United States after each trip abroad. Persons of Chinese descent were subjected to racially discriminatory legislation that not only restricted their movement in and out of the country, but also placed limitations on American citizenship and landownership.

Perhaps most detrimental to Wong's career were the anti-miscegenation laws that prohibited interracial relationships—a restriction that carried over onto the silver screen and was strictly enforced under the Motion Picture Production Code. By this mandate, she was forbidden from engaging in on-screen intimacy with any of her white male costars, thereby preventing her from ever playing a romantic lead.

BELOW

A publicity photo from the British film *Piccadilly* (1929, British International Pictures, dir. E. A. Dupont) shows a captured Wong, who often claimed that she "died a thousand deaths" over the span of her film career. Although she escaped the worst of racial typecasting in Europe, she could not slip that fate here.

OPPOSITE

Throughout the 1920s, Wong was styled as a spirited young flapper. In the final scene of *Pavement Butterfly* (1929, British International Pictures, dir. Richard Eichberg), she wears the fashionable ensemble in this publicity photo, which captures the essence of this decadent era.

ANNA MAY WONG

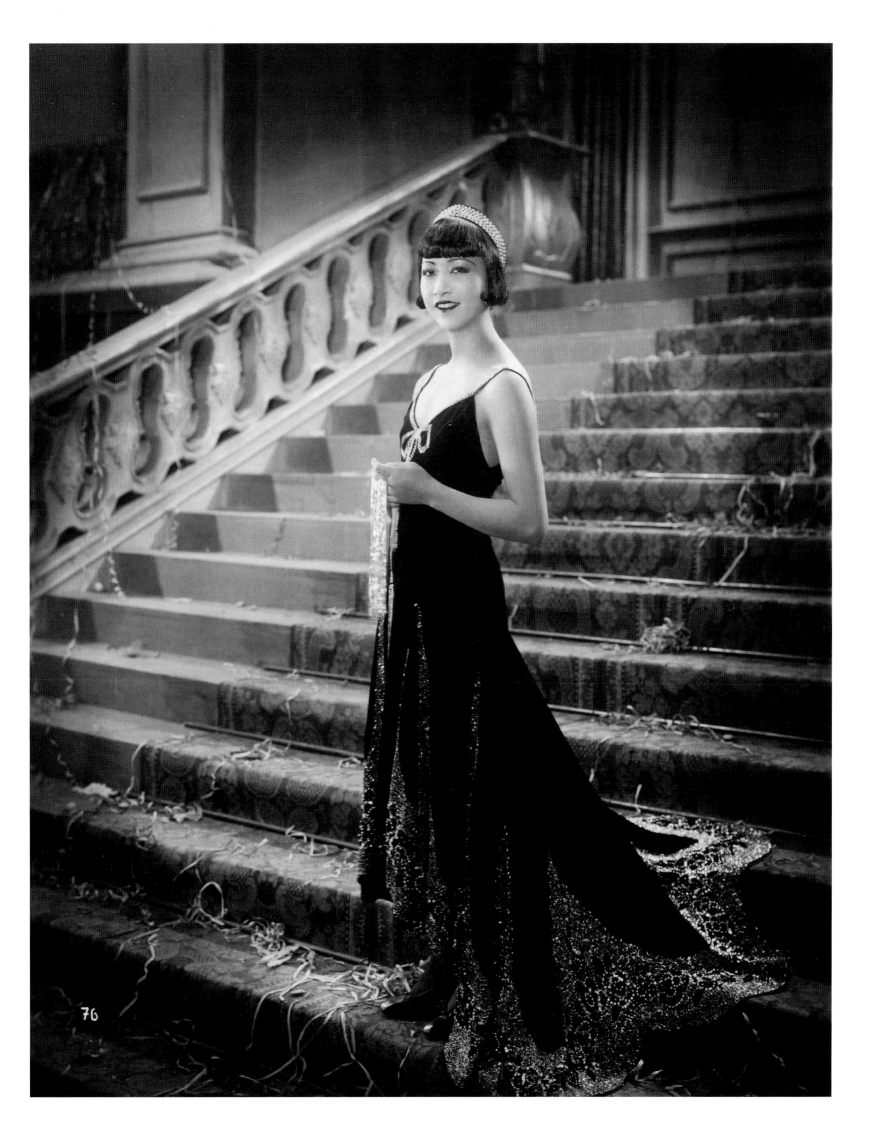

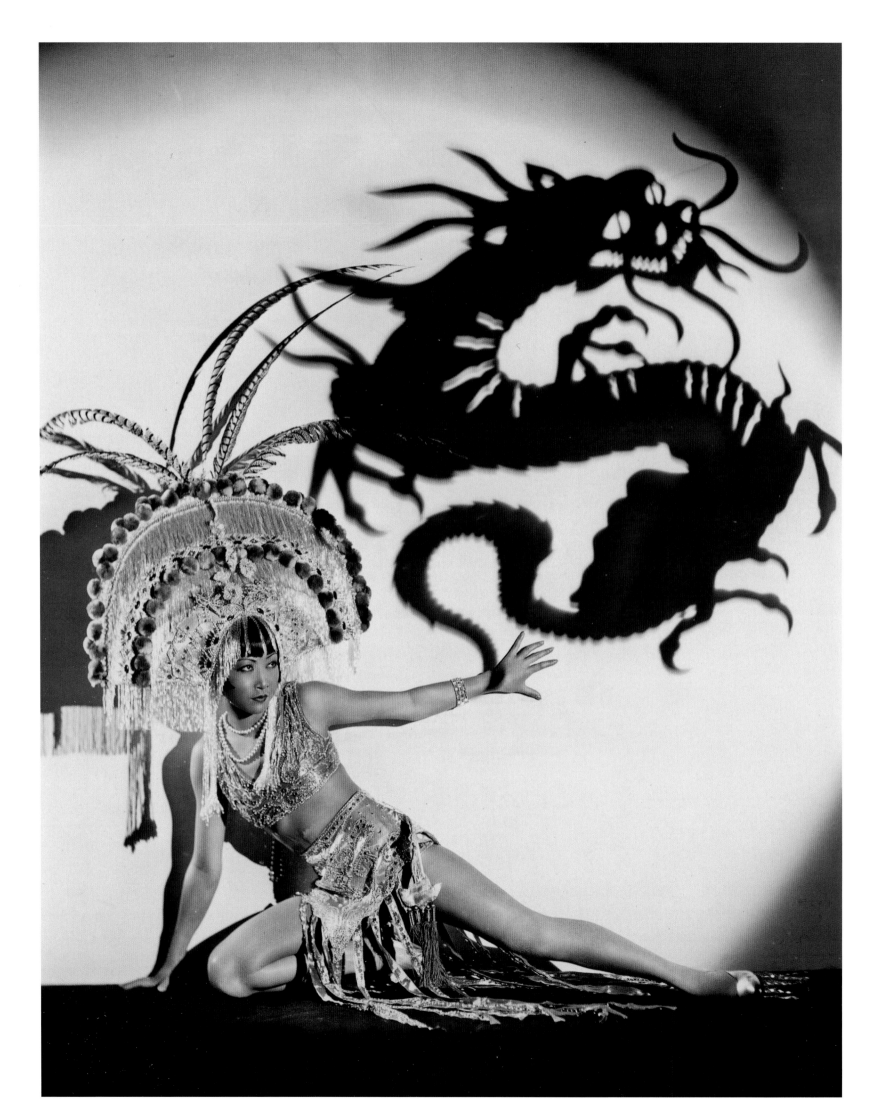

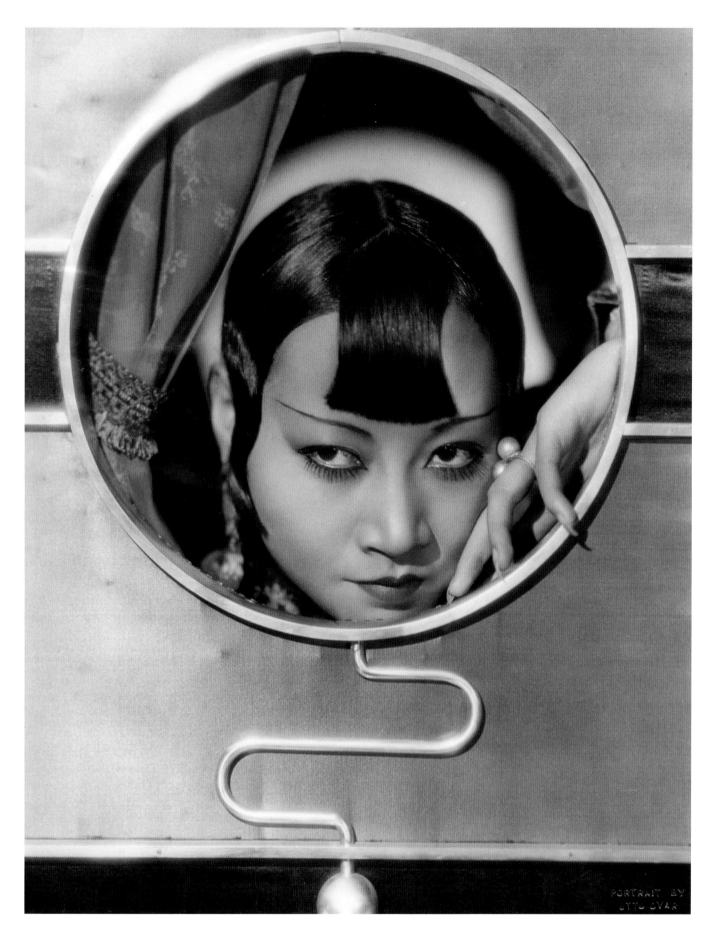

PORTRAIT BY
OTTO DYAR

OPPOSITE

In this publicity photo by Eugene Robert Richee, Wong epitomizes the Dragon Lady archetype as the child of Fu Manchu for *Daughter of the Dragon* (1931, Paramount Pictures, dir. Lloyd Corrigan). The use of the dragon to villainize Asian women in American cinema is ironic, given its auspicious and powerful symbolism in Chinese culture.

ABOVE

Wong was dramatically photographed by Otto Dyar for one of her highest-grossing and most popular films, *Shanghai Express* (1932, Paramount Pictures, dir. Josef von Sternberg).

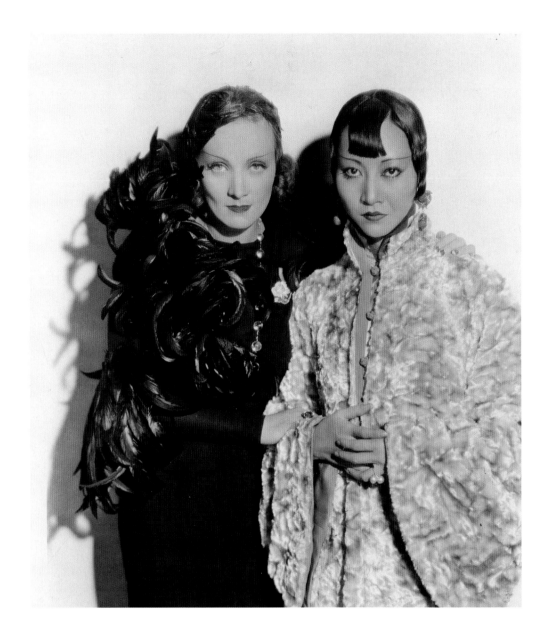

LEFT
This publicity photo for *Shanghai Express* captures the chemistry between Wong and costar Marlene Dietrich. They had become acquainted in Germany before they appeared together in the film. The sexual tension in their scenes fueled rumors of romantic involvement.

OPPOSITE
Throughout her career, Wong was forced to reconcile her concurrent Chinese and American identities—aptly captured in this 1932 Paramount studio portrait by Dyar. Hers was an incredible balancing act that considered audiences both at home and abroad.

As a result, she was confined to parts in which she would never get the guy and usually doomed to meet an untimely end. Such was the case in two of her best-known films—*Daughter of the Dragon* (1931) and *Limehouse Blues* (1934). However, these restraints on romantic involvement seemed less of an issue in Wong's personal life. She was an independent woman who loved her work and never married, declaring, "My career has been all important to me. I have thought of nothing else these years. I have learned to be self-reliant, to depend upon myself, to do things for myself."

Wong managed to escape death in her most famous film, *Shanghai Express* (1932). Although Marlene Dietrich received top billing, many believed she was upstaged in the scenes they shared. Wong played the vengeful courtesan Hui Fei, who kills a powerful warlord and ultimately rescues the train passengers who had been held hostage. Wong also lived to see the end of *Daughter of Shanghai* (1937), in which she was given the opportunity to play a Chinese American character, instead of

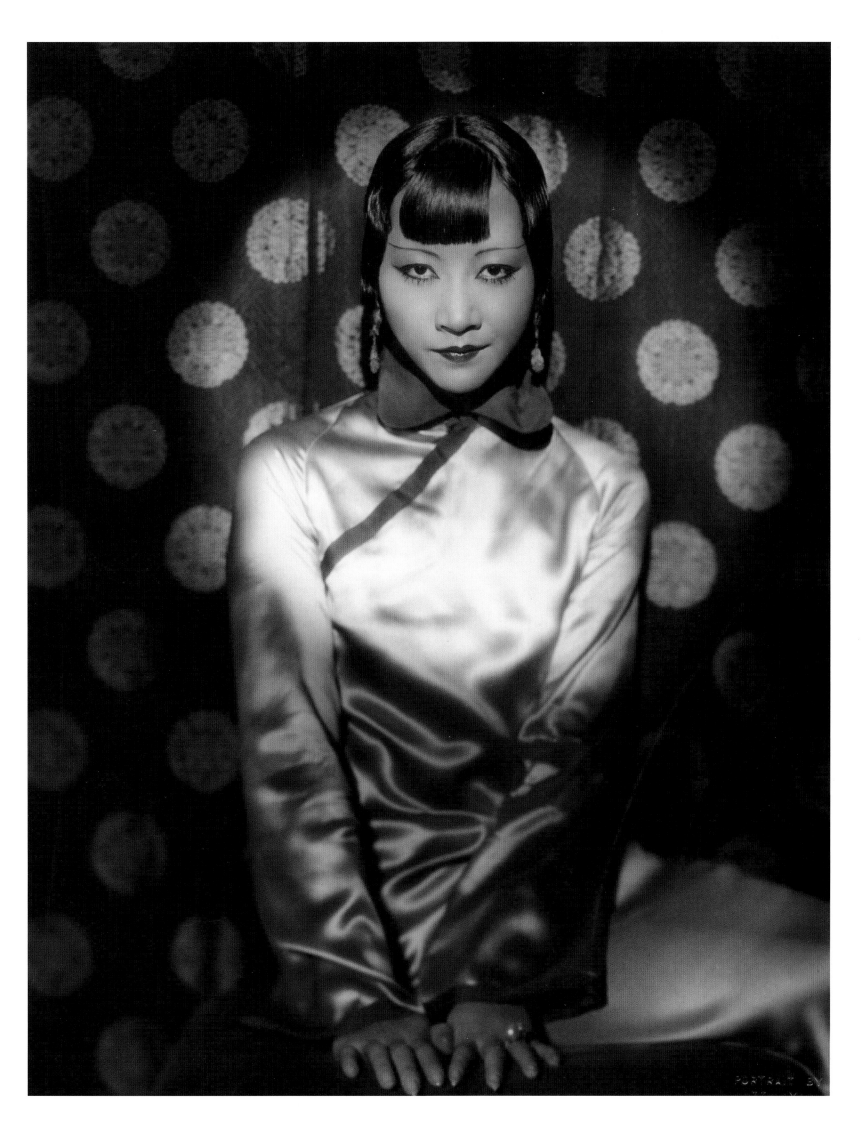

the usual exotic foreigner. The film is especially notable in that she starred opposite Korean American actor Philip Ahn—which finally allowed for the happy ending that had unfairly eluded her up to this point.

She unfortunately did not get her happy ending in 1935 in a casting debacle that proved to be the greatest injustice of her career. When MGM obtained the film rights to Pearl S. Buck's Pulitzer Prize–winning novel *The Good Earth*, Wong recognized the opportunity to at last secure a role worthy of her star power and talent. She lobbied for the lead character of O-lan and was certainly the obvious choice to star in a film that centered around a Chinese community. However, when the white actor Paul Muni was named the male lead, Wong's casting became a cruel impossibility. The role of O-lan went to German-born actress Luise Rainer, and the two would lead an all-white cast in yellowface. Wong was considered for the supporting character of Lotus, yet another unsympathetic concubine role. Her response to the insult: "I do not see why I, at this stage of my career, should take a step backward and accept a minor role in a Chinese play that will surround me entirely with an all-Caucasian cast." She refused—no longer would she suffer such an indignity.

Rather than remain in Hollywood after the devastating experience, Wong hired a cinematographer and went to China to make a film that prioritized her own perspective. During this work, she was at times met with condemnation for her unfavorable representation of the Chinese people for the sake of American au-

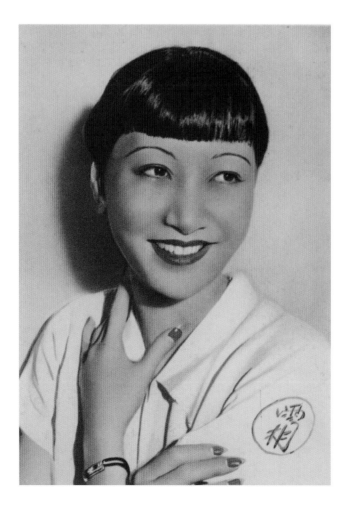

The blunt fringe hairstyle in this 1930 German postcard was famously associated with Wong and would be copied by fans around the world during the height of her career.

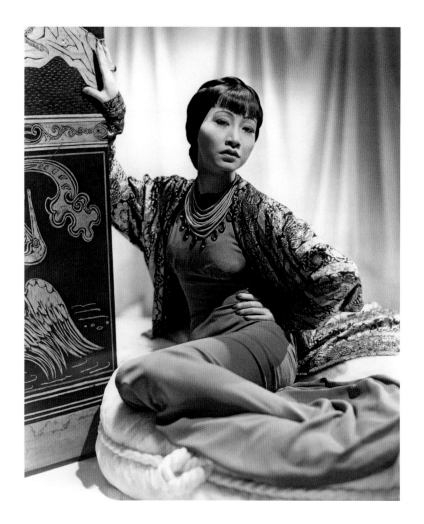

Publicity photo for *Dangerous to Know* (1938, Paramount Pictures, dir. Robert Florey), a film adaptation of *On the Spot*, in which Wong reprises the role she played in the original 1930 Broadway production.

diences—but these accusations were not unfamiliar to her. In considering her unique position between both worlds, she said, "I had to be sure whether I was really playing a Chinese [woman] or merely giving an American interpretation of one." For the whole of her acting career, she was forced to contend with the duality of her Chinese American identity and sought to honor both sides of her complex persona.

After World War II, Wong had mostly retired from film, but made several notable appearances on television in her later years. She played the title character in the series *The Gallery of Madame Liu-Tsong* (1951), making her the first Asian American to lead a television show. She was poised for a comeback when she was cast in the film adaptation of *Flower Drum Song* (1961)—a movie she sadly never got to finish as she passed away the same year.

Wong faced seemingly insurmountable obstacles in her rise to movie stardom. And while it may be tempting to view her story through a tragic lens, it is ultimately one of triumph. Her moxie was her courage, and with it she persevered in spite of her harsh circumstances. Hers is an evolving, complex legacy—after years of being criticized and dismissed for upholding harmful racial stereotypes, her body of work has been reexamined and recognized for its monumental significance. Anna May Wong was a pioneer who has rightfully earned her place in film history.

ANNA MAY WONG

CLAUDETTE COLBERT

1903–1996

Claudette Colbert was the utmost embodiment of sophistication on the silver screen who brought her velvet voice and worldly charm to over sixty films. Her supple wit made her particularly suited to romantic comedies, and she is credited as a pioneer of the screwball comedy. That she was able to endure the zany antics of the genre with such aplomb is a credit to her unflappable elegance. She wore clothes wonderfully, along with her trademark curled bangs and apple-cheeked grin. Behind the scenes, she had the nerve of a true businesswoman. Using her industry savvy, she negotiated contracts that made her the highest-paid actress in Hollywood at the peak of her career, while also enjoying the independence of freelance work at a time when the studio system reigned supreme.

Émilie Chauchoin was born in France on September 13, 1903. Her family emigrated to the United States while she was just a toddler and settled in New York City, where her name was legally changed to Lily Claudette Chauchoin. By the time she reached high school, she had developed a love for the visual arts and enrolled at the Art Students League of New York. She worked at a dress shop and gave French lessons to pay for her tuition; however, a chance encounter with a playwright at a party steered her toward a career on the stage. She had never taken acting lessons, but discovered she had a natural aptitude, later recalling, "I just went right onstage, and I learned by watching. I've always believed that acting is instinct to start with; you either have it or you don't." Upon making her Broadway debut in *The Wild Westcotts* in 1923, she began using the stage name Claudette Colbert.

Claudette Colbert was extremely exacting when it came to her appearance in studio portraits, like this one from 1932 for Paramount Pictures. She was particular about things like wardrobe and light placement—but was especially insistent about having the left side of her face featured. She was so notorious for favoring her left profile that photographers and film crews referred to the right side of her face as "the dark side of the moon."

Her acting career was off to a quick start, and she achieved great success playing ingénues on the Great White Way. Her theatrical talent would eventually bring her to Hollywood—just as talkies were taking off and studios found it necessary to recruit actors who could handle spoken dialogue. Colbert's eloquence, as well as her ability to speak in mid-Atlantic and British accents, earned her a contract offer from Paramount Pictures.

Upon her arrival at Paramount, Colbert played a series of ingénues and heroines in early films like *The Lady Lies* (1929) and *The Smiling Lieutenant* (1931). However, she confessed, "I was bored with those roles, but because I happened to look like a lady, that's all they wanted me to play. Working with DeMille opened up a whole other field; they realized I could look sexy." Indeed, Colbert unlocked her vamp potential in two historical epics directed by Cecil B. DeMille. She played the sensual Empress Poppaea in *The Sign of the Cross* (1932), which featured an infamous scene of Colbert bathing in what the studio publicized as "asses' milk." She later revealed it to be a powdered milk solution, but the legend still stands. The film significantly boosted her career, and she reteamed with DeMille for *Cleopatra* (1934) shortly after. As the queen of the Nile, Colbert smoldered in wickedly glamorous costumes by Paramount studio designer Travis Banton—who allegedly

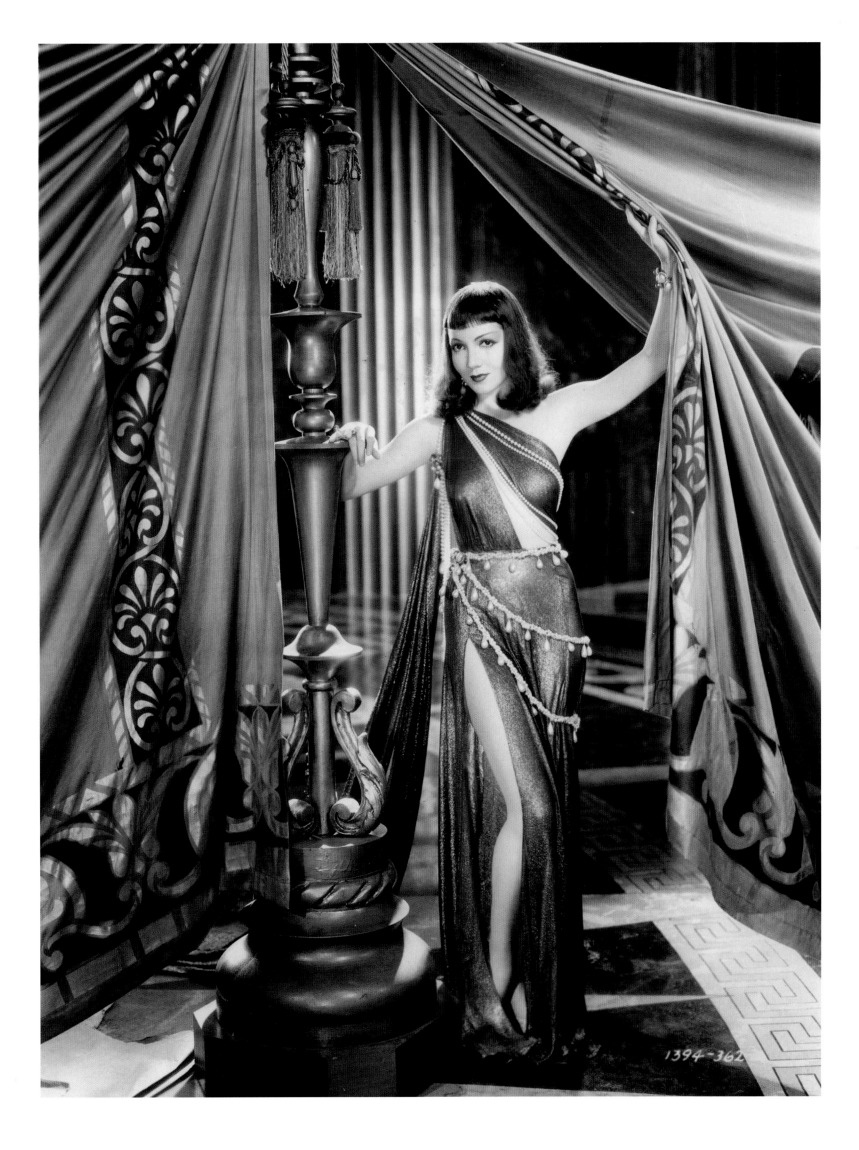

1394-362

1492·327

redesigned her entire wardrobe at the last minute when the star deemed the original ones "unacceptable." Audiences were dazzled by the lavish historical epic, in which Colbert delivered one of her most iconic performances. She later said, "DeMille's films were special: somehow when he put everything together, there was a special kind of glamour and sincerity."

The year 1934 turned out to be a banner one for Colbert. Before the extravagance of *Cleopatra*, she was loaned out to Columbia Pictures for a low-budget, unglamorous "road movie" many high-profile actresses had passed on. She was understandably reluctant, but *It Happened One Night* (1934) would cement her stardom and bring her an Academy Award.

Often cited as the first screwball comedy, the film paired Colbert with Clark Gable, on loan from MGM to the lesser studio as "punishment." She played the headstrong heiress Ellie Andrews, who runs away from her millionaire father when he refuses to accept her marriage to a fortune-seeker, opposite Gable as an embittered news reporter who meets her on a night bus to New York. It's a simple story about two strong-minded individuals from different social classes whose adversarial relationship evolves into a romantic one. Colbert managed to make Ellie endearing and relatable despite also being spoiled and out of touch in a nuanced performance worthy of an Oscar nomination. She famously did not expect to win for Best Actress and skipped the ceremony to board a train to New York. When the

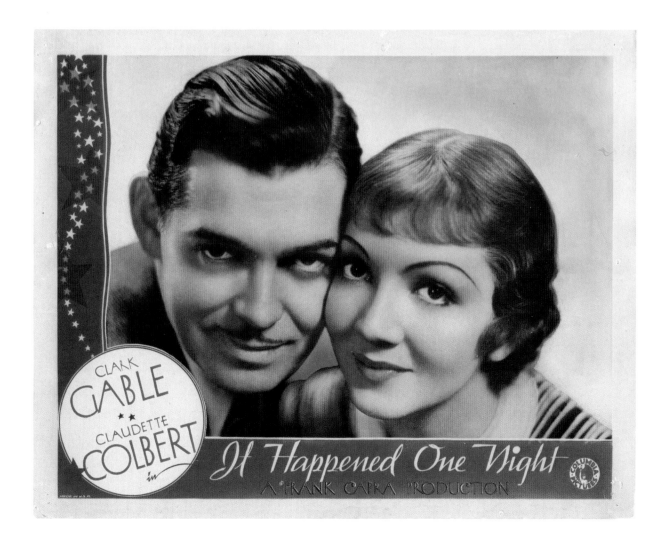

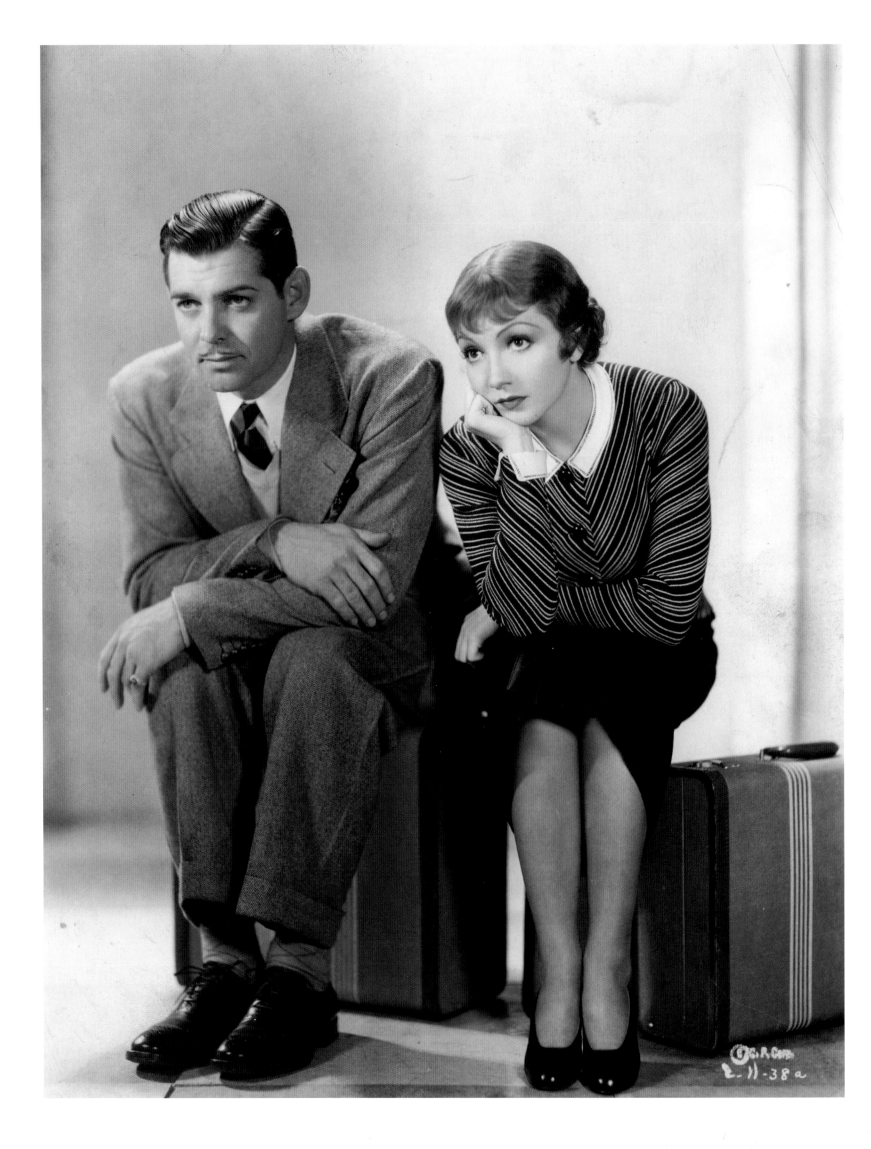

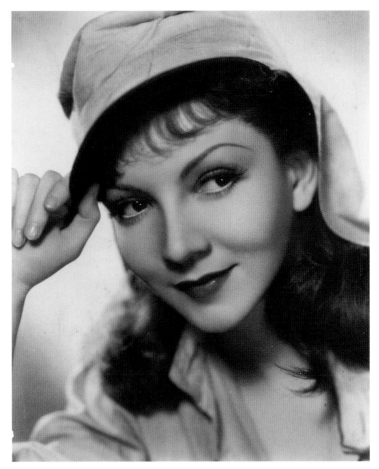

OPPOSITE
The staging of this publicity photo for *It Happened One Night* recalls a memorable scene in which Clark Gable and Colbert are stranded on the side of the road—until she famously uses her shapely legs to dramatically improve their hitchhiking efforts.

ABOVE LEFT
Despite her noblesse on-screen, Colbert was by all accounts quite down-to-earth in her off-screen life. In this press photo from 1935, she (*right*) gleefully makes use of the slide at the Venice Pier Fun House with Marlene Dietrich.

ABOVE RIGHT
The adventure film *Under Two Flags* (1936, 20th Century Fox, dir. Frank Lloyd) was based on the 1867 novel of the same name. Colbert plays a café singer named Cigarette and is featured in this promotional photo with her signature bangs curled beneath her cap.

news of her win reached her, she rushed right over and accepted the award in her traveling clothes. Perhaps more impressive was the fact that Colbert appeared in three of the films nominated for Best Picture that year—the only actress ever to do so in the Academy's history. In addition to *Cleopatra* and *It Happened One Night*, she also starred in the heart-wrenching drama *Imitation of Life* (1934), a film that radically confronted the complexities of single motherhood and racial identity. That any actress could achieve this range over the course of her career is extraordinary—but to do so in a single year was an astonishing feat.

Colbert may have earned adoration from fans and critical acclaim through her performances on-screen, but it was her business acumen behind the scenes that made her such a Hollywood power player. Even prior to 1934, she had negotiated a clause in her Paramount contract that allowed her to make films at other studios, which gave her the ability to be selective about the roles she accepted—a privilege not afforded to most contract players. With the Academy Award in hand, she returned to the bargaining table and walked away with a hefty salary increase. At the height of her fame in the late 1930s, she became Hollywood's highest-paid actress and was reported to be making $150,000 per film. During this phase of her career, she was able to prioritize diversity in her screen credits. She was especially mindful after the Oscar win, saying, "Everything that is being offered to me now is comedy. It's up to me to guard against an overdose of it because I like variation in

my work." For the remainder of the decade, she alternated romantic comedies like *The Gilded Lily* (1935) and *Bluebeard's Eighth Wife* (1938) with melodramas such as *Private Worlds* (1935) and *Drums Along the Mohawk* (1939).

Although her career slowed in the 1940s, Colbert delivered another celebrated screwball comedy performance in *The Palm Beach Story* (1942) and appeared in several war films during World War II—*So Proudly We Hail!* (1943), *Since You Went Away* (1944), and later, *Three Came Home* (1950). She continued to work freelance after cutting ties with Paramount in 1944 and had mostly transitioned into television by the 1950s. She would eventually return to the Broadway stage, where she got her start all those years earlier. In a 1978 interview, she said, "Hollywood was not my dream, you know. I only left Broadway when the crash came. The Depression killed the theater, and the pictures were manna from heaven."

She may not have set out to conquer the film industry, but she certainly left her mark on it with her many contributions. She remains beloved by fans for the warmth, wit, and charm she brought to the movies. In that sense, she achieved the goal set for herself in a 1938 interview with *Picturegoer Weekly*: "I suppose . . . you might say that is really the height of my ambition—to be a likeable human being; just to be loved."

BELOW

In *The Palm Beach Story* (1942, Paramount Pictures, dir. Preston Sturges) as well as this publicity photo, Colbert delights as a runaway wife who flees her financially struggling husband, only to fall into the lap of an eccentric millionaire on her way to get a divorce.

OPPOSITE

Colbert plays the title character in *Zaza* (1938, Paramount Pictures, dir. George Cukor)—an alluring French cabaret performer who falls in love with a married aristocrat during the Belle Époque.

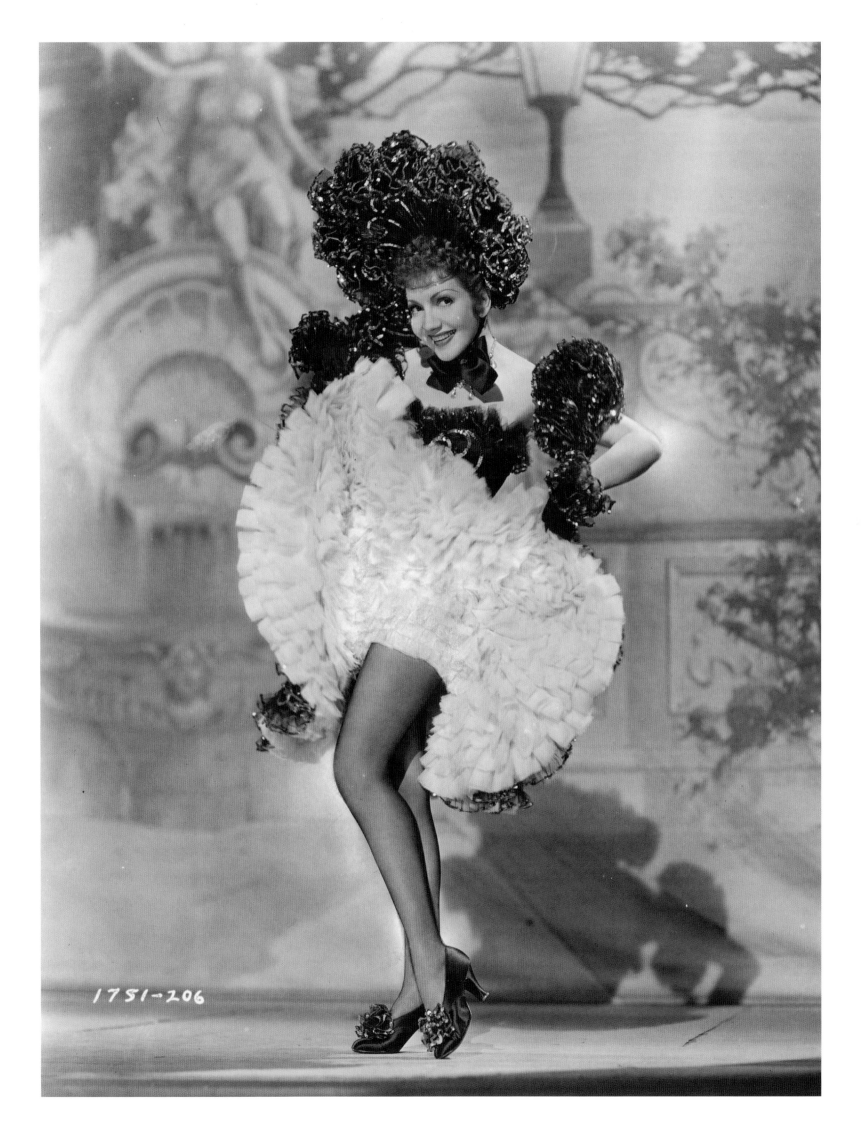

1751-206

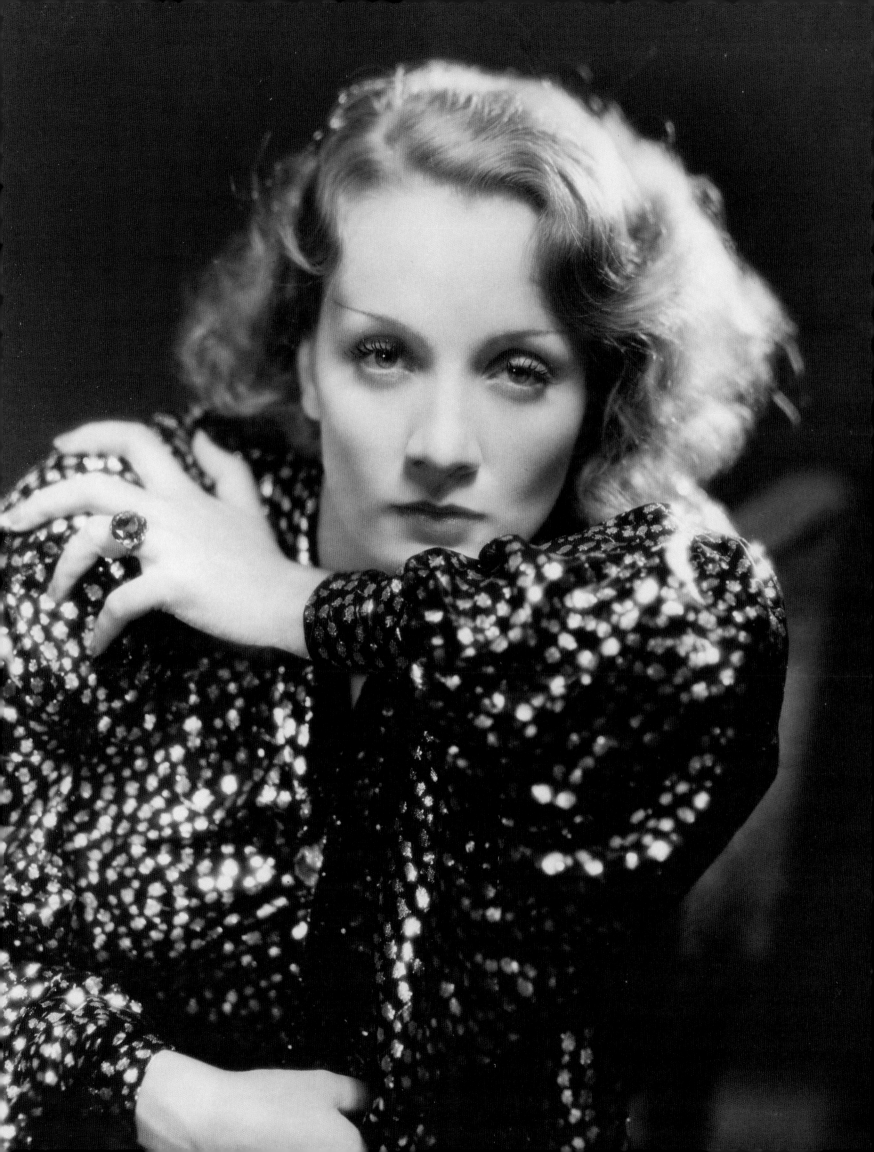

MARLENE DIETRICH

I f there were ever a name to readily conjure the grandeur of Hollywood's golden age, it is Marlene Dietrich—whose carefully crafted image was that of the definitive movie star. Heralded as an international symbol of glamour, she captivated the public with her worldly sophistication, mysterious allure, and inimitable sense of style. For the entirety of her career, she was unfailingly outfitted to perfection—whether in her famously masculine leisure attire or in some of the most sumptuous studio-designed costumes ever to grace the silver screen. That she could appear enchantingly feminine at one moment and then provocatively androgynous the next demonstrated her uncanny ability to embody contradiction. As an actress, she was both axiom and enigma. She was a hard worker, yet impassively cool. She was, at once, the epitome of mainstream movie stardom and also an iconoclast who challenged societal norms. Above all, she was wholly self-aware and cultivated an unmistakably distinctive persona that added magic to all aspects of her work.

Born Marie Magdalene Dietrich on December 27, 1901, in Berlin, Marlene—as she called herself, combining her first two names—was a self-proclaimed "girl from a good family." She was drawn to music at a young age and had plans to become a concert violinist before a wrist injury forced her to pursue other theatrical passions. After making her stage debut as a chorus girl in 1921, she performed in an assortment of plays and vaudeville revues. Her film debut was a small part in *The Little Napoleon* (1923), and in the years that followed, she appeared in German silent films in increasingly more visible roles. Before long, she caught the attention

Paramount Pictures photographer Eugene Robert Richee captures Marlene Dietrich's glamorous mystique in this studio portrait from 1932. Hers was a uniquely cinematic beauty—marked by features destined to be immortalized by a camera. With the sharpest cheekbones in the business, she could cut an exquisite profile, while her haunting, wide-set eyes were perfectly positioned beneath the dramatic arch of her thin eyebrows.

of visionary filmmaker Josef von Sternberg. Austrian-born and Hollywood-famous, von Sternberg was on the hunt for the next great screen siren to star in his upcoming film. In Dietrich, he found not only a leading lady for *The Blue Angel* (1930), but also a muse. Their professional collaboration yielded seven films and facilitated her ascendency to superstardom. Always generous when speaking of von Sternberg's influence on her career, Dietrich claimed that "he shaped her appearance, highlighted her charm, minimized her defects, and molded her into an aphrodisiacal phenomenon." Indeed, the spectacular manner in which he captured her unmitigated sensuality on film was akin to sexual idolatry.

The Blue Angel, Germany's first sound feature, launched Dietrich's career. She played the seductive cabaret entertainer Lola Lola, whom she described as "an ordinary, brazen, sexy and impetuous floozie." That she is the object of fascination to a group of randy schoolboys is unexceptional; however, the true extent of her sexual potency becomes apparent when even their respectable professor falls victim to her charms. The film, which was shot in both German and English, made her an international sensation and led to a contract offer from Paramount Pictures. That year, Dietrich left her homeland and relocated to Hollywood, which she called "the most disreputable and most mythical place in the world." Under the direction of von Sternberg, she made her American film debut in *Morocco* (1930) wherein she portrayed another nightclub chanteuse—one that exuded erotically

BELOW
Dietrich's breakout performance in *The Blue Angel* (1930, UFA, dir. Josef von Sternberg) set the tone for the rest of her career. Her rendition of "Falling in Love Again"—a song which would become her signature—is the source of the memorable image of the leggy star-to-be seductively perching atop a barrel, as seen in this film still.

OPPOSITE
This portrait, taken in Berlin to promote the German film *Gefahren der Brautzeit / Dangers of the Engagement Period* (1930, Strauss Film, dir. Fred Sauer), features Dietrich swathed in soft, glowing light. It is evident that her luminosity was present from the start of her film career.

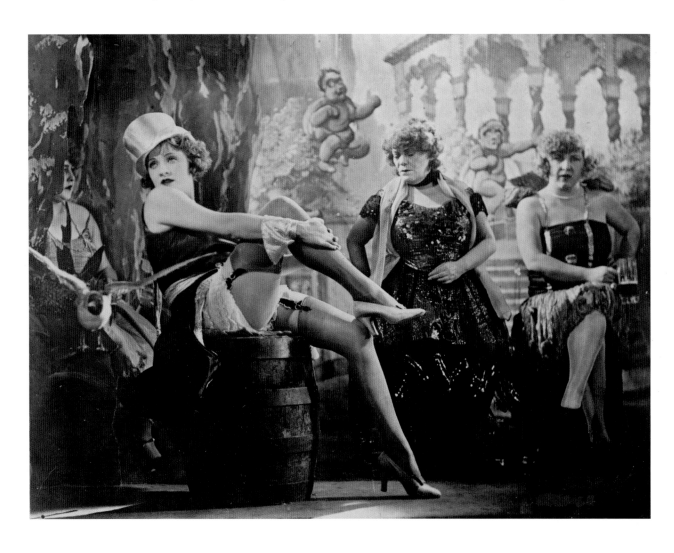

In this publicity photo for *The Blue Angel*, Dietrich wears a side-cocked top hat and playful smirk. Her Lola Lola epitomizes Weimar-era Germany as its quintessential cabaret performer.

Based on the 1905 novel *Professor Unrat* by Heinrich Mann, *The Blue Angel* chronicles the downfall of an honorable educator (played by Emil Jannings) at the hands of Dietrich's proto–femme fatale. This title lobby card illustrates the villainous undertone to her character, who was described as a "dissolute young girl." Dietrich responds to this description in her memoir, saying, "In my opinion I have always played 'dissolute young girls,' and they were, as von Sternberg once said, certainly more interesting than the 'nice roles.'"

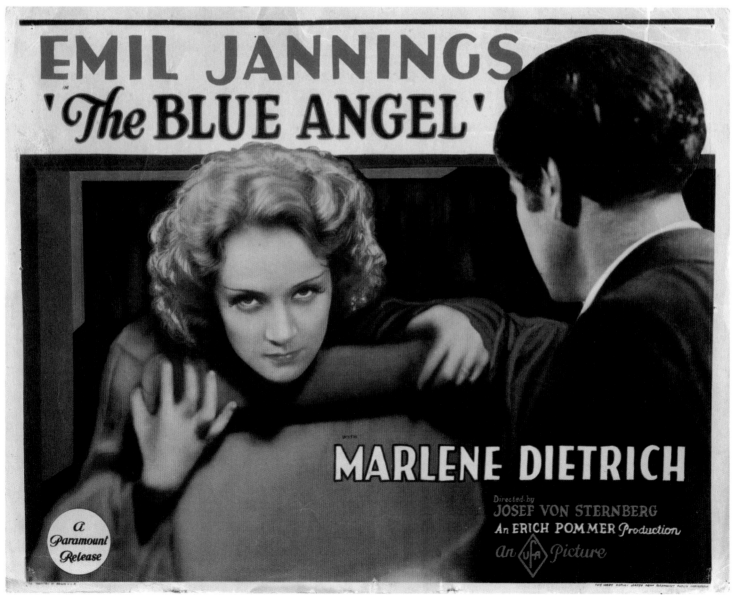

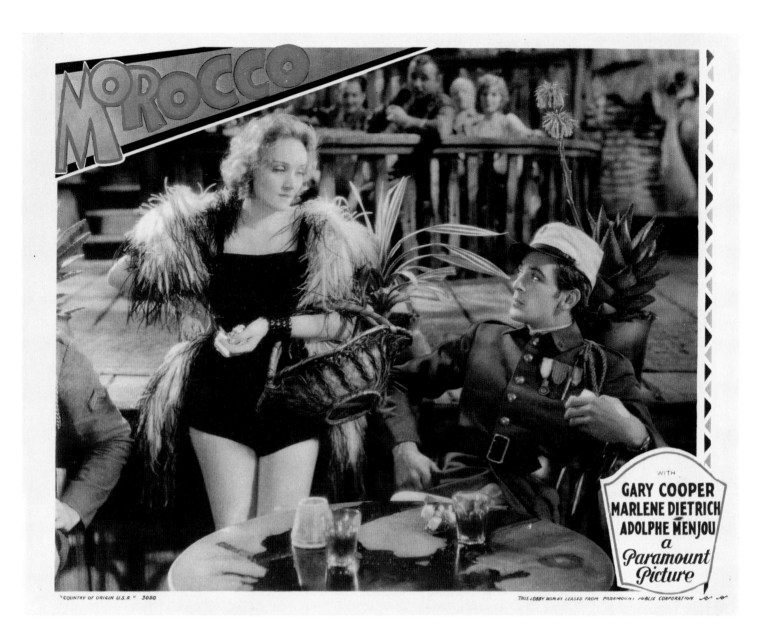

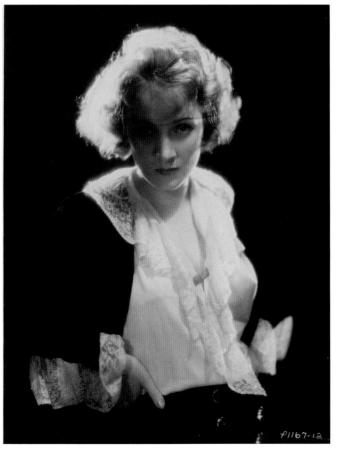

ABOVE

In *Morocco* (1930, Paramount Pictures, dir. Josef von Sternberg), Dietrich stars opposite Gary Cooper early in his career. Their chemistry in the film is visible on this lobby card.

LEFT

Dietrich's world-weary posture and expression in this publicity photo for *Morocco* hints at her character's mysterious past. Although she claimed, "An aura of mysteriousness has never been my forte," Dietrich excelled at bringing a sense of enigmatic allure to her performance in this film and in many thereafter.

This publicity photo shows Dietrich as Marie Kolverer, who assumes the code name Agent X-27 when she enlists as a spy in *Dishonored* (1931, Paramount Pictures, dir. Josef von Sternberg). This fantastical depiction of espionage culminates in a death sentence carried out with such exaggerated stylishness that Dietrich later likened it to kitsch. Marie insists on being dressed in the flamboyant clothes she wore as a prostitute for her execution and coolly applies lipstick as she stands in front of a firing squad.

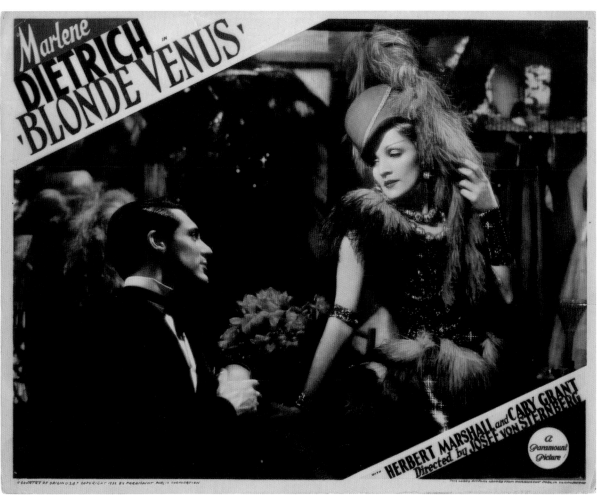

In *Blonde Venus* (1932, Paramount Pictures, dir. Josef von Sternberg), Dietrich's sultry crooning acts as a siren call to a wealthy playboy (portrayed by a young Cary Grant) who becomes her lover and benefactor, pictured on the film's lobby card (*left*). The promotional photo (*opposite*) immortalizes another of Dietrich's iconic tuxedo moments, which further established her penchant for gender-bending.

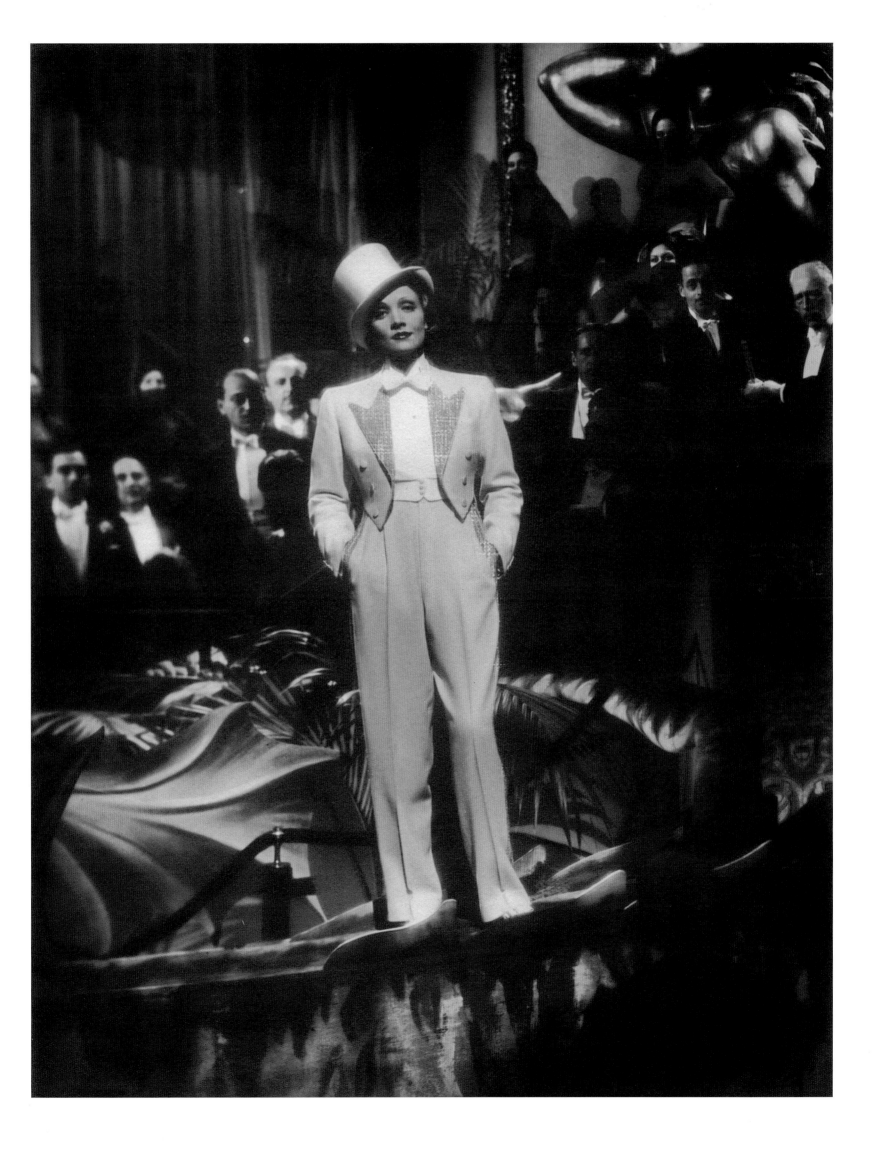

charged bravado. In one of the most memorable scenes in movie history, she dons a masculine top hat and tails ensemble and swaggers her way through a musical performance in which she kisses a female audience member. This moment helped to cultivate the sexual ambiguity that would become an essential facet of her persona. That unforgettable image of the tuxedo-clad Dietrich locking lips with a woman—coupled with the apparent nonsecrecy of her bisexuality—initiated her glorification as a queer icon.

To capitalize on their enormous success with *The Blue Angel* and *Morocco*, Dietrich and von Sternberg rushed into production for *Dishonored* (1931), a romantic spy drama set in Europe during World War I. She played a war widow–turned-streetwalker who is recruited as a spy by the Austrian Secret Service. Using her talents for seduction and duplicity, she outfoxes her adversaries and remains in command up to the very end of her fatal mission. Dietrich portrayed another sex worker in her next film, *Shanghai Express* (1932), in which she and Anna May Wong played a pair of courtesans on an adventure-filled train ride through war-torn China. Dietrich's Shanghai Lily takes delight in her reputation as a notorious woman of easy virtue, and even the mounting tension of an escalating hostage situation does nothing to diminish her impeccably styled nonchalance. The subsequent *Blonde Venus* (1932) gave Dietrich the opportunity to show off her range as a devoted mother who must resurrect her career as a cabaret singer to finance her husband's medical treatment. Interspersed between some gloriously bombastic stage performances are tender scenes that gave audiences the chance to see her in a new, melodramatic light.

With *The Scarlet Empress* (1934), Dietrich and von Sternberg ventured into the realm of period drama—albeit in a way that prioritized spectacle over accuracy. In the highly dramatized retelling of Catherine the Great's troubled marriage, romantic dalliances, and ultimate rise to power, the director used the historical setting as an opportunity to heighten his visual style to a new level of baroque extravagance. *The Devil Is a Woman* (1935) was the last film they made together, after which they terminated both their professional affiliation and a romantic affair. That he was instrumental in the formation of her star persona and career cannot be discounted; however, she proved entirely capable of carrying a film without him at the helm. The first one she made following the dissolution of their collaboration was *Desire* (1936)—a romantic comedy centered around a jewel heist that allowed Dietrich to shine in a genre she had not previously explored. It was a commercial success, and critics noted the freshness of her performance in how "vibrantly alive" she was when "freed from Josef von Sternberg's artistic bondage." Though she would dismiss her next few film roles as mediocre in comparison, she had inarguably established herself as more than just a director's muse—she was a preeminent star in her own right.

Dietrich's enthralling portrayal of Shanghai Lily is captured in this promotional photograph (*above*) and lobby card (*below*) for *Shanghai Express* (1932, Paramount Pictures, dir. Josef von Sternberg). This film, often regarded as the pinnacle of the von Sternberg–Dietrich collaboration, is celebrated for its atmospheric lighting and dramatic visual style—resulting in a series of stunning shots that capture the star's otherworldly beauty.

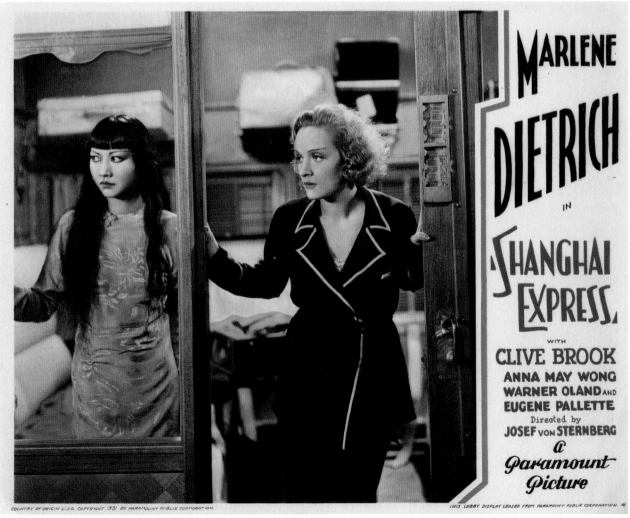

MARLENE
DIETRICH
IN
SHANGHAI
EXPRESS
WITH
CLIVE BROOK
ANNA MAY WONG
WARNER OLAND AND
EUGENE PALLETTE
Directed by
JOSEF von STERNBERG
a
Paramount
Picture

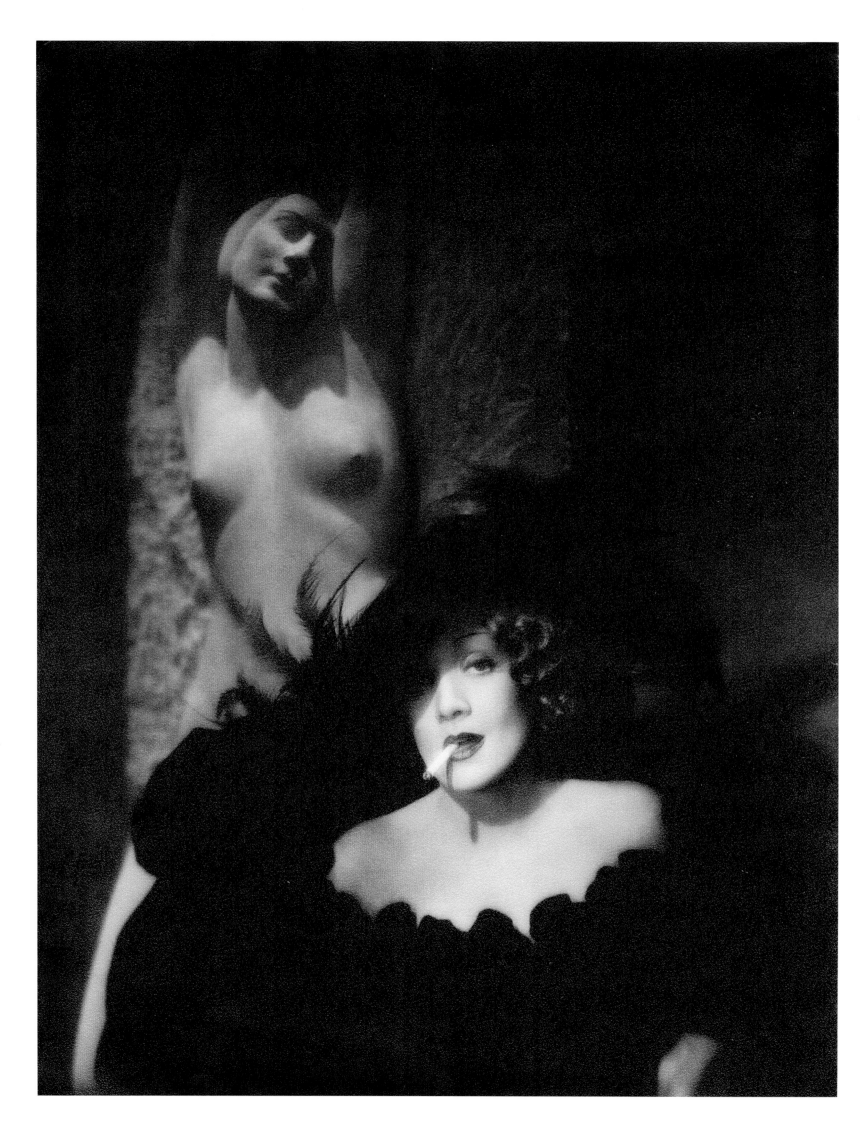

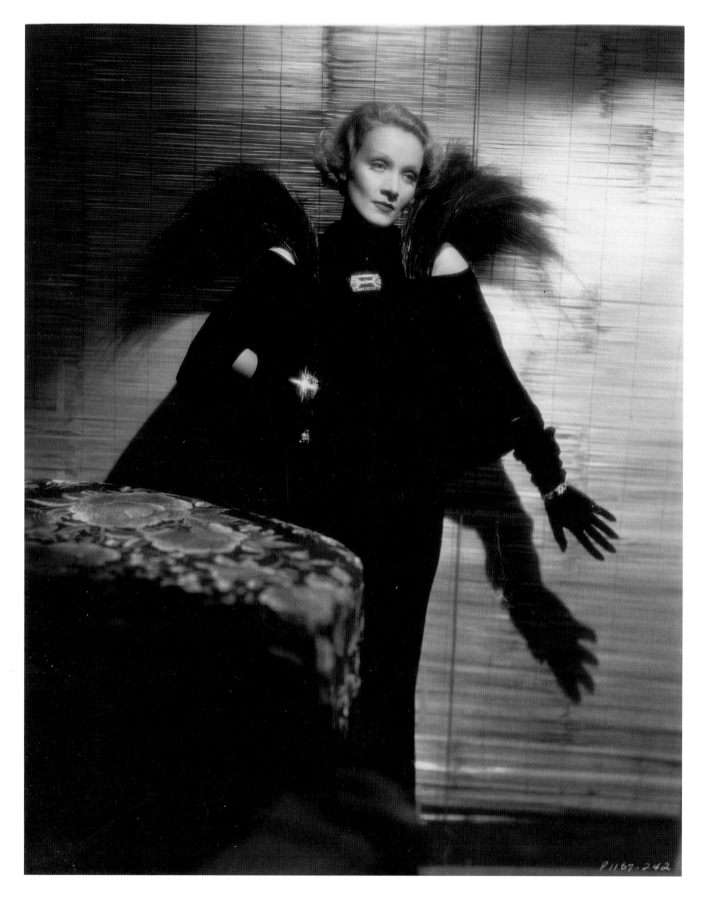

The lavish costumes in *The Scarlet Empress* (1934, Paramount Pictures, dir. Josef von Sternberg) were created by Paramount's head designer Travis Banton, whose long collaboration with Dietrich proved fundamental to both of their careers. She was the star he was best known for dressing, and he was responsible for creating the impossibly glamorous image upon which her stardom was built. His designs for Dietrich are among the most extravagant in his body of work—often enveloping her in a decadent profusion of feathers and fur, as seen in this promotional photograph.

While making *The Song of Songs* (1933, Paramount Pictures, dir. Rouben Mamoulian), her first film without von Sternberg, Dietrich took commanding charge of her image—instructing cameramen where to place lights to properly illuminate her face and bringing in a full-length mirror to check her lighting before each take.

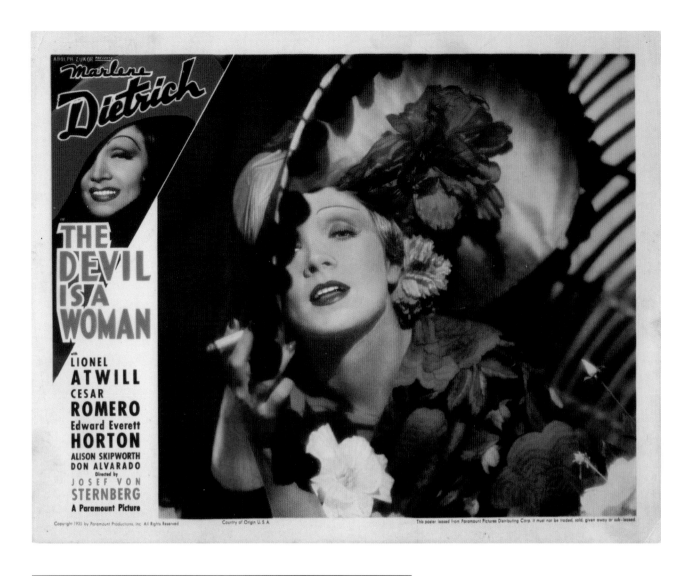

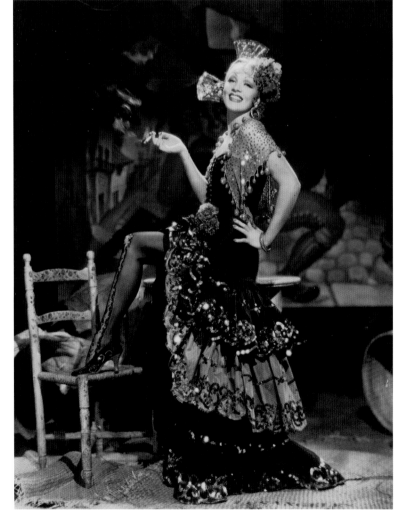

Lobby card (*above*) and promotional photograph (*left*) for *The Devil Is a Woman* (1935, Paramount Pictures, dir. Josef von Sternberg), which Dietrich cited as her favorite film because she thought she looked the most beautiful in it. She plays an exotic femme fatale who seduces and discards men with reckless abandon in turn-of-the-twentieth-century Spain. Despite its lavishness, the film was not received well and was controversial for its unfavorable representation of Spanish culture.

At the onset of World War II, Dietrich renounced her German citizenship and officially became a U.S. citizen in 1939. She was an outspoken critic of Nazism and used her celebrity to help the war effort by any means—volunteering at the Hollywood Canteen, recording music for the Office of Strategic Services, and traveling across the country to sell war bonds. She was one of the first public figures to do so and sold an estimated $1 million from 1942 to 1943. Most famously, she joined two USO tours between 1944 and 1945, roughing it on the front lines so that she could entertain Allied troops and boost the morale of American soldiers. Of her dual national identities, she said, "I was born German, and I shall always remain German, regardless of what has been said about me on this score. I had to change my citizenship when Hitler came to power. . . . America took me into her bosom when I no longer had a native country worthy of the name, and I am thankful to her for it." Dietrich considered her wartime work her proudest achievement and was awarded the Medal of Freedom by the U.S. government in 1947—the highest civilian honor. The following year, she appeared in Billy Wilder's comedy-romance set in postwar Berlin in which she portrayed an ex-Nazi café singer. While she initially had reservations, Dietrich delivered a dignified performance in *A Foreign Affair* (1948) and repurposed gowns from her USO tours for the film's musical numbers.

In *Desire* (1936, Paramount Pictures, dir. Frank Borzage), Dietrich plays the cunning and urbane jewel thief Madeleine de Beaupre, who steals the valuable strand of pearls seen on this lobby card.

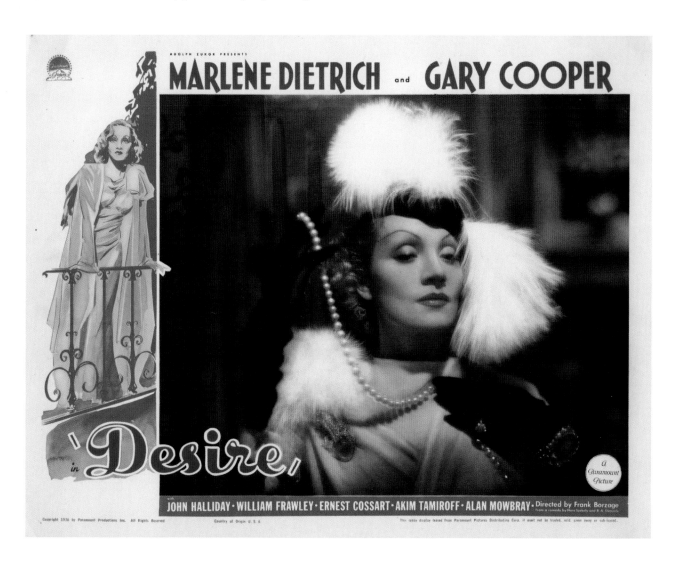

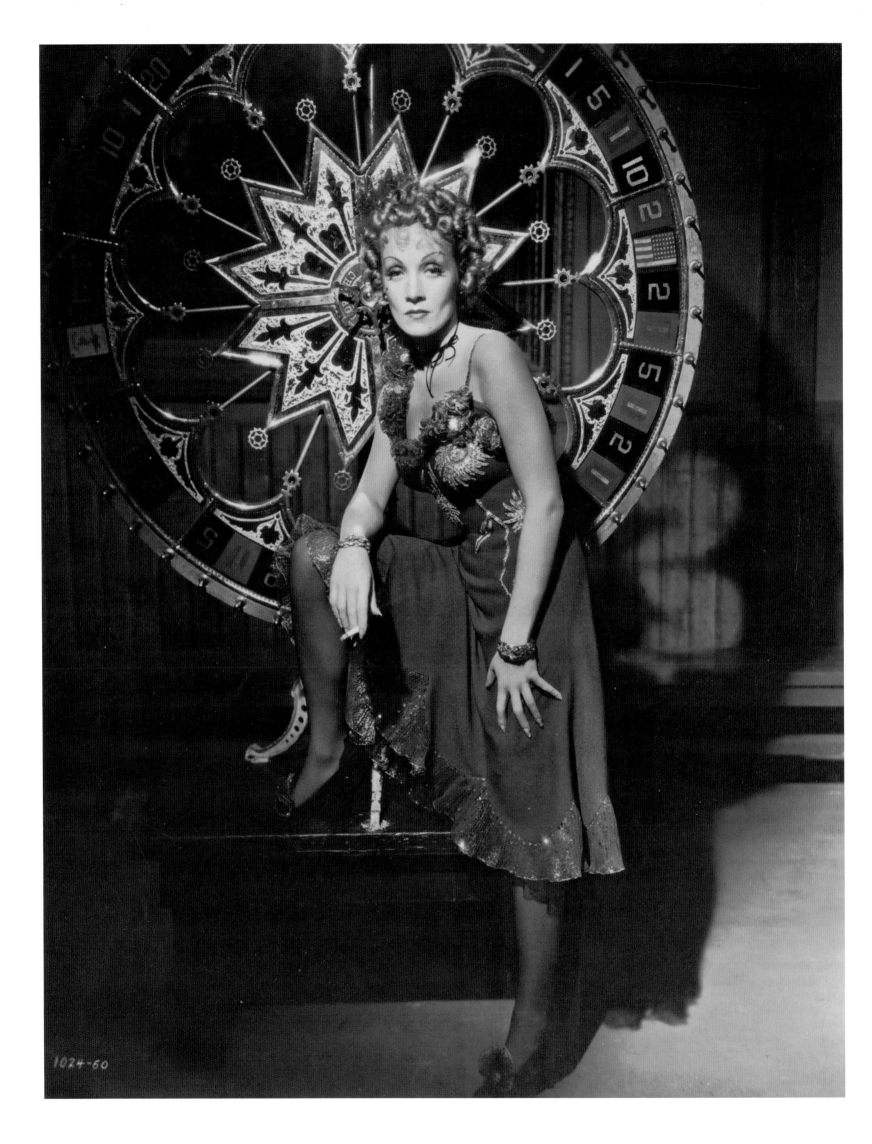

OPPOSITE

In the Western comedy *Destry Rides Again* (1939, Universal Pictures, dir. George Marshall), Dietrich plays a sultry saloon singer opposite Jimmy Stewart's amiable deputy sheriff, who is determined to bring order to the corrupt town of Bottleneck. One memorable scene features her feverishly embroiled in an epic bar brawl outfitted in the full saloon regalia pictured in this promotional photograph.

RIGHT

Dietrich shows off one of her best assets in this Warner Brothers studio portrait from 1941. From the moment she struck that iconic pose in *The Blue Angel*, her legs were an object of public fascination—whether bare, stockinged, or trousered. Of this obsession, she said, "My legs, always my legs! Yet for me they only have one purpose, they make it possible for me to walk."

After the war, Dietrich returned to acting and delivered several noteworthy performances in the decade that followed. Chief among them was her portrayal of a glamorous stage actress suspected of killing her husband in Alfred Hitchcock's noir thriller *Stage Fright* (1950). She was adamant about wearing the finest Parisian couture for the role; when the studio bristled, she famously declared: "No Dior, no Dietrich!" And so, she appeared—chic as ever—in the designer's sculpted suits and voluminous skirts. In *Witness for the Prosecution* (1957), an adaptation of the Agatha Christie tale, she played the cold German wife of an accused murderer. She made a brief but impactful appearance as a madam of a Mexican whorehouse in *Touch of Evil* (1958), for which she assembled her own outrageous costume. Her final significant role was in *Judgment at Nuremberg* (1961), as the widow of an executed war criminal.

Dietrich shifted her focus toward a career as a cabaret entertainer beginning in 1954 and was selling out large venues in major cities worldwide until the 1970s. For these live performances, she alternated between dazzlingly beaded illusion net gowns and her signature tuxedo and top hat—delivering both the glamour and androgyny that were the cornerstones of her image. By this point, she was entirely self-aware of her constructed persona and perpetuated it to a degree that bordered on self-parody. She famously said, "I'm not an actress, I'm a personality." Her star quality was unmatched, and her legacy extends beyond the silver screen and the cabaret stage—it is etched into the very cultural memory of a bygone era.

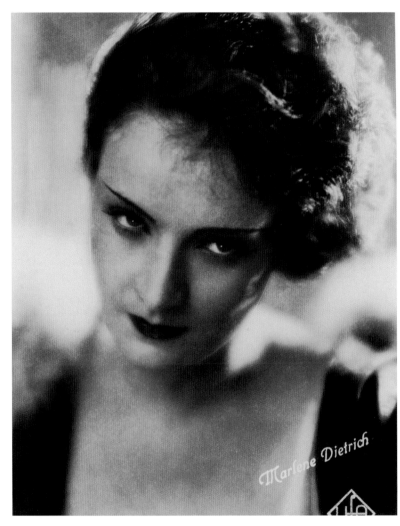

ABOVE LEFT

This Paramount studio portrait by Richee taken c. 1931 demonstrates Dietrich's uncanny ability to appear simultaneously earthy and ethereal. With her heavy eyelids set in a spellbinding stare, she emanates the languorous allure that characterizes many of her stage and screen performances.

ABOVE RIGHT

This sultry photograph was taken early in Dietrich's career, when she refused to have her hair bleached like the countless blonde starlets flooding the industry in the early 1930s. "My hair looked too dark on film," she recalled. "A floodlight was beamed on my hair from above, from the side, and, above all, from the rear so that the tips of my hair lit up, creating a halo effect"—as seen in this UFA studio portrait promoting the release of *The Blue Angel.*

OPPOSITE

"I've always been fascinated by the magical effect of cameras and light," Dietrich says in her memoir. She explains the secret to her sparkling iridescence and contoured features: "The higher [the] key light is placed, the longer and narrower the face will appear on the screen. If an actress happens to be blessed with high cheekbones, such lighting sketches attractive, soft shadows on both cheeks," as demonstrated in this Paramount studio portrait by Richee from 1932.

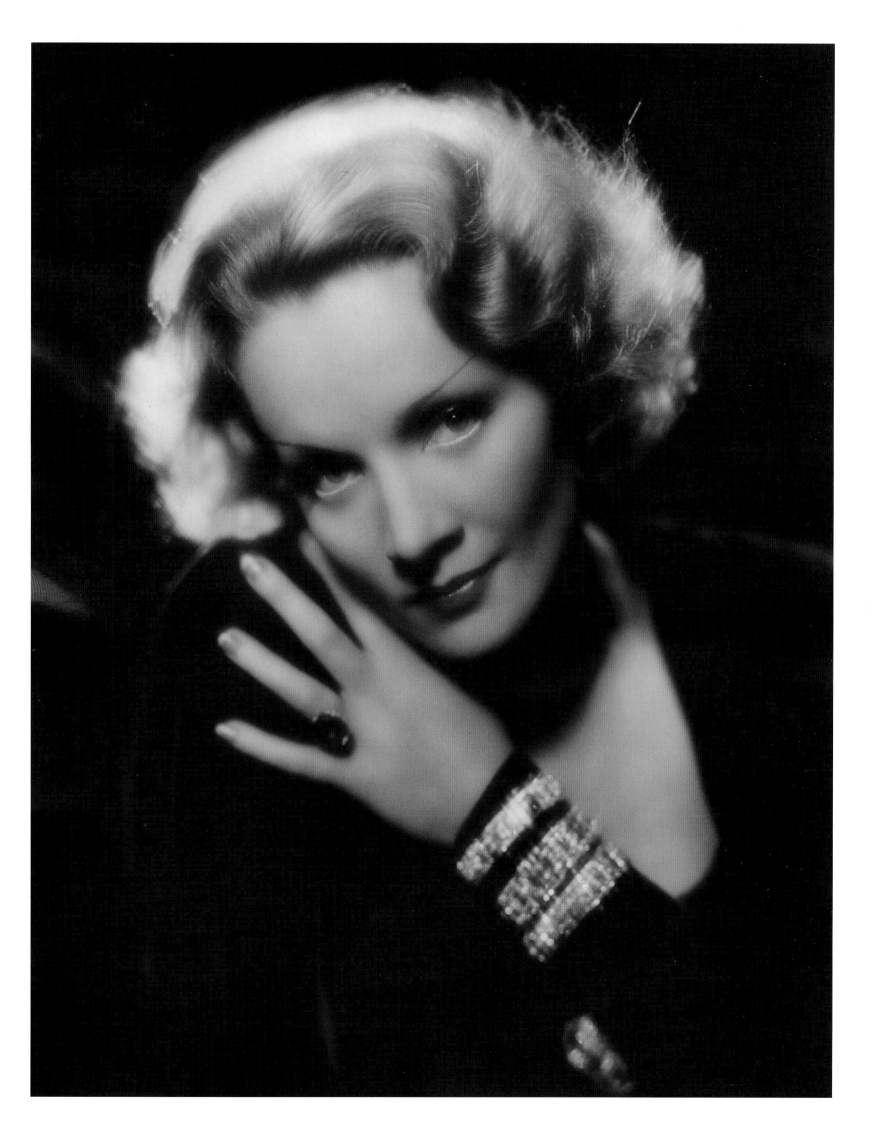

This Warner Brothers studio portrait taken by Scotty Welbourne in 1941 presents Dietrich not in her usual glitzy movie star wardrobe, but in her own casual attire. Of her famously masculine style, she said, "I am sincere in my preference for men's clothes—I do not wear them to be sensational. . . . I think I am much more alluring in these clothes. . . . Wearing such clothes, too, there is a sense of perfect freedom and comfort."

With the attitude and ease of a self-assured dandy, Dietrich was photographed attending the preview of *Design for Living* (1933) in this rakish ensemble. After being instructed by Paramount to wear a black dress and a mink coat when disembarking from the ship upon her arrival in the United States, she professed, "After this incident, I resolutely refused to follow the studio's orders in such matters and dressed as I pleased."

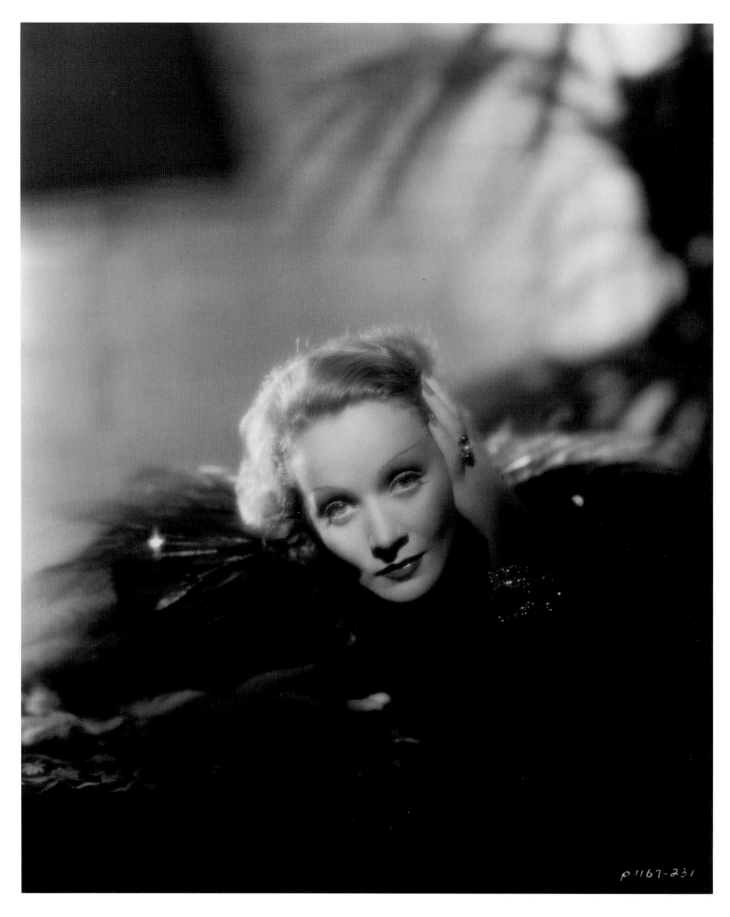

p 1167-231

ABOVE

That Dietrich was the apotheosis of movie stardom is evident in this breathtaking Paramount studio portrait from 1934. Here, there is no shortage of drama, mystery, or—most of all—glamour. She defined glamour as "assurance . . . a kind of knowing that you are all right in every way, mentally and physically and in appearance, and that, whatever the occasion or the situation, you are equal to it."

OPPOSITE

Dietrich strikes a powerful pose in this photo by László Willinger from 1942. Not only does it showcase her strikingly androgynous ensemble, but it captures the essence of the distinctive persona she meticulously crafted over the course of her career. "I dress for the image," she said. "Not for myself, not for the public, not for fashion, not for men." The image? "A conglomerate of all the parts I've ever played on screen."

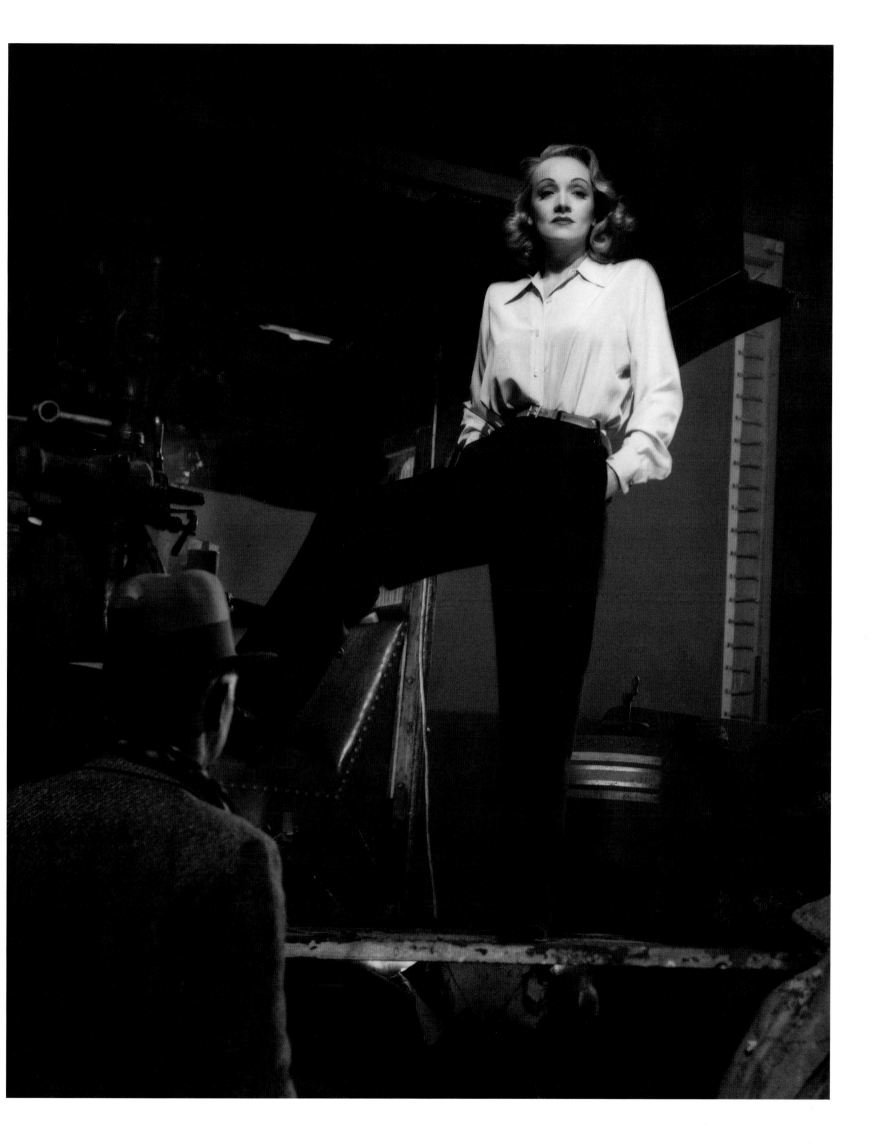

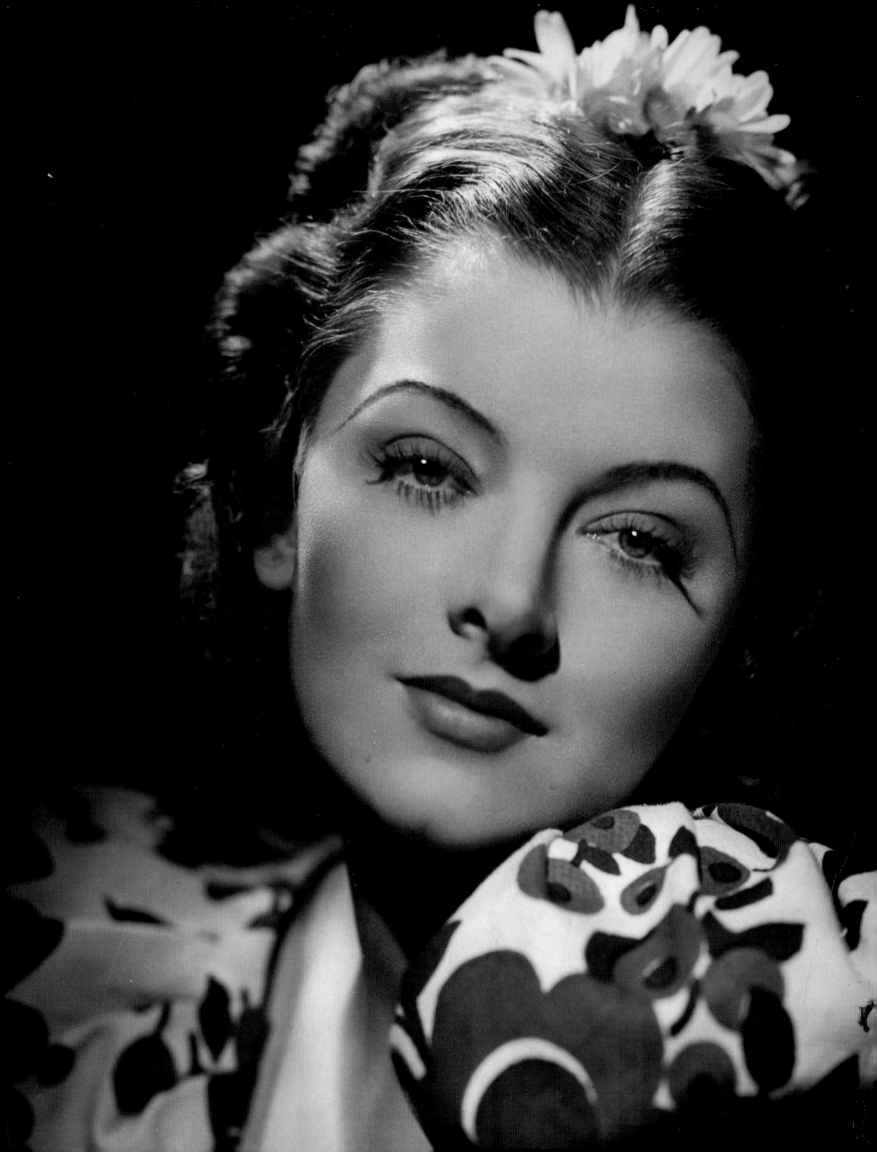

MYRNA LOY

1905–1993

At the height of the studio system, few actresses were as universally adored as Myrna Loy, whose wit, urbanity, and piquant charm made her the darling of romantic comedies. She was popular with fans, acclaimed by critics, and bankable at the box office—an industry triple threat if Hollywood ever saw one. Still, her persona was never so inflated as to make her untouchably glamorous; rather, she seemed exceptionally real in her muted coolness. Her style of acting was characterized by wry underplaying and ingenious subtlety, and her minimalist approach to comedy was often transmitted through a raised eyebrow, a fleeting expression, or a drily delivered line. Often—if not tiringly—described as the personification of "the perfect wife," she has been praised for adapting each performance to suit her on-screen leading man. In actuality, she did so to skillfully position herself as the equal to any male costar, daring him to match her wits.

Myrna Williams was born on August 2, 1905, in Helena, Montana, and spent her childhood on the family ranch. Eager for a change of scenery, her mother moved the family to Southern California following her father's death in 1918. There, Myrna took an interest in dance and trained with the intention to pursue it professionally. In order to help with the family's finances, she left school at eighteen and got a job dancing in the live prologues that preceded feature films at Grauman's Egyptian Theatre in Hollywood. It was while performing an East Indian nautch dance ahead of *Thief of Bagdad* (1924) that she was discovered by a notable portrait photographer who shot pictures of her. Those photos caught the eye of

Myrna Loy's understated comedic performances were built on her mastery of subtle facial movements, like the lowering of her long eyelashes in this 1937 studio portrait by George Hurrell. Her pointedly raised eyebrow could speak volumes louder than a raised voice. The same went for the playful twitch of her sleek, patrician nose—which was so envied that women rushed right off to their plastic surgeons to have one just like it.

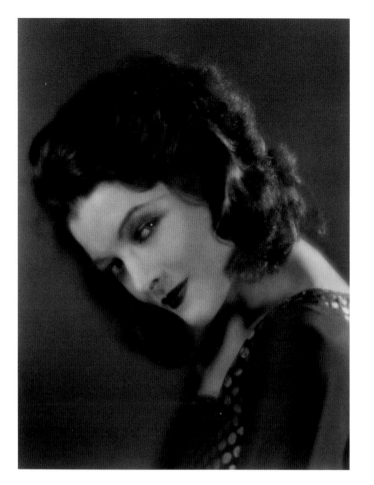

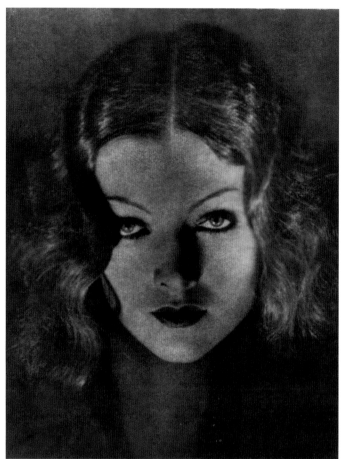

Rudolph Valentino who, with his costume designer wife Natacha Rambova, called her in to do a screen test for the lead role in their first independently produced film, *Cobra* (1925). Although Myrna did not get that part, she was soon after cast as an extra in *Pretty Ladies* (1925) and played a chorus girl alongside the up-and-coming Joan Crawford. Rambova returned with an offer for Myrna to play a small role in her next production, *What Price Beauty?* (1925). The film wouldn't be released for three years, but photos taken in her exotic costume were published in *Motion Picture Magazine* and led to a contract with Warner Brothers, where she was newly christened Myrna Loy.

Despite being an auburn-haired, green-eyed girl from Montana, Loy was woefully miscast in the exotic roles that defined her early career. Warner Brothers was determined to market her as a vamp—a seductive, villainous cinematic archetype deeply entrenched in exoticism. Because of the racial fetishization employed to characterize the vamp, Loy was often made to play foreign characters that were stereotypical and one-dimensional. They were usually of Asian descent, as was the case in *A Girl in Every Port* (1928) and *The Crimson City* (1928), but also included seductresses of all ethnicities—a Mexican singer in *Rogue of the Rio Grande* (1930), a Romani servant in *The Squall* (1929), and an Indian princess in *The Black Watch* (1929). Loy herself was incredulous about this problematic typecasting, and retorted, "Talk about racism!" Her disapproval is evident in her memoir, in which she laments that it was the success of *The Desert Song* (1929)

ABOVE LEFT
For *Noah's Ark* (1928, Warner Brothers, dir. Michael Curtiz), Loy is credited with the small role of Dancer/Slave Girl. This was a common trope for actresses deemed "exotic" by white standards.

ABOVE RIGHT
Loy's piercing gaze in this dramatic portrait from c. 1929–30 speaks to her characterization as a femme fatale and is reminiscent of photos of Theda Bara—the prototypical vamp—from the previous decade.

OPPOSITE
Loy had a featured role in the silent film *Why Good Girls Go Back Home* (1926, Warner Brothers, dir. James Flood), in which she plays Broadway performer Sally Short as captured in this publicity photo. It is now considered a lost film, with no prints surviving in any archives.

MYRNA LOY

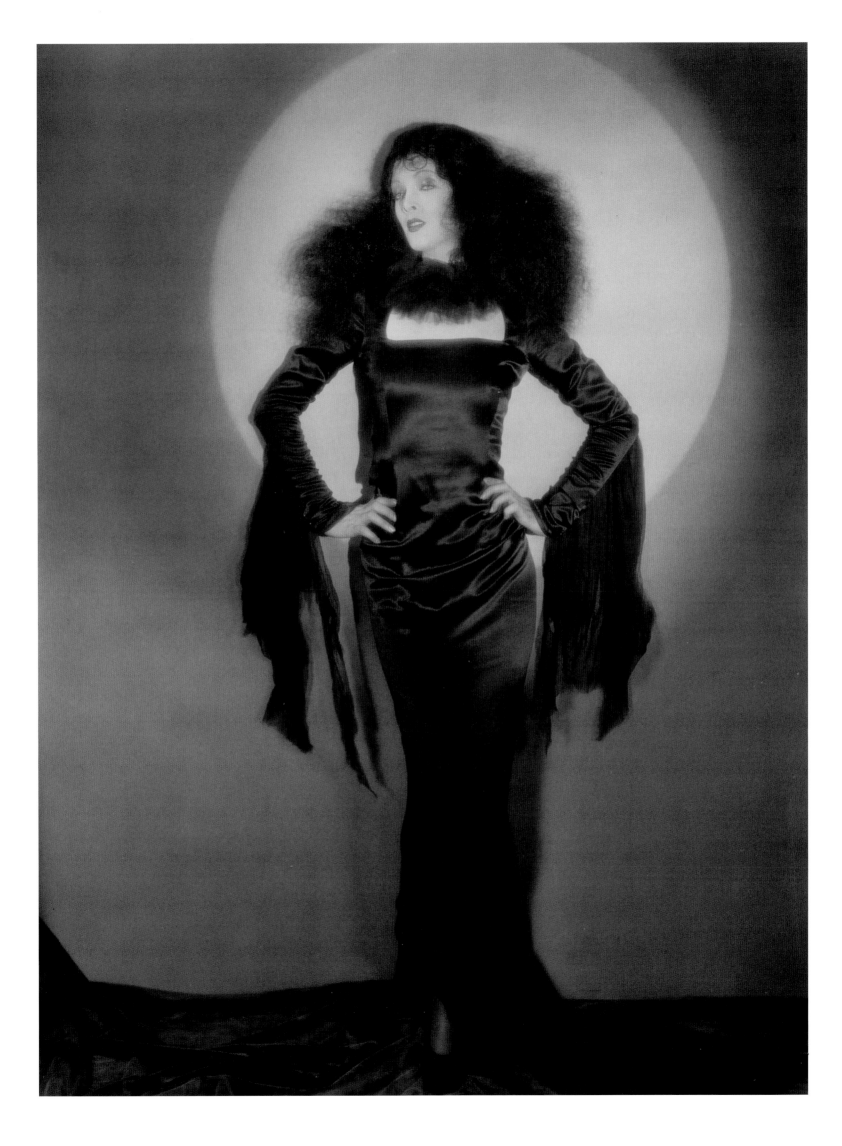

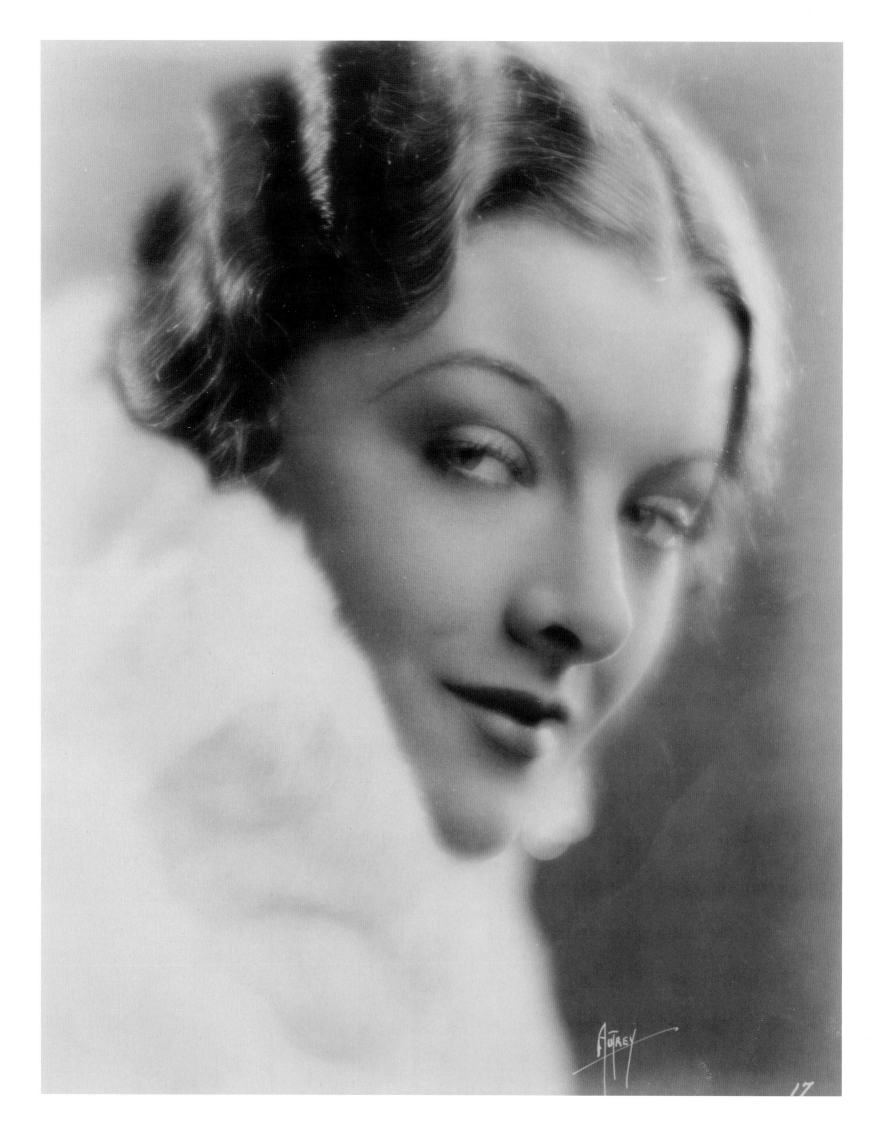

This studio portrait by Max Munn Autrey was taken between two films Loy did with the Fox Film Corporation—*Hush Money* (1931), in which she appears as a blonde, and *Transatlantic* (1931). While neither was very consequential, this photograph captures the urbanity for which she would soon become known.

In this undated portrait from c. 1928–31, Loy has been styled with the darkened eyes and lips of a moody, dramatic actress—an image that would give way to a more natural, wholesome persona as she explored her potential in comedic roles.

that "solidified my exotic non-American image." Of *Thirteen Women* (1932), a psychological thriller in which she played a half-Javanese woman seeking revenge against her schoolmates, she writes, "I recall little about that racist concoction." She declared *The Mask of Fu Manchu* (1932) "the last straw" and vowed it would be her final exotic role.

Loy signed with Metro-Goldwyn-Mayer in 1931, just as it was emerging as the prestige studio. Typecasting had limited her career up to then, and she was determined to expand her range with this new contract. She had played a few small roles in early musicals at Warner Brothers like *The Jazz Singer* (1927), *The Show of Shows* (1929), and *Under a Texas Moon* (1930), but it was a loan-out to Paramount for the musical comedy *Love Me Tonight* (1932) that really helped her break free from the vamp. In the man-crazy Countess Valentine she found her first comedic role, and with it, the "first realization that I could make people laugh." It was a pivotal moment that brought on "a new awareness of my abilities" and spurred her to venture into other genres. Less than two years into her MGM contract, Loy had already racked up fifteen movie credits. Of them, it was the pre-Code crime film *Manhattan Melodrama* (1934) that proved most consequential. She starred opposite Clark Gable and William Powell—two actors with whom she would frequently collaborate for the rest of her career. She flourished under the direction of W. S. Van Dyke, who thought she would make the perfect leading lady for his next venture.

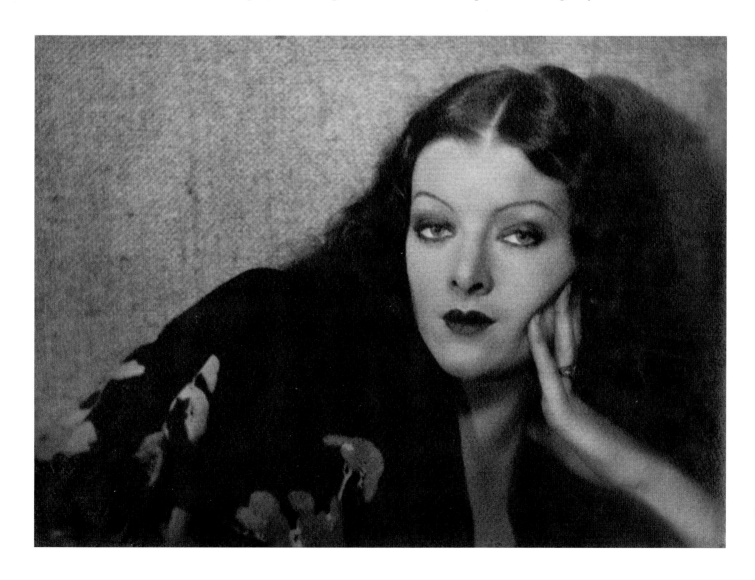

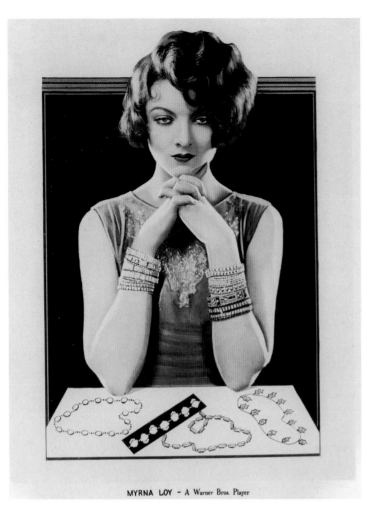

MYRNA LOY – A Warner Bros. Player

Publicity photo for *The Girl from Chicago* (1927, Warner Brothers, dir. Ray Enright), a synchronized sound film based on a short story that appeared in *Redbook*. In one of her earliest starring roles, Loy goes under- cover as a Chicago gun moll in order to exonerate her brother for a crime he did not commit.

BELOW

A lobby card from the pre-Code musical comedy *Love Me Tonight* (1932, Paramount Pictures, dir. Rouben Mamoulian), which featured music by Rodgers and Hart. Loy sang a verse of the popular song "Mimi"—the only time she ever sang in a movie. However, it was cut when the film was reissued after the Hays Code went into effect due to the purportedly scandal- ous figure-hugging nightgown she wore in the scene.

OPPOSITE

A publicity photo for *Emma* (1932, Metro-Goldwyn-Mayer, dir. Clarence Brown), starring Marie Dressler, in which Loy plays a supporting role. The veteran actor encouraged Loy to keep working at her career despite a string of disappointing roles, saying, "Get your chin up, kid. You've got the whole world ahead of you." In just a few years, she would be proven right.

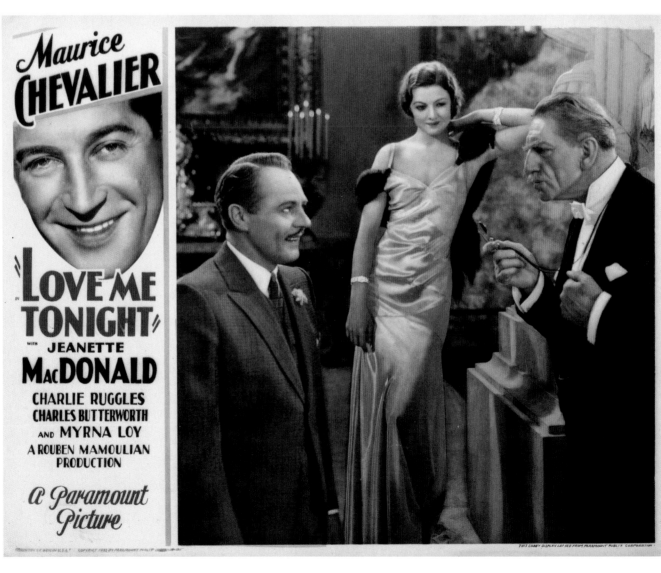

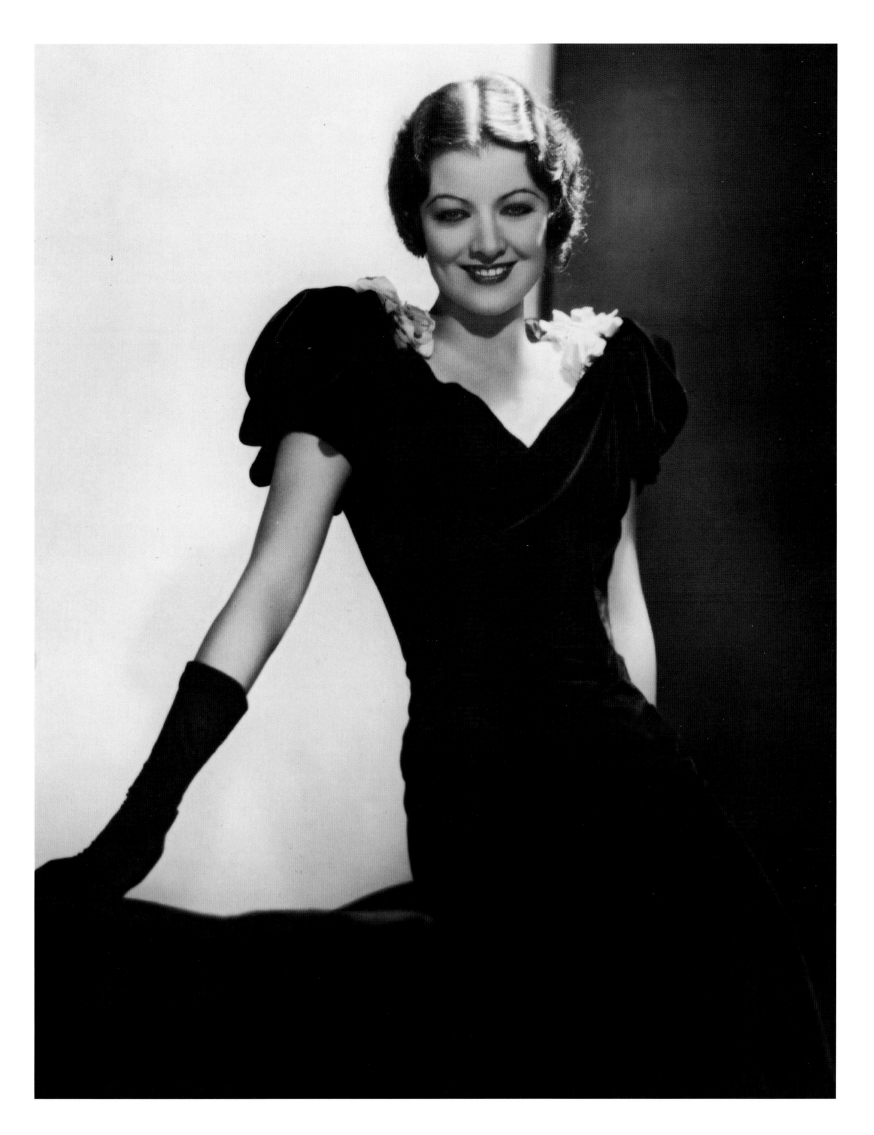

At last, Loy got her big break in *The Thin Man* (1934), which she called "the film that finally *made* me." She had already appeared in over eighty movies by that point, but had not yet been given the opportunity to achieve her full comedic potential. Louis B. Mayer considered Loy a strictly dramatic actress and was dead against casting her as the female lead, but Van Dyke insisted on her capability and threatened to walk out if she didn't get the part. Mayer relented, and after just sixteen days of filming, the legendary partnership between William Powell and Myrna Loy was forged. As the mystery-solving, cocktail-quaffing Nick and Nora Charles, they revolutionized the cinematic portrayal of marriage. Theirs was brimming with witty repartee, flirtatious exchanges, and comic adventure—but ultimately rooted in mutual respect and implicit trust. So popular was the charismatic duo that they reprised their snappy banter in an additional five *Thin Man* films between 1936 and 1947. The pairing of Loy and Powell became one of the most prolific in cinematic history—yielding a total of fourteen films ranging from comedies like *Libeled Lady* (1936) and *Love Crazy* (1941) to dramas like *Evelyn Prentice* (1934) and *The Great Ziegfeld* (1936). Loy wrote of the magic in their chemistry: "From that very first scene, something curious passed between us, a feeling of rhythm, complete understanding, and instinct for how one could bring out the best in the other."

A lobby card for *The Thin Man* (1934, Metro-Goldwyn-Mayer, dir. W. S. Van Dyke) based on the best-selling novel by Dashiell Hammett. The film introduced moviegoers to Nick and Nora Charles, who would come to represent a new ideal for modern married couples. They are the roles most associated with William Powell and Loy, who brought them to life in a series of six *Thin Man* films.

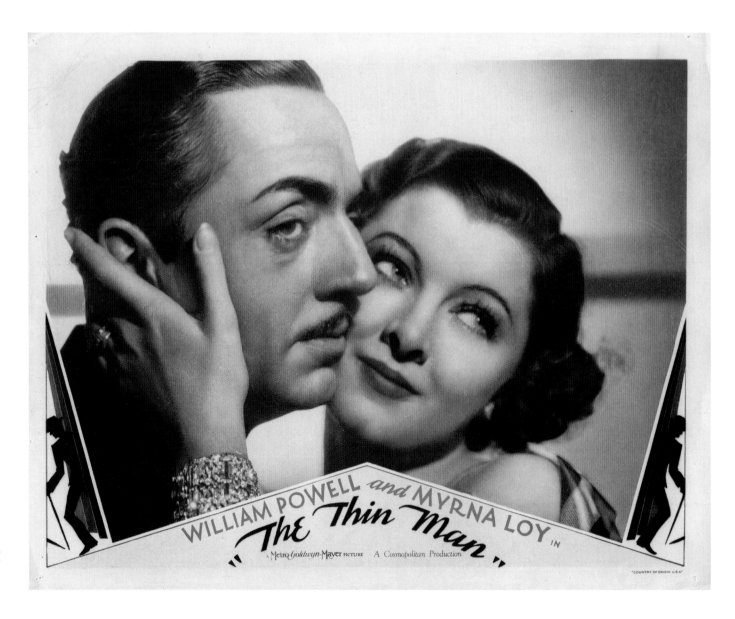

Loy was loaned out to Paramount to do *Wings in the Dark* (1935, Paramount Pictures, dir. James Flood), produced by her first husband, Arthur Hornblow Jr. She plays skywriter and stunt pilot Sheila Mason in a film that capitalized on the popularity of aviatrixes in the 1930s. Aviation superstar Amelia Earhart was even brought on to serve as a technical consultant on set.

Loy was catapulted into stardom after *The Thin Man* (1934); however, her status as a box office draw was not reflected in her wages. At $1,500 per week, she was making just half of Powell's salary. In 1935, she staged a one-woman protest for equal pay, asserting, "I wanted what Bill was getting, that's all. I was his costar—they already considered us a team—with equal responsibilities." Before long, the studio was begging her to come back to work. She got her pay raise, plus an additional $25,000 bonus, and starred in a series of hits in the years that followed. When she reteamed with Gable in *Wife versus Secretary* (1936), they became such a sensation that they were crowned "King and Queen of the Movies" after a nationwide poll. With that film, she cemented the moniker that would be used to describe her for the rest of her career: "The Perfect Wife." Indeed, she often played a married sophisticate who was praised for being beautiful, clever, elegant, and charming. These characters tended to be well-dressed women of leisure who were easily likable and entirely self-possessed. It was a label that made her appealing to both men and women, which was the secret to her seemingly universal popularity. She was featured on the April 1937 cover of *Picture Play* alongside the headline "Why is Myrna Loy the Perfect Wife?" and soon "Men Must Marry Myrna" fan clubs sprang up all over the country. The greatest irony, however, was that Loy was married four times—each one ending in divorce.

MYRNA LOY

Loy's career continued into the 1940s, but she stepped back from acting at the onset of World War II. She focused her energy on the war effort by working with the Red Cross and speaking out against Hitler and all forms of totalitarianism. Her political involvements made her the target of anti-Communist smear campaigns, but she proved her mettle by following in the footsteps of her character in *Libeled Lady*. She sued *The Hollywood Reporter* for a million dollars and was awarded a retraction. After the war, she starred in a few more notable films like *The Best Years of Our Lives* (1946), *The Bachelor and the Bobby-Soxer* (1947), and *Cheaper by the Dozen* (1950); nevertheless, the remainder of her life was largely dedicated to political causes and civil rights activism.

That she was so beloved by audiences and had such a celebrated cinematic career makes it all the more inconceivable that Loy never won a competitive acting award, nor did she ever receive an Oscar nomination. True, the roles she played were not particularly flashy or dramatic, like those that netted other actresses awards and accolades—still, her legacy as a fan favorite has secured her place as a film legend in her own right. In 1991, she was finally recognized by the Academy and presented with the Honorary Award "in recognition of her extraordinary qualities both on-screen and off, with appreciation for a lifetime's worth of indelible performances."

MYRNA LOY

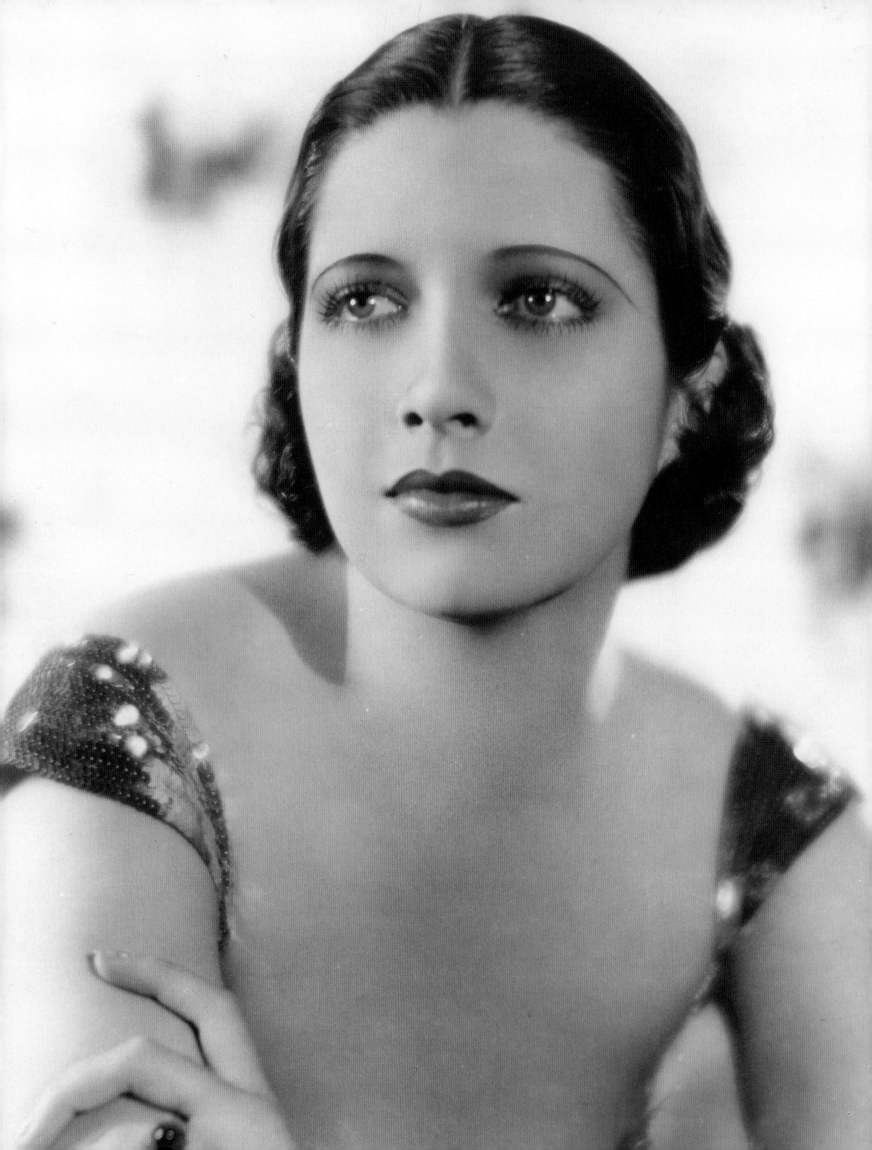

KAY FRANCIS

1905–1968

At the height of her career, Kay Francis was the undisputed best-dressed woman in Hollywood. With her statuesque physique and slender frame, she wore the sleek lines of 1930s fashion like no one else and carried even the most avant-garde ensembles with sophistication and ease. She was frequently cast as moneyed socialites in glamour vehicles that promoted Depression-era escapism, and her stately demeanor lent a touch of class to even the most risqué flirtations on-screen. Off-screen, however, she enjoyed the libertine lifestyle of a spirited playgirl. The combination of these qualities made her particularly suited to the hedonistic elegance of the pre-Code era—a period when she was especially prolific. For her many commercially successful movies she earned the title "Queen of Warner Brothers" and was the highest-paid actress at the studio for the better part of the decade. But even at the peak of her popularity, the press recognized that she had "seldom been given the right role to show what she can do." Indeed, the brevity of her films rarely gave her a chance to develop a substantive character, and their often thin storylines prioritized opportunities for costume changes over plot. Nevertheless, her captivating presence carried her to stardom in incomparable style.

Kay Francis was born Katharine Edwina Gibbs in Oklahoma City on January 13, 1905. Her father was an alcoholic who left when she was young, and her mother was an aspiring actress with whom Kay lived a transient life on the vaudeville circuit. She did not readily follow her mother into show business, but instead enrolled in secretarial school and dabbled in modeling, appearing in advertisements in

Kay Francis appears as stylish and urbane as ever in this studio portrait by Elmer Fryer for *The British Agent* (1934, First National Pictures, dir. Michael Curtiz). Described as a "darkling beauty," she had mercurial gray-green eyes and raven hair that she wore with a distinctive center part.

Harper's Bazaar. She traveled to Paris for the first time in 1925 and was a sensation within expat society circles. It was during this trip that she recalled, "I had a sudden feeling of tremendous self-confidence. I felt very indomitable. . . . It was the stage or nothing, from then on." She made her Broadway debut in a modern adaptation of *Hamlet* in November of 1925, and by 1929 had landed a screen test with Paramount Pictures.

Paramount offered Francis a contract for $300 per week with a five-week guarantee. As talking pictures grew in popularity, studios were eager to sign stage performers unafraid of spoken dialogue. As Francis put it, "What is there in a [microphone] to scare you after you are used to 1,500 people?" She excelled in talkies despite a noticeable speech impediment and masked her difficulty pronouncing the letter *r* with a posh Transatlantic accent and a low, throaty voice. She made her screen debut as the office vamp at a newspaper publisher in *Gentlemen of the Press* (1929), which was produced at Paramount's Astoria Studios in Queens, New York. With her performance well-received, she was relocated to the main studio lot in California and heralded as "Gotham's Gift to Hollywood" by *Screenland*. She was quickly put to work in a string of noteworthy supporting roles in films like *Dangerous Curves* (1929) and *Street of Chance* (1930) before securing her first lead in *Raffles* (1930), wherein she came into her own as the love interest of a notorious yet debonair jewel thief—an oddly specific type of character she would

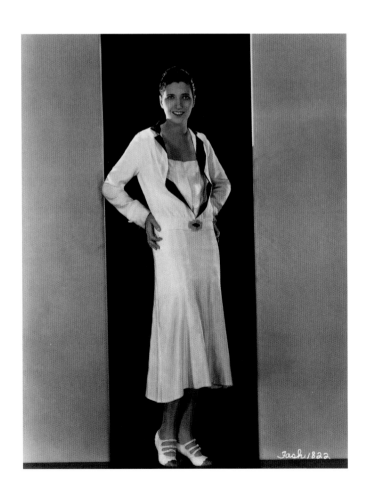

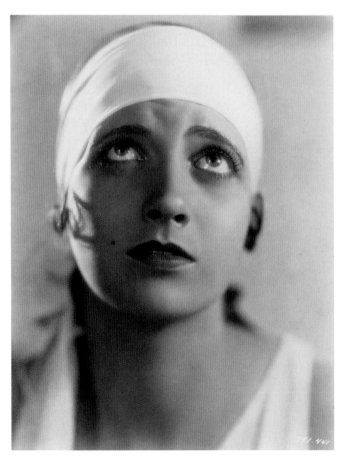

KAY FRANCIS

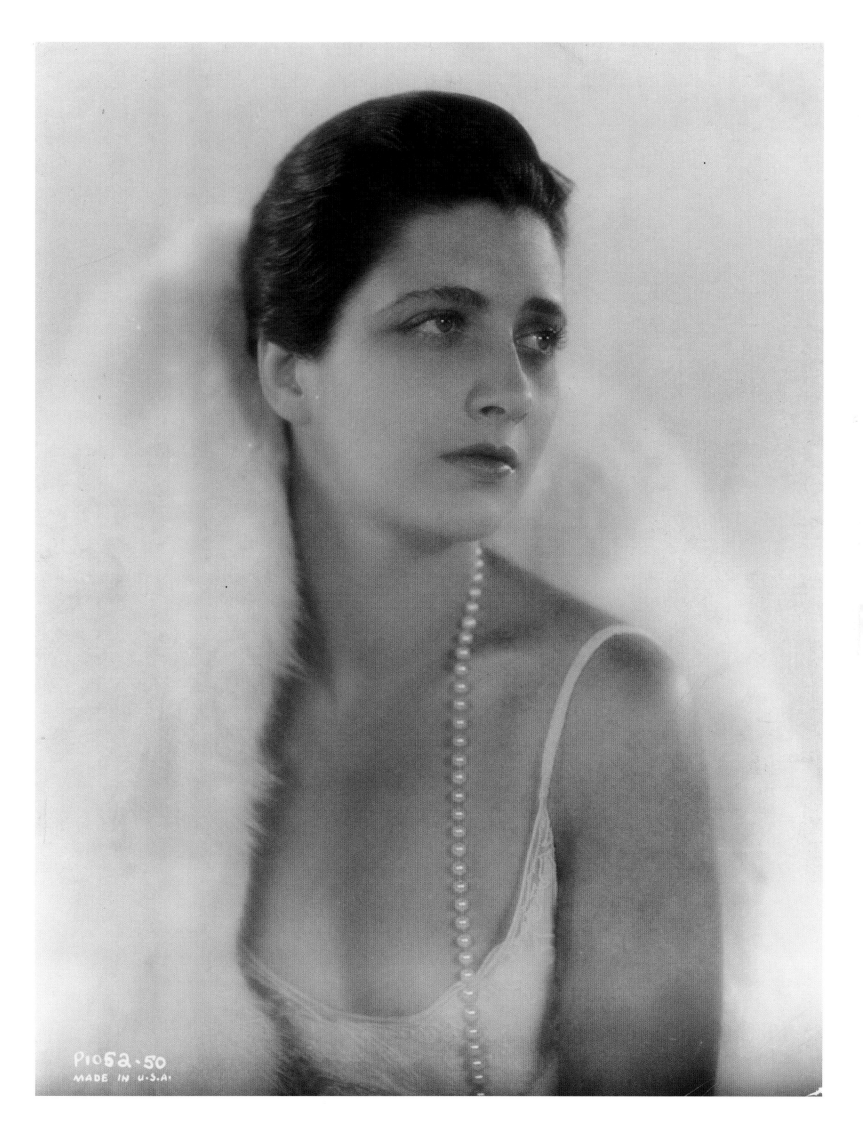

OPPOSITE
Francis is outfitted in a flamboyant costume designed by Travis Banton in this promotional photo for *Behind the Make-Up* (1930, Paramount Pictures, dir. Robert Milton and Dorothy Arzner), in which she plays the seductive actress Kitty Parker opposite William Powell—the first of six films they would make together. It was one of several vamp-type roles that characterized her early film career.

RIGHT
The raunchy undertones of *Jewel Robbery* (1932, Warner Brothers, dir. William Dieterle) are evident on this movie poster. The playful, yet flagrant depictions of adultery and drug use in the film are characteristic of pre-Code moviemaking. Despite the subject matter, Francis's supreme elegance ensured that she could act naughty without ever being perceived as vulgar.

BELOW
As the fabulously wealthy Madame Colet, Francis falls victim to the charms of a gentleman thief played by Herbert Marshall, pictured on this lobby card for *Trouble in Paradise* (1932, Paramount Pictures, dir. Ernst Lubitsch). It is her best-known film and upheld as the premier example of Lubitsch's brilliantly visual comedies.

reprise in subsequent films. As she laid the foundation for her cinematic persona in these early years, she was already being recognized for her innate sense of style. In 1929, *Picture Play Magazine* reported on "that nameless something" that she had "in the manner of wearing clothes, which sets her apart from the many and makes her one of the very few." The same year, she told *Photoplay*, "I want to graduate, eventually, from these siren things and play sophisticated leads." In just a few short years, she would make good on that ambition.

Despite it being one of the lowest points of the Great Depression, 1932 was Kay Francis's best year—bolstered by seven film releases, as well as a lucrative contract offer from Warner Brothers. Francis did not hesitate to switch studios for a raise that brought her to $2,000 per week. She was unapologetic about her desire to earn money. Motivated by a difficult childhood in which her mother struggled to make ends meet, Francis was determined to secure both of their financial futures. At Warner Brothers, she was able to take on roles for which she was much better suited—affluent sophisticates with an appetite for luxury. In *Jewel Robbery* (1932),

Of all the films Francis made, *One Way Passage* (1932, Warner Brothers, dir. Tay Garnett) was her favorite. In what was one of her most critically acclaimed performances, she portrays a terminally ill woman who falls in love with a man while on board an ocean liner, unaware that he is a convicted murderer sentenced to execution upon their arrival at port. The doomed lovers—shown on this lobby card—hold each other in an affectionate gaze, seemingly undeterred by their impending fates.

KAY FRANCIS

This promotional photo captures a pensive moment from *Man Wanted* (1932, Warner Brothers, dir. William Dieterle), Francis's first film under contract with Warner Brothers. She portrays the editor of *400 Magazine*, who hires a male secretary after the woman who works for her quits. The reversal of traditional gender roles—placing women in positions of power typically held by men—is a common feature in the Kay Francis canon.

she played a diamond-obsessed baroness desperately seeking excitement beyond the doldrums of her marriage. She finds both in a gentleman jewel thief with whom she shamelessly exchanges flirtatious innuendo in the presence of both her husband and her lover. Such a scenario could only belong to the pre-Code genre with its cavalier attitude toward sex, and Francis was the perfect vessel for this type of thing. Already having married and divorced twice by the time she arrived in Hollywood, she was uninhibited in her erotic indulgences and recorded her many dalliances with men and women alike in her diary. Her sexual encounters were never portrayed quite as frankly in her movies and were instead couched in double entendre and suggestive witticisms—as was the case in *Trouble in Paradise* (1932), a romantic comedy that created the template for cinematic love triangles. Francis played Mariette Colet, the owner of a prosperous perfume company who falls in love with her suave male secretary, only to later discover his true identity as—what else—a notorious thief. In her robber lovers and sumptuous wardrobes, Kay Francis had found her niche.

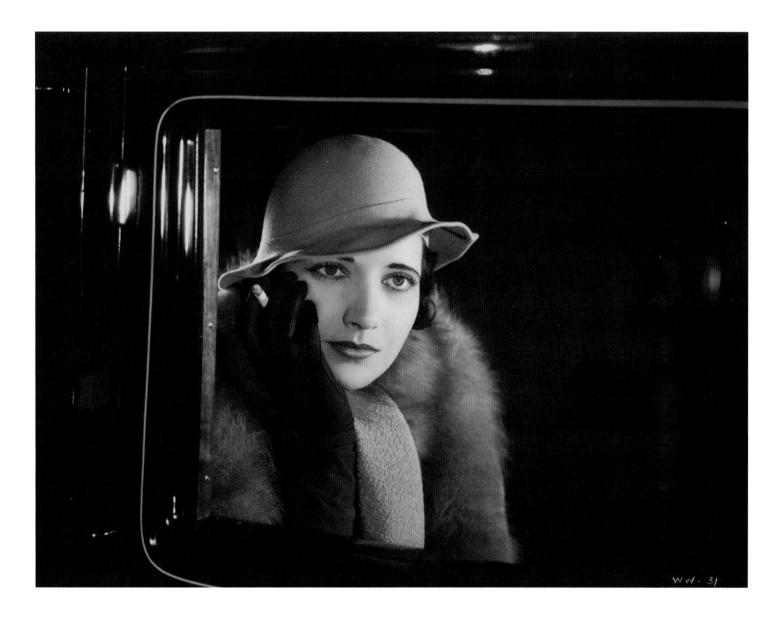

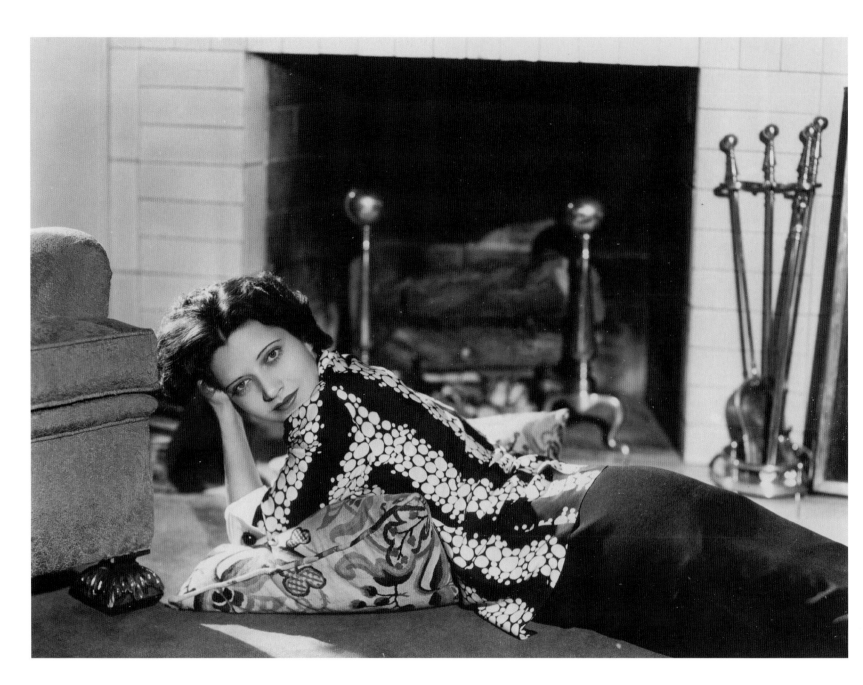

Francis's characteristically languid elegance is evident in this Warner Brothers studio portrait from the peak of her career, c. 1933. Unlike most of her peers, she was disinterested in the upkeep required for maintaining her fame. Ironically, this insouciance made her seem all the more like a true movie star.

Following her triumphs in 1932, Francis was consistently the highest-paid actress at Warner Brothers in the years that followed. In addition to her roster of well-dressed socialites, Francis also had a talent for embodying successful career women. In *Man Wanted* (1932), her character is a prominent magazine editor, and, in *Street of Women* (1932), the head designer at a thriving couture house. It seemed natural to cast her in films set within the world of fashion—and not only for the parade of lavish ensembles that audiences came to expect from a Kay Francis movie. By this point, her reputation as a clotheshorse was so ingrained that she was considered an authority on fashion herself. As movie magazines delighted in the sublime frockery of her latest films, they also enthusiastically reported on the actress's "style secrets"—all while fans wrote to her seeking advice on how to dress. It was Francis's atypical body type that initially made her so suitable for the fashions of the day. At 5'9", she was unusually tall compared to the mostly petite starlets of the studio era. This she used to her advantage, and told the readers of *Modern Screen*, "It is silly to be conscious of your height. . . . Tall girls should dare to be pictorial; that is their special forte." The same article notes "another tradition of tall girls she rebels at—low heels. Kay's are *high*." By owning her unique trait, she embodied the confidence necessary for her success. In 1936, Warner Brothers renewed Francis's contract at $250,000 for forty weeks of work. It was an impressive offer; however, the quality of her films was slowly declining. Francis had been a box office draw for female audiences, who flocked to the movie theaters to see her show off the latest modes. These so-called "woman's films" were her métier—but not exactly the forte of her studio.

Francis sued Warner Brothers in 1937. Having held up her end of the contract, she felt that the studio had failed her by relegating her to subpar films—and she wanted out. She resented "being handed a poor story with the idea that your name and popularity will carry it. . . . No star is better than her script." The studio settled and stipulated that her contract would end in September 1938, but then assigned her to bad movies hoping she would quit before then and forfeit the settlement. It has been argued that Warner Brothers engineered Francis's downfall to make room for their rising star Bette Davis—who had just engaged in her own legal battle with the studio. Regardless, the damning "Box Office Poison" advertisement that ran in *The Hollywood Reporter* on May 4, 1938, was the true death sentence for Francis's film career. The ad was taken out by the Independent Theater Owners Association and pegged stars they believed to be overpaid and declining in public appeal. They made her the scapegoat for Hollywood's unchecked glamour, which began to seem gauche as the Depression dragged on and World War II loomed. Almost all of the others named in the ad were able to bounce back—but for Francis, the damage was irreparable. She managed to land supporting roles in *In Name*

Only (1939) at RKO and *The Feminine Touch* (1941) at MGM, but was soon after forced into B-movies at lesser studios. In 1944, she signed a deal to star in and produce her own films with "Poverty Row" studio Monogram Pictures and later returned to the stage in the Broadway and touring productions of *State of the Union.* She had always been outspoken in the press, and was especially so as her career waned. Rather than wallow in her ruin after the Box Office Poison incident, she boldly announced, "I can't wait to be forgotten." It was a line she repeated several times without bitterness—she really meant it. She elaborated in an interview with *Photoplay*, saying, "I've done everything I set out to do and now I'm going to enjoy myself.... Now, I'm free!" In the end, she did not need Hollywood's ongoing validation. And though she languished in undeserved obscurity for decades, her sartorial splendor and divinely decadent films will—much to her chagrin—never be forgotten.

Francis makes quite a fashion statement in a chic sportswear ensemble paired with a wide-brimmed sun hat in this promotional photo for *Man Wanted.*

Francis wears a luminous satin gown by Orry-Kelly in this promotional photo for *First Lady* (1937, Warner Brothers, dir. Stanley Logan)—a satirical political comedy for which she had eighteen major costume changes, with coordinating shoes and handbags made to order. That she invariably achieved elegance without extravagance is a sign she was never outshone by her clothing. She insisted this was the key to sartorial success, claiming, "I think a woman is well dressed when she, herself, is predominant and her clothes seem like part of her—like her skin."

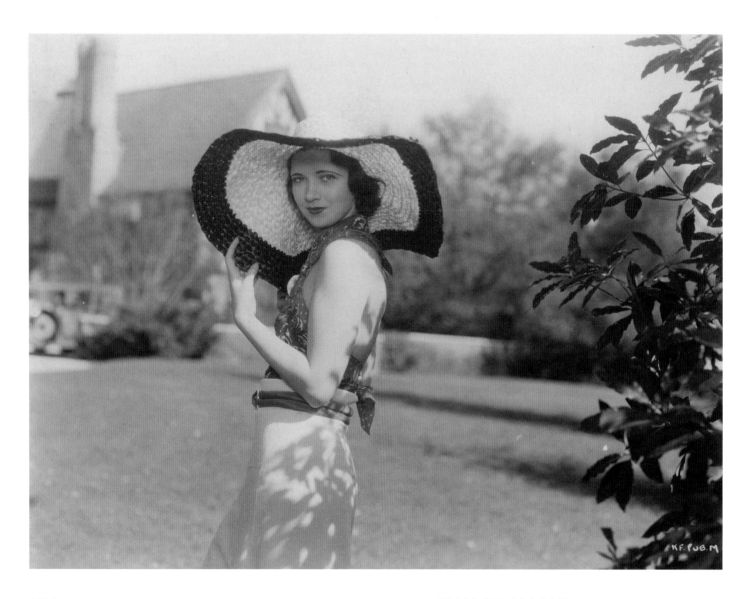

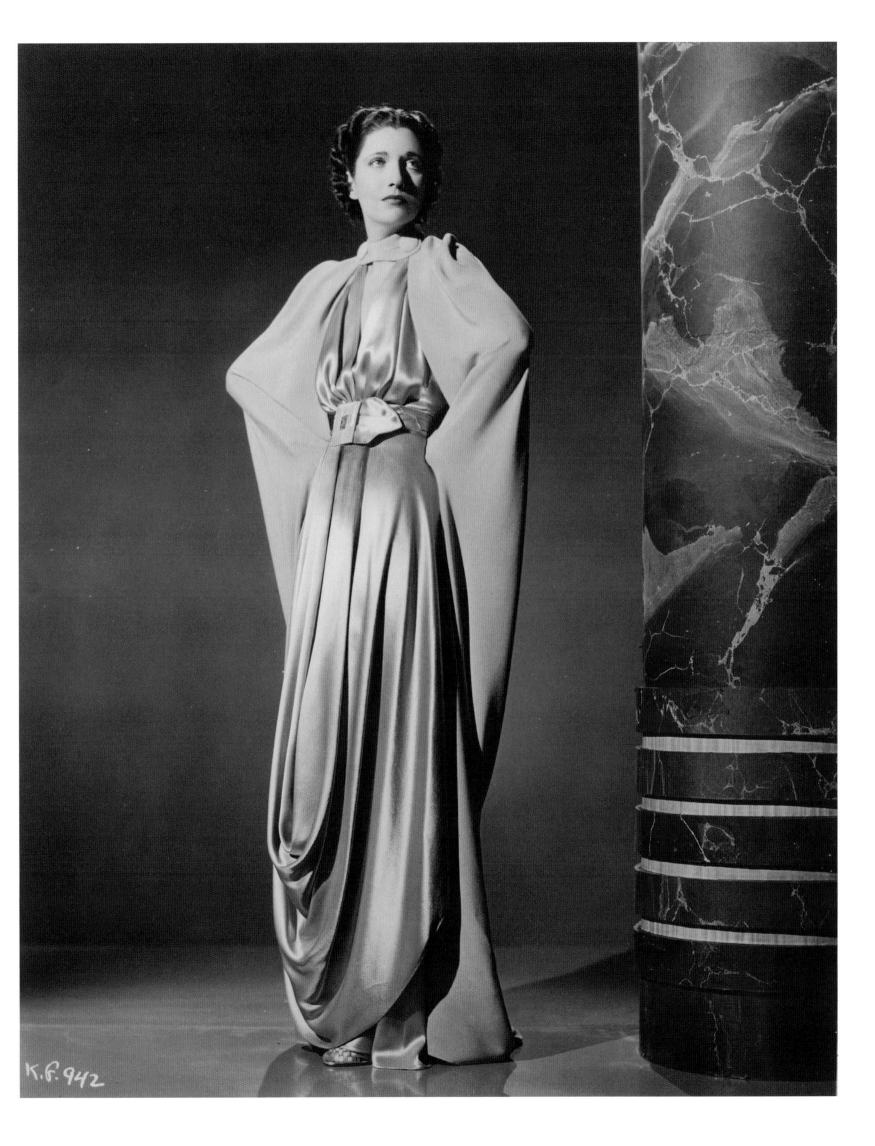

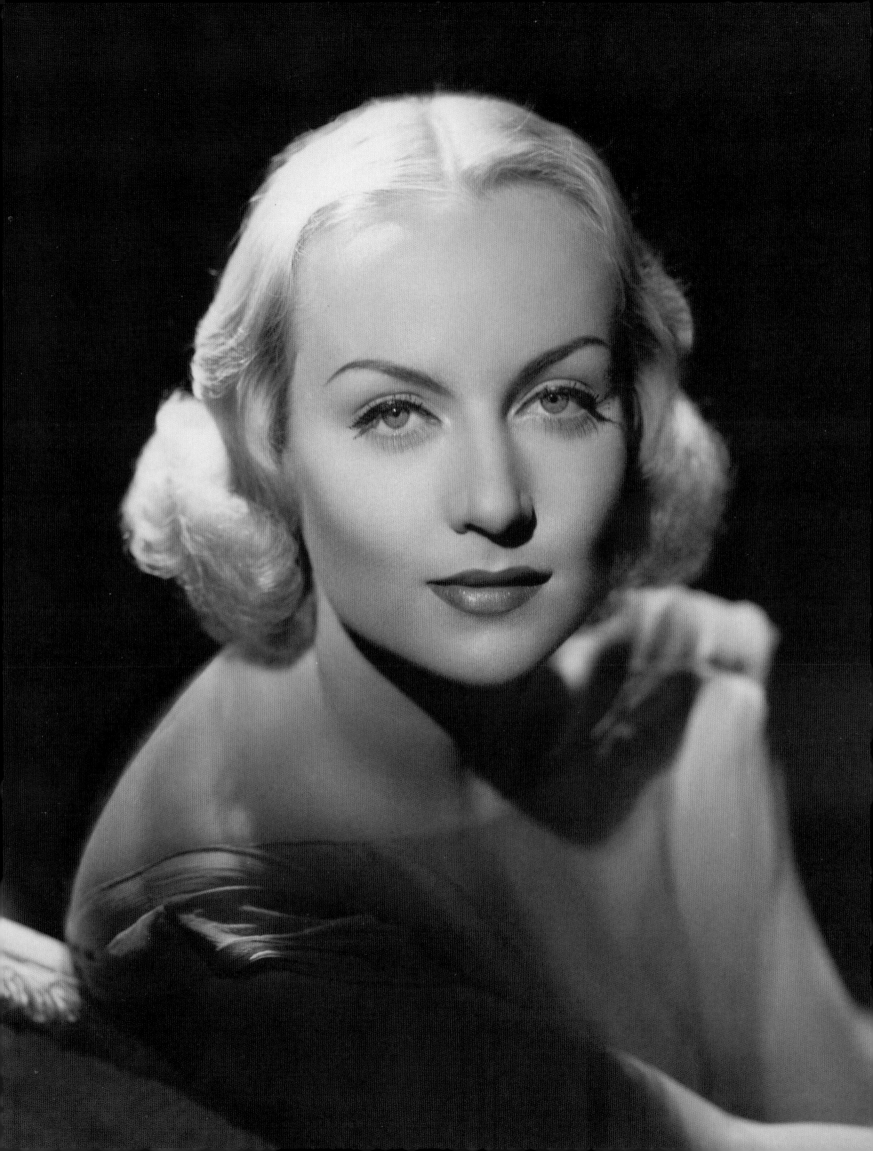

CAROLE LOMBARD

1908–1942

The undisputed "Queen of Screwball Comedy," Carole Lombard lit up the silver screen with her raucous charisma, razor-sharp sass, and incandescent beauty. With her knack for rollicking physicality and rapid-fire dialogue, she shaped the genre that brought levity to the nethermost years of the Great Depression. Screwball comedy, in all its histrionic absurdity, never took itself too seriously—and neither did she. While headstrong and confident in her abilities, Lombard was refreshingly unpretentious in her approach to stardom. She left the Tinseltown glitz on the studio lot and chose not to live extravagantly despite being one of the top-earning actresses in the industry. Her affable charm was matched by her vivacious spunk and an affinity for cursing, which earned her the nickname "the profane angel." Her tragic death in 1942 marked Hollywood's first World War II casualty and the end of an exuberant life cut short.

Carole Lombard was born Jane Alice Peters on October 6, 1908, in Fort Wayne, Indiana. A natural tomboy with a proclivity for sports, she caught the attention of a film director while playing baseball at the age of twelve, which led to her first film role in *A Perfect Crime* (1921). It was a small part in an insignificant movie, but it motivated her to pursue acting more seriously. When offered a contract with the Fox Film Corporation in 1924, the sixteen-year-old dropped out of high school and signed with the studio, changing her name in the process. As Carole Lombard, she began in bit parts before securing her first leading role in the drama *Marriage in Transit* (1925). But just as the young actress was getting started, she suffered a

The luminosity of Carole Lombard's singular beauty shines through this Paramount studio portrait from 1935. The previous year, she had spoken of self-acceptance in an interview with *Hollywood Magazine*, stating, "I found that individuality was more important than conforming to the classic ideas of beauty. I just let my face be moon-shaped and my nose be my nose and let it go at that."

major setback when she was injured in a car crash that nearly destroyed her face. It was only with experimental plastic surgery—and her astonishing fortitude to endure it without anesthetic—that Lombard was able to emerge with just a faint scar on her left cheek. She learned to conceal it with makeup and strategic lighting and resumed her acting pursuits with renewed vigor. In 1927, she began a professional affiliation with producer Mack Sennett and appeared as one of his "Bathing Beauties" in a series of two-reel comedies. Though she was initially reluctant to engage with his signature slapstickery, Lombard unknowingly began training for her forthcoming career as a comedienne.

Lombard signed a contract with Paramount Pictures in 1930 and was immediately thrust into roles that had her glamorously gowned by the studio's star costume designer, Travis Banton. She established a reputation as a clotheshorse in the five films she made in 1931—two of which cast her opposite Paramount's top male star William Powell, whom she married later that year. Their on-screen pairings in *Man of the World* (1931) and *Ladies' Man* (1931), combined with their off-screen partnership, banked a substantial increase of star power for Lombard. Although the marriage lasted little more than two years, they remained lifelong friends. Her

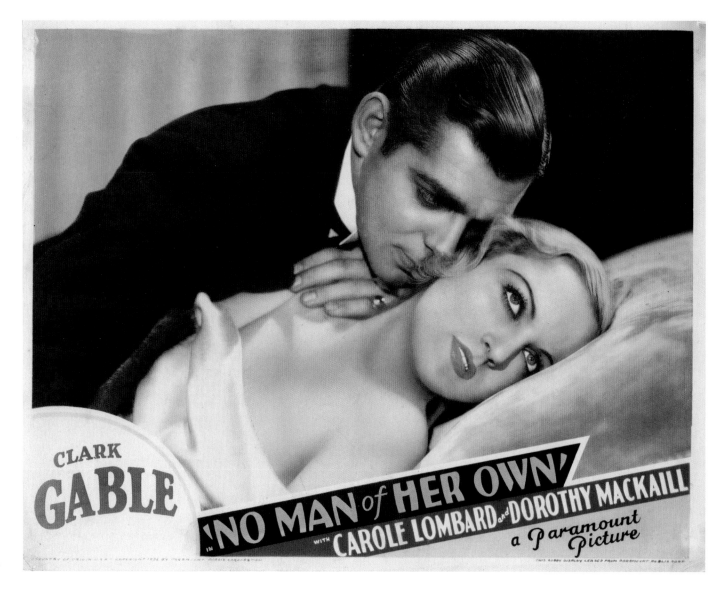

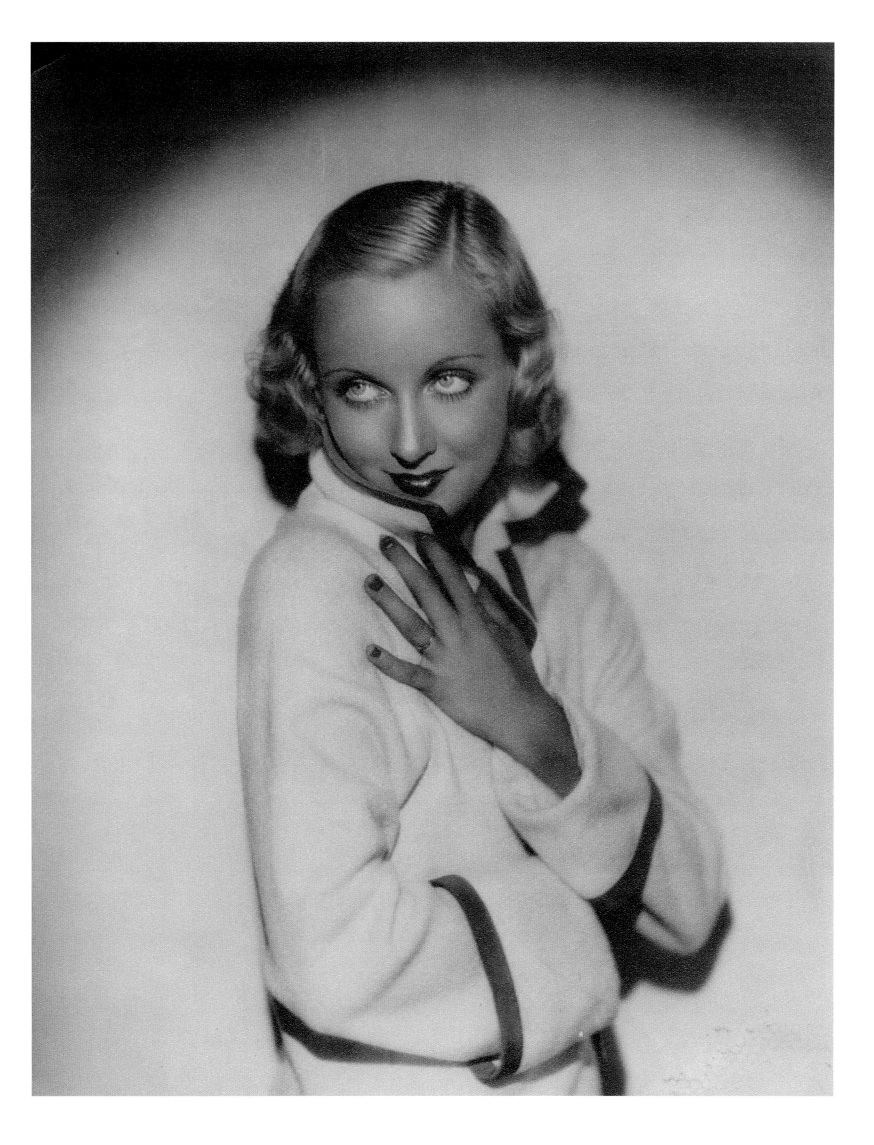

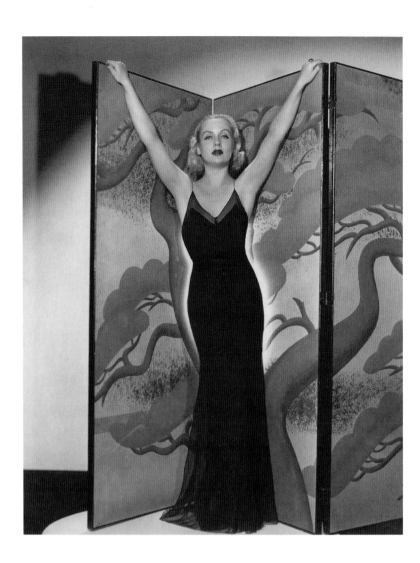

LEFT

Dubbed "Carole of the Curves" by Mack Sennett, Lombard's shapely figure is visibly highlighted in this publicity photo for *White Woman* (1933, Paramount Pictures, dir. Stuart Walker).

BELOW

Lombard was photographed by Eugene Robert Richee as a promotion for *White Woman*, wherein she plays a nightclub singer in Malaysia threatened with deportation for indecency. Her daringly low-cut garment is indicative of the costumes permitted during the provocative pre-Code era.

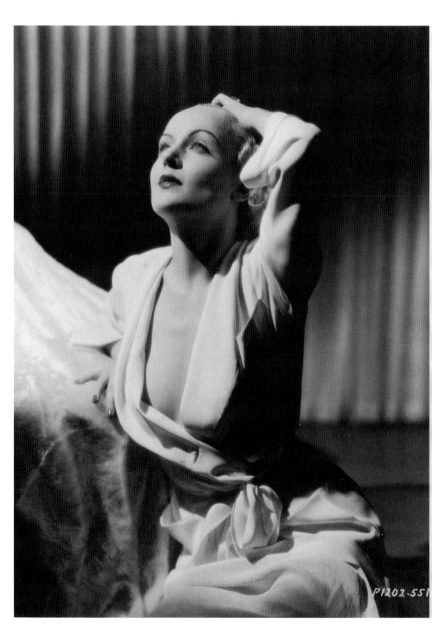

Twentieth Century (1934, Columbia Pictures, dir. Howard Hawks) was a seminal screwball comedy that marked a watershed moment in Lombard's career. In this publicity photo, her character's feisty spirit simmers beneath a disapproving glance.

career ascendant, Lombard appeared in another five films in 1932, including *No Man of Her Own* with Clark Gable. They had no romantic involvement at the time, but theirs would soon become a love story for the ages. In 1933, she yet again netted five films that ranged from horror (*Supernatural*) to action (*The Eagle and the Hawk*) to romance (*Brief Moment*). During these early years at Paramount, Lombard's films reportedly never lost money—a testament to her growing popularity and steady upward trajectory.

While on loan to Columbia Pictures, Lombard turned down the leading role in *It Happened One Night* (1934)—the film widely recognized as the inaugural screwball comedy. She chose instead to star in *Twentieth Century* (1934), another film that established the genre's essential ingredients and elevated her fame to new heights. Up to this point, Lombard's on-screen persona was largely built on her general magnetism and physical allure; however, director Howard Hawks saw the glimmering possibility of something more while observing her behavior at a party. The uninhibited starlet was tossing back drinks, chattering a mile a minute, and swearing with reckless abandon. In casting her as the pugnacious lingerie model–turned-diva stage actress Lily Garland, Hawks sought to capture this previously unseen facet of Lombard's lively personality. In *Twentieth Century*, she faced off with stage and screen veteran John Barrymore as her theatrical Svengali. Hawks

directed Lombard to react to his character's domineering as she would to any man in her own life—and what resulted was an explosive performance peppered with rambunctious kicking, brassy back talk, and unbridled moxie. The film marked a vital turning point in Lombard's career that ultimately created a pathway for her to achieve her full potential as a comedic actress.

Following her breakout in *Twentieth Century*, Lombard starred in a string of screwball comedies that established her as one of Hollywood's foremost comediennes. In a loan-out to MGM, she played a gold-digging chorus girl with a penchant for wisecracks in *The Gay Bride* (1934). In *Hands Across the Table* (1935), she portrayed another fortune-seeker—this time a manicurist with dreams of finding a rich husband. The following year, she juggled the affections of two insistent suitors at the center of a zany love triangle in *Love Before Breakfast* (1936). Because Lombard had the belief "that we bring to the screen the same qualities we bring to living," she cultivated a quirky public persona that complemented her cinematic self. She threw delightfully kooky theme parties and embraced her reputation as the industry's most madcap hostess. She was also known to be a practical joker—in one instance, bringing a herd of cows to the set of *Mr. & Mrs. Smith* (1941) in response to director Alfred Hitchcock's infamous claim that "all actors are

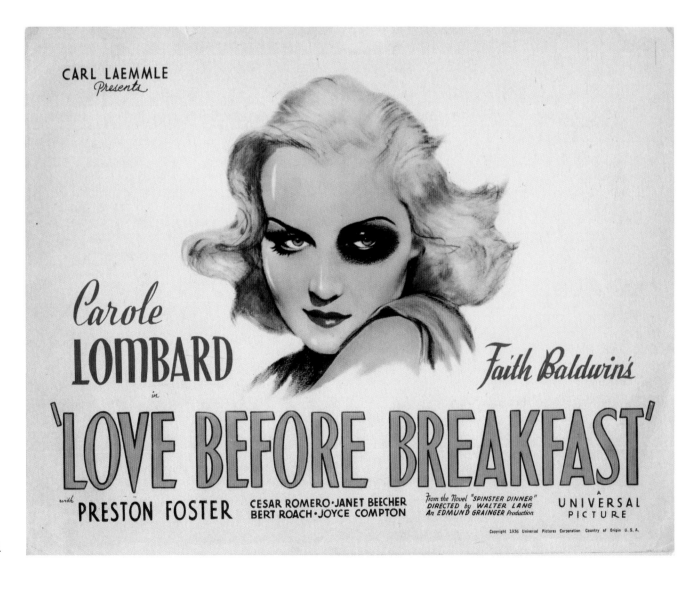

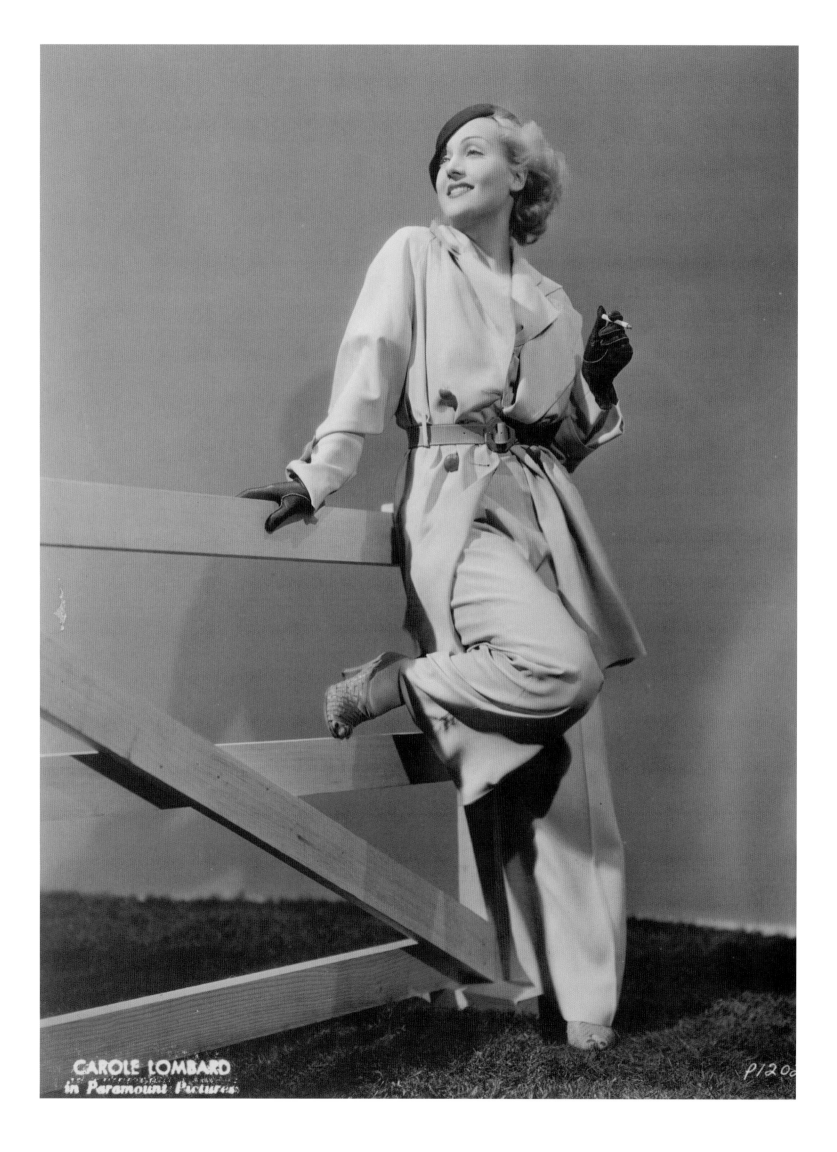

CAROLE LOMBARD
in Paramount Pictures

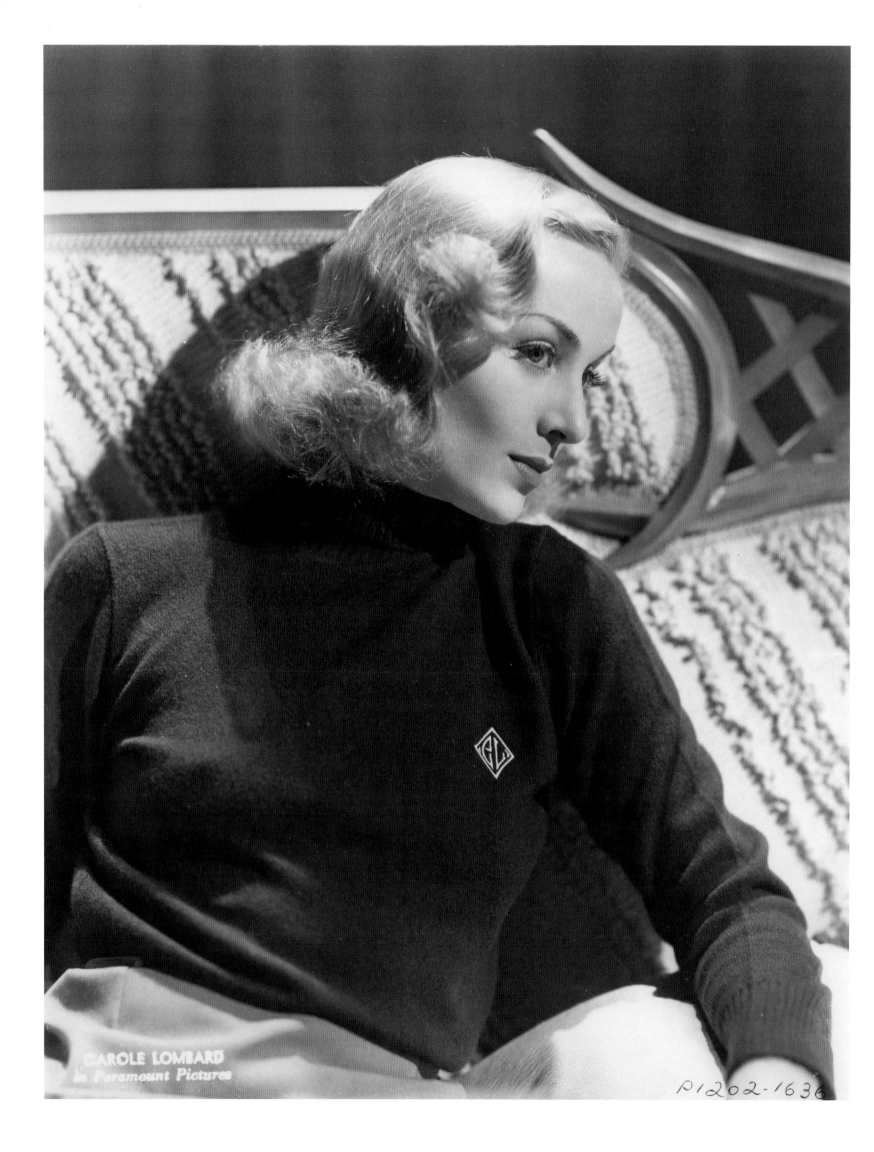

CAROLE LOMBARD
in Paramount Pictures

P1202-1636

cattle." It was this wicked sense of humor that set her apart from Hollywood's bevy of blondes and made her so well-suited to the genre. And much like the screwball heroines she played on-screen—who often found themselves entrenched in a farcical battle of the sexes—Lombard outmatched tyrannical directors and stood up for crew members who were treated unfairly.

With *My Man Godfrey* (1936), Lombard reached a career high and solidified her standing as the queen of screwball comedy. She played the ditzy heiress Irene Bullock, who takes pity on a "forgotten man" living at the city dump and hires him as a butler to her nutty family—only to develop an incurable infatuation that heightens the household's antics. She starred opposite her ex-husband William Powell, who only agreed to do the film if Lombard was cast as the leading lady. For her endearing portrayal of the scatterbrained, lovelorn socialite, she earned her only Oscar nomination for Best Actress. It is the role for which she is best known, and one that she called "the most difficult part I ever played. Because Irene was a complicated and, believe it or not, essentially a tragic person." Even amid the screwy shenanigans, Lombard managed to achieve surprising nuance. Of her approach to humor, she said, "Back of all comedy, there is tragedy; back of every good belly-laugh there is a familiarity with things not funny at all. There must be. You laugh with tears in your eyes, don't you?"

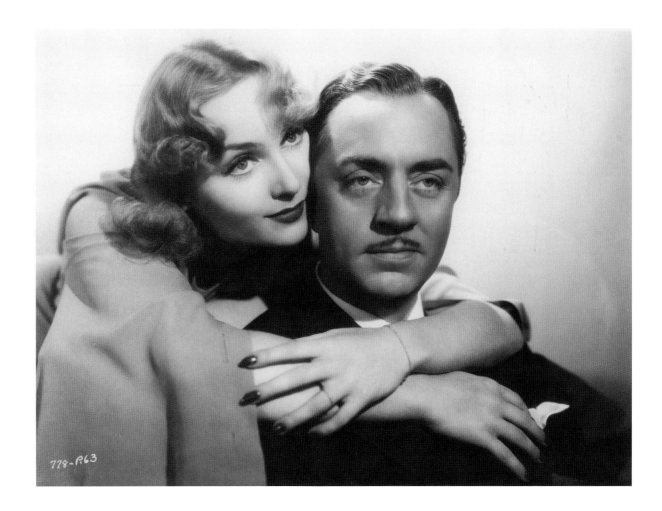

778-P63

CAROLE LOMBARD

Fresh off her success in *Godfrey*, Lombard starred in *Nothing Sacred* (1937), a screwball comedy written specifically for her and her first film in Technicolor. She was, at this point, one of the highest-paid actresses in Hollywood with a reported salary of $500,000—much of which went to taxes that she happily paid to benefit the country beleaguered by the Great Depression. Lombard also experienced an influx of popularity in 1939 when she married Clark Gable and became queen to the "King of Hollywood." She dabbled in dramatic roles with films like *Made for Each Other* (1939) and *They Knew What They Wanted* (1940), but returned to screwball with Hitchcock's *Mr. & Mrs. Smith* (1941)—wherein she had the honor of directing the director for his trademark cameo.

To Be or Not to Be (1942) would be Carole Lombard's final film—a black comedy about an acting troupe in Occupied Warsaw that becomes embroiled in Nazi dealings. Her character, an esteemed actress, heroically outwits the German soldiers and helps save the Polish resistance. Lombard was dedicated to aiding the war effort in her real life as well. When Gable was named chairman of the Hollywood Victory Committee, she jumped at the opportunity to participate in one of the first war bond drives. She managed to raise an astounding $2 million in a single evening at a rally in her home state of Indiana. Eager to return home to Gable, Lombard decided to fly back to California instead of taking the train as planned. TWA Flight 3 made a stop to refuel in Las Vegas, and shortly after takeoff, the plane crashed into a mountain. On January 16, 1942, she became Hollywood's first World War II casualty and was deeply mourned by the movie industry.

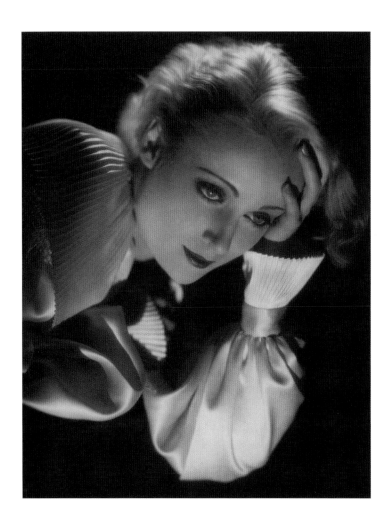

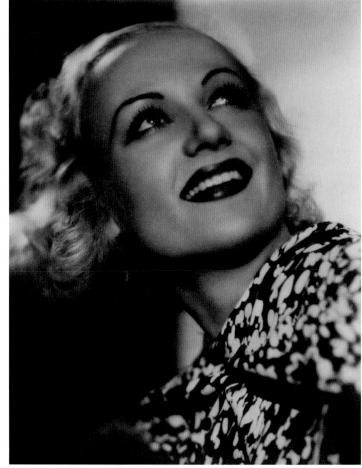

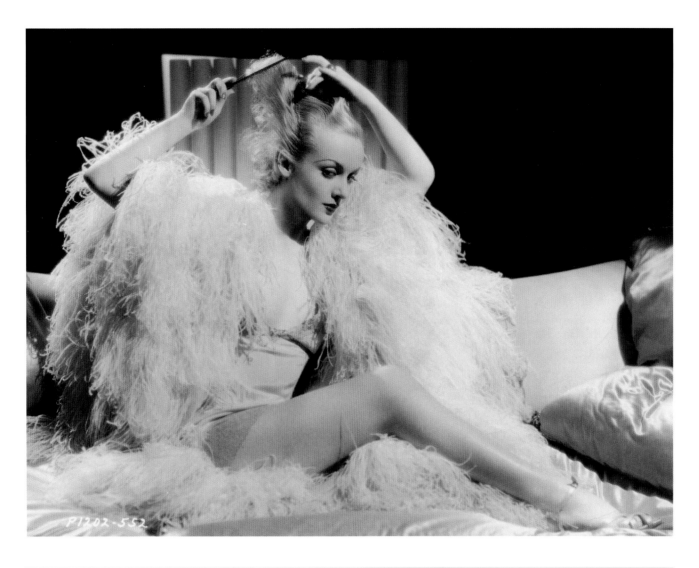

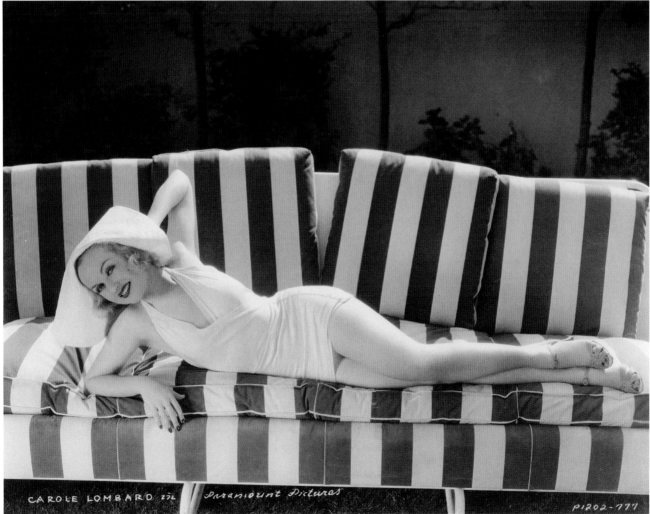

CAROLE LOMBARD 202 *Paramount Pictures*

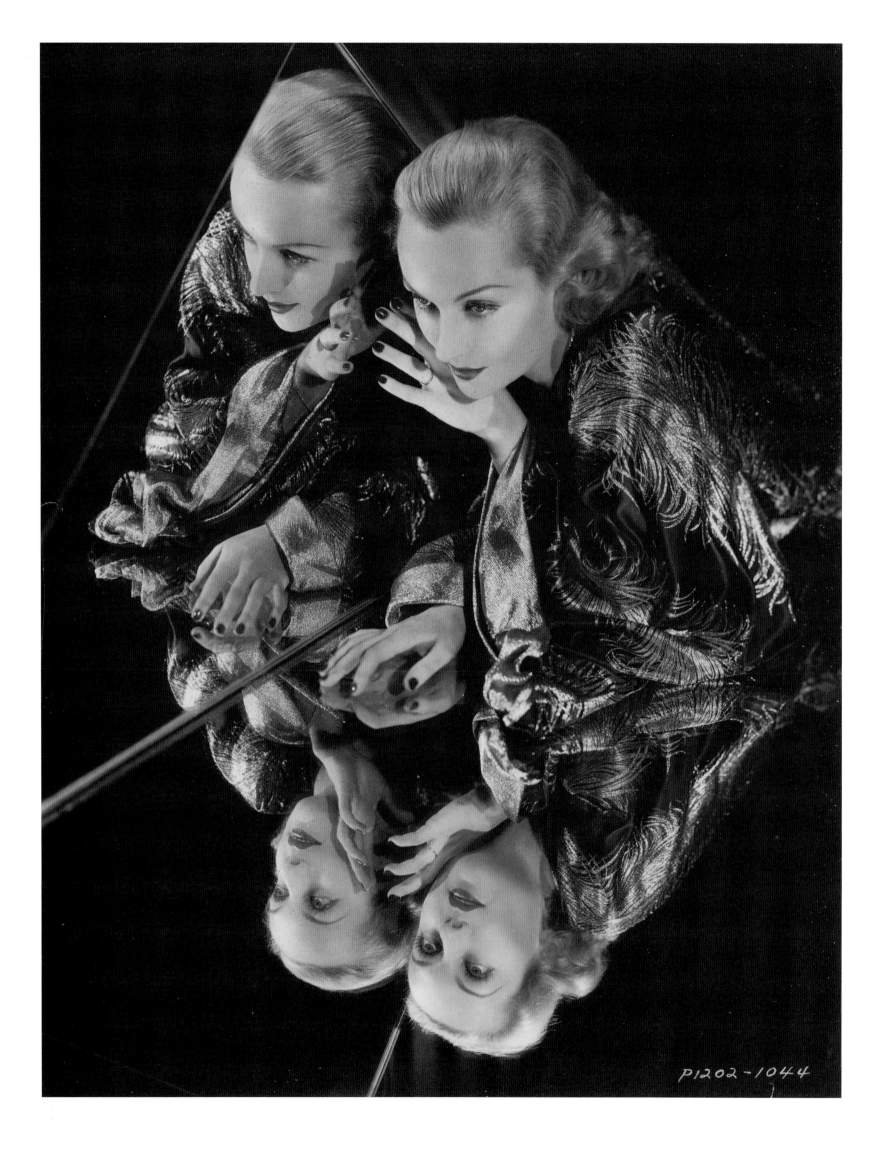

P1202-1044

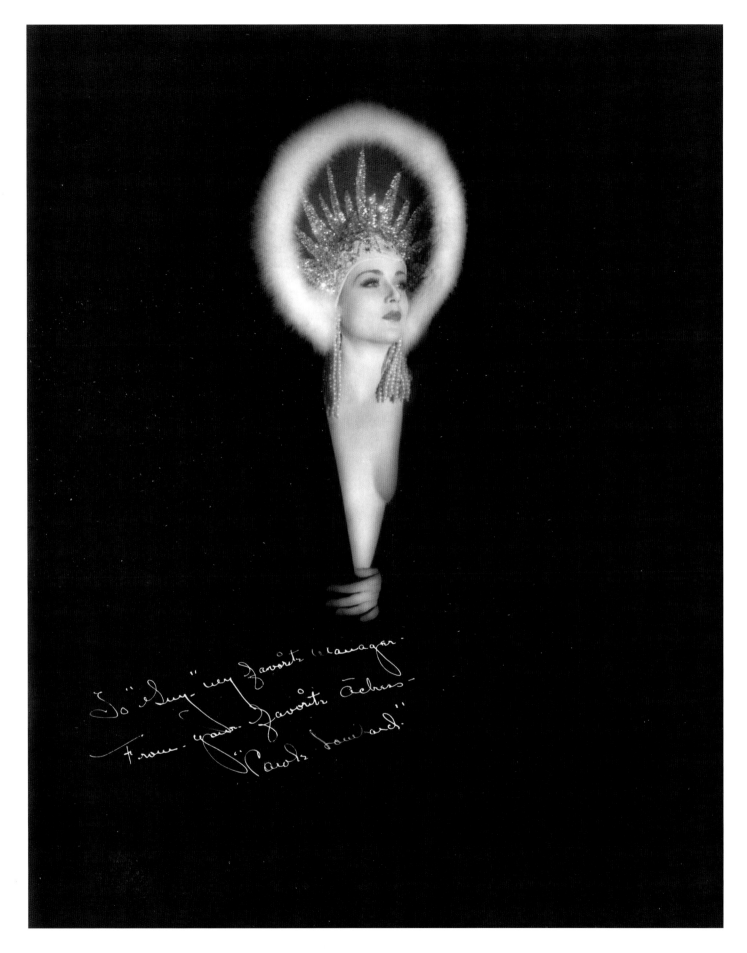

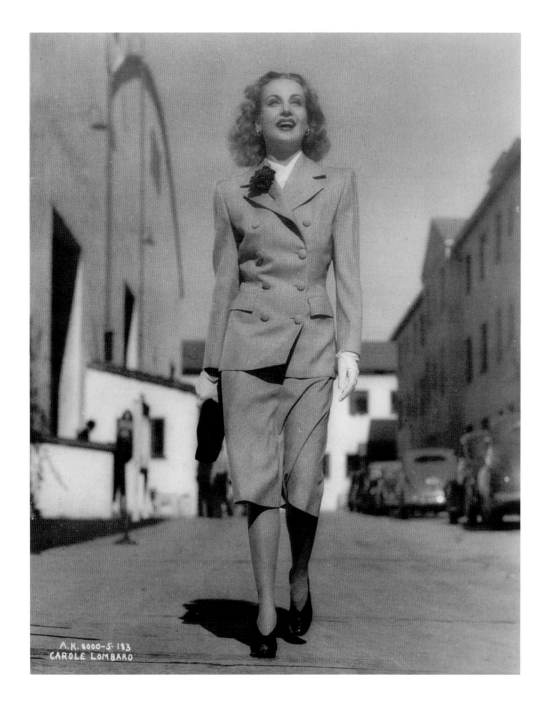

A.K. 8000-5-193
CAROLE LOMBARD

This publicity photo for Lombard's final film captures her inextinguishable zest for life. In 1938, she made this declaration in *Motion Picture Magazine*: "I *love* everything I do. I'm intensely interested in and enthusiastic about everything I do, *everything*. No matter what it is I'm doing, no matter how trivial, it isn't trivial to me. I give it all I got and love it. I love living, I love life."

Lombard is exquisitely captured in this publicity photo for *To Be or Not to Be* (1942, United Artists, dir. Ernst Lubitsch). The movie's reception was impeded by apprehension regarding its subject matter and inopportune timing. The Nazi satire was filmed just before the United States joined WWII and released mere weeks after Lombard's tragic death, which many perceived as distasteful. The film has since been reevaluated and deemed a Lubitsch classic.

Lombard was thirty-three years old when she died and in the prime of her career. Like other gone-too-soon stars in film history, she has been immortalized in her radiant youth. Still, there is cruel irony that—in an industry obsessed with youth—it was an actress unafraid of age who was taken prematurely. In an interview just a few years earlier, she poignantly stated: "With age there comes a richness that's *divine*. . . . I don't know of anything in the world more beautiful, more fascinating than a woman ripe with years, rich and lush as velvet with experience. . . . I LOVE the idea of getting old."

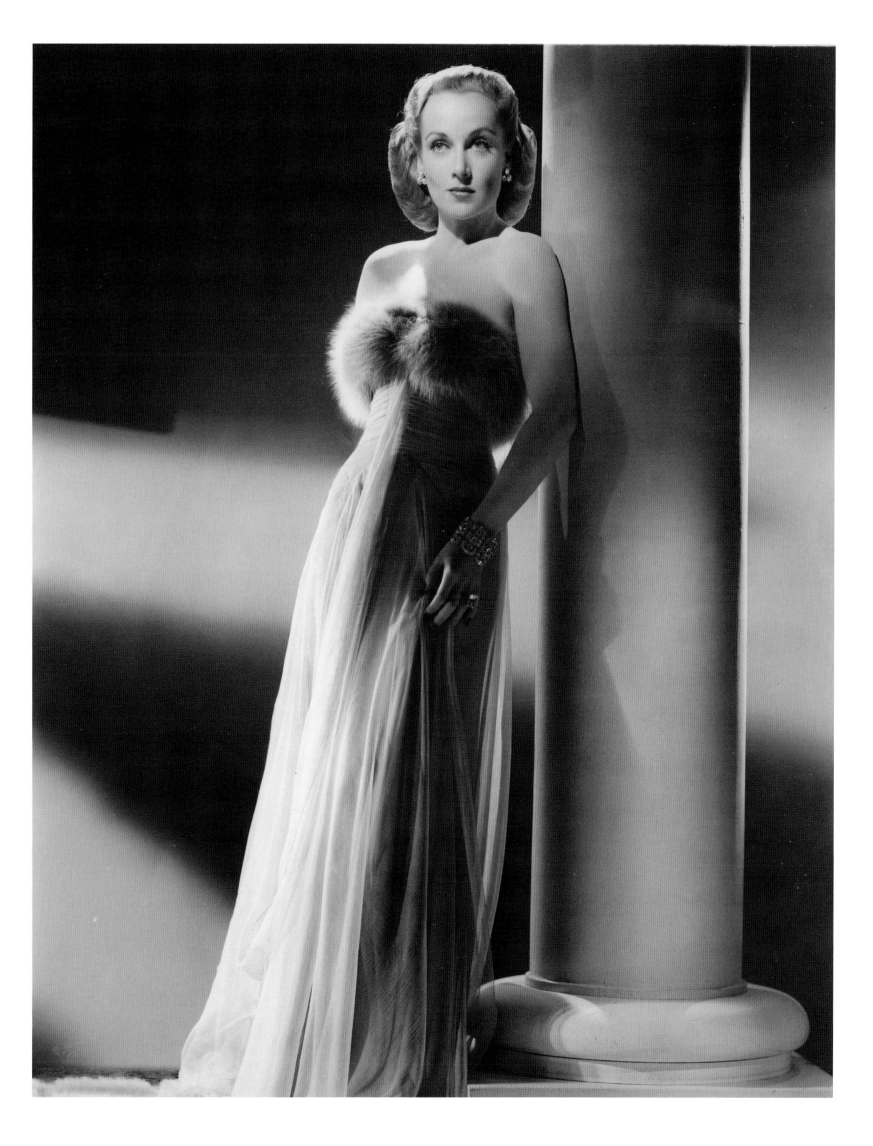

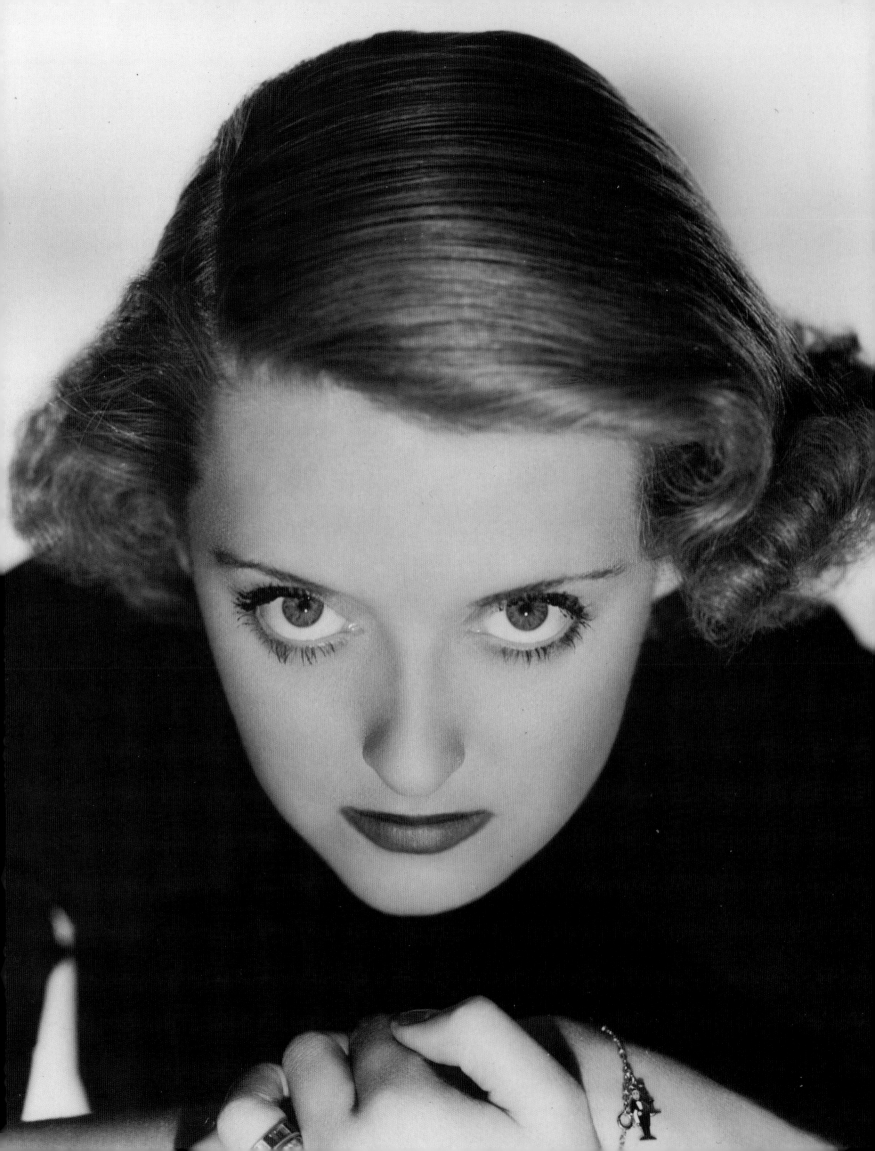

BETTE DAVIS

Widely regarded as one of Hollywood's greatest actresses, Bette Davis had a monumental career that spanned over five decades, one hundred films, and numerous genres. The so-called "First Lady of the American Screen," she was the first person to garner a record ten Academy Award acting nominations. She possessed a talent for playing tempestuous, strong-willed women—and did so with exhilarating depth and complexity. Instantly recognizable for her expressive eyes, idiosyncratic diction, and distinctive mannerisms, she was known to punctuate each gesture with the emphatic flick of an ever-present cigarette. She famously eschewed the glamour of movie stardom and was unafraid to take on roles that made her appear unattractive or dislikable. Her acting prowess was only matched by her professional tenacity, which earned her a reputation for being forthright and demanding—evidence of the unrelenting ambition that powered her legendary career.

Born in Lowell, Massachusetts, on April 5, 1908, Ruth Elizabeth "Bette" Davis made her grand entrance as a bolt of lightning struck a nearby tree at the moment of her birth. After her parents divorced in 1915, she was raised by her mother, who encouraged her pursuit of acting and moved the family to New York City. She made her stage debut at the age of twenty and took her first Broadway bow the following year. Soon after, she caught the eye of a talent scout who invited her to Hollywood for a screen test, and by 1930, she had signed with Universal.

The intensity of Bette Davis's gaze in this promotional photo for *Satan Met a Lady* (1936, Warner Brothers, dir. William Dieterle) demonstrates the strength of conviction with which she would forge a legendary, lasting career.

From her arrival in Hollywood, it was clear that Davis would not fit the mold of a traditional starlet. Her film debut in the pre-Code drama *Bad Sister* (1931) was followed by several lackluster films, and ultimately, the studio chose not to renew her contract due to a purported lack of sex appeal. When Davis signed with Warner Brothers in 1932, she embarked on a career-defining relationship with the studio, though one with an inauspicious start.

At first, she was styled as a charming blonde ingénue à la Constance Bennett, and her early roles saw her miscast in conventional models of cinematic femininity. She played variations on the gangster moll archetype in *20,000 Years in Sing Sing* (1932) and *Parachute Jumper* (1933) before getting the full Hollywood glamour girl treatment in films like *Ex-Lady* (1933) and *Fashions of 1934* (1934)—complete with platinum locks, false eyelashes, and figure-hugging gowns. She was, however, indifferent toward the glitzy trappings that brought fame to other actresses at the time, claiming, "I knew it was possible with my ambitions for acting rather than for glamour that I might never equal their popularity. But I was I!"

Indeed, it was a loan-out to RKO that would bring Davis her breakout role—one that was decidedly unglamorous but served to showcase her acting ability. In *Of Human Bondage* (1934), she played Mildred Rogers, a disdainful waitress who becomes the ruinous object of a man's obsession and eventually succumbs to a tawdry

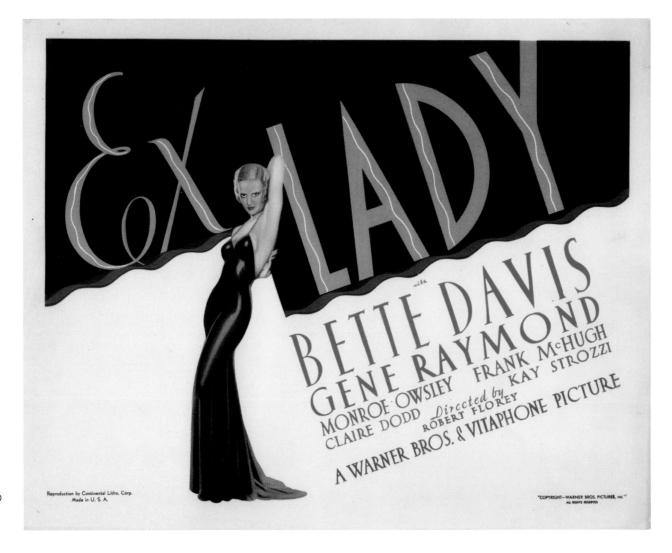

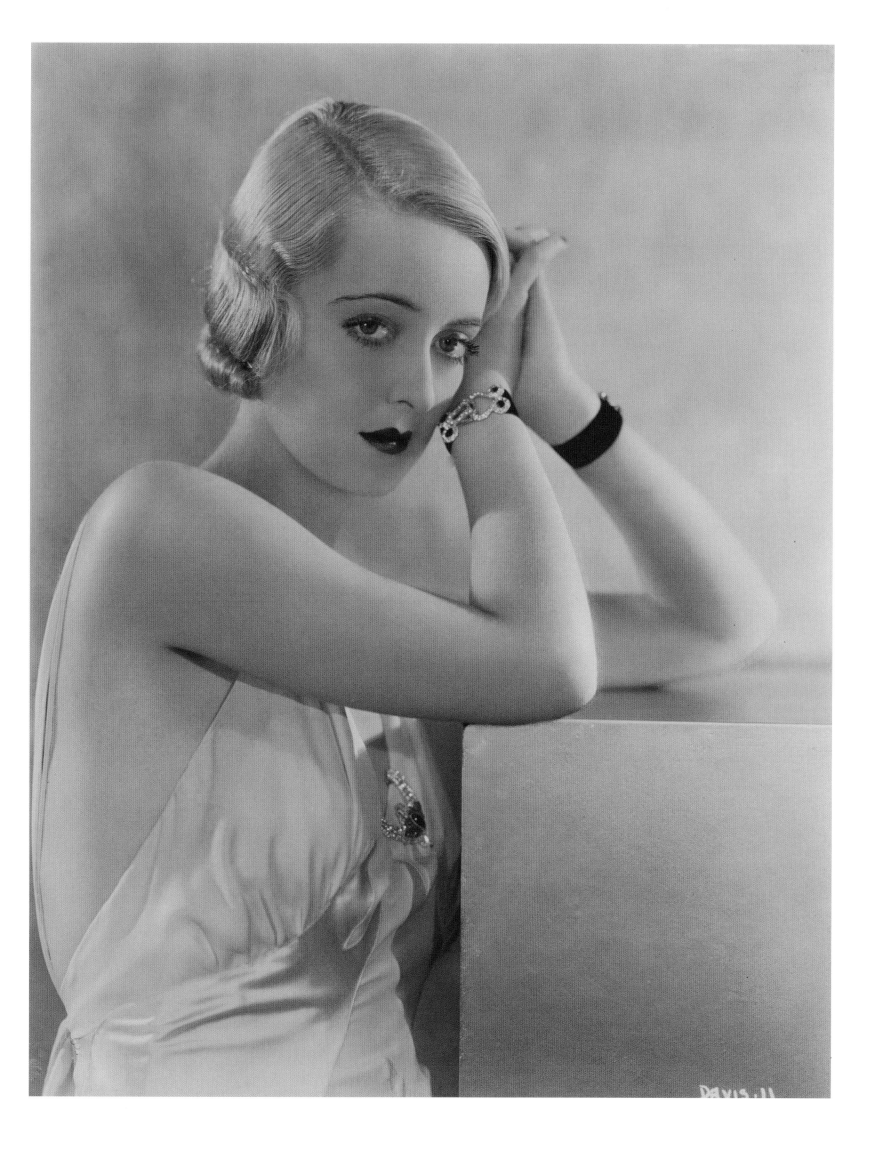

life of prostitution. So committed was she to the portrayal of Mildred's downfall, that Davis insisted on doing her own makeup for the final scene, claiming, "The last stages of consumption, poverty, and neglect are not pretty and I [intend] to be convincing-looking." Her impassioned display of contempt and vulgarity in the film was lauded by critics and audiences alike—which made her omission from the Best Actress category one of the greatest scandals in Academy Award history.

The following year, she won an Oscar for the comparatively inferior *Dangerous* (1935), in which she played a down-and-out actress with destructive tendencies. Though it is generally agreed that the award was a consolation for the Academy's oversight the previous year, the win established her virtuosity for playing complicated, unsympathetic characters.

Davis's initial triumph was followed by a period of conflict at Warner Brothers. She demanded a salary increase commensurate with her critical acclaim and repeatedly turned down inconsequential roles she thought were beneath her. When placed on suspension for refusal to work, she attempted to seek better parts abroad, only to be sued by the studio for breach of contract in 1936. During the trial, Davis was treated unfavorably by the press and portrayed as a spoiled brat

A lobby card for *Of Human Bondage* (1934, RKO Pictures, dir. John Cromwell), in which Davis stars opposite Leslie Howard in the role that would redefine her on-screen persona and ultimately lead her to her first Academy Award.

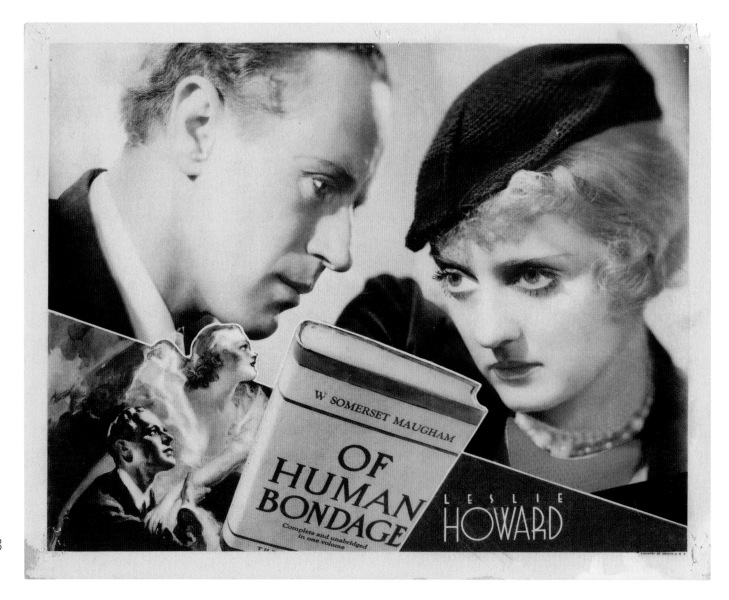

Davis's direct gaze captures her character's disdain in the lobby card for *Dangerous* (1935, Warner Brothers, dir. Alfred E. Green) *(right)*. In the lobby card for *Marked Woman* (1937, Warner Brothers, dir. Lloyd Bacon) *(below)*, her visage is further intensified by the graphic quality of the design, which draws attention to her piercing eyes and tempestuous pout.

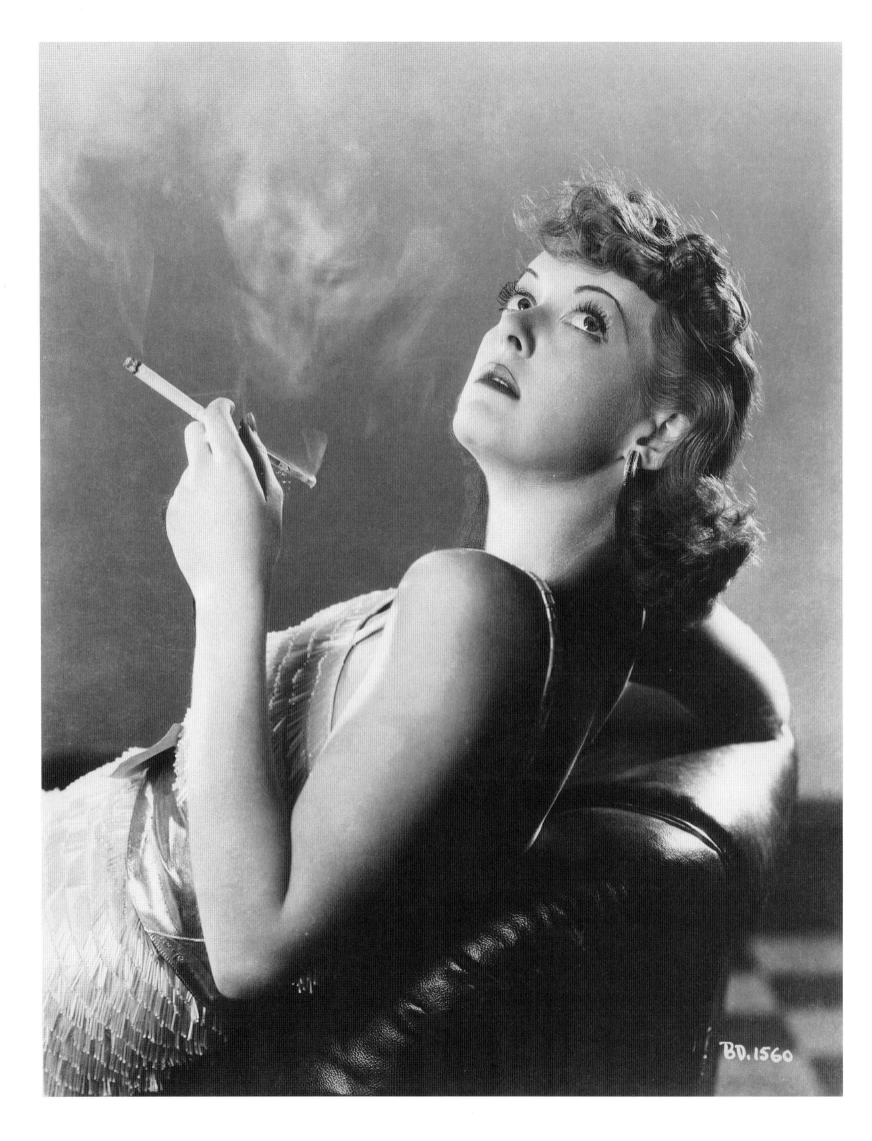

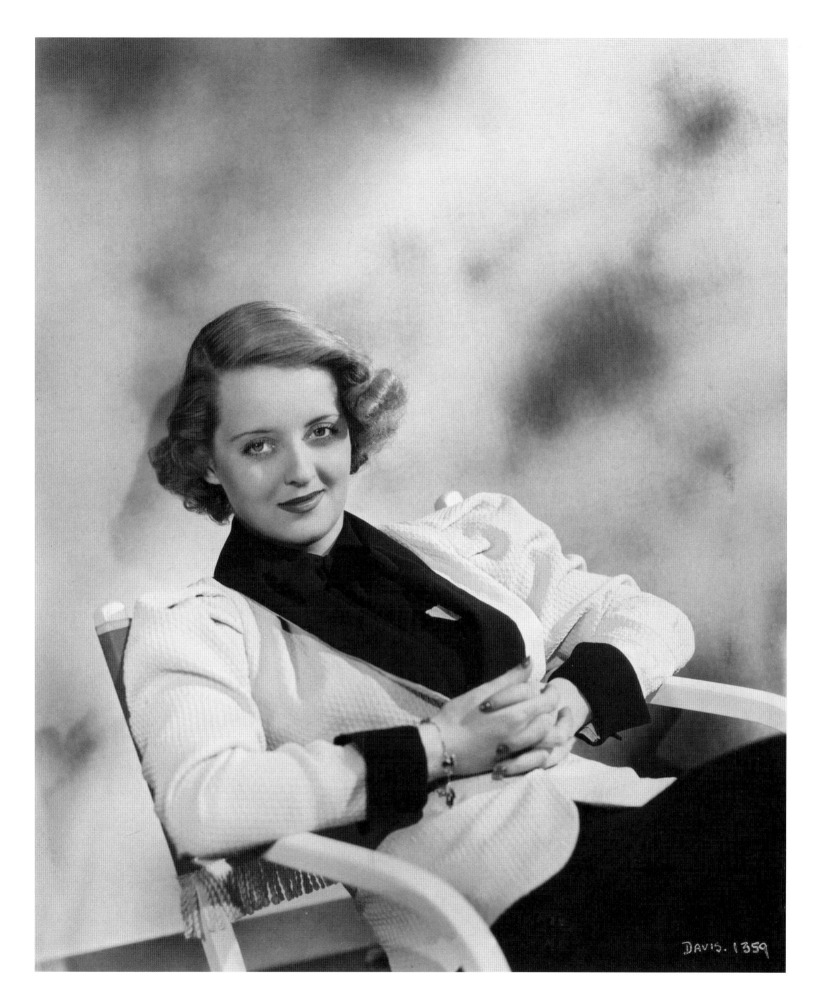

DAVIS. 1359

In this publicity photo for *Marked Woman,* Davis is framed by wisps of smoke from a lit cigarette—an accessory that would become integral to her persona.

The self-assuredness of Bette Davis captured in this 1936 studio portrait speaks to her resolve in taking on the studio executives in a landmark legal case. Despite her loss, she would return to Warner Brothers with newfound vigor.

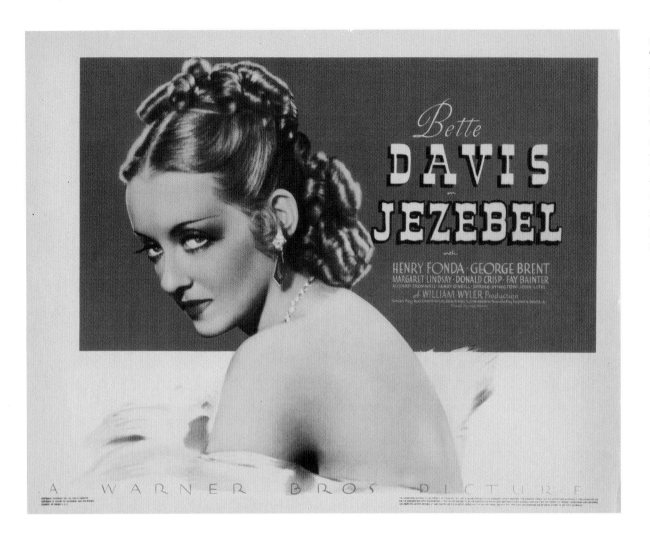

The scandalous nature of the shoulder-baring ball gown seen in this wardrobe test is emphasized in the lobby card for *Jezebel* (1938, Warner Brothers, dir. William Wyler) (*left*). Designed by Orry-Kelly, the "red" dress is central to both character development and plot. And while the brazen hue of the garment cannot be physically seen in this black-and-white movie (*opposite*), Davis's fierce performance imbues it—and the rest of the film—with a sense of vibrant color.

and "unemployed movie star." She nevertheless held firm in her conviction and asserted her claim, later stating, "I knew that, if I continued to appear in any more mediocre pictures, I would have no career worth fighting for." Although she ended up losing the legal case against Warner Brothers, her bold display of moxie earned her newfound respect upon her return to the studio lot—which ultimately led to the substantial roles and increased pay she had been fighting for. When looking back on this pivotal moment in her career, Davis confessed, "In a way, my defeat was a victory. . . . In the long view, there is no question but that I won after all."

Davis—along with every other actress in Hollywood—vied for the chance to play Scarlett O'Hara in the highly anticipated adaptation of *Gone with the Wind* (1939). She didn't get the part, but Warner Brothers beat the film to the box office with its own period drama. In *Jezebel* (1938), Davis played Julie Marsden, a head-strong antebellum southern belle who brazenly wears a red dress to a ball where unmarried young ladies were expected to appear in virginal white. It was a commanding performance that brought her a second Oscar win and marked the beginning of the most successful phase of her career at Warner Brothers.

BETTE DAVIS

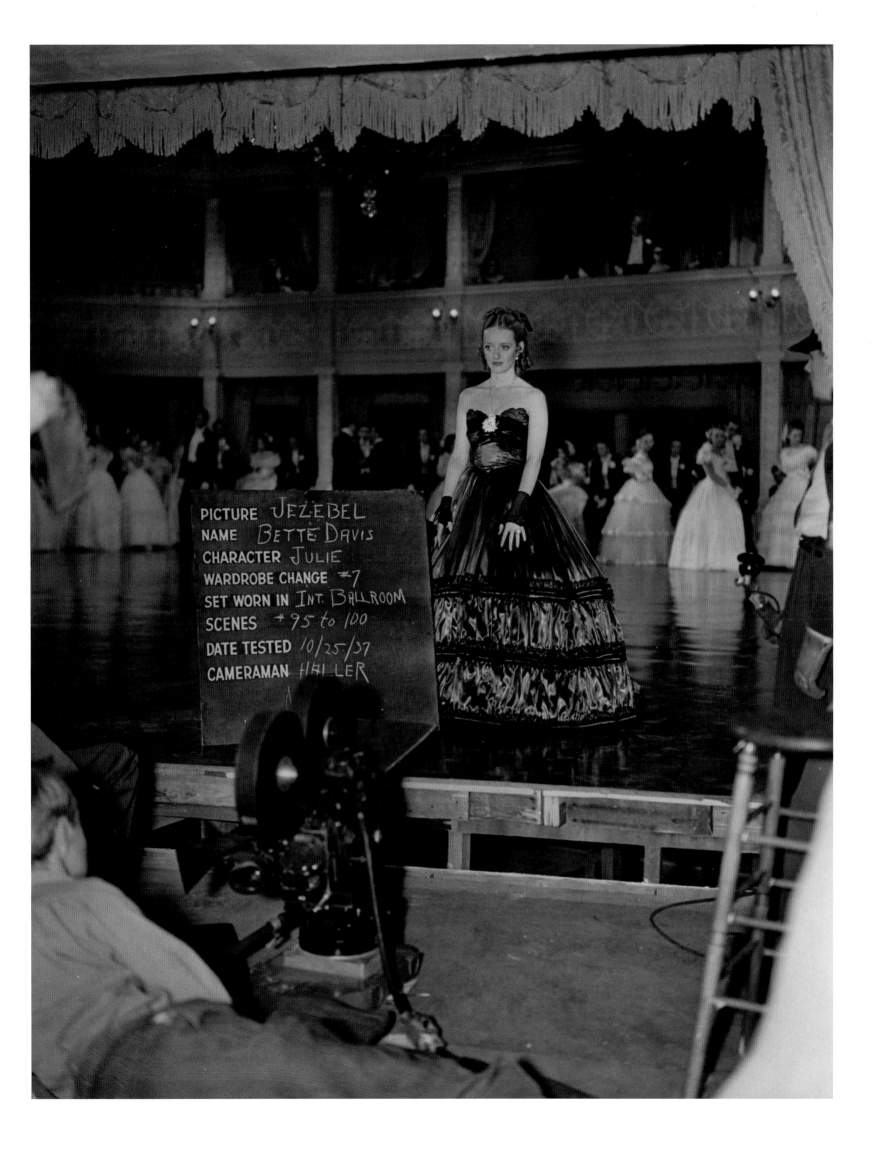

PICTURE JEZEBEL
NAME BETTE DAVIS
CHARACTER JULIE
WARDROBE CHANGE #7
SET WORN IN INT. BALLROOM
SCENES #95 to 100
DATE TESTED 10/25/37
CAMERAMAN HALLER

During this period, Davis became the studio's highest-earning star and was fittingly nicknamed "the Fifth Warner Brother." She shone as a modern heroine in films like *Dark Victory* (1939), in which she played a young, carefree socialite who reconsiders her lifestyle after receiving a terminal diagnosis. In *Now, Voyager* (1942), her character Charlotte Vale transforms from the dowdy, timid daughter of a domineering Boston dowager to a self-assured, independent woman with an elegant wardrobe to match. Davis also excelled at playing temperamental women in corsets in period dramas like *The Little Foxes* (1940) and historical biopics like *The Private Lives of Elizabeth and Essex* (1939). She would reprise her portrayal of Queen Elizabeth I in *The Virgin Queen* (1955), but only after a series of professional setbacks resulting in the end of her long tenure at Warner Brothers in 1949.

Davis reached the apex of her career with *All About Eve* (1950), in a role that would define her legacy. As the antiheroine Margo Channing—a Broadway star whose ambitious young protégé attempts to take over her career and love life—Davis came into her full grandeur. She delivered a pyrotechnic display of acerbic quips

Davis showed incredible range during the height of her career at Warner Brothers in melodramas like *Dark Victory* (1939, Warner Brothers, dir. Edmund Goulding) and noir thrillers like *The Letter* (1940, Warner Brothers, dir. William Wyler) depicted on these midget window cards.

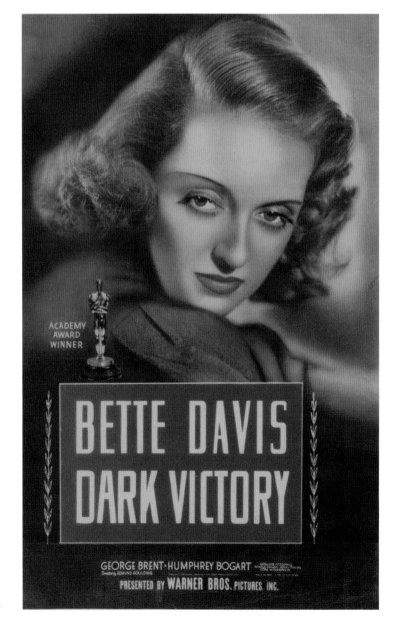

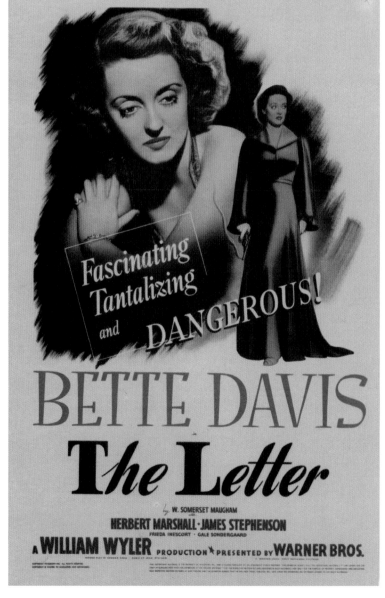

In her most definitive role, Davis led an all-star cast that included Anne Baxter, Marilyn Monroe, and George Saunders—featured in this lobby card for *All About Eve* (1950, 20th Century Fox, dir. Joseph L. Mankiewicz).

and downed martinis, with nostrils flared and eyes ablaze. It is the quintessential performance in the "aging actress" genre—delivered with all the gravitas and technical bravura of a seasoned screen veteran. Though her comeback was short-lived, Davis reinvented herself yet again in the 1960s and found renewed success with horror films like *Whatever Happened to Baby Jane?* (1962) and *Hush . . . Hush, Sweet Charlotte* (1964).

Upon reflection on her life's work, Davis expressed, "The cornerstone of my career in films was the power for action with which all women identified." Indeed, the many characters she brought to life demonstrate a range and depth of the female experience in all of its over-the-top, messy glory. Over the course of almost sixty years, she weathered the vicissitudes of a long career in Hollywood with sheer tenacity—her epitaph providing the perfect summation of her perseverance: "She did it the hard way."

BETTE DAVIS

To
Marjorie —
kindest Regards
Barbara Stanwyck

BARBARA STANWYCK

1907–1990

n 1935, *Motion Picture Magazine* declared Barbara Stanwyck "The Star They All Want!" The reason? Her "depth of feeling: emotion, sensitiveness, fire, sincerity, loyalty, bitterness, generosity and *unlimited courage!*" Indeed, she was all of this and more—as demonstrated by her long, prolific career, in which she played a remarkable range of roles. Few others had the versatility to conquer melodramas, screwball comedies, and noir thrillers as adeptly as she had. The characters she played were, much like herself, ambitious and upwardly mobile. As an unconventional beauty, she was never reliant on the traditional notions of glamour that built many a Hollywood starlet's career. Instead, Stanwyck cashed in on her talent for bringing genuine and emotionally accessible portrayals of strong women to the silver screen. That so many of her performances have gone on to become definitive roles in their respective genres is a true testament to her seemingly limitless capability.

Born Ruby Stevens on July 16, 1907, Barbara Stanwyck was a native New Yorker who never lost her Brooklyn brass. She was orphaned by the age of four and eventually placed in foster care. After surviving a challenging childhood, she dropped out of school at fourteen and immediately started working various jobs in order to become financially independent—an early marker of the self-sufficiency she would bring to many of her film characters. Ruby was intent on following her older sister into show business, and by sixteen had landed a job as a dancer in the *Ziegfeld Follies*. After several years as a chorus girl, she successfully transitioned into acting with the 1926 play *The Noose*. It was then that she took on the name Barbara

This c. 1940s signed portrait hints at the underlying toughness in every character Barbara Stanwyck brought to life over the course of her long career. Her versatility and emotional honesty made her exhilarating to watch in film after film—across decades and genres.

C-5-41

BS.30

OPPOSITE

Stanwyck's film career was off to a rocky start with terrible talkies like *Mexicali Rose* (1929, Columbia Pictures, dir. Erle C. Kenton). Her character captured in this publicity photo is a promiscuous young woman with little regard for morality, which seems to foreshadow the roles she would make famous later in her career.

ABOVE

The pre-Code film *Ladies They Talk About* (1933, Warner Brothers, dir. Howard Bretherton and William Keighley) was an early example of the "women in prison" subgenre. In it, Stanwyck plays a career criminal who is jailed for bank robbery and rises in the ranks of the prison hierarchy.

Stanwyck and saw her star rise on Broadway. Before long, Hollywood came calling, and she was off to try her luck in the movies. Her first screen appearance was a minor part in the silent film *Broadway Nights* (1927), followed by a few unsuccessful early sound films. It was a rough start, to be sure—but Stanwyck was a trooper and would soon hit her stride.

Her New York grit would serve her well in the pre-Code era—a period from 1930 to 1934 when the censorship guidelines of the Motion Picture Production Code were not yet heavily enforced, allowing studios to get away with sordid and sexually explicit films. Toughened by a harsh upbringing, Stanwyck quickly found her talent for portraying girls from the wrong side of the tracks. She played a good-time call girl in *Ladies of Leisure* (1930), a tawdry taxi dancer in *Ten Cents a Dance* (1931), and an imprisoned gangstress in *Ladies They Talk About* (1933)—all gutsy roles built on her unflinching street smarts and sardonic cadence. Her most consequential performance was in *Baby Face* (1933), a film that epitomized the pre-Code era and cemented her status as the poster girl for the genre. Stanwyck played antiheroine Lily Powers, who unapologetically exploits men as a means of survival.

This film still from *Baby Face* (1933, Warner Brothers, dir. Alfred E. Green) depicts an early scene in which Stanwyck's character responds to an unwelcome suitor putting his hand on her knee by nonchalantly pouring hot coffee on him. Soon after, she thwarts his efforts to assault her by smashing a bottle over his head—before taking an unbothered swig of beer.

"BABY FACE" *starring* BARBARA STANWYCK ~ A Warner Bros. & Vitaphone Picture.

A lobby card for the pre-Code romantic drama *Shopworn* (1932, Columbia Pictures, dir. Nick Grinde). Stanwyck plays a poor waitress who falls in love with a would-be doctor, much to the disapproval of his upper-class family. She goes on to a successful career as a showgirl—in the same tradition as her many upwardly mobile characters.

Raised in a sleazy speakeasy where she had to constantly fend off lecherous men, Lily is determined to improve her circumstances, no matter how unscrupulous her methods. As the film progresses, she uses her sexual prowess to quite literally sleep her way to the top of an international bank—floor by floor, from clerk to executive to president. It is easy to dismiss her ascent as immoral, but Stanwyck's portrayal is powerful in its refusal to tolerate any further subjugation by men.

After a string of negligible films in the mid-1930s, Stanwyck was hungry for a substantial role to sink her teeth into. When she heard that Samuel Goldwyn was to make an adaptation of Olive Higgins Prouty's novel *Stella Dallas*, she told reporters: "I'd give my soul for a chance at that." She campaigned heavily for the role, and even went to the producer himself to say: "I think I can play the part—you think I can't play it. However, it's still a matter of opinion, Mr. Goldwyn." He was finally convinced, and what resulted was her single most virtuosic screen performance. Stanwyck played the socially ambitious title character, a humble mill worker who marries above her station and becomes determined to bring her daughter up in society. When Stella discovers that she cannot escape her working-class ways, she

sacrifices her own happiness to give her daughter the life she always wanted. In this categorically complex role, Stanwyck demonstrated her boundless range by embodying often contradictory qualities—she manages to be simultaneously brash and vulnerable, vulgar and noble. The heart-wrenching emotion with which she played the final scene earned her an Oscar nomination and ultimately helped make *Stella Dallas* (1937) the gold standard of melodramas.

Firmly established as a star to be reckoned with, Stanwyck went on to play her fair share of romantic leads and admirable heroines in films like *Golden Boy* (1939) and *Remember the Night* (1940). Many of her characters during this period were capable career women, perhaps reflective of Stanwyck's own stature as a working actress. She played an ambitious columnist in *Meet John Doe* (1941) and a celebrated magazine writer in *Christmas in Connecticut* (1945)—in both cases, unmarried women dedicated to their work who eventually fall in love with their subjects. In *You Belong to Me* (1941), she played a highly competent doctor who endeavors to balance the demands of her job with her new marriage. In each of these roles, Stanwyck is exceptionally genuine and relatable. She strove for truthfulness in each performance, stating:

> Perhaps the most important thing is to be honest with yourself and toward your work. It's of the utmost importance on the screen, because if you don't believe completely in what you are doing you can't make your audience believe it either.

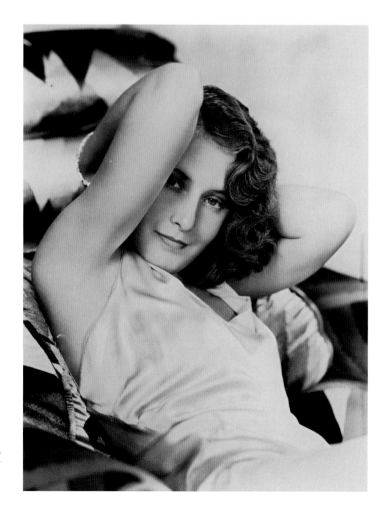
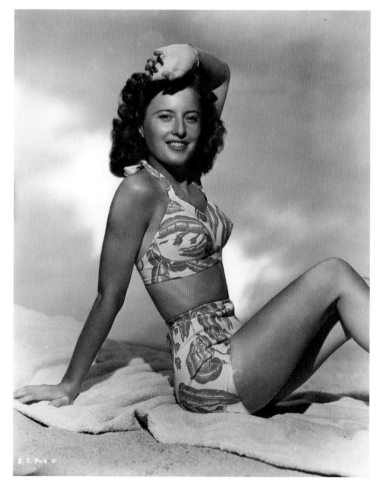

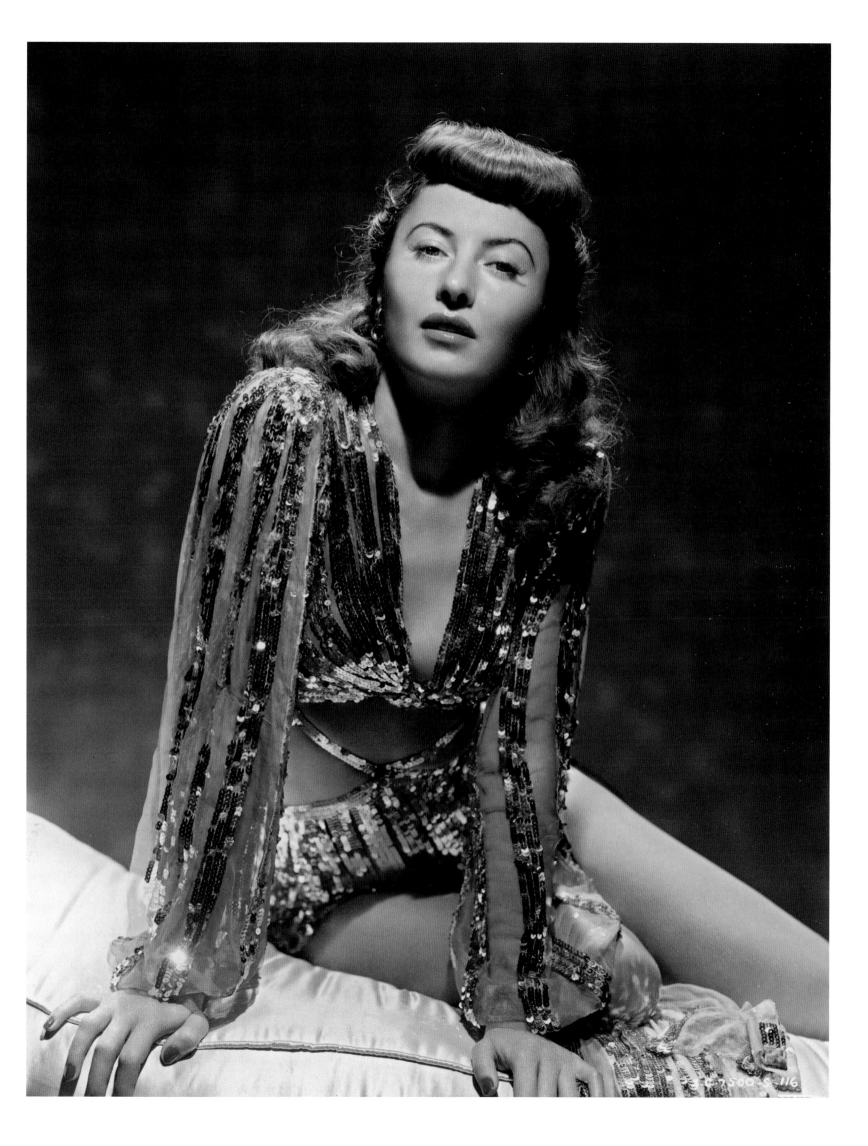

Stanwyck may have made a name for herself as the master of melodrama, but she sure proved to have quite a knack for comedy. Her electric performance in *The Lady Eve* (1941)—one of the all-time great screwballs—is a blazing display of unabashed moxie. In the dual role of con artist Jean Harrington and British aristocrat Lady Eve Sidwich, Stanwyck is whip-smart and resourceful, ensnaring Henry Fonda's endearingly naive Charles Pike. *The Lady Eve* was her first "fashion picture," in which she donned over twenty alluring ensembles by Edith Head. This effectively transformed her image, leading to repeated collaborations and a life-long friendship between the costume designer and star. That same year, they did *Ball of Fire* (1941)—a madcap comedy that presented Stanwyck at her absolute brassiest. She is nothing short of explosive as the wisecracking, tongue-clicking, slang-slinging Sugarpuss O'Shea. But even amid the zany theatrics in this delightful take on the "Snow White and the Seven Dwarves" story, her affection for Gary Cooper's bookish professor is heartfelt and sincere.

In one of her most iconic films, Stanwyck plays both the lady and the tramp. *The Lady Eve* (1941, Paramount Pictures, dir. Preston Sturges) marked one of three pairings with Henry Fonda, with whom she had undeniable on-screen chemistry. This lobby card depicts a scene that is equally romantic and hilarious, in which an impressive continuous shot lasting nearly four minutes solidifies their attraction.

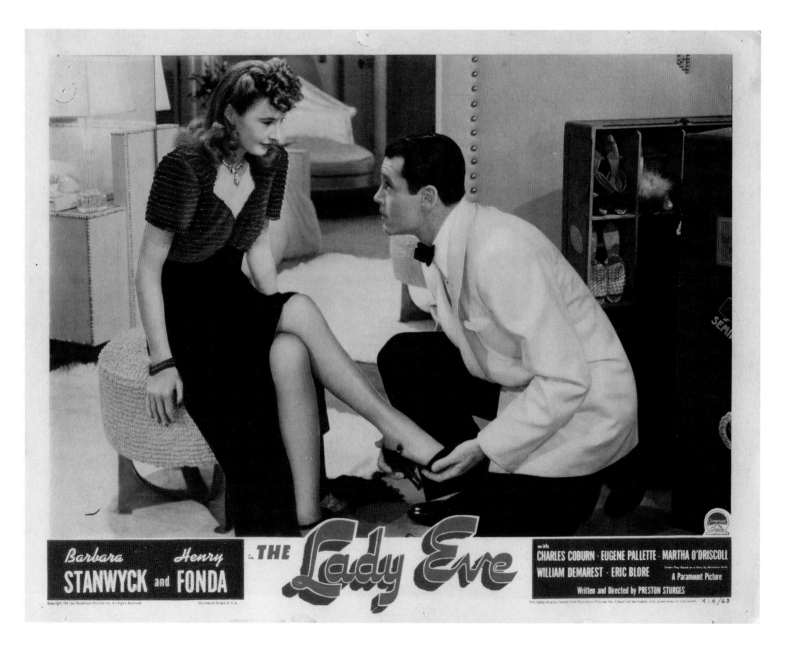

BARBARA STANWYCK

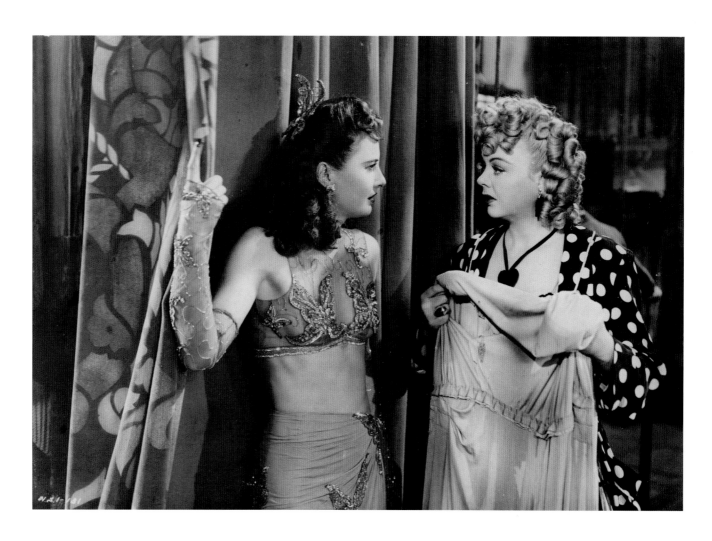

Stanwyck (*left*) returns to her showgirl roots in *Lady of Burlesque* (1943, United Artists, dir. William A. Wellman), a murder mystery film adapted from *The G-String Murders* written by the legendary burlesque performer Gypsy Rose Lee. Set amid the backstage drama of a theater, as seen in this film still, it was an environment that Ruby Stevens would have been familiar with.

Stanwyck conquered yet another genre as World War II ushered in the era of film noir. She was well-suited to these stylish crime dramas, which exhibited the maturation of the cynical attitudes and sexual motivations that colored her pre-Code performances. *Double Indemnity* (1944) is considered by many to be the quintessential noir film, and in it Stanwyck played Phyllis Dietrichson—a duplicitous woman that Fred MacMurray's antihero protagonist describes as "rotten to the core." She is the truest example of a femme fatale: using her powers of seduction, she manipulates an insurance salesman into murdering her husband in order to claim a hefty life insurance payout. Phyllis is a remorseless villain, and a significant enough departure from Stanwyck's previous roles to make her approach the film with trepidation. She noted, "I had played medium heavies . . . but never an out-and-out killer." Whatever uncertainty she may have had about playing baddies was nowhere to be found by the time she made *The Strange Love of Martha Ivers* (1946)—another noteworthy noir film in which she portrayed a scheming power player undeterred by murder.

Stanwyck continued her commanding streak in the film noir genre with thrillers like *Cry Wolf* (1947), *Sorry, Wrong Number* (1948), and *Witness to Murder* (1954). In an unexpected pivot, she became a fixture in the world of Westerns—horse-riding and sharpshooting her way through films like *Cattle Queen of Mon-*

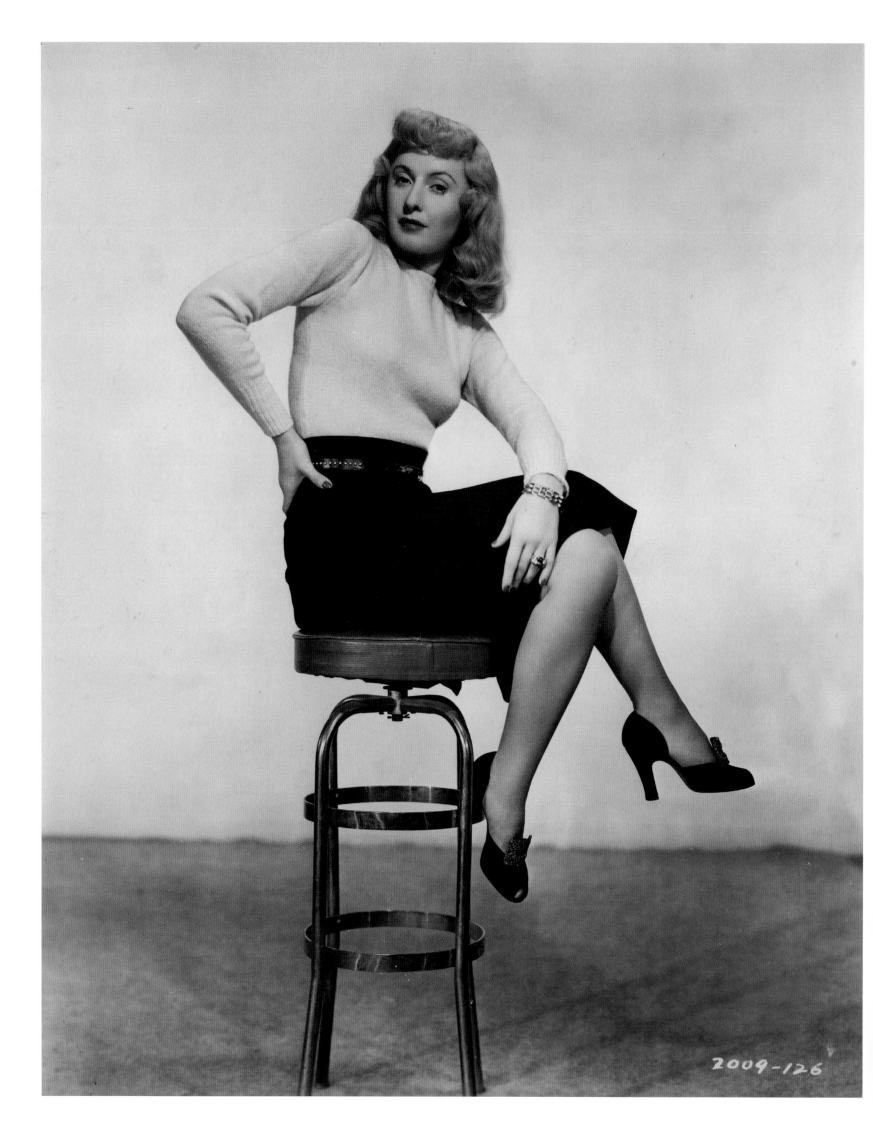

2009-126

tana (1954) and *Forty Guns* (1957), in which she also performed her own stunts. She transitioned into television in her later career, notably hosting and starring in her own anthology series. For *The Barbara Stanwyck Show* (1960–61), she earned an Emmy Award for Outstanding Performance by an Actress in a Series.

It is odd that a woman of Stanwyck's extraordinary talent never won an acting Oscar. The Academy eventually presented her with the Honorary Award in 1982 "for superlative creativity and unique contribution to the art of screen acting." True, every single performance is marked by emotional honesty and her uncanny ability to level with us—a unique quality that is indelibly captured on film and reflected in her impressive body of work. *The Exhibitor* perfectly summed up her legacy in a 1950 article that extols her versatility and heralds her as "a real gal":

> From deep emotional tragedy to sparkling, brilliant comedy, from chaotic neurotics to cold, blase career women, from life-beaten characters to explosive, shooting stars of feminine authority, this remarkable actress has delivered the goods on the silver screen.

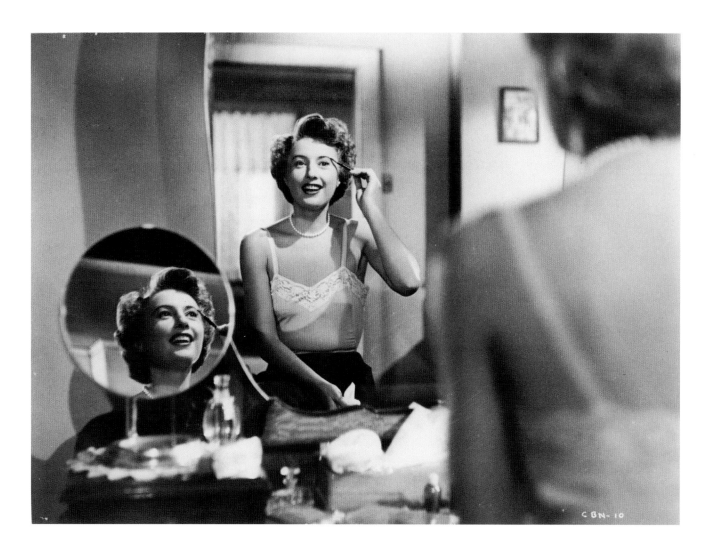

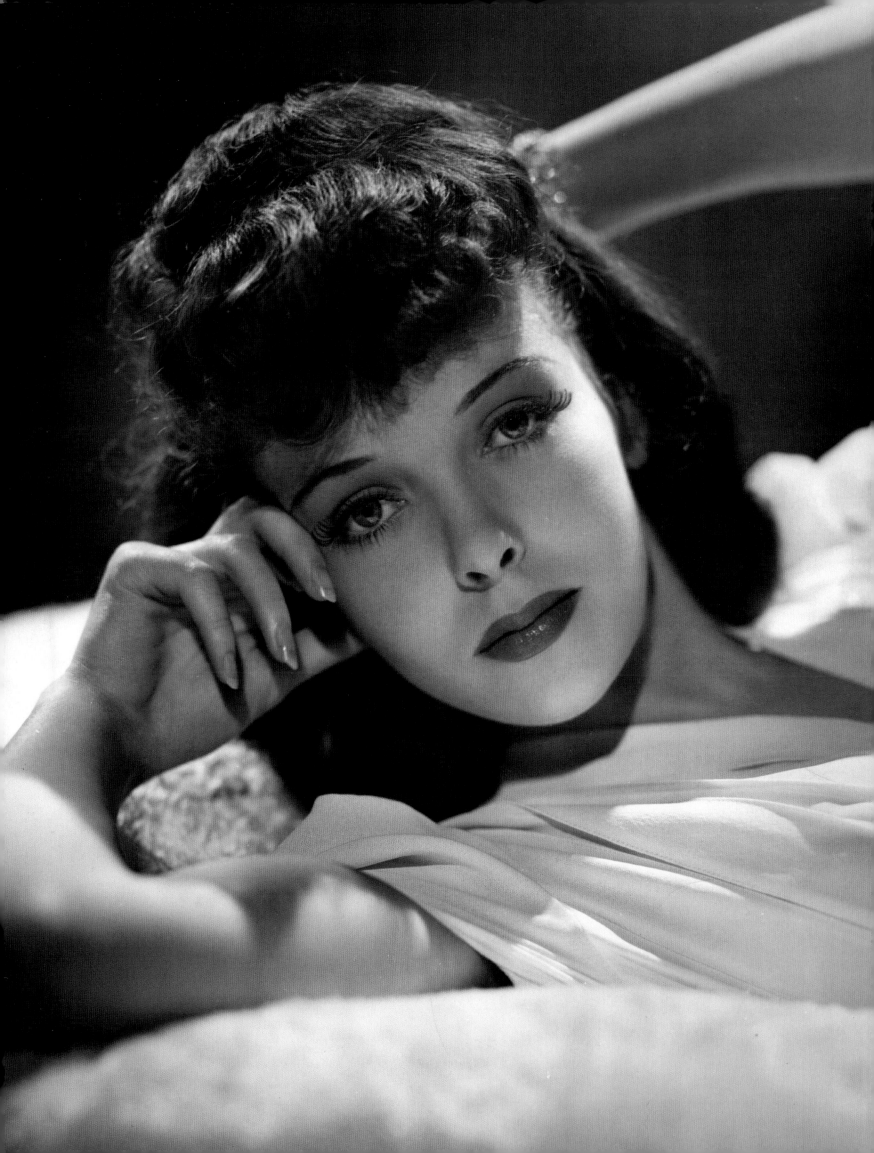

IDA LUPINO

da Lupino had moxie that could not be contained by the studio system, with all its gendered constraints and power imbalances. After establishing herself as a consummate actress, she broke the celluloid ceiling as a pioneering independent filmmaker—launching undaunted into a second career that included directing, producing, and screenwriting. In front of the camera, she was a tough-talking gal not to be trifled with, excelling in film noir and melodrama. Behind the camera, she crafted a persona that commanded respect and admiration from her colleagues. She was the second woman admitted to the Directors Guild of America (preceded by Dorothy Arzner) and the only female member during the 1950s, when the union was addressed as "Gentlemen and Miss Lupino." Ever the industrious creator, she also wrote short stories and composed music—a Renaissance woman if Hollywood ever saw one.

Ida Lupino was born in London on February 4, 1918, and into a theatrical dynasty that traced its lineage back to the seventeenth century. Dubbed the "Royal Family of Greasepaint" by Edward VII, the Lupinos boasted a long line of actors, dancers, singers, vaudevillians, and puppeteers. Ida could not escape the dramatics that flowed through her veins and was thrust into the acting profession. She exhibited an aptitude for writing and directing at a young age—penning her first play at just seven years old and directing her cousins in home movies. She enrolled at the prestigious Royal Academy of Dramatic Art at thirteen, only to depart shortly after she made her film debut in *The Love Race* (1931). She secured her first lead in *Her First Affaire* (1932) in a role originally intended for her mother. She then appeared

This Paramount Pictures studio portrait was taken by William Walling in 1939—the year Ida Lupino proved herself a force to be reckoned with following her explosive performance in *The Light That Failed* (1939, Paramount Pictures, dir. William A. Wellman).

in five British films for Warner Brothers sporting bleached blonde hair and rose to fame as "the English Jean Harlow." Before long, the fifteen-year-old was on her way to the United States, having been discovered by Paramount and invited to do a screen test for *Alice in Wonderland* (1933). Upon her arrival, studio executives found the young Lupino to be unexpectedly sultry and far too mature to play an innocent like Alice. Still, they recognized her potential and offered her a contract.

Lupino's first film at Paramount was *Search for Beauty* (1934), a pre-Code comedy in which she starred as an Olympic diver brought on as an editor of a health and fitness magazine, only to discover it to be a front for salacious photos and stories. Just a year into her contract, Lupino was placed on suspension for refusing a role in *Cleopatra* (1934), which would have had her waving a palm frond behind Claudette Colbert and uttering only a few lines. That Lupino started showing such mettle so soon into her Hollywood career was an indication of the tenacity that would later power her to new heights. In these early Paramount roles, she was mostly cast as a precocious seductress—a "baby vamp" simultaneously portrayed as a "delectable ingénue." Lupino fired back at this characterization in an interview with *Motion Picture Magazine*, declaring, "I am NOT a 'delectable ingénue.' I am NOT a 'dizzy little thing.' I am not, in the first place, an ingénue at all." Indeed, her worldliness and bravado—especially in her rambunctious off-screen social life— negated any illusory claims of naivety by the press. After a few years of shallow roles in mediocre films, Lupino chose not to renew her Paramount contract. She knew she had greater potential and wanted better parts, so she decided to take her

BELOW

This studio portrait coincides with the release of her second Paramount film, *Come On, Marines!* (1934, Paramount Pictures, dir. Henry Hathaway), another "good girl/bad girl" pre-Code role that had her prancing about in her underwear.

OPPOSITE

Too mature to play the title character in *Alice in Wonderland* (1933), fifteen-year-old Lupino was instead styled after the platinum blonde bombshell Jean Harlow and, here, flirtatiously photographed clad in lacy lingerie.

ADOLPH ZUKOR presents

R eady for LOVE

IDA LUPINO · RICHARD ARLEN
MARJORIE RAMBEAU

Directed by
MARION GERING

a
Paramount
Picture

OPPOSITE

Lupino wears a sleek pageboy hairstyle in this publicity photo for *Artists and Models* (1937, Paramount Pictures, dir. Raoul Walsh), one of her last films under contract with Paramount before she left the studio in search of better parts.

ABOVE

Lupino's piercing blue eyes are faithfully represented in this lobby card for *Ready for Love* (1934, Paramount Pictures, dir. Marion Gering). She pushed through the film shoot despite suffering a bout with polio that nearly left her paralyzed.

chances at other studios. "It was a chance I *had* to take," she later told *Screenland*. "It was a cinch I'd be forgotten if I *didn't* do something—and this way there was a *chance* for me. I stayed off the screen for eighteen months—studying, studying, studying." In that time, she completely transformed her appearance, growing out her eyebrows and ditching the artificially blonde hair. She realized, "I *should* be a brunette—it's my natural coloring. I believe there's nothing so conducive to success as being yourself. And believe me, I shelved a lot of nasty little complexes along with the blonde locks."

Lupino finally got the chance to demonstrate her proficiency and gravitas as a dramatic actress in *The Light That Failed* (1939). So determined was she to land the role of Bessie Broke that she stole a copy of the script, prepared to read the most difficult scene on the spot, and burst into the director's office to demand an audition. She declared it to be *her* part, and hers it became. Her blistering portrayal of the tempestuous model invited comparisons to Bette Davis's career-changing star turn in *Of Human Bondage* (1934)—namely, in the Cockney accent and uninhibited vitriol. This led to a contract offer from Warner Brothers in 1940, where she was brought in to play roles turned down by the reigning queen of the studio. Although she jokingly referred to herself as the "poor man's Bette Davis," Lupino

IDA LUPINO

ultimately proved to be just as talented and fiercely determined—and like Davis, she often ended up on suspension for refusing unsatisfactory parts. Some of her best performances at Warner Brothers saw her cast as a femme fatale, as she was in *They Drive by Night* (1940). Starring alongside Humphrey Bogart, Lupino delivered a gutsy performance that stole film and netted rave reviews. She reteamed with Bogart for *High Sierra* (1941), receiving top billing and critical recognition. Other notable roles include an escaped convict in the adventuresome *The Sea Wolf* (1941) and an ambitious, manipulative sister in *The Hard Way* (1943). Lupino left Warner Brothers in 1947, but continued her acting career as a freelancer in films like *Road House* (1948) with 20th Century Fox and *On Dangerous Ground* (1951) with RKO. Adept at playing fearless women on the silver screen, Lupino's next cinematic venture would bring her boldness to the other side of the camera.

Following her departure from Warner Brothers, Lupino embarked on a new career as an intrepid independent filmmaker. In 1948, she and her then-husband Collier Young formed the production company The Filmakers, Inc., with the goal of making realistic, issue-oriented films. The company produced twelve feature films, for which Lupino did a combination of writing, directing, producing, and acting. These scrappy, low-budget movies did not shy away from controversial subjects— she wanted to "do pictures with poor bewildered people because that's what we are." The first was *Not Wanted* (1949), a hard-hitting drama that addressed the

plight of unwed mothers and tackled the topic of unwanted pregnancies. Lupino cowrote and coproduced, but was also forced to take over for director Elmer Clifton after a heart attack sidelined him just a few days into shooting. It was deemed a success, costing $153,000 to make and earning $1 million at the box office. Lupino went on to direct *Never Fear* (1949), a film that drew from her harrowing experience with polio; *Outrage* (1950), one of the first to handle the repercussions of rape; and *Hard, Fast, and Beautiful* (1951), which explored the dark side of a tennis star's fame. She directed and starred in *The Bigamist* (1953) shortly after giving birth to a daughter. The film's narrative was reflective of the drama in her personal life that included her costar Joan Fontaine taking up with her husband while she engaged in her own extramarital affair. Perhaps most notable among her credits is *The Hitch-Hiker* (1953), which holds the distinction of being the only classic film noir directed by a woman.

In 1950, The Filmakers took out a full-page ad in *Variety* to publish a "Declaration of Independents" that publicly asserted their autonomy from mainstream Hollywood. With Lupino's courage and steely resolve, the company produced memorable, taboo-busting films that delivered incisive commentary on social issues. On the set, she took charge using an unconventional—if not masterful—leadership style, in which she meticulously preserved her femininity and referred to herself as "Mother." In doing so, she was able to exercise authority without alienating her cast and crew members. Even after her production company shuttered in 1955, she kept her seat in the director's chair—emblazoned with the moniker "Mother of Us All." Lupino had a prolific career in episodic television during the following

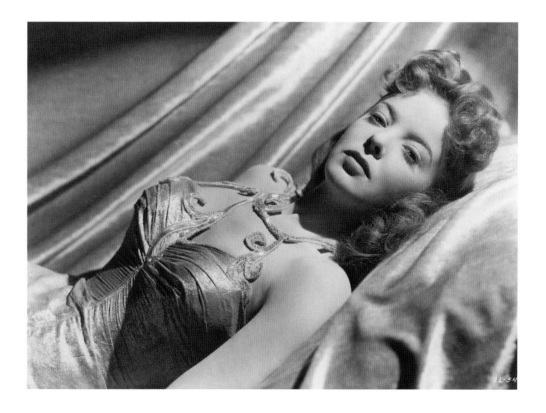

decade, boasting directorial credits for popular shows like *The Twilight Zone* in 1964, *Bewitched* in 1965, and *Gilligan's Island* in 1966. She directed her biggest feature film, *The Trouble with Angels*, in 1966, and would occasionally reappear in front of the camera.

Ida Lupino broke ground for women in Hollywood by daring to venture outside the parameters set by the studio system. But despite her standing as a pioneering female filmmaker, she never sought to take advantage of her sex, nor did she ever single herself out as an exception. She remained dedicated to her work and navigated the industry with unprecedented diligence. In response to her critics, she remarked, "I am 'mad,' they say. I am temperamental and dizzy and disagreeable. Well, let them talk. I can take it. Only one person can hurt me—her name is Ida Lupino." With this unflinching fearlessness, she left behind a trailblazing legacy.

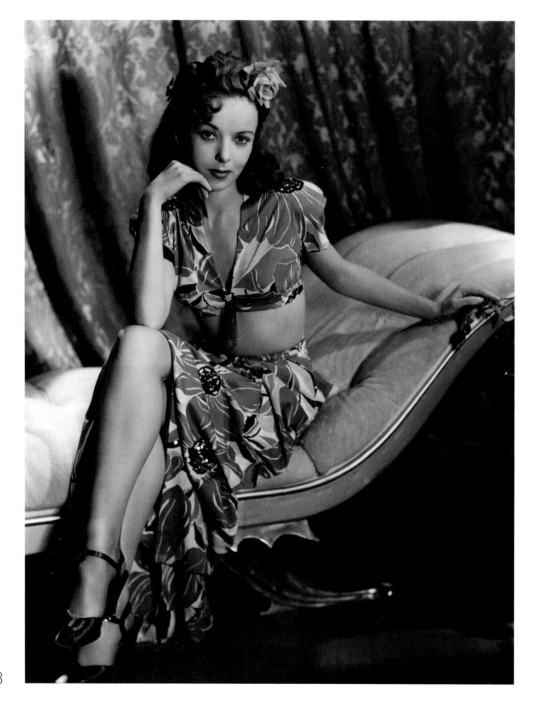

158

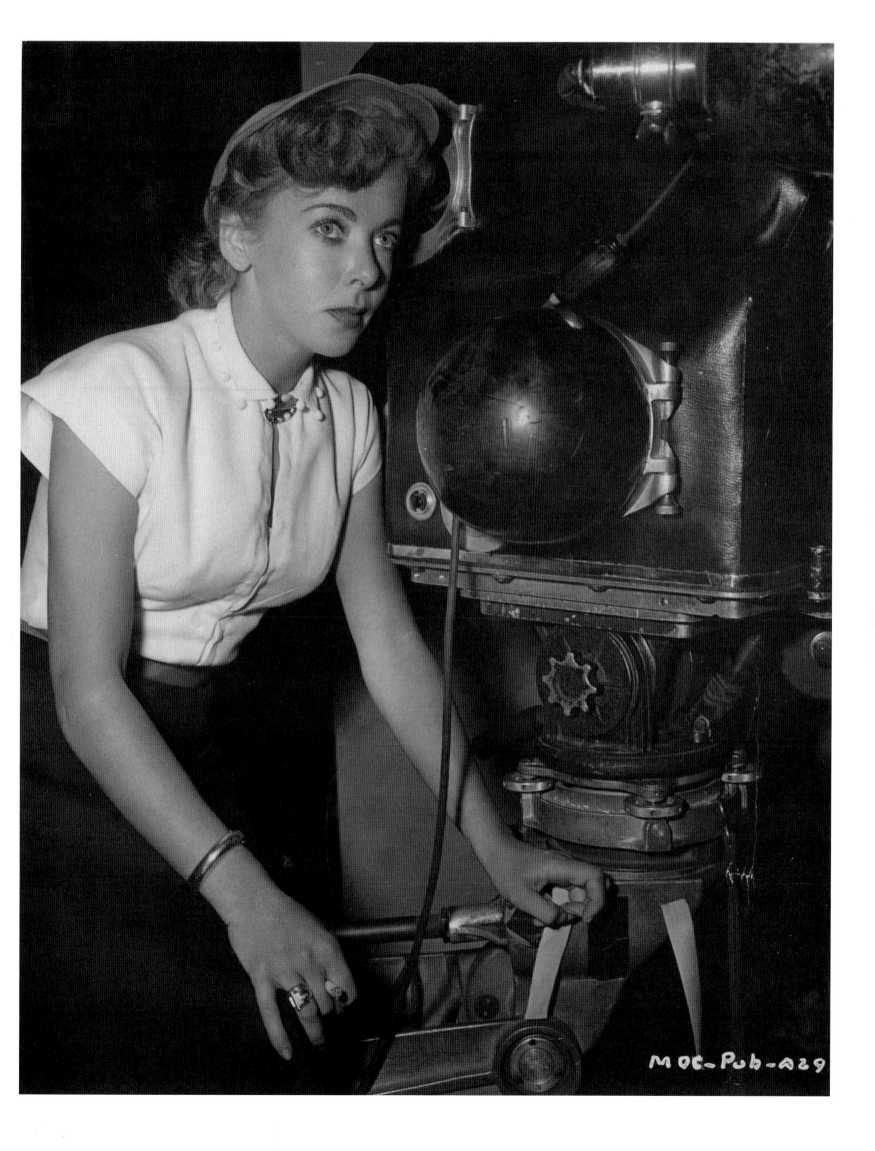

MOC-Pub-A29

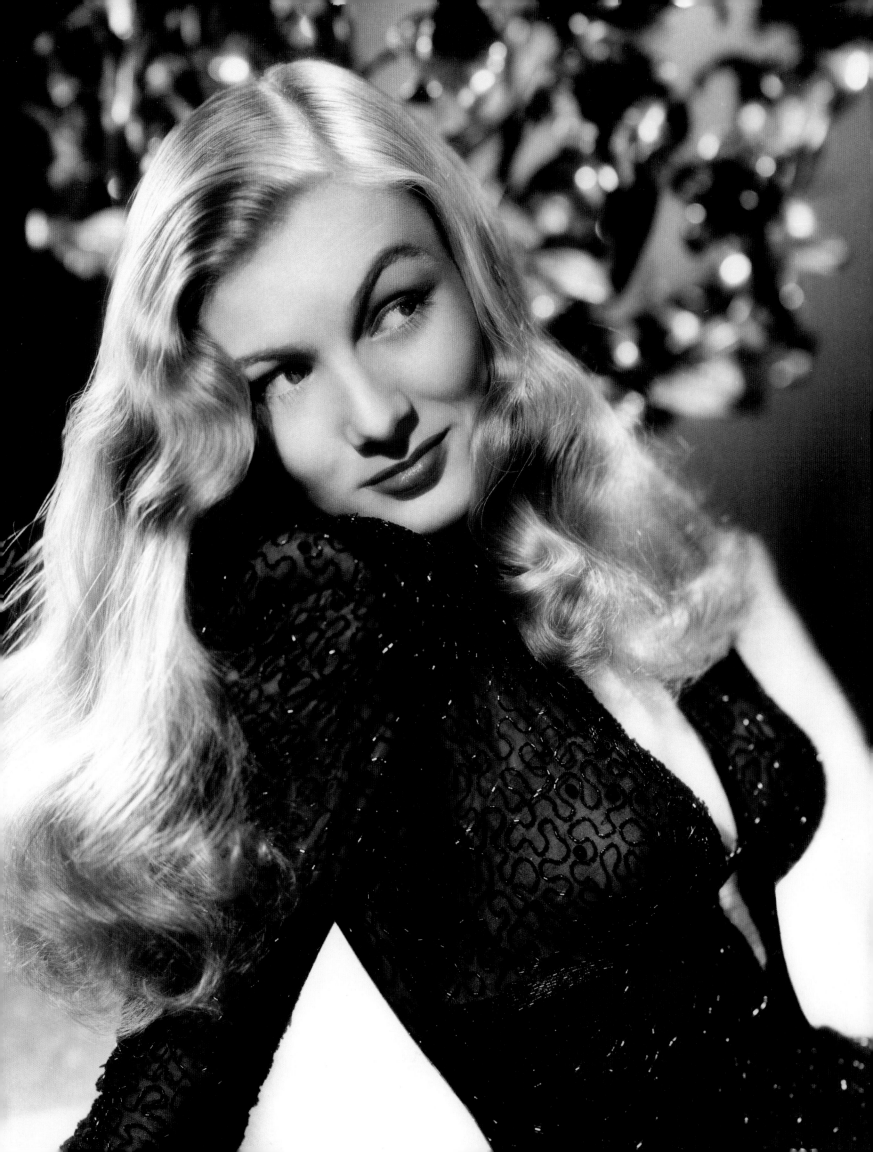

VERONICA LAKE

1922–1973

"Veronica Lake is a Hollywood creation." So begins the autobiography of the bewitching blonde who took the town by storm and became the unequivocal embodiment of 1940s glamour. She was best known—if not exclusively known—for her flirty "peek-a-boo" hairstyle, which remains a visual touchstone of Old Hollywood and continues to be just as popular now as it was in her heyday. But Lake was more than just a magnificent head of hair. She was a headstrong beauty bursting with attitude and allure. That she was celebrated primarily as a sex symbol is beyond question, as evidenced by the terms often used to describe her—*siren, seductress, vixen, vamp, femme fatale.* With these monikers, she was almost exclusively defined by the male gaze, arguably to the detriment of her legacy. It's true, she was relentlessly sexualized; however, she never succumbed to the casting couch or allowed herself to be exploited by the industry. Based on the brevity of her acting career, it is tempting to view her as a victim of Hollywood's cruelties—but in her short time, her star shone brighter than most others.

Before Veronica Lake, there was Constance Ockelman. "Connie," as she preferred to be called, was born on November 14, 1922, in Brooklyn, New York. She grew into a spunky, self-reliant teenager who was prone to trouble at her high school and described by her mother as "too beautiful for her own good." Connie took charge of her sexuality at a young age and put her charms to work in a local beauty contest. It was a judge's offhand comment about Connie's star potential that convinced her mother to pack up the family and move to Hollywood, where she could live

Taken at the height of her fame in 1942, this studio portrait for Paramount Pictures captures the sensuality and sass that made Veronica Lake an instant box office draw.

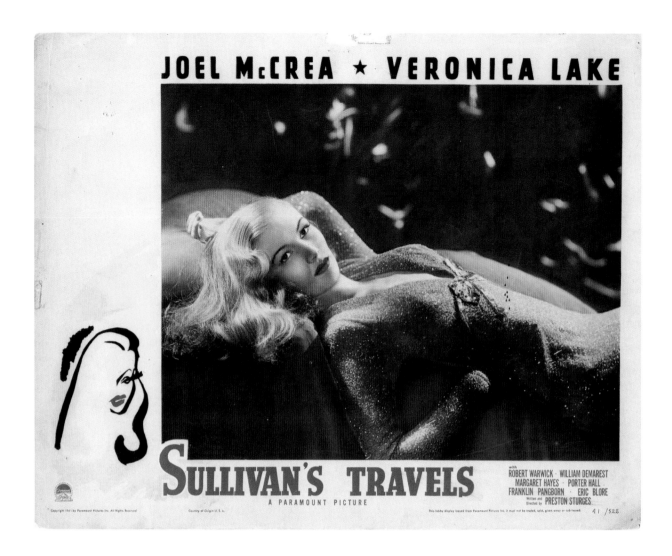

JOEL McCREA ★ VERONICA LAKE

SULLIVAN'S TRAVELS
A PARAMOUNT PICTURE

with ROBERT WARWICK · WILLIAM DEMAREST
MARGARET HAYES · PORTER HALL
FRANKLIN PANGBORN · ERIC BLORE
Written and Directed by PRESTON STURGES

vicariously through her up-and-coming daughter. When they arrived in California, Connie started out as an extra but quickly worked her way up to bit parts in films like *Sorority House* (1939) and *Forty Little Mothers* (1940). It wasn't long before she caught the eye of producers at Paramount, who called the seventeen-year-old in for a screen test that would change her life.

Connie was certain that her screen test for Paramount's war drama *I Wanted Wings* (1941) was a complete disaster. Not only did she have a wardrobe malfunction when she leaned over, but her tumble of hair fell over one eye and became a terrible distraction. She spent the remainder of the test trying to shake it out of her face and was in tears as soon as she left the set, certain that she had blown her chance. Much to her surprise, she received a call a few days later from the film's producer, Arthur Hornblow Jr., who offered her the part on the condition that she kept the unruly lock of hair. Connie knew that you had to have a gimmick to make it in the movie industry, "and my gimmick, my one featured feature was my hair, fine blonde hair hanging loose over one eye. Something I always considered a detriment to my appearance became my greatest asset. That's Hollywood folks." Hornblow also insisted that she take a new name and suggested that of his secretary, Veronica, paired with the surname "Lake," inspired by her blue eyes.

ABOVE
In this lobby card for *Sullivan's Travels* (1941, Paramount Pictures, dir. Preston Sturges), a glittering gown designed by Edith Head highlights Lake's shapely physique. Head often resorted to design tricks to elongate the star's petite frame.

OPPOSITE
This autographed studio portrait from 1941 is inscribed to Lake's stand-in, Barbara "Babe" Cain. Lake signed using her newly minted name, given to her by Paramount producer Arthur Hornblow Jr.

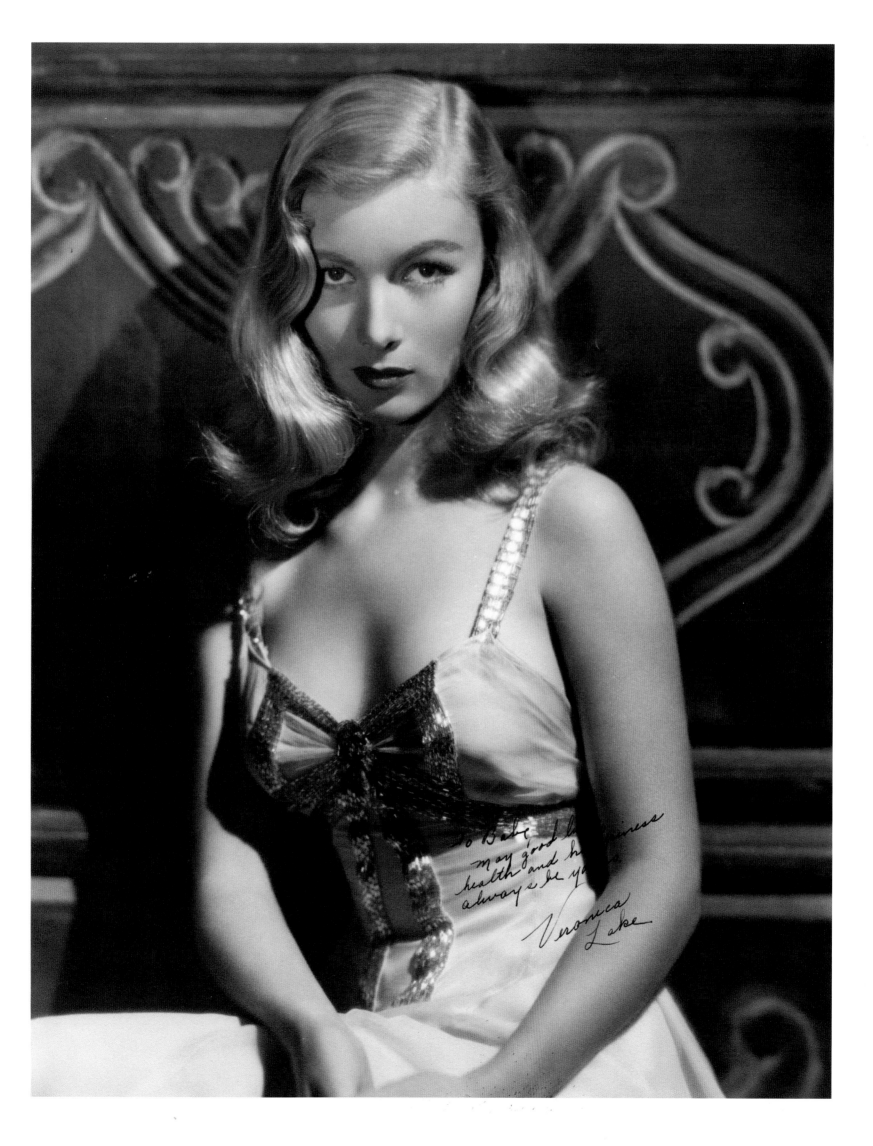

To Babe
may good luck, happiness
health and h...
always be yo...

Veronica
Lake

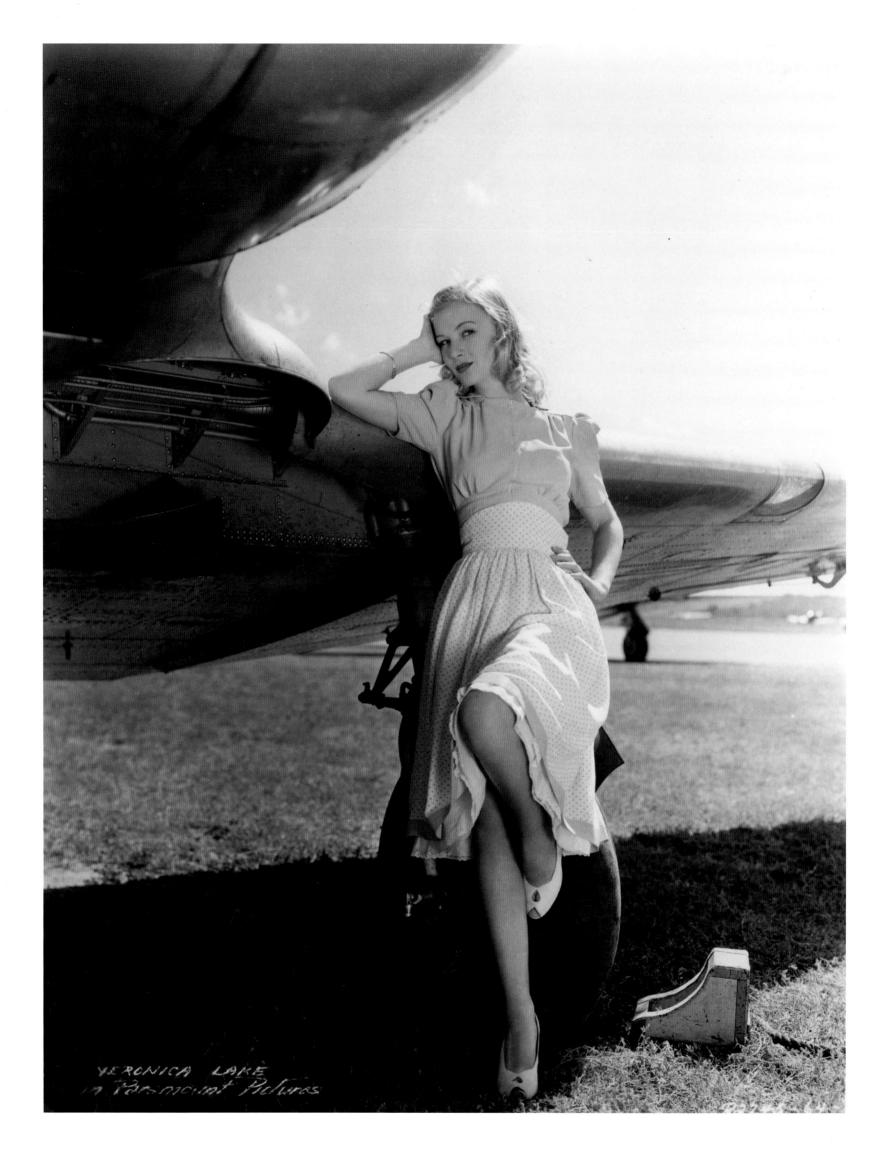

VERONICA LAKE
in Paramount Pictures

This famous publicity photo shoot for *I Wanted Wings* (1941, Paramount Pictures, dir. Mitchell Leisen) features Lake flirtatiously posing with a B-17 bomber. These photographs marked her introduction to the public and were distributed nationwide in popular newspapers and magazines. "Not a bad break, you'll admit," she later said.

RIGHT

In *Sullivan's Travels*, Lake's character is simply credited as "The Girl"—a poor, aspiring actress who accompanies a disillusioned Hollywood director on a journey to gain real-life experience as research for his next film.

While shooting *I Wanted Wings*, Lake had so much trouble with the director that she threatened to leave the picture. "Guts, huh? My first role and I'm telling them I'm walking out," she later recalled. This gutsy move led to him being replaced with Mitchell Leisen, whose name appeared on the film when it was released and hailed as a box office hit. Her first leading role was a triumph, and Lake became an overnight sensation. Her ascendency to stardom was immediate, thanks to the constant stream of press facilitated by the studio's publicity department. Her "peek-a-boo" hairstyle, as it came to be called, quickly turned into a source of public fascination. *LIFE Magazine* even ran a feature that glorified her luscious locks to the point of estimating the number of hairs on her head—150,000 strands, each with a 0.0024 inch diameter.

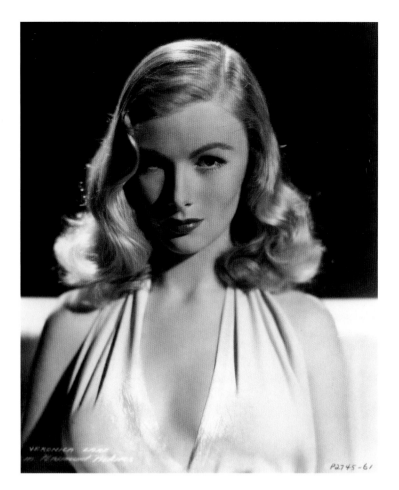 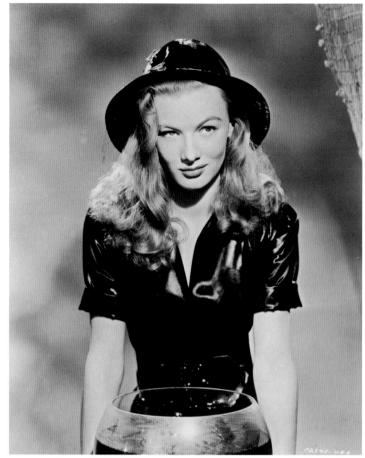

Although Paramount was determined to groom her as a vamp, director Preston Sturges was insistent on casting Lake as the lead in his next film—the screwball comedy *Sullivan's Travels* (1941). Lake did not have experience in the genre, but he was convinced that she could do it based on the feisty attitude he saw in her previous picture. She proved herself capable of handling the quick, witty dialogue that was a Sturges hallmark. She also proved that she didn't need to rely on her most famous assets—her signature hairstyle and knockout curves—in order to be captivating on-screen. For part of the film, she wears oversize men's clothing and has her hair tucked into a hat—and yet is every bit as entertaining to watch. *Sullivan's Travels* was Lake's favorite film, and she reflected on it fondly in her memoir, saying, "It pleases me greatly to see this particular motion picture reach some plateau of critical acceptance. It at least gives me a running chance to be remembered for my best work, the secret dream of any actress."

Lake may have proven her acting ability and comic chops in *Sullivan's Travels*, but Paramount knew how easy and profitable it would be to market her as a femme fatale. She was next cast in the noir film *This Gun for Hire* (1942) opposite new-comer Alan Ladd. There was no doubt about her ability to play the seductive character, but it was actually her diminutive stature that got her the part—at just 4'11", she was petite enough to be paired with the 5'5" Ladd. Lake expressed disappointment that she "was right back in the low-cut gowns and wearing the sexy

ABOVE LEFT
Often described as an "icy blonde," Lake emanated an essence of cool that added mystery to her allure. That quality is especially evident in this publicity photo for *This Gun for Hire* (1942, Paramount Pictures, dir. Frank Tuttle).

ABOVE RIGHT
In *This Gun for Hire*, Lake plays a nightclub singer and stage magician. She wears a stylized fishing outfit in this publicity photo for one of her musical numbers in which she performs magic tricks using a fishbowl.

hair," but she excelled in the role and *This Gun for Hire* would turn out to be a milestone movie in the film noir genre. Lake and Ladd sizzled on the silver screen. Their chemistry was so intense and their popularity with fans so overwhelming that Paramount rushed to reunite them that same year in *The Glass Key* (1942). This second film would solidify their on-screen alliance, as well as their individual star power.

At the height of America's involvement in World War II, Lake traveled the country to raise money for war bonds. However, it was unsurprising that Lake's hair helped to achieve her greatest wartime impact. Women across the nation enthusiastically imitated her long, flowing hairstyle—even when reporting to the factory floor for their wartime jobs, which often involved heavy machinery. So great was Lake's influence that the U.S. government requested that she change her hairstyle to safeguard women war workers against hazardous incidents. She was commissioned by the Office of War Information to create a newsreel that showed her donning a no-nonsense updo. As soon as the war ended, however, her trademark tresses were back—and just in time for another pair of films with Ladd. Their postwar reteaming was perhaps Paramount's answer to Bogie and Bacall, who emerged as the new favorite film noir couple over at Warner Brothers. Lake and Ladd responded with *The Blue Dahlia* (1946), with an original screenplay by Raymond Chandler, one of the genre's most celebrated scribes. They would join forces once more in *Saigon* (1948), which would be one of Lake's last films under studio contract.

Lake's iconic golden tresses are prominently featured in this lobby card for *The Glass Key* (1942, Paramount Pictures, dir. Stuart Heisler)—an adaptation of Dashiell Hammett's successful novel and her second film starring opposite Alan Ladd.

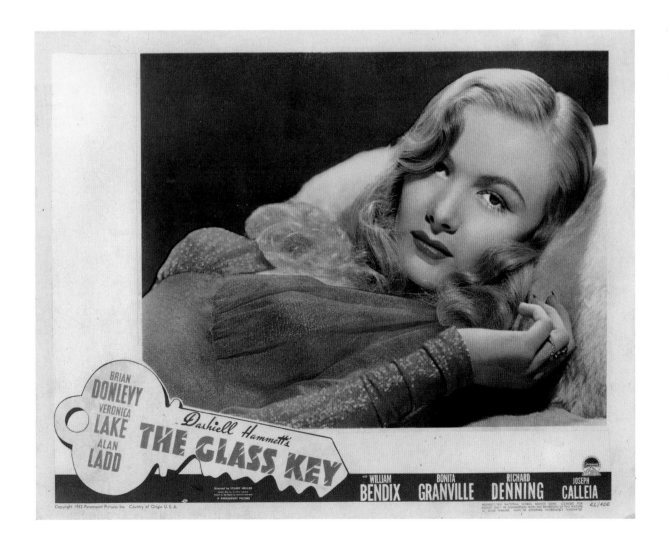

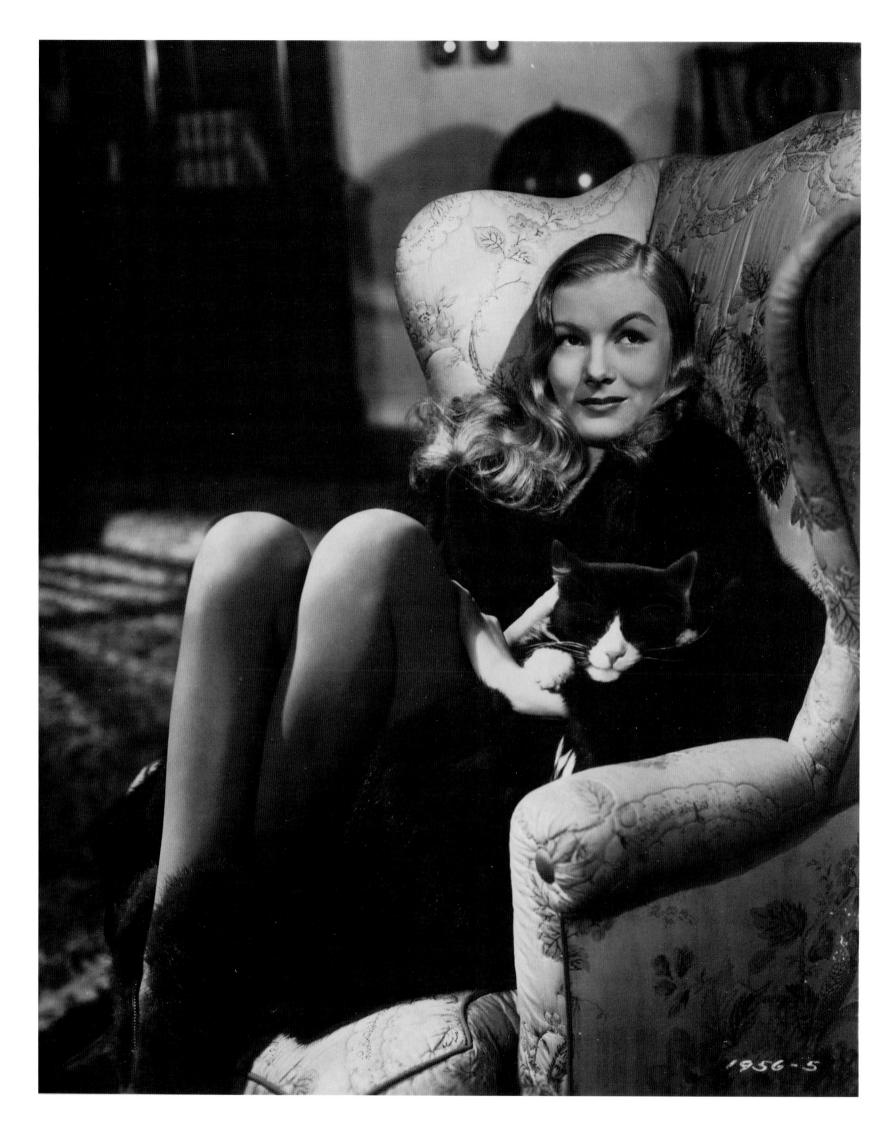

1956-5

Following her film noir doubleheader with Ladd in 1942, Lake was able to escape the confines of her screen siren persona and return to screwball in *I Married a Witch* (1942). As the Salem witch Jennifer Wooley, Lake manages to combine her talents for seduction and comic wit. She is deliciously beguiling as she pursues her vengeance—only to fall in love with the man she set out to destroy. She was originally slated to star opposite her *Sullivan's Travels* costar Joel McCrea, with whom she had a difficult working relationship, but he was eventually replaced by Fredric March. He and Lake didn't get along either. March thought of her as a "brainless little blonde sexpot" and treated her terribly on set. Turns out, Lake was just as charmingly vindictive as her character in the film and found little ways to torment her spiteful leading man. When shooting a scene in which March was to carry her off into the distance, Lake slyly rigged a forty-pound weight under her dress. She was barely 100 pounds on her own, but the added load made the lift quite a difficult task to repeat for multiple takes. This prank enraged March, especially when Lake coyly blamed the weight on "big bones." Despite their feud, the resulting film was well-received and Lake was named the top female box office star by *Variety* for 1942.

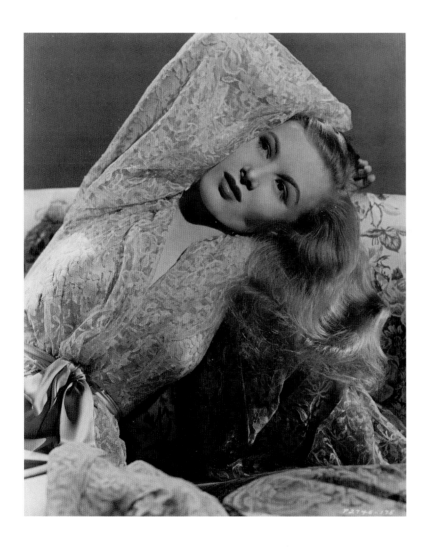

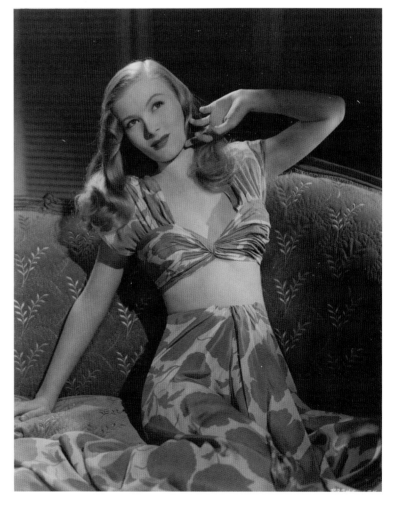

In the late 1940s, Lake dabbled in other movie genres with films like *Ramrod* (1947), *The Sainted Sisters* (1948), and *Isn't It Romantic?* (1948). By this point her celebrity was in decline, and Paramount decided not to renew her contract. She would soon cut her hair short—which many argued also cut her career short. Finally free from Hollywood's grasp, she decamped to her native New York.

The remainder of Lake's life was rough by all accounts. But even at her most down-and-out, she retained the fierceness on which she had built her stardom. In re-examining Lake's legacy, it is essential that she be remembered for more than just her hair and her sex appeal. It was through her headstrong spirit and resilience that she achieved her moxie, as captured in the courageous memoir she published shortly before her death in 1973. It is rife with wisecracks and searingly honest commentary, but ultimately showed that Lake had a remarkable sense of self-awareness—enough to look back on her life and say, "The world looks very different through *both* eyes."

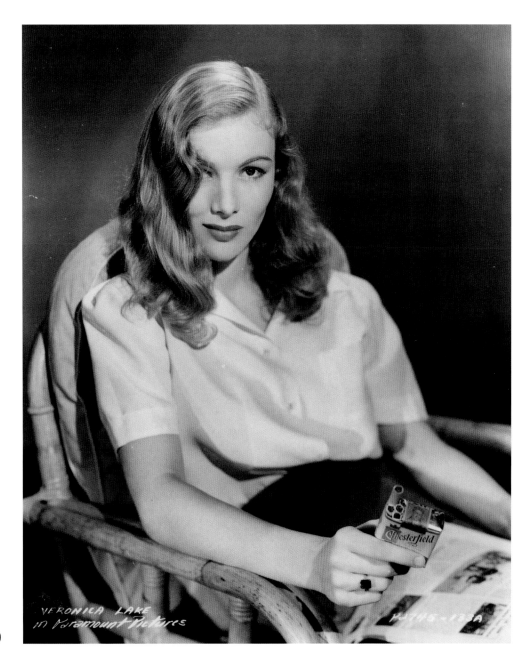

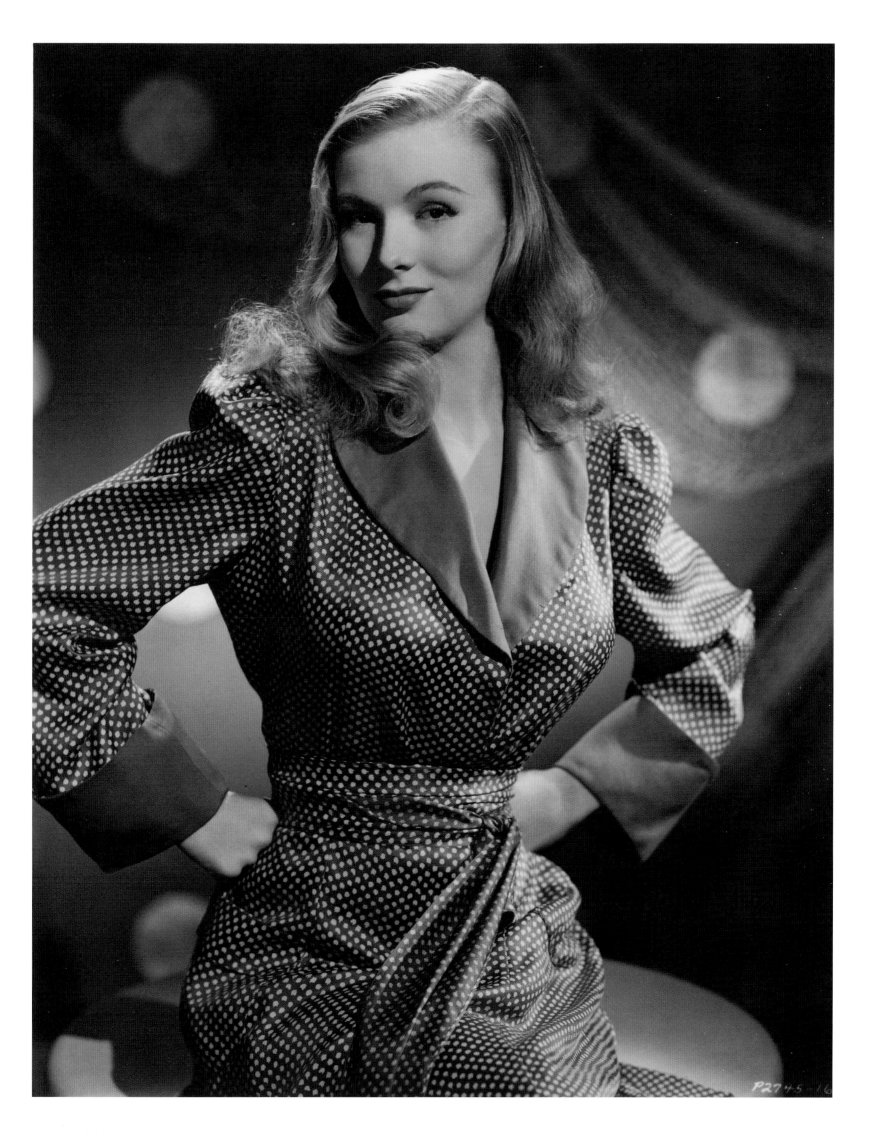

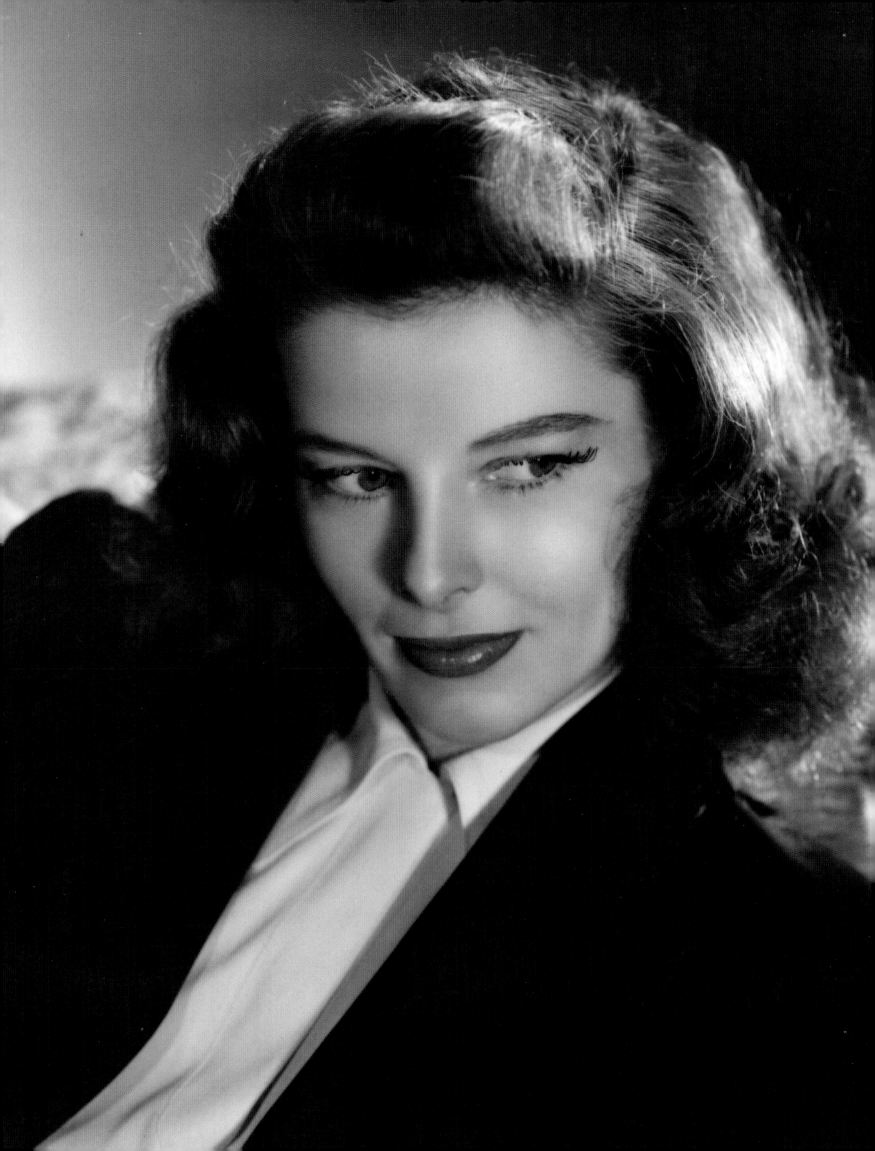

KATHARINE HEPBURN

1907–2003

It was with unabashed independence and the courage to live unconventionally that Katharine Hepburn achieved a stratum of moxie unrivaled by her Hollywood peers. She is, to date, the only person to have the distinction of winning four Academy Awards for acting. The headstrong characters she portrayed often mirrored her own firebrand persona—blending together to create a paradigm of modern womanhood. By all accounts a unique individual, her beauty was marked by a stately angularity and her distinctive voice tinged with the round vowels of her well-born New England upbringing. However, it was with her ferocious sense of autonomy and indefatigable spirit that she overcame many professional setbacks and ultimately forged a legendary career spanning six decades. She was innately rebellious and did not play by the rules of movie stardom regarding how to dress or behave. Her outright refusal to comply with societal expectations of women—as well as her famous penchant for wearing pants—broke the mold of traditional femininity and made her a national heroine.

There is an air of self-satisfaction and a hint of mischief in Katharine Hepburn's sidelong glance and subtle smirk in this publicity photo from 1942. She achieved stardom on her own terms and remained true to her ideals, claiming, "Hollywood tries to make each person into a set pattern. Well, it can't cut me into a pattern. All I have is myself, my own personality."

Katharine Houghton Hepburn was born on May 12, 1907, in Hartford, Connecticut, into a wealthy, well-educated family. She was encouraged to think freely from a young age by her progressive parents—her father a successful doctor and her mother a prominent advocate for women's suffrage and access to birth control. In her idyllic childhood, she was a tomboy who cut her hair short and called herself "Jimmy." She said, "I wished I was a boy because I thought boys had all the fun," and described herself as "skinny and very strong and utterly fearless." It was while attending Bryn Mawr College, her mother's alma mater, that she started perform-

ing in school plays and became determined to be an actress. She graduated in 1928 and made her Broadway debut the same year in the short-lived play *These Days*. Her theatrical career had a rocky start—troubled by multiple firings and an imprudent marriage for which she intended to give up her acting pursuits, but found that she could not. She kept at it, eventually landing her breakout stage role in *The Warrior's Husband* in 1932. From the moment her impressive entrance was met with thundering applause, she "was just full of the joy of life and opportunity and a wild desire to be absolutely fascinating."

Hepburn's triumph on Broadway led to an invitation to do a screen test for RKO Pictures. She was offered a role in the pre-Code drama *A Bill of Divorcement* (1932) starring renowned actors of stage and screen John Barrymore and Billie Burke as her parents. The young actress was unintimidated working alongside such illustrious stars and thrived under the direction of George Cukor, with whom she would go on to make ten more films. For her debut, she asked for $1,500 per week—an unheard-of sum for an unknown actress—and was given a short-term contract based on her potential. When the film premiered to critical acclaim and Hepburn became an overnight success, RKO extended a long-term offer.

It was with her breakthrough performance in *The Warrior's Husband* on Broadway in 1932 that Hepburn "began to feel for the first time like a real actress." She played Antiope, the commander of an Amazon warrior army, and entered with a bounding leap down a flight of stairs with a dead stag slung over her shoulder. Her sensational display of athleticism won over Broadway audiences and critics, eventually leading to her discovery by a Hollywood talent scout.

From the moment she landed in Hollywood, Hepburn achieved notoriety for arriving at the studio lot wearing jeans or dungarees. In this photograph taken during the filming of *Christopher Strong* (1933, RKO Pictures, dir. Dorothy Arzner), she pairs them with a fur coat and unapologetic sass. While on set shooting a scene, her jeans were allegedly confiscated by disapproving studio executives—which she protested by wearing no pants at all until they were returned to her. She held firm, asserting, "Should I wear a different kind of clothes just because Hollywood wants to make me over? Never!"

Hepburn poses in a leather flying helmet in this promotional photograph for *Christopher Strong*. At the helm of the aviation drama was Dorothy Arzner, the first woman to join the Directors Guild. Of her leading lady, she said, "Kate wasn't someone you could mold easily, that you could control. . . . She was extremely strong-willed." Hepburn had her own recollections of her collaboration with Arzner: "She wore pants. So did I. We had a good time working together."

In *Christopher Strong*, Hepburn plays Lady Cynthia Darrington—a female aviator who attempts to break the world altitude record in a climactic scene depicted on this lobby card. Both character and actress were untethered to social norms of femininity. Later in life, Hepburn professed, "I have not lived as a woman, I have lived as a man. . . . I have just done what I damn well wanted to and I made enough money to support myself and I ain't afraid of being alone."

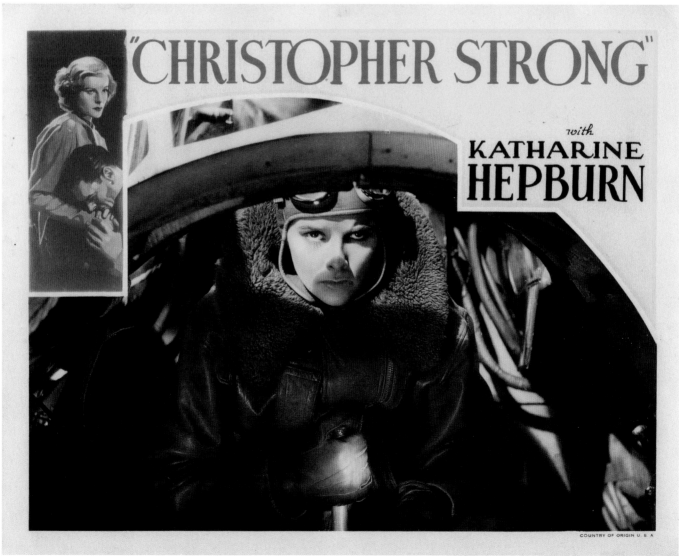

In her first few years at the studio, Hepburn established her talent for portraying strong-willed, independent young women. She played an intrepid aviatrix in her second film, *Christopher Strong* (1933), and an eager aspiring actress in her third, *Morning Glory* (1933). The latter was originally intended for established star Constance Bennett, but Hepburn saw herself in the character and insisted that the role was hers. She proved herself right, earning her first Academy Award for Best Actress. Next came a powerful performance as the literary heroine Jo March in the popular film adaptation of Louisa May Alcott's *Little Women* (1933), followed by more films either penned by female screenwriters or based on novels written by women—*Break of Hearts* (1935), *Alice Adams* (1935), and *A Woman Rebels* (1936).

During the mid-1930s, Hepburn encountered a series of career setbacks beginning with an unfortunate miscasting as a mountain hillbilly in *Spitfire* (1934). She thought it best to make a pivot back to the Broadway stage in *The Lake*, but the play was poorly received and her performance widely panned. Dorothy Parker, ever the vicious wit, famously quipped in her review, "Go to the Martin Beck [Theatre] and see Katharine Hepburn run the gamut of emotion from A to B." Instead

Hepburn dons this fanciful "moth" costume designed by Walter Plunkett for a masquerade ball in *Christopher Strong*. Constructed of tiny metallic squares, the dress gleamed on camera and dramatically showcased the actress's otherworldly beauty.

Sylvia Scarlett (1935, RKO Pictures, dir. George Cukor) marked Hepburn's first on-screen pairing with Cary Grant, with whom she would star in three more films (*above left*). In the dual role of Sylvia/Sylvester, she alternates between male and female identities. She appears especially androgynous with her hair cropped in this promotional photo (*above right*).

of enduring the embarrassment of an extended run, Hepburn paid the producer her life savings to close the show—later citing this as the incident that taught her to take responsibility for her own career. She was set on rebuilding it upon her return to Hollywood, but was met with less than satisfactory scripts. In *Sylvia Scarlett* (1935), which she called "a real disaster," she played a woman who disguises herself as a young man in order to move more freely in society. This subversive gender-bending fueled rumors about Hepburn's sexuality—which became a topic of debate after she divorced her husband in 1934 and began living with a female companion. She wrote that her "career was at a low ebb" when she signed on to star in *Stage Door* (1937) opposite RKO's other leading lady, Ginger Rogers—who was incredibly popular and much more willing to abide by the studio's expectations. Hepburn had a strong aversion to celebrity culture and had no interest in perpetuating the illusion of movie stardom. She didn't dress glamorously, didn't sign autographs, and didn't give interviews. She developed a difficult relationship with film audiences and the press, who became suspicious—even hostile—over her refusal to play by the rules of the industry's game. In 1934, she told *Motion Picture Magazine*: "I'm not living my life for Hollywood or publicity, and I never will. Why should I have to change my personality?"

KATHARINE HEPBURN

Although the zany screwball comedy *Bringing Up Baby* (1938) was not a box office success when it premiered, it has since become a beloved classic. Hepburn hit her comedic stride as the endearingly scatterbrained heiress Susan Vance, who terrorizes a hapless paleontologist played by Cary Grant with her madcap misadventures involving a rare dinosaur bone and a pet leopard. Grant was not keen on working with the live animal, but Hepburn claimed, "I didn't have brains enough to be scared, so I did a lot of scenes with the leopard just roaming around." Soon after the film's release, the Independent Theater Owners Association took out a now-infamous advertisement in *The Hollywood Reporter* that listed stars they considered "Box Office Poison"—Hepburn was among them. The studios weaponized this proclamation and used it as grounds to punish the named stars. RKO presented Hepburn with insulting offers for B-movies, which she readily refused, instead buying out her studio contract and striking out on her own. She reteamed with Grant at Columbia Pictures for *Holiday* (1938), a romantic comedy based on a Philip Barry play for which she had been an understudy ten years earlier. Positive reviews were not enough to overcome the damage done by the Box Office Poison notice, and the film suffered as a result. At this point, Hepburn knew she had to do something truly monumental to resurrect her career.

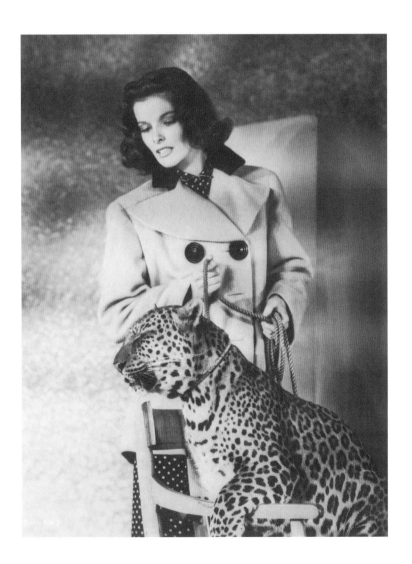

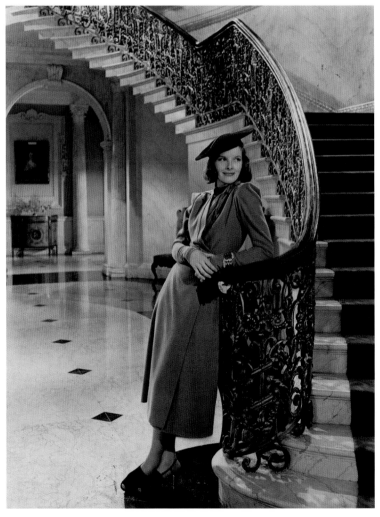

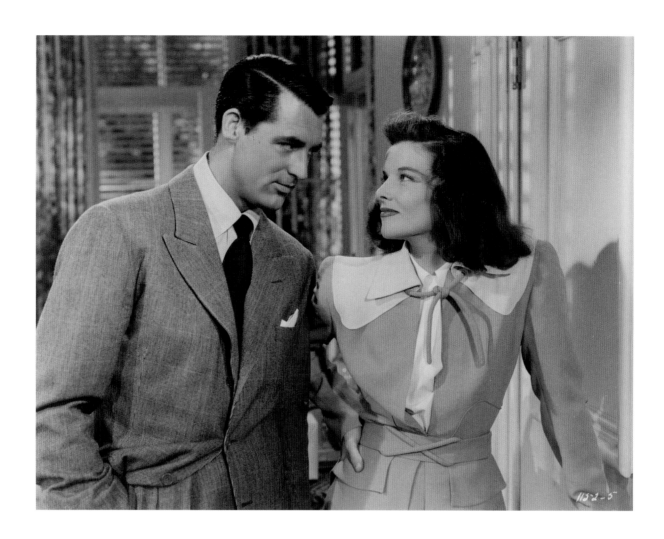

Grant and Hepburn face off in this promotional photo for the film adaptation of *The Philadelphia Story* (1940, Metro-Goldwyn-Mayer, dir. George Cukor), their final and most consequential on-screen collaboration.

In perhaps her boldest move, Hepburn orchestrated her own comeback by overseeing the successful stage-to-screen adaptation of *The Philadelphia Story*—now upheld as one of the greatest classic films of all time. She and playwright Philip Barry created a vehicle tailored to her strengths, and the resulting work was received with fanfare on Broadway and ran for over 400 performances. Hepburn had the business acumen to acquire the film rights and stood in a position of power when Hollywood came calling to adapt the play for the silver screen. She sold the rights to MGM—the most prestigious of the studios—and used her talent for negotiation to broker a deal that would guarantee her not only the starring role, but her choice of director and costars. As the haughty socialite Tracy Lord, Hepburn was entirely herself and yet exhibited a sense of vulnerability not seen in her previous roles. Indeed, Tracy's character arc—as the aloof "goddess" brought down to earth—mirrored her own. With *The Philadelphia Story*, she redirected the course of her career and regained Hollywood's favor. She found the perfect follow-up in *Woman of the Year* (1942)—another property she developed herself and sold to MGM for a whopping $250,000. Her performance as the hypercompetent and exceedingly accomplished political journalist Tess Harding is as Hepburn as Hepburn gets. The film was her first with Spencer Tracy, with whom she would remain intrinsically linked through their nine cinematic collaborations and long, legendary love affair. Of their relationship, she said, "We just passed twenty-seven years together in what was to me absolute bliss."

KATHARINE HEPBURN

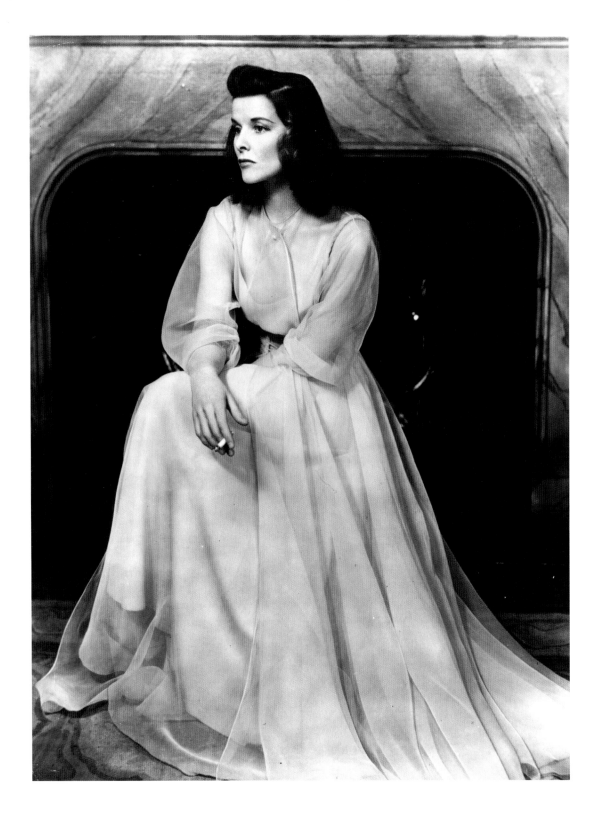

Hepburn was photographed at the Vandamm Studio—the premier destination for stars of the performing arts—for the Broadway production of *The Philadelphia Story* in 1939. In this portrait, she wears a diaphanous stage costume designed by Valentina, an American couturière revered for her exquisitely simple, timeless styles.

Hepburn's films with Tracy were exhilarating battles between equals, characterized by a magical push-and-pull tension between the two actors as they simultaneously worked with and against each other. They faced off as opposing attorneys for a high-stakes court case in *Adam's Rib* (1949), as a star athlete and her demanding manager chasing a championship in *Pat and Mike* (1952), as an engineer and a reference librarian clashing over computerization in *Desk Set* (1957), and as liberal parents challenged by their daughter's interracial marriage in *Guess Who's Coming to Dinner* (1967)—for which Hepburn earned her second Academy Award.

KATHARINE HEPBURN

Hepburn and her costar Humphrey Bogart are vibrantly represented on this lobby card for *The African Queen* (1951, United Artists, dir. John Huston). It was her first Technicolor film and marked a new era of her career as a mature, distinguished actress.

In her later career, she made a habit of playing mature, eccentric, and usually unmarried women in films like *The African Queen* (1951) and *Summertime* (1955). She won a third Oscar for her portrayal of Eleanor of Aquitaine in *The Lion in Winter* (1968) and a record-breaking fourth for *On Golden Pond* (1981), which made her the most decorated actor of all time. That the majority of these awards and accolades came later in her life illustrates that she was able to age in tandem with her characters, all while maintaining the distinctly powerful persona upon which she built her career. It is telling that she never attended an awards ceremony to accept any of her Oscars. "As for me, prizes are nothing," she said. "My prize is my work." That tireless dedication to her career is at the core of her cinematic legacy, and with it, she has rightfully earned her place as one of the foremost stars in the Hollywood pantheon.

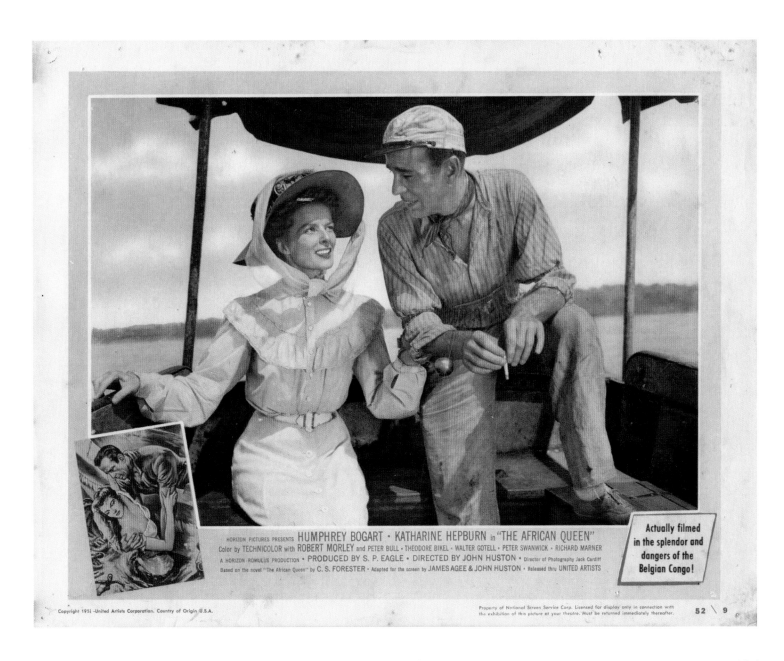

HORIZON PICTURES PRESENTS HUMPHREY BOGART · KATHARINE HEPBURN in "THE AFRICAN QUEEN"
Color by TECHNICOLOR with ROBERT MORLEY and PETER BULL · THEODORE BIKEL · WALTER GOTELL · PETER SWANWICK · RICHARD MARNER
A HORIZON-ROMULUS PRODUCTION · PRODUCED BY S. P. EAGLE · DIRECTED BY JOHN HUSTON · Director of Photography Jack Cardiff
Based on the novel "The African Queen" by C. S. FORESTER · Adapted for the screen by JAMES AGEE & JOHN HUSTON · Released thru UNITED ARTISTS

Actually filmed in the splendor and dangers of the Belgian Congo!

52 \ 9

KATHARINE HEPBURN

This promotional photo for *Woman of the Year* (1942, Metro-Goldwyn-Mayer, dir. George Stevens) shows Hepburn as we first see her—through the eyes of Spencer Tracy's character. This film was just the beginning of their long partnership. It importantly led to a contract with MGM for Hepburn, which allowed them to continue making movies together.

Things were looking up for Hepburn with the success of *Woman of the Year*—a film that delivered an empowering display of unapologetic feminism.

This studio portrait was used to publicize *Quality Street* (1937, RKO Pictures, dir. George Stevens), a historical comedy set in early nineteenth-century England. Interestingly, Hepburn is not shown wearing period costume, but rather con-temporary clothing. While this seems out of step with the film, it is entirely fitting given Hepburn's persona as a thoroughly modern woman—if not one ahead of her own time.

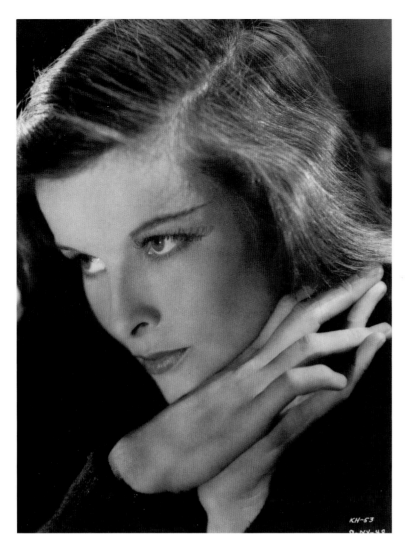

ABOVE LEFT

In this early RKO studio portrait taken by Ernest Bachrach c. 1932, we see a somewhat reserved version of the young actress. Throughout her career, Hepburn remained fiercely private. She lived authentically, but was judicious about how much of herself she gave away. "You wish to be wholly sincere in your dealings with [the film audience]," she said, "not only in what you offer on the screen but in the way you represent your real self."

BELOW LEFT

This portrait was taken at the Vandamm Studio c. 1939 for the Broadway production of *The Philadelphia Story*. There is a hopeful quality to Hepburn's upward gaze, as if she knew that it would be the thing to turn her career around. The year after the film adaptation was released, she told *Screenland*, "I am very grateful to *The Philadelphia Story*. It gave me a lift when I needed it most."

OPPOSITE

Hepburn wears her signature slacks and a rebellious facial expression to match in this photograph from the 1930s.

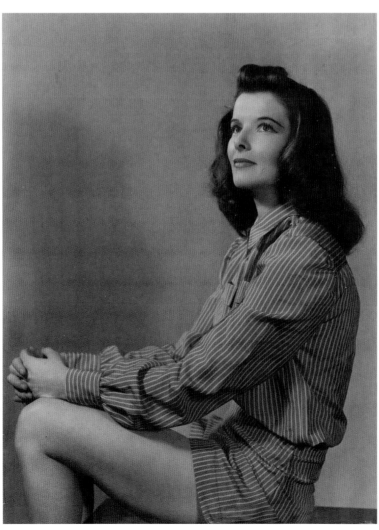

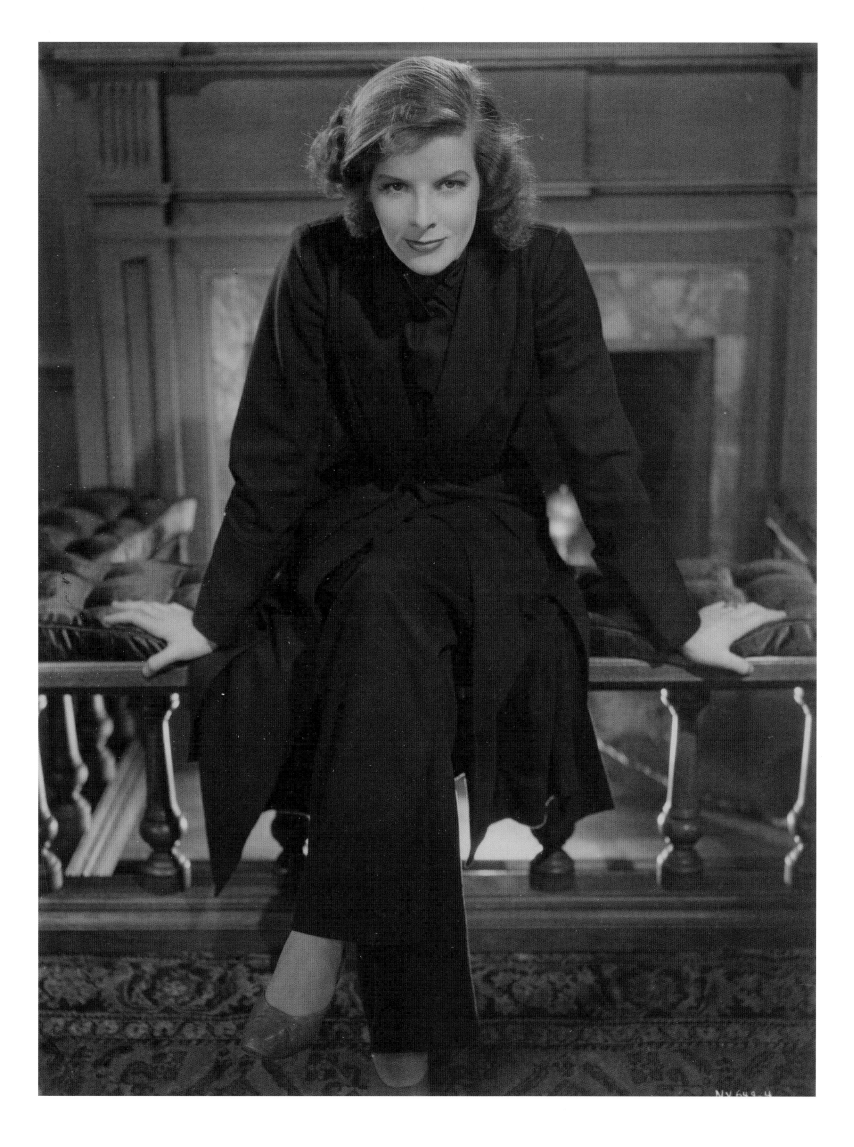

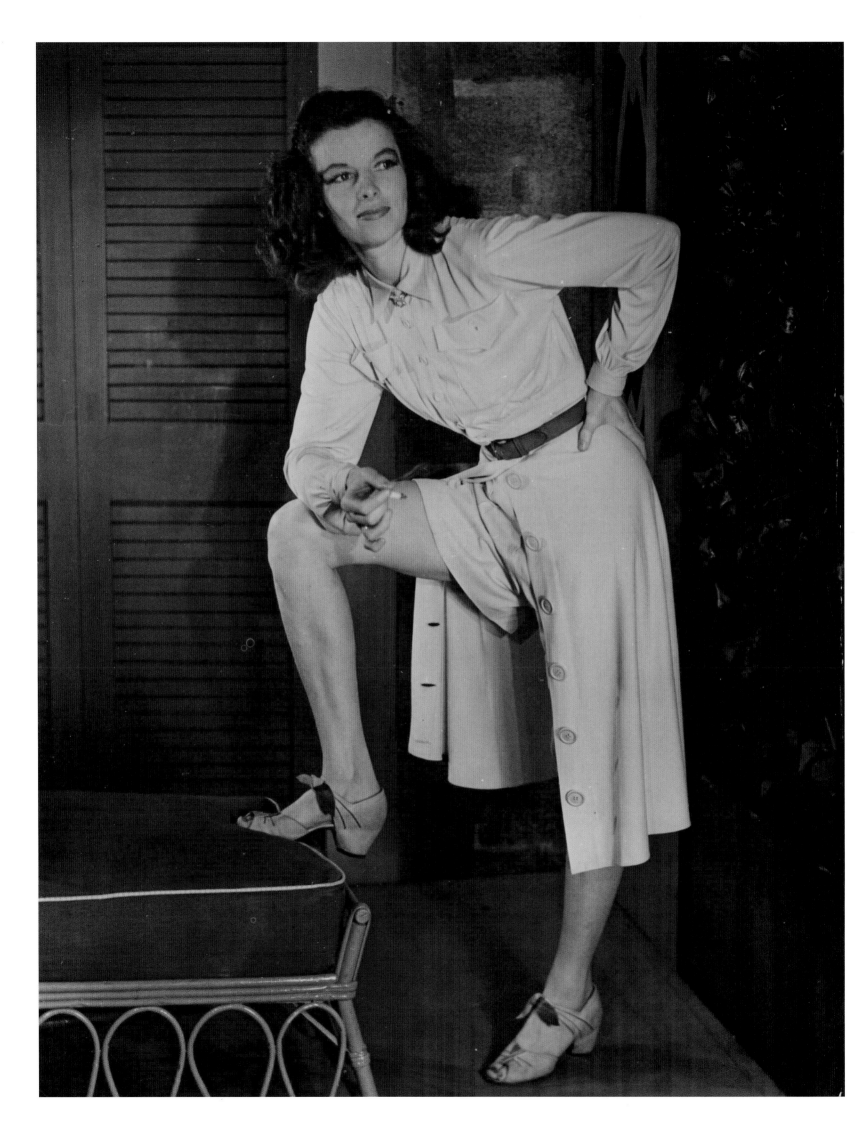

A self-assured Hepburn appears to be at home on the Broadway set of *The Philadelphia Story*, photographed here by Alfred Eisenstaedt for *LIFE Magazine* in 1939.

Hepburn's steely demeanor is on full display in this intense studio portrait from c. 1935. Her hand clutched to her chest reflects how she held fast to her individuality. In an interview from around this time, she declared, "The whole town of Hollywood isn't going to take myself away from me!"

Hepburn carries herself with an air of aloofness in this RKO studio portrait by Bachrach from 1935. Tiringly made the subject of criticism, she was often perceived as spoiled, snobbish, or rude and given the nickname "Katharine of Arrogance" by hostile members of the press.

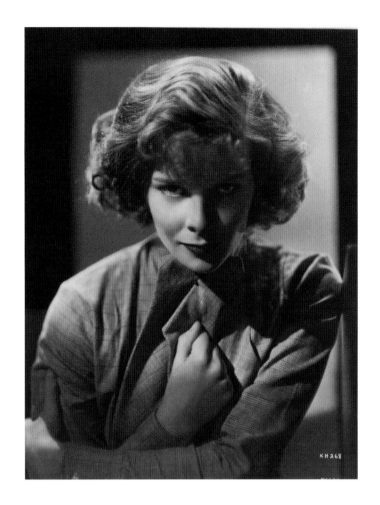

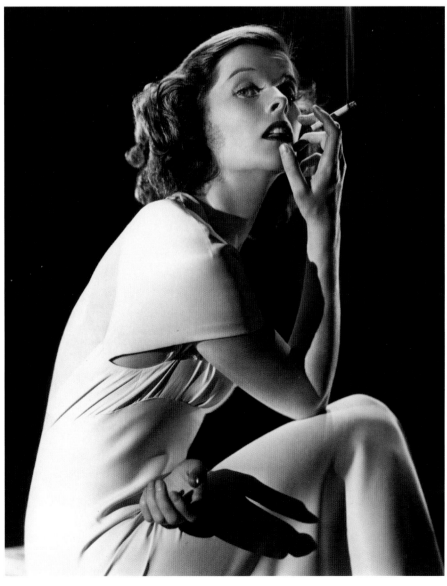

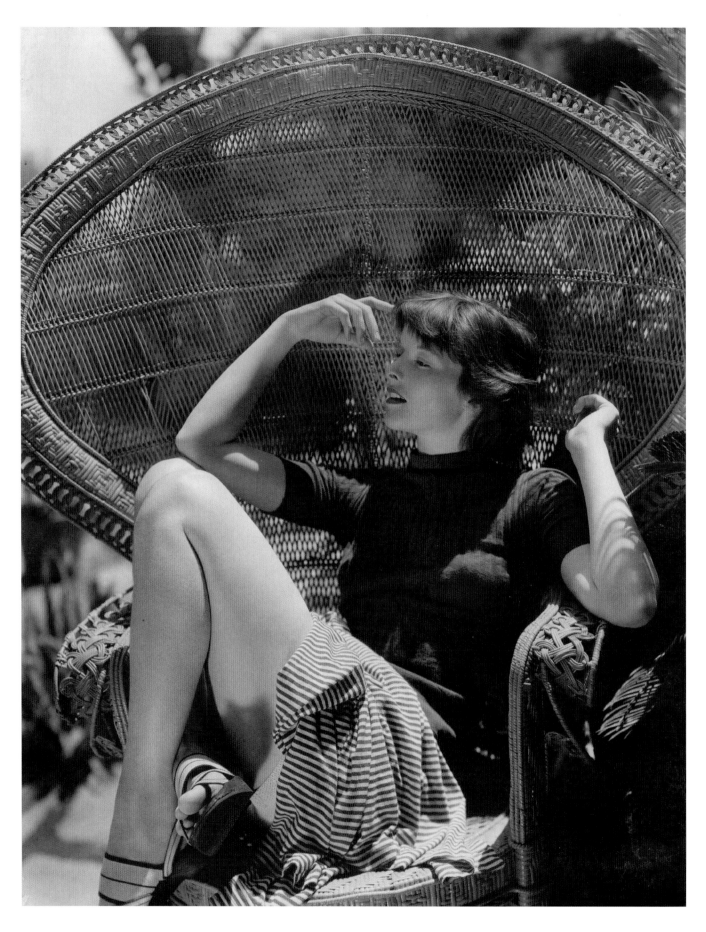

This unconventionally laid-back photo of Hepburn was taken by George Hoyningen-Huene in 1934, still early in the actress's career. It perfectly captures the spirit of the youthful tomboy as she grew into an esteemed lady.

This photo by Clarence S. Bull from 1940 features the actress wearing an understated ensemble bearing her KHH monogram. Hepburn's style was striking, yet decidedly unfussy. Here, the crisp lines of her broad-shouldered blouse accentuate the angularity of her extraordinary bone structure. Muriel King—the fashion and costume designer who created pieces for Hepburn's personal wardrobe—said of her star client, "She has far too definite a personality to fit into just any clothes. She has such good bones, such good carriage, so much distinction that her wardrobe cries for distinction, too."

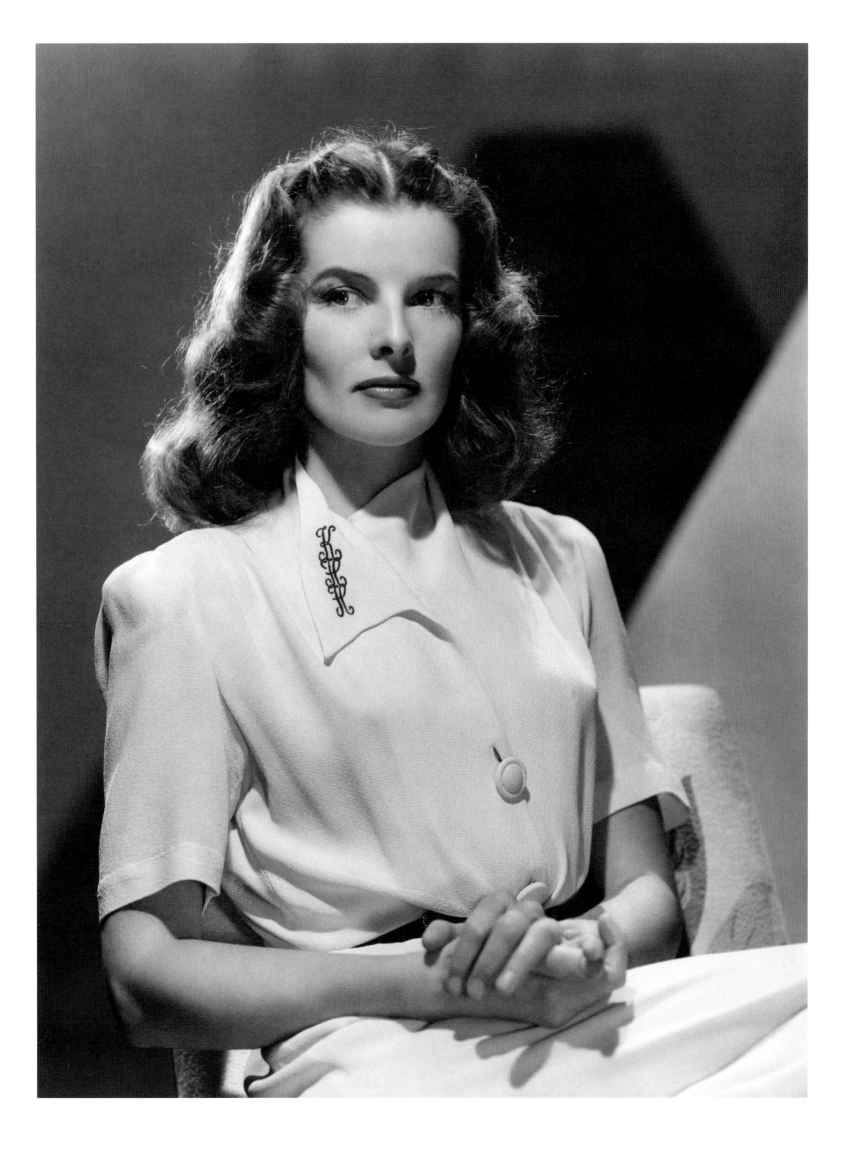

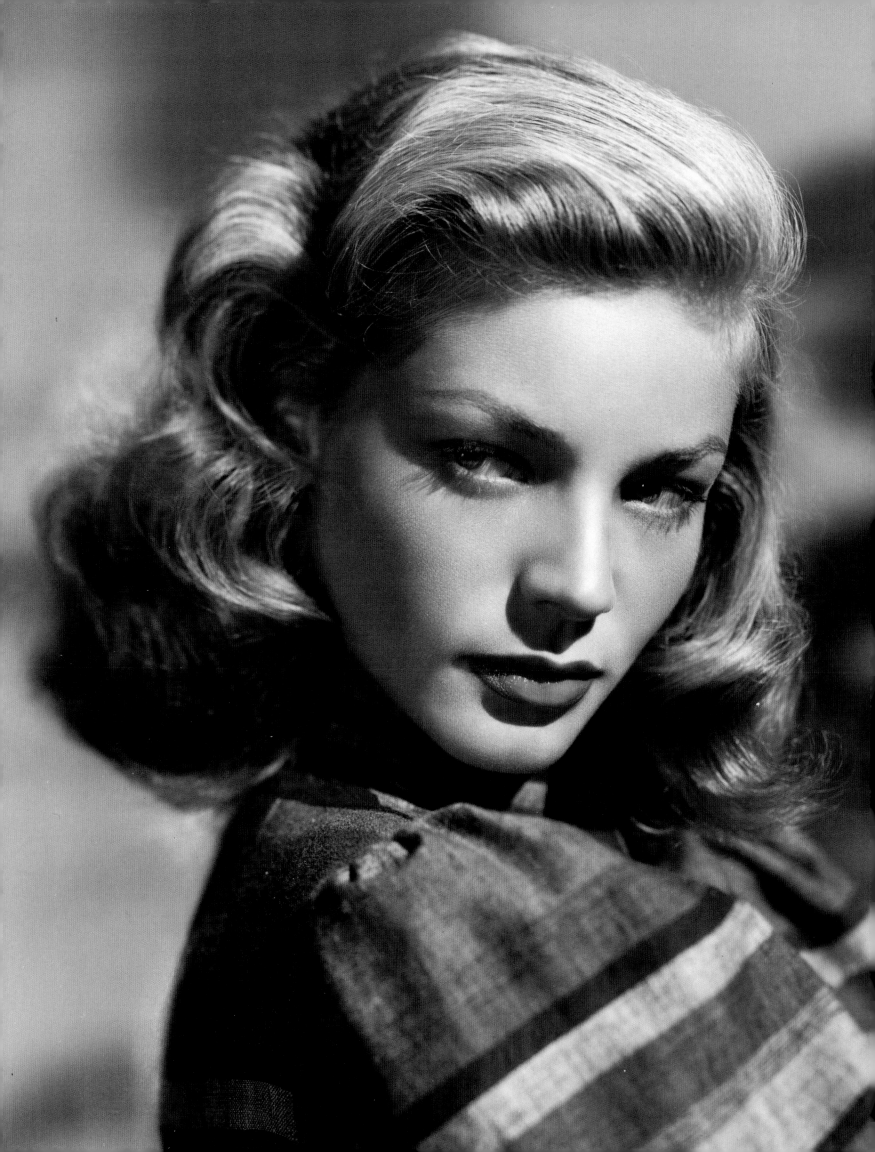

LAUREN BACALL

1924–2014

Few stars have managed to become as instantly iconic as Lauren Bacall, who burst onto the scene at just nineteen years old and shifted the landscape of American cinema with her very first film appearance. In an article entitled "That New Girl!" *Screenland* heralded her arrival: "She has the talent, the looks, and the audacity. You look at her and decide instantly that she's an actress." Bacall's star quality was indeed unmistakable at the outset, but it was also potent enough to sustain a long and illustrious career on stage and screen. Utilizing her distinctively husky voice and seductive, piercing gaze, she delivered some of the most influential performances in film noir—a genre she would help shape in her early years. She brought a commanding presence to every role she ever played and lived an incredible life that itself was the stuff of Hollywood legend.

Born in the Bronx on September 16, 1924, Betty Joan Perske grew up idolizing the great ladies of the silver screen—most especially Bette Davis and Katharine Hepburn. After seeing the 1939 Broadway production of *The Philadelphia Story*, she recalled, "Katharine Hepburn that afternoon made me glad to be alive—and sure that being an actress was the *only* goal in life." When she could no longer afford to attend the American Academy of Dramatic Arts, she supported herself by working as a Broadway theater usher and made a habit of hanging around Sardi's during lunch hours in an effort to get noticed by producers. She made her stage debut at seventeen with a small walk-on role in the short-lived Broadway play *Johnny 2 × 4*. While Betty continued pounding the pavement in her acting pursuits, she

With her throaty voice and sultry stare—as in this studio portrait for *The Big Sleep* (1946, Warner Brothers, dir. Howard Hawks)—Lauren Bacall possessed a sense of maturity far beyond her years. She held fast to her personal style in an era that often saw young starlets reshaped by studio executives, which ensured that she was always uniquely recognizable.

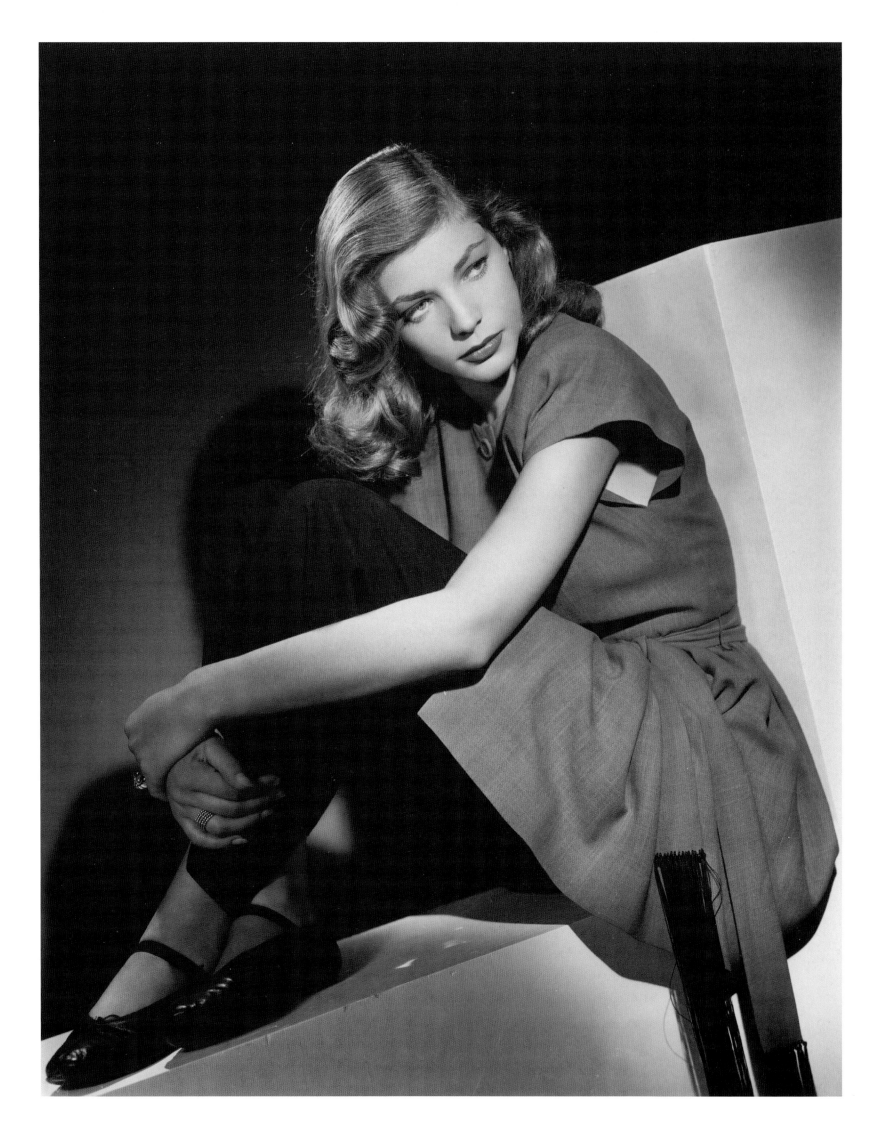

found work modeling evening gowns for Seventh Avenue dress designers. Before long, she found herself in the office of Diana Vreeland, the famed fashion editor of *Harper's Bazaar*. Vreeland arranged to have the young model shoot with the celebrated photographer Louise Dahl-Wolfe, which resulted in the well-known image of the stylishly dressed eighteen-year-old posed in front of an American Red Cross office. The photo appeared on the cover of the March 1943 issue of the magazine and ended up being Betty's golden ticket to Hollywood, where she would take on the name Lauren Bacall.

The *Harper's Bazaar* cover caught the eye of Slim Hawks—socialite, style icon, and wife of Hollywood director Howard Hawks. Slim urged her husband to invite the young model to do a screen test for his next film, and he was so taken with Bacall that he signed her to a seven-year contract with Warner Brothers. As soon as she arrived, the inevitable happened—in a standard industry ritual, the studio endeavored to reshape the image of its new star. However, Bacall adamantly refused, claiming, "I was bought for what I was, and I'm going to stay that way. There'll be no changes." She insisted on owning her image and wearing her hair in the way that she liked, with a deep side part and a wave "on the right side—starting to curve at the corner of my eyebrow and ending, sloping downward, at my cheekbone." It was the style she wore in her meteoric breakout role in *To Have and Have Not* (1944).

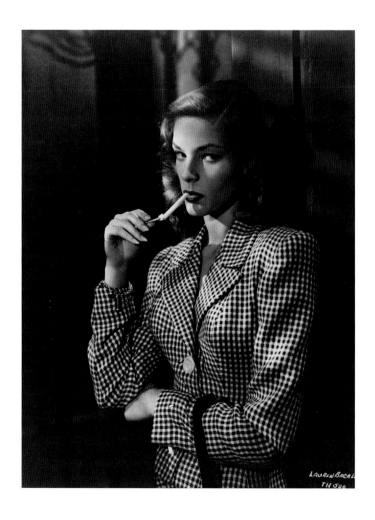 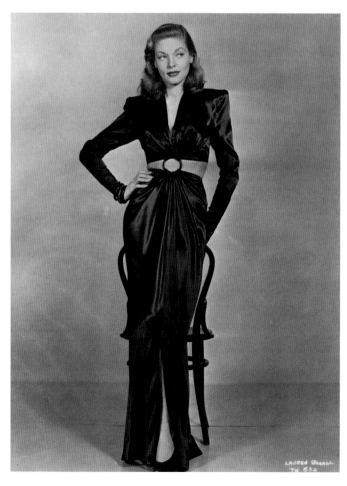

LAUREN BACALL

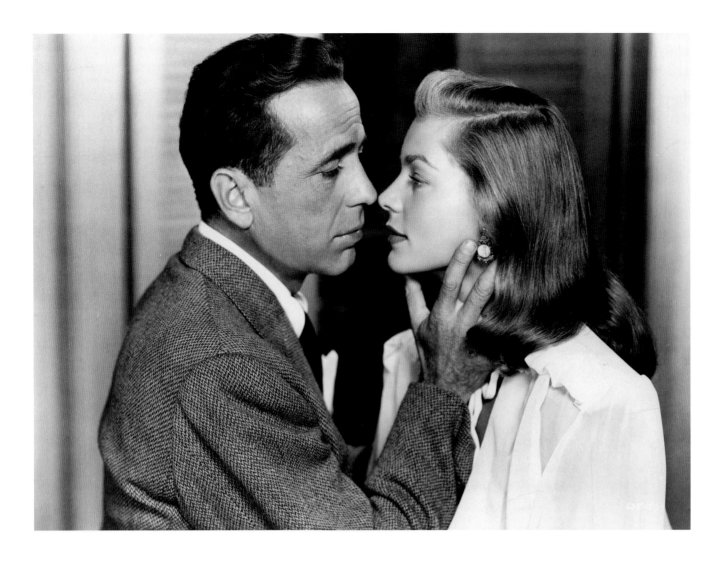

Her character—who went by "Slim," in a nod to her benefactress—exudes a palpable air of confidence and maturity, moving through the film with something between and slink and a swagger. In actuality, the nineteen-year-old was fraught with nerves and found herself shaking uncontrollably when filming a scene opposite Humphrey Bogart. She found a remedy that proved to be a career-defining move: "By the third or fourth take, I realized that one way to hold my trembling head still was to keep it down, chin low, almost to my chest, and eye up at Bogart. It worked, and turned out to be the beginning of 'The Look.'" It became her trademark and her nickname. However, it was the pairing with Bogart that would most dramatically change the course of her life and career.

It was on the set of *To Have and Have Not* (1944) that Humphrey Bogart and Lauren Bacall began a romantic relationship that would lead to one of the most high-profile marriages in Hollywood history. Bogie and Bacall, as they had become known, wed on May 21, 1945, while in production for their second film together, *The Big Sleep* (1946). The adaptation of Raymond Chandler's best-selling crime novel would cement Bacall's prestige in the film noir genre and lead to two more on-screen pairings with her husband—*Dark Passage* (1947) and *Key Largo* (1948). These four films preserved their courtship and union on celluloid and would en-

ABOVE
A film still from *Dark Passage* (1947, Warner Brothers, dir. Delmer Daves). The studio fed the public's fascination with Bogie and Bacall with this third film collaboration.

OPPOSITE
Following the great success of *To Have and Have Not*, Bogart and Bacall reprised their on-screen pairing in *The Big Sleep*, with their great chemistry evident in this film still.

LAUREN BACALL

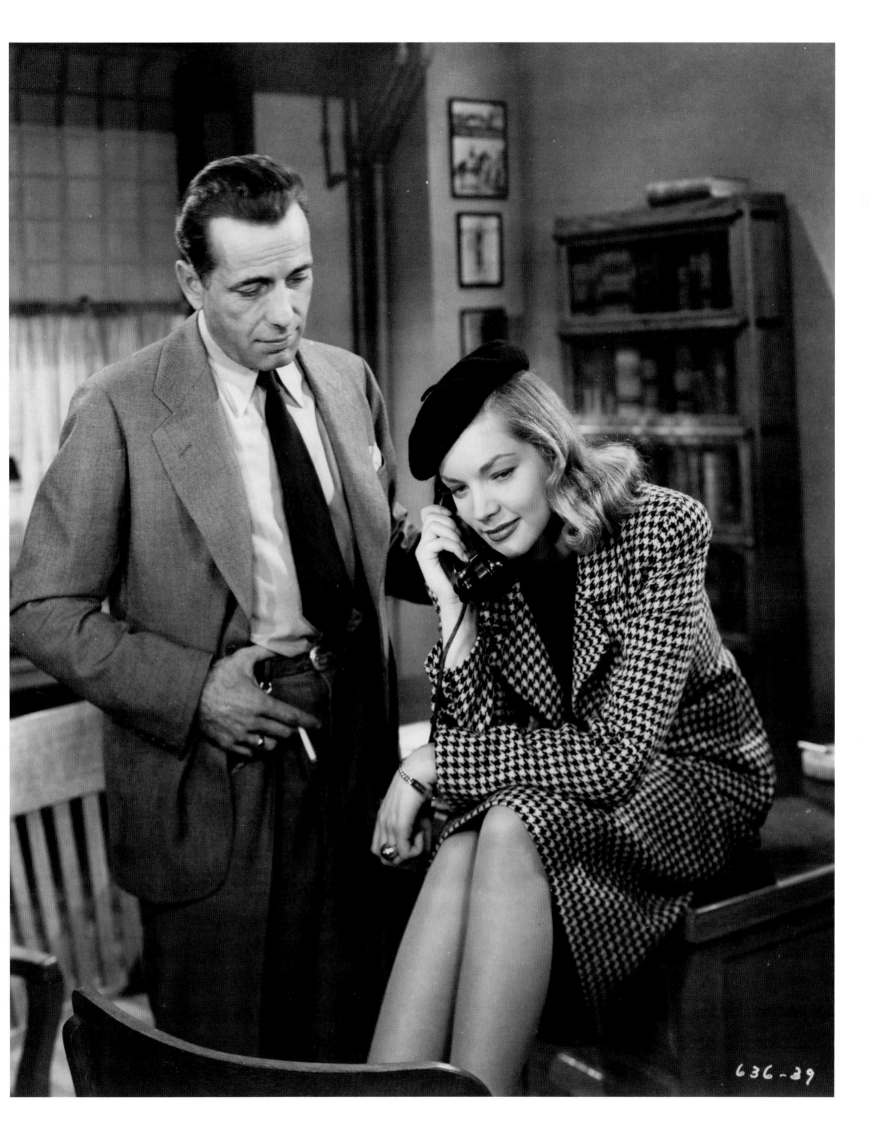

636-89

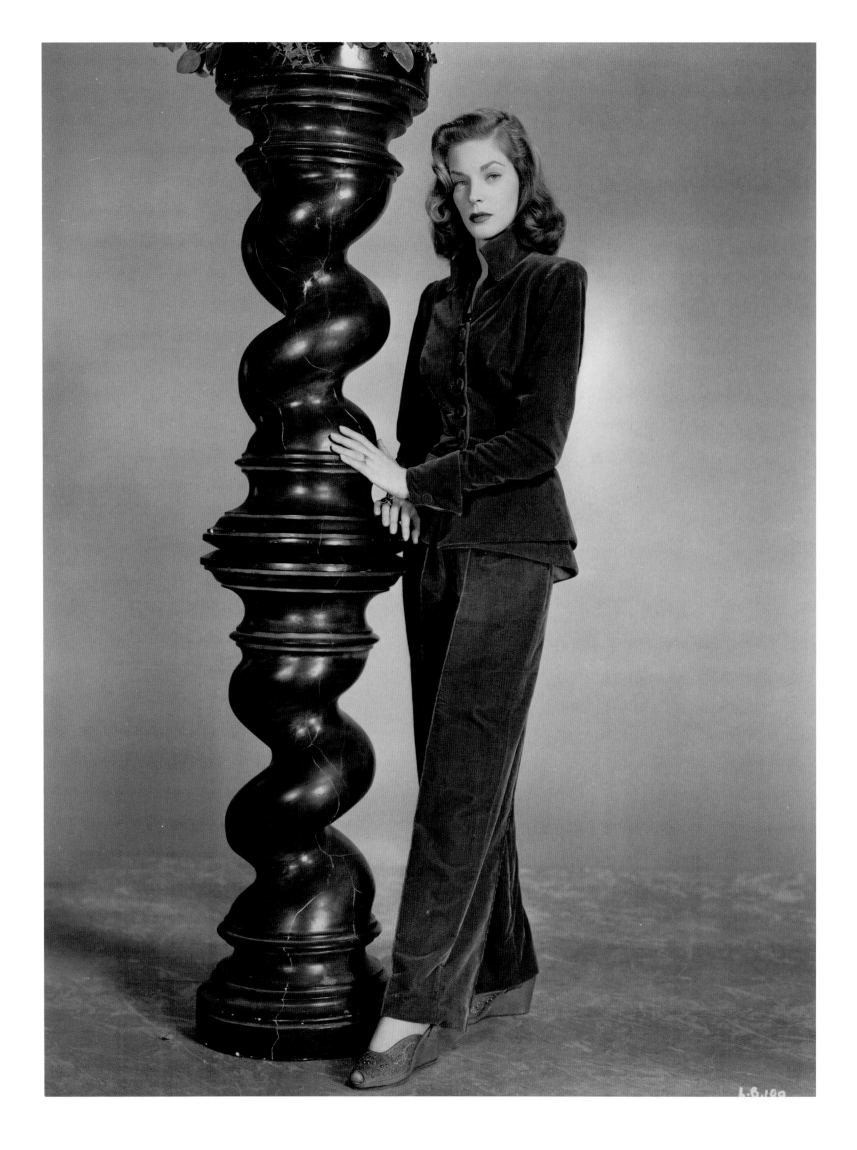

Bacall's previous career as a fashion model served her well in studio publicity photos like this one from *Dark Passage*. She models a velvet pantsuit designed by Bernard Newman for the film.

sure that their names and legacies would remain eternally linked. Of their love story, Bacall fondly wrote in her memoir, "No one has ever written a romance better than we lived it." They remained inseparable until Bogart's death in 1957. And while their twelve years of marriage loom large in her personal narrative, it was ultimately a small fraction of her long and storied life. Later in her career, Bacall became frustrated that she was unable to separate her own persona from Bogart's memory. In 1970, she told the *New York Times*, "I think I've damn well earned the right to be judged on my own. It's time I was allowed a life of my own, to be judged and thought of as a person, as *me*."

As she worked out the remainder of her contract with Warner Brothers, Bacall would follow in the footsteps of her hero Bette Davis in challenging studio executives. She repeatedly rejected bad scripts and was suspended without salary twelve times for her refusal to accept roles she deemed unworthy. Hawks called her "insolent"—but, like Davis, Bacall was determined to maintain her high caliber of work. She negotiated an early end to her contract in 1950 and subsequently went on to play great roles at other studios. At 20th Century Fox, she starred alongside Marilyn Monroe and Betty Grable in *How to Marry a Millionaire* (1953), a delightful comedy about three gold-digging fashion models. She returned to her fashion roots yet again in *Designing Woman* (1957), as a high-society fashion designer who falls in love with a down-to-earth sportswriter played by Gregory Peck.

After Bogart's death, Bacall moved back to New York and enjoyed a robust career on the stage. She found success on Broadway, in shows like *Applause* (1970), based on the 1950 film *All About Eve*, and *Woman of the Year* (1981), based on the 1942 film of the same name. Interestingly, both were musical adaptations in which she played roles originated by her idols—Davis and Hepburn. In the poetic fulfillment of her childhood dreams, Bacall won the Tony Award for Best Actress in a Musical for both performances. And though she was still primarily known for her work in movies, she did not receive an Oscar nomination until 1997 for *The Mirror Has Two Faces* (1996). She was eventually presented with the Academy Honorary Award in 2010 "in recognition of her central place in the Golden Age of motion pictures." That she made such an explosive debut at a young age and still managed to find longevity in her career attests to Lauren Bacall's incredible star power.

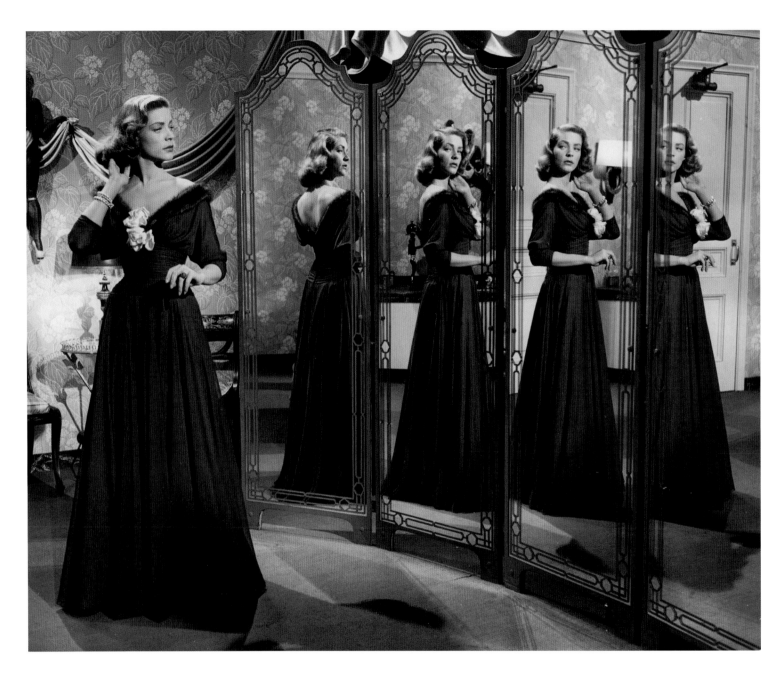

ABOVE

In the Technicolor screwball comedy *How to Marry a Millionaire* (1953, 20th Century Fox, dir. Jean Negulesco), Bacall plays the fortune-seeker Schatze Page, outfitted in a beautiful dinner dress by William Travilla in this publicity photo for what she called "the best part I'd had in years."

OPPOSITE

This studio portrait taken by Six was used as part of the publicity campaign for *Confidential Agent* (1945, Warner Brothers, dir. Herman Shumlin), the unsuccessful film she starred in opposite Charles Boyer in between her first two films with Bogart. It was specifically used as an advertisement for "'The Look' Contest," in which the studio encouraged submissions of Bacall look-alikes.

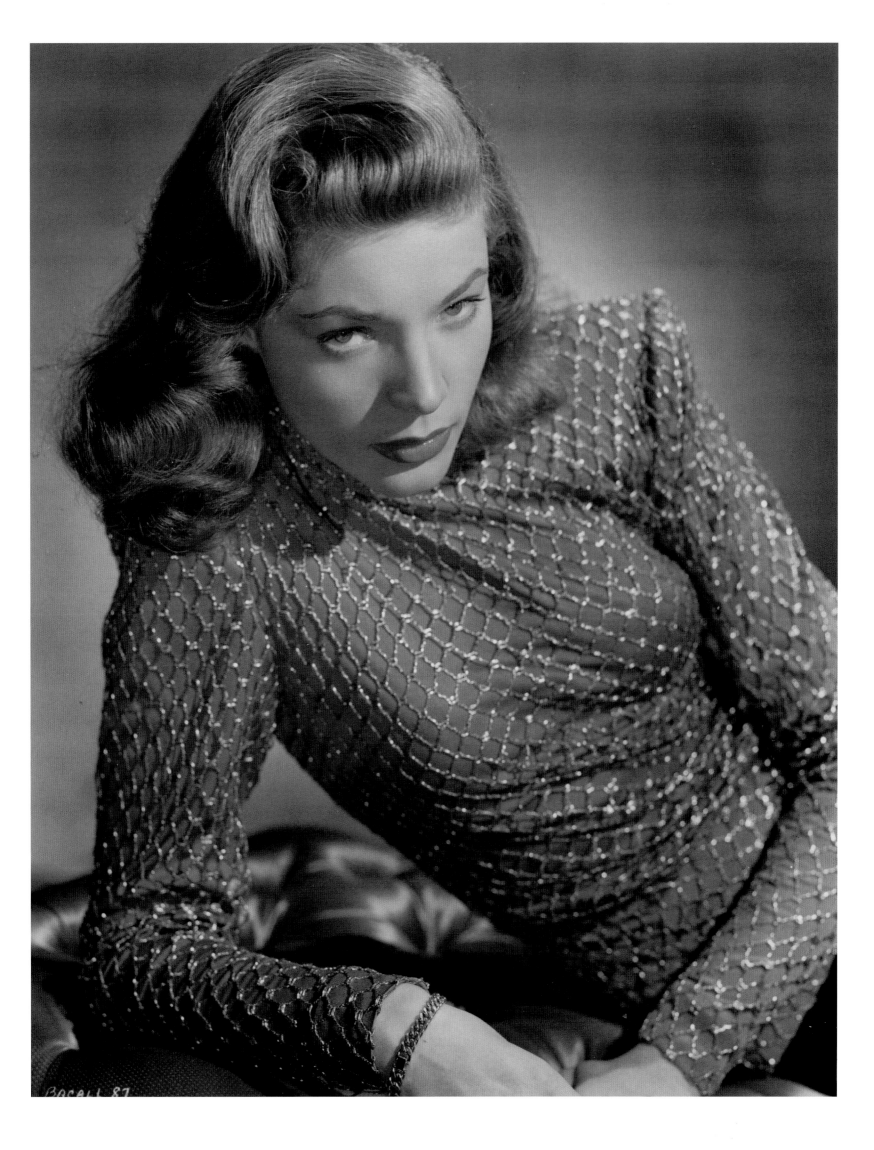

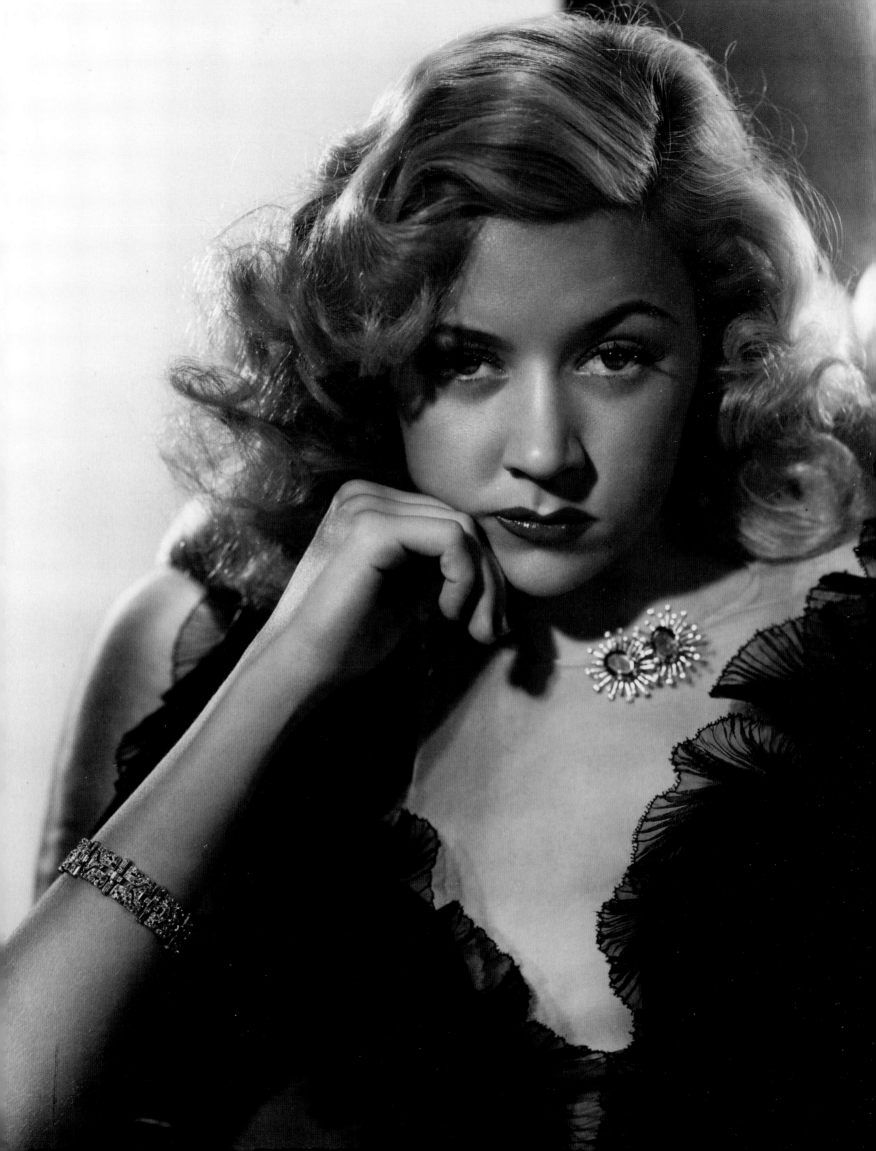

GLORIA GRAHAME

1923–1981

O f all the deadly dames to leave their scorch marks on the film noir genre, Gloria Grahame was perhaps the fieriest. She was the definitive incarnation of the femme fatale—a designation earned through her bad girl persona both on-screen and in her tumultuous personal life. Best known for her earthy sensuality and tough-as-nails attitude, she was also capable of delivering a softer type of flirtatious charm when called upon. She excelled at playing troubled women brimming with brash nerve and streetwise cynicism, given depth by an intriguing tinge of vulnerability. Although she was relegated to supporting roles for much of her career, her performances were no less stirring and memorable.

Gloria Hallward was born in Los Angeles on November 28, 1923. Her mother, an actress and theater director who used the stage name Jean Grahame, began coaching her at an early age. Gloria enrolled at Hollywood High School when she got serious about acting, but was spotted by a producer before graduation and dropped out to accept a role in a play that brought her to Chicago in 1942. Her success in that show inspired her to move to New York, where she made her Broadway debut the following year. Gloria was performing in the play *Highland Fling* when she caught the attention of an MGM talent scout, who brought in Louis B. Mayer to see her. Mayer was so taken with the young actress that he offered her a lucrative studio contract despite her disinterest in doing a screen test—on the condition that she take her mother's last name because he liked the alliterative effect. And so, Gloria Grahame returned to Hollywood. She made her film debut in *Blonde Fever* (1944),

In this promotional photo for *Crossfire* (1947, RKO Radio Pictures, dir. Edward Dmytryck), Gloria Grahame wears her signature sultry pout and glowers with a brassy attitude. Her role in this film would launch her into the dark world of film noir, the genre she would be most identified with.

cast in a gold-digger role that did little to advance her career. But her breakout moment came before long when director Frank Capra arranged a loan-out to RKO for his next film, *It's a Wonderful Life* (1946). As the head-turning town flirt Violet Bick, she lit up the screen with her coquettish allure.

When he signed Grahame to MGM, Mayer had initially intended to market her as an all-American girl, with her blonde hair and cherubic dimples. However, it became evident that the studio could not figure out what to do with their new acquisition. In 1947, Grahame's contract was sold to RKO Radio Pictures—a studio much better suited to develop her star potential.

Grahame's career soared to new heights with her introduction to film noir in the social issue film *Crossfire* (1947). She played Ginny, a tawdry taxi dancer—the first of numerous "floozy" roles that would become her trademark. Not only did *Crossfire* establish her presence in the noir genre, but it also marked a turning point in her professional development as an actress. She credited director Bill Watts, who helped her focus on "*who* the character was, *where* she was, *what* she was until I was so immersed in what it was all about." The industry took notice of her ability and commended her with an Oscar nomination for Best Supporting Actress.

Grahame starred opposite Humphrey Bogart in *In A Lonely Place* (1950, Columbia Pictures, dir. Nicholas Ray), in a role originally intended for his wife Lauren Bacall.

Grahame is all smiles and dimples in this flirty promotional photograph. An image from this same photo shoot appeared on the cover of *LIFE Magazine* for October 1946, with an accompanying feature that heralded her as an up-and-coming starlet following her breakout role in *It's a Wonderful Life* (1946, RKO Radio Pictures, dir. Frank Capra).

GG·13b

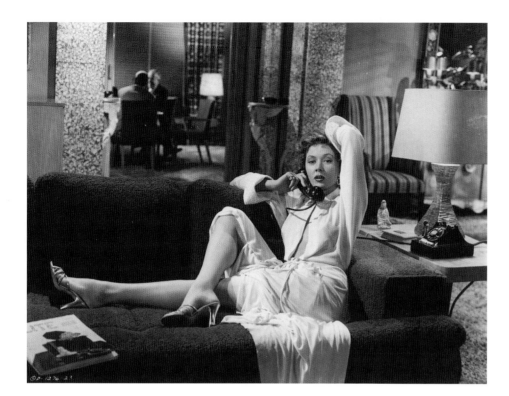

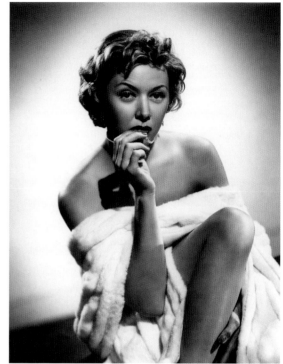

In *In A Lonely Place* (1950), she played an unsuccessful aspiring actress and the object of affection to Humphrey Bogart's volatile screenwriter-turned–murder suspect. The film was directed by her then-husband Nicholas Ray, who painted a drama that mirrored the turbulent dynamics of their own disintegrating marriage. Grahame gave an enrapturing performance that heightened the thriller's suspense as her character vacillates between fear and desire. She would reach the peak of her success in 1952, a year wherein she appeared in four feature films. Chief among them was *The Bad and the Beautiful* (1952)—another film that exposed the dark underbelly of the movie industry, in which she played a dutiful wife who meets a tragic end when she strays from her screenwriter husband. Grahame needed just nine minutes of screen time to captivate critics and audiences. With record-setting brevity, she took home the Academy Award for Best Supporting Actress—the first award presented in the first nationally televised ceremony.

However mercilessly seductive, the femmes fatales played by Grahame often retained an endearingly tragic quality. Not so in *Sudden Fear* (1952), wherein she embodied pure malevolence as a greedy, conniving mistress who manipulates her lover into murdering his wealthy wife. Her character's unbridled cruelty and lack of remorse make for a delicious departure from her other noir roles. Grahame excelled at playing troubled women in all their histrionic melodrama and humanizing complexity. In no film is this talent better spotlighted than *The Big Heat* (1953). As the hard-bitten girlfriend of an abusive gangster, she presents a gutsy facade while barely concealing her wounded vulnerability. She was unafraid to portray the grislier aspects of noir violence, as demonstrated by a horrifying scene in which her boyfriend throws boiling coffee in her face, leaving her scarred and disfigured. Not one to succumb as a victim, she retaliates with the same scalding treatment

This promotional still from *The Big Heat* (1953, Columbia Pictures, dir. Fritz Lang) captures an early scene with Grahame as Debby Marsh enjoying the leisurely life as a gangster's moll before her situation turns violent.

Hyperaware of the value placed on her appearance, Grahame was interminably insecure about her upper lip, which she consciously hides in this photo. She underwent many cosmetic procedures during her lifetime to address it, and even resorted to stuffing tissue in her mouth in an effort to improve its appearance.

The promotional photos for *The Big Heat* are unblushingly sultry, with Grahame appearing to wear nothing more than a fur coat and a strand of pearls.

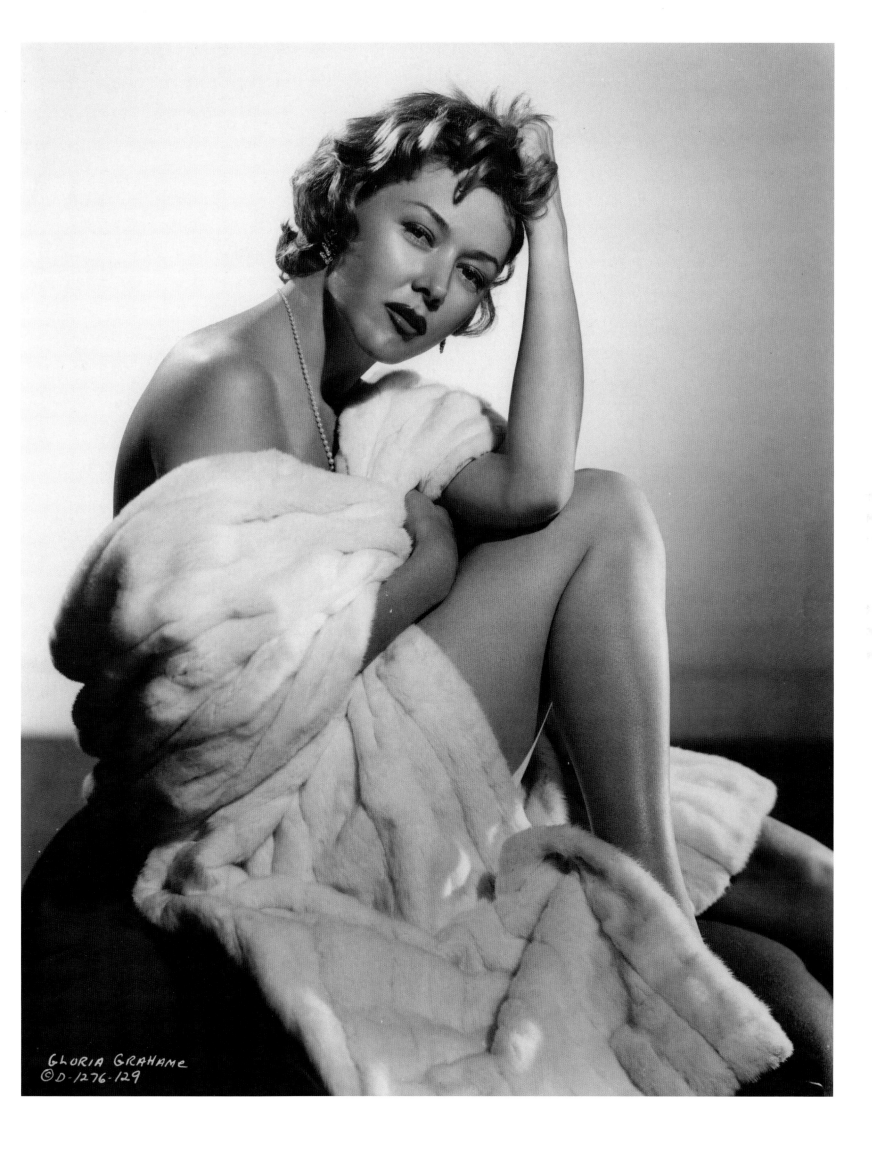

GLORIA GRAHAME
©D-1276-129

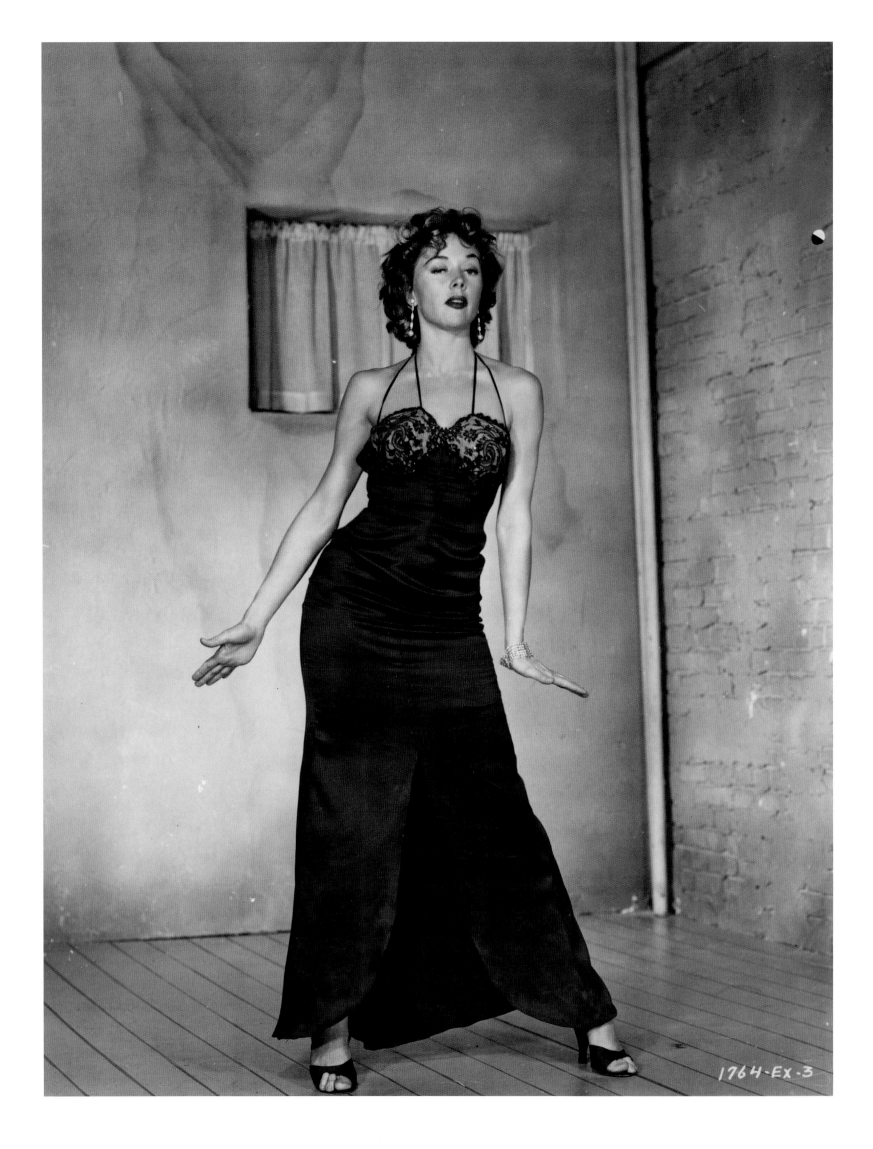

1764-EX-3

later in the film while orchestrating his downfall. That she managed to turn a police crime drama into a woman's revenge film illustrates the command, intensity, and magnetism of her screen presence. In the end, her femme fatale had a heart of gold, sacrificing herself in carrying out the dirty work necessary for justice to be served. Her redemption arc ends with an emotional death scene, delivered with aching sincerity. In an interview with *Silver Screen*, she discussed how she relished this opportunity: "I dote on death scenes . . . because it is those scenes which linger in an audience's memory. I don't want to be typed as a woman with a face nice enough to look at, but I am interested in roles that sometimes turn a cinema-goer away in horror."

At the height of her success, Grahame contended with the most trouble in her personal life while being the most in demand as an actress. Following a painful divorce, she decamped to England for a month to star in the British crime film *The Good Die Young* (1954), earning $25,000 for just three weeks of work. She then reunited with Glenn Ford, her costar from *The Big Heat*, for a second Fritz Lang noir drama, *Human Desire* (1954), loosely based on Émile Zola's 1890 novel *La Bête humaine*. Although the film failed to have the same impact as its predecessor, it further solidified her screen persona rooted in allure and tragedy—delivering on the sensational tagline emblazoned on the theatrical release poster: "She was born to be bad . . . to be kissed . . . to make trouble!" The film ended with another grievous death scene, inspiring a quip about nicknaming herself "Miss

uary." Grahame's next film, *Naked Alibi* (1954), was a familiarly lurid melodrama in which she was typecast as a dangerously beautiful woman on a mission to free herself from an abusive lover. Although she had a few more supporting roles in later noir films like *Not as a Stranger* (1955), her career wound down as the genre faded in popularity by the end of the decade.

Grahame's career took an unexpected turn when she was cast as the boy-crazy farm girl Ado Annie in the film adaptation of Richard Rodgers and Oscar Hammerstein II's inaugural musical *Oklahoma!* (1955). While she was unquestionably miscast, her coy interpretation of "I Cain't Say No" was a rather tongue-in-cheek response to a career built on roles that vilified her promiscuity. Grahame soon after stepped away from film acting and returned to theater, while occasionally making television appearances until her death at the age of fifty-seven.

Underused and underappreciated, Gloria Grahame was never quite able to achieve the same name recognition as the heavy hitters of Hollywood's golden age—due, in part, to her refusal to abide by Hollywood's unwritten rules of conduct. Still, her performances are held up as some of the most compelling and indelible exemplars of acting within the film noir pantheon.

BELOW
Grahame is every bit the blonde bombshell in this RKO studio portrait taken around the release of *Crossfire*. This image perfectly captures the actress in her prime as she smolders in repose with a cool, detached gaze—eternalizing her legacy as the quintessential femme fatale.

OPPOSITE
This RKO studio portrait from 1947 encapsulates Grahame's uncanny ability to appear simultaneously sweet and sexy, which allowed her to play more nuanced versions of cinematic sirens.

ALSO STARRING...

GLORIA SWANSON 1899–1983

Hailed as "the most glittering goddess of Hollywood's golden youth," Gloria Swanson was the preeminent fashion star of the silent film era. She was the first of the "clothes horse" type, and her lavish screen costumes created the template for movie star glamour. But it was not just her penchant for extravagance that made her a sartorial tastemaker—it was the majesty with which she carried herself and her clothing. "Dressing is not a matter of general styles, only," she claimed, "it is a matter of a personality's particular style!"

Her entry to the film industry could have been a movie plot itself—in 1914, the teenager donned her most fashionable ensemble for a visit to Essanay Studios in Chicago, where she was discovered by a casting director and began with small walk-on roles. She relocated to Hollywood in 1916 and did light comedies at Mack Sennett's Keystone Company before signing with Famous Players-Lasky, later to become Paramount Pictures. There, she thrived under the direction of Cecil B. DeMille in bedroom farces like *Male and Female* (1919), *Don't Change Your Husband* (1919), and *Why Change Your Wife?* (1920). As her celebrity grew with each successful picture, she established a "worldly woman" persona on-screen—one who lived life on her own terms. "I have studied the modern woman—she is my business," she told *Photoplay* in 1922. By 1925, she was the most bankable star in Hollywood and so bold was her spirit of independence that she turned down a million-dollar contract renewal in order to strike out on her own. In partnership with the

Sunset Boulevard (1950, Paramount Pictures, dir. Billy Wilder) was Gloria Swanson's greatest triumph. In what was a seminal performance in the "aging actress" archetype, she delivers all the histrionics of faded stardom to a degree of glorious self-parody. To embody Norma Desmond, she and Edith Head "together created perfect clothes for my character—a trifle exotic, a trifle exaggerated, a trifle out of date."

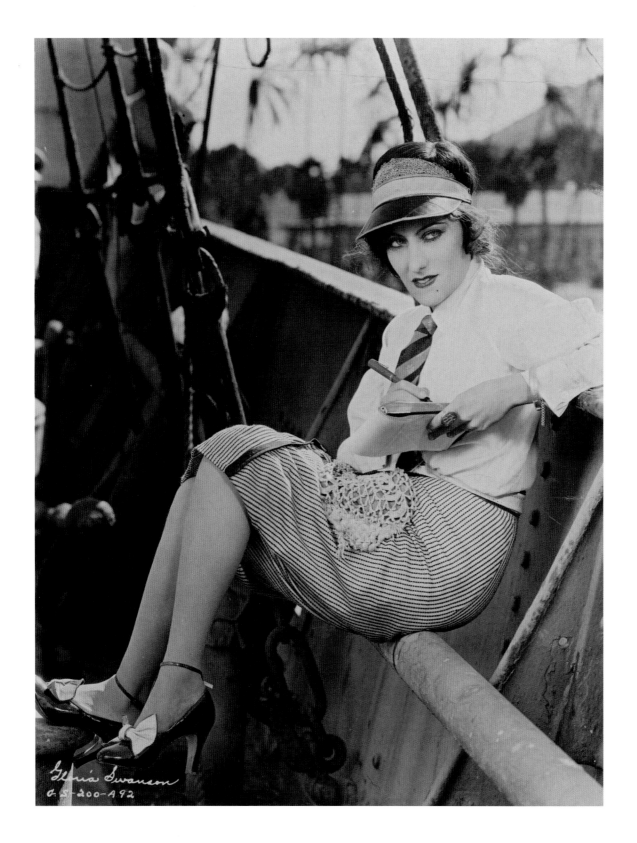

newly formed United Artists Corporation, she founded her own production company—producing and starring in films like *Sadie Thompson* (1928) and *The Trespasser* (1929), her first talking picture. Though her career waned with the rise of talkies in the 1930s, Swanson made one of the greatest comebacks in film history decades later in *Sunset Boulevard* (1950). With her career-defining portrayal of the erstwhile silent film star Norma Desmond, she enshrined her own legend and cemented her place as an enduring screen icon.

In her memoir, Swanson called *Sadie Thompson* (1928, Gloria Swanson Productions, dir. Raoul Walsh) "the best thing I've ever done. Ever!" The film was a critical and financial success, and her spirited performance as the scandalous title character earned her a Best Actress nomination for the first Academy Awards.

Stage Struck (1925, Paramount Pictures, dir. Allan Dwan) was one of the last films Swanson made while under contract at Paramount, in which she plays a diner waitress who fantasizes about a glamorous life as a stage actress. In this publicity photo, she is outfitted in an exotic costume dripping with jewels and pearls—such lavish adornments were her métier in the heyday of her silent film career.

This portrait was taken by Paramount's resident photographer Eugene Robert Richee at the height of Swanson's career, c. 1920–25. She had a different look from the sweet-faced ingénues of early cinema—with distinctive facial features that made for a striking close-up.

MIRIAM HOPKINS

OPPOSITE

Miriam Hopkins sports a sassy expression and a frizzy hairdo in this promotional photo for *Fast and Loose* (1930, Paramount Pictures, dir. Fred C. Newmeyer), her first feature film. She plays an unmanageable heiress engaged to a dullard of an English lord who defies her family by taking an interest in a mechanic.

BELOW

Design for Living (1933, Paramount Pictures, dir. Ernst Lubitsch) was a sexy, sophisticated pre-Code romantic comedy based on a Noël Coward play that gave Hopkins a chance to embody a character not too different from herself. As the commercial artist Gilda Farrell, she enters into a ménage à trois with a painter and a playwright when she finds herself unwilling to choose between the two equally dashing lovers.

Miriam Hopkins was a feisty blonde whose verbal fireworks lit up the silver screen during the pre-Code era. She had a reputation as a troublemaker—notorious for upstaging her costars and engaging in feuds with fellow actresses. But, it was this fighting spirit that made her so exhilarating to watch on-screen. She was best when confrontational, and her exaggerated acting style made for delightfully entertaining temper tantrums and hyperbolic facial expressions.

A vivacious southern belle from Savannah, Georgia, Hopkins signed with Paramount Pictures in 1930 and made her feature film debut in *Fast and Loose* (1930). Stardom came quickly after the success of her second picture, *The Smiling Lieutenant* (1931)—a musical comedy and the first of three films she did with Ernst Lubitsch. Her most celebrated performance was as a cunning pickpocket in Lubitsch's masterpiece *Trouble in Paradise* (1932), wherein she teams up with a master thief to con a perfume company owner in a delightful flurry of sly banter. Though she excelled in comedy, Hopkins also had an inclination for dramatic roles that underscored her brazen, masochistic sexuality in films like the horror classic *Dr. Jekyll and Mr. Hyde* (1931) and the controversial *The Story of Temple Drake* (1933). As a star, she resisted categorization. *Photoplay* called her "a rebel against life," saying, "You can't pigeon-hole the Hopkins person. She fits no mold." By the end of the decade, her fame had declined as she became increasingly disenchanted with what Hollywood had to offer. And though she never reached the upper echelons of celebrity, the press recognized that "she had achieved that state of blessedness in which she simply did not do anything she didn't want to do."

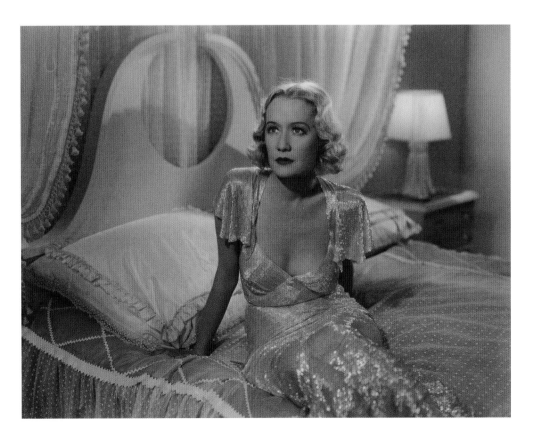

215

During the heyday of the studio system, MGM's roster of contract players boasted an unrivaled magnitude of star power. Of all its leading ladies, "Not one of them ever successfully, consistently, progressively, artfully portrayed sophisticated ladies of the upper strata of society as Norma Shearer," *Photoplay* extolled. Indeed, she possessed a unique brand of patrician chic, yet never lost sight of an approachable, down-to-earth demeanor. She was lionized as "a woman's idol. . . . She is what every woman thinks she might have been—or would like to be."

Shearer had much difficulty getting her career off the ground after being repeatedly told by theatrical producers and film directors that she was not conventionally beautiful enough to make it in the industry. Undeterred by their criticism, she banked on her sparkling charm and poise to land a small part in a B-movie that would eventually lead to a contract offer from Louis B. Mayer Pictures in 1923—just before the company merged with Metro Pictures and the Samuel Goldwyn Company. She was cast in the first Metro-Goldwyn-Mayer production, *He Who Gets Slapped* (1924), and continued to star in a string of commercially successful films in the years that followed. When she married MGM's "Boy Wonder" exec-

BELOW

This lobby card for *The Divorcee* (1930, Metro-Goldwyn-Mayer, dir. Robert Z. Leonard) illustrates the dazzling charisma that won Norma Shearer an Academy Award for her career-changing performance as a woman who retaliates against her unfaithful husband by carrying on affairs of her own.

OPPOSITE

This saucy promotional photo for *Strangers May Kiss* (1931, Metro-Goldwyn-Mayer, dir. George Fitzmaurice) by George Hurrell is reminiscent of those he took of Shearer perched upon boudoir furniture wearing a gold brocaded negligee the year before. Those photographs recast her as a siren and led to more scandalous pre-Code roles like the one in this film.

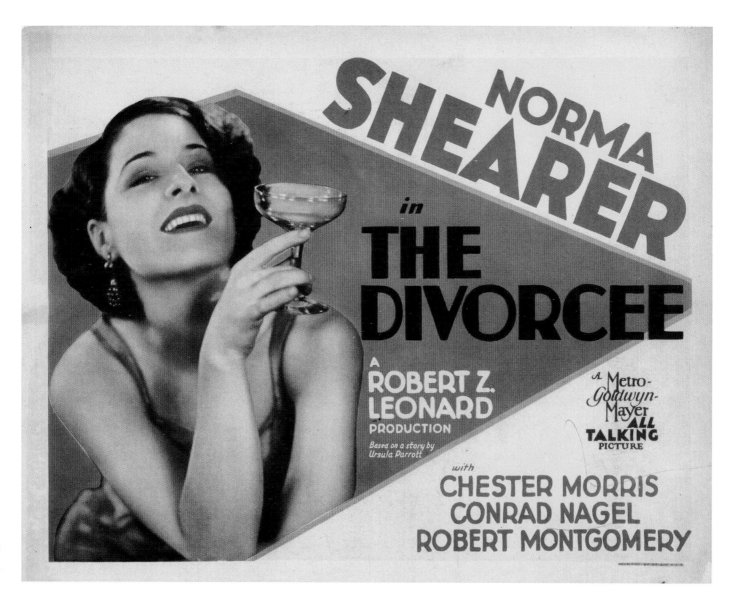

NORMA SHEARER in THE DIVORCEE

A ROBERT Z. LEONARD PRODUCTION

Based on a story by Ursula Parrott

A Metro-Goldwyn-Mayer ALL TALKING PICTURE

with CHESTER MORRIS CONRAD NAGEL ROBERT MONTGOMERY

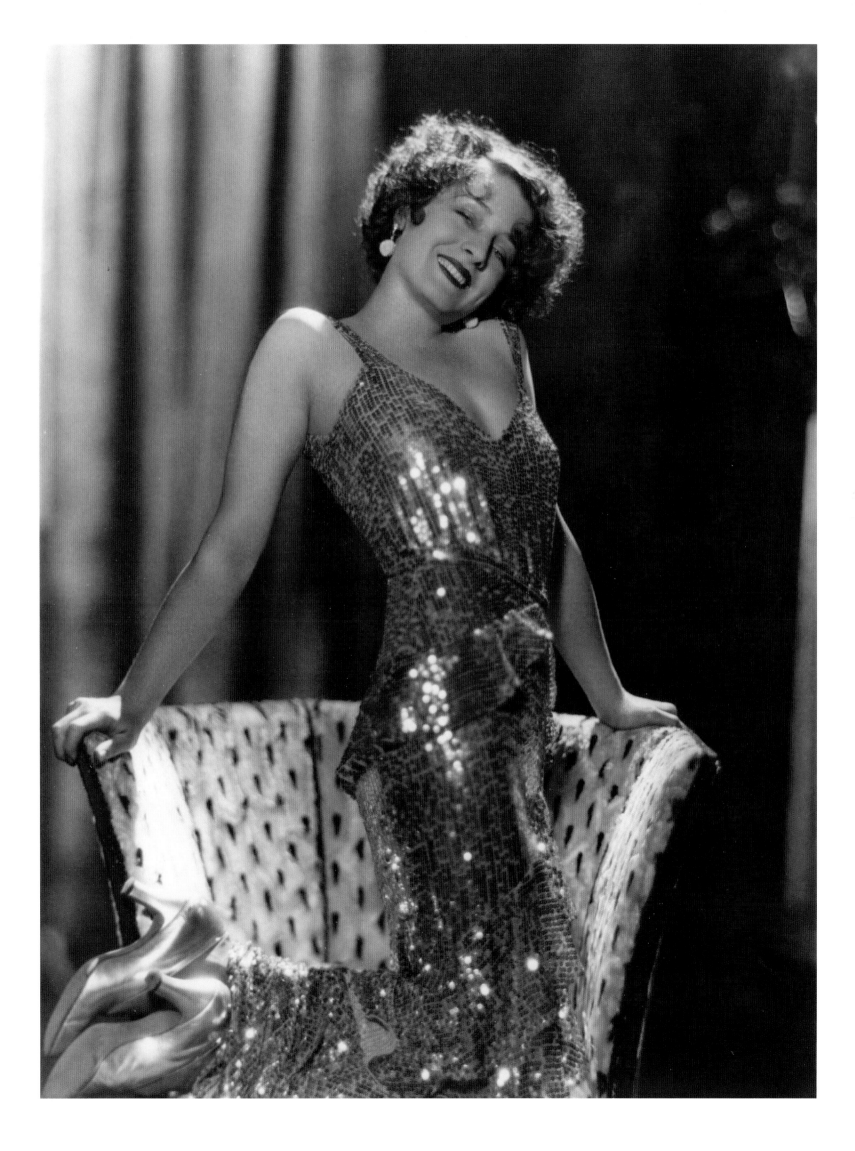

utive producer Irving Thalberg in 1927, she gained unprecedented power and her pick of the scripts. Still, he and the studio were unconvinced that she had what it took to play the scandalous lead in *The Divorcee* (1930), given her reputation for depicting girlish ingénues in the silent era. But she was determined and sought out glamour photographer George Hurrell to take sultry photos that not only got her the part, but helped remake her image as a vibrant pre-Code vixen. When the Production Code cut down on racy plotlines, Shearer transitioned to prestige films— playing the title characters in lavish adaptations of *Romeo and Juliet* (1936) and *Marie Antoinette* (1938). As the noble lead in the studio's all-star production *The Women* (1939), she solidified her standing as the "First Lady of MGM."

ROSALIND RUSSELL <inline>1907–1976</inline>

Rosalind Russell was the fastest and the talkingest of Hollywood's fast-talking dames. A peerless comedienne, she handled manic screwball pacing with uncanny ease—rattling off snappy dialogue at a mile a minute without sacrificing an ounce of effervescent charisma. She flourished in savvy career girl roles, which showcased her nimble wit and rip-roaring moxie. Hers was a seemingly effortless transition into middle age, and she continued to deliver career-defining performances decades after she burst onto the scene. That she maintained such longevity in her career can be attributed to her unique star persona, which, from the get-go, did not rely on sex appeal. It was an unconventional approach for a young, beautiful actress, but one that ultimately proved worthwhile. As she told *Screenland,* "I am a gambler by nature, a rebel, an experimenter—upsetting the apple-cart is my favorite outdoor sport."

A graduate of the American Academy of Dramatic Arts who made her Broadway debut in 1930, Russell signed with Universal Pictures in 1934, only to find immediate dissatisfaction with what was then considered a second-rate studio. With her sights set higher, she used ingeniously sly tactics to get out of her contract and upgraded to the prestigious MGM, making her screen debut in *Evelyn Prentice* (1934). She was repeatedly cast as haughty socialites in her subsequent films—limiting assignments that did not take full advantage of her capabilities. Determined to break out of this mold, Russell campaigned for a catty comedic role in *The Women* (1939). As the acid-tongued busybody Sylvia Fowler, she stood out from the all-female cast and proved her comic chops. She solidified her star power

Rosalind Russell portrays an embittered war widow in the psychological drama *The Guilt of Janet Ames* (1947, Columbia Pictures, dir. Henry Levin). The intensity shown in this promotional photo is a dramatic departure from the lighter fare for which she was better known, but she was an actress who continuously challenged herself in different roles.

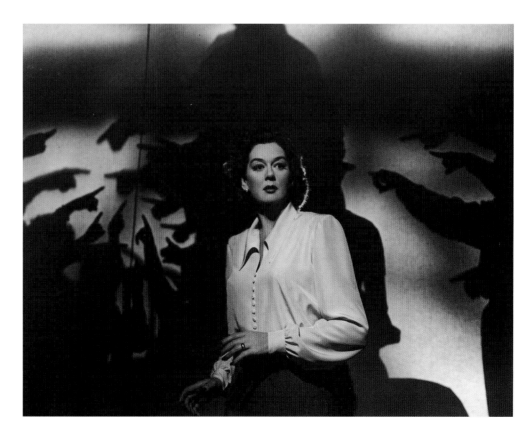

in her next film, *His Girl Friday* (1940)—a rapid-fire remarriage comedy in which her talents soared. Though she had found her niche, she resisted typecasting, saying, "Each [producer] wants me to do the same part, in different stories, over and over again. But I won't do it!" She alternated in comedy and drama throughout the 1940s and expressed her disdain for "straight" roles, of which she said, "They not only bore me but I don't believe in them. . . . I want to get away from them— play toothless hags and horned harpies—any part I was half-way successful in was when I had something to cut my dainty teeth on." She had the soul of a character actress in a leading lady's body and eventually found the theatrics she so craved when she returned to the stage in the 1950s. She met with great success on Broadway, starring in the megahits *Wonderful Town* and *Auntie Mame*. She reprised her role as the eccentric aunt with a flair for delicious living in the 1958 film adaptation and brought musical theater favorite Mama Rose to the silver screen in *Gypsy* (1962). Like these brassy, iconic characters, Russell had a presence—and a legacy—that was larger than life.

BELOW

Russell plays a refined English society widow alongside Clark Gable and Jean Harlow in *China Seas* (1935, Metro-Goldwyn-Mayer, dir. Tay Garnett). She felt stuck in these lackluster aristocratic roles and was desperate to break away from typecasting in order to realize her full potential.

OPPOSITE

Cary Grant and Russell are well-matched as a charismatic newspaper editor and his star reporter ex-wife in *His Girl Friday* (1940, Columbia Pictures, dir. Howard Hawks)—an adaptation of the 1928 play *The Front Page* reimagined with a female lead and tailored to suit Russell's strengths. Encouraged to ad-lib by director Hawks, she shines as the fast-talking newspaperwoman Hildy Johnson—her commanding presence evident in this promotional photo (*above*) and lobby card (*below*).

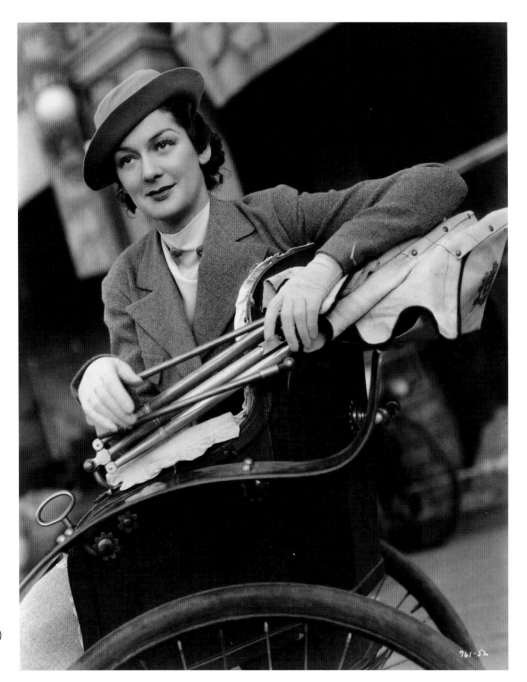

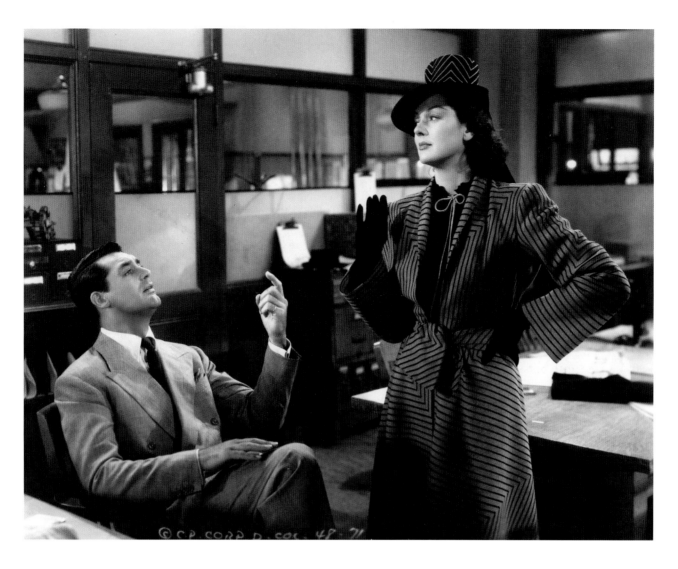

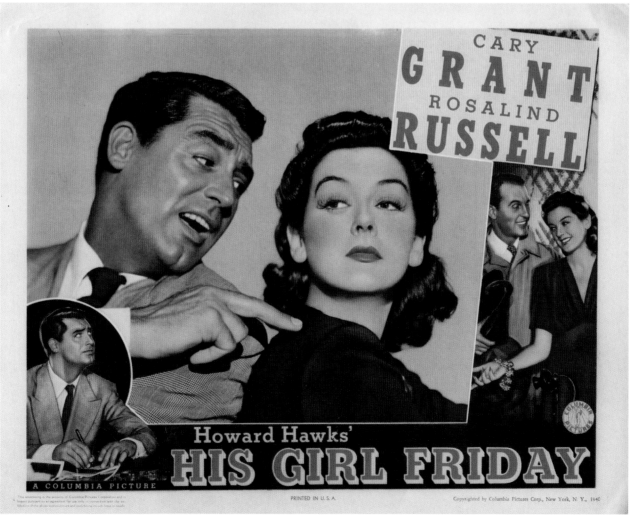

INGRID BERGMAN 1915–1982

Despite the industry's efforts to reshape—and later undermine—her character, Ingrid Bergman managed to remain true to herself in every way. A Swedish-born multilingual actress, she was committed to international cinema and left Hollywood at the peak of her career to explore Italian Neorealism, which she found more creatively stimulating. She was resolute in retaining her identity and refused to participate in the customary practices of changing her name or undergoing a makeover. Consequently, she was heralded for her natural beauty and became the counterpoint to the studio era's glamour goddesses. Not only did she bring invigorating freshness and sincerity to each performance, but she was selective about her films and intentional in her professional development. She prioritized her own artistic fulfillment over commercial success—consistently placing the quality of her work above ambitions of stardom, saying, "I don't think I'm so important. But I think my acting is."

OPPOSITE

Ingrid Bergman was immortalized as Ilsa Lund in *Casablanca* (1942, Warner Brothers, dir. Michael Curtiz), one of the most beloved classic films of all time— her natural beauty perfectly captured in this promotional photograph.

RIGHT

Bergman is radiant with noblesse in this promotional photo for *Notorious* (1946, RKO Pictures, dir. Alfred Hitchcock), one of three films she made with the legendary director.

Born in Stockholm, Bergman began her film career in Sweden and had her breakout in *Intermezzo* (1936) as a pianist who has a love affair with a married violinist—a role she reprised in the 1939 English-language remake. It was this film that brought her to Hollywood and made her a star, but she would cement her place in film history as the leading lady opposite Humphrey Bogart in *Casablanca* (1942). She won her first Oscar for *Gaslight* (1944), wherein she portrayed a Victorian woman who ultimately triumphs over her psychologically abusive husband. While studio executives perpetuated her wholesome persona throughout the 1940s, Bergman was further elevated to sainthood for her portrayal of religious figures—a nun in *The Bells of St. Mary's* (1945) and the title character in *Joan of Arc* (1948). That she was so celebrated for her cinematic virtue made the scandal of her extramarital affair with Italian director Roberto Rossellini in 1950 all the more detrimental to her image. She was denounced by Hollywood gossip queens Hedda Hopper and Louella Parsons, of whom she said, "Their power shocked me, and I thought it very wrong that the film industry had allowed them to build up to such an extent that they could ruin people's careers and lives." Bergman withstood the industry's cruelties with astonishing dignity, but never begged for its forgiveness—she didn't need it. When she returned to the United States after the ordeal, she proclaimed, "I have no regrets for what I have done. I only regret the things I haven't done." Her valiant comeback resulted in two additional Academy Awards—for *Anastasia* (1956) and *Murder on the Orient Express* (1974)—and an acting career that continued until her death in 1982.

ELIZABETH TAYLOR

1932–2011

A dominating force both on and off-screen, Elizabeth Taylor was the epitome of movie stardom. All the qualities you could ask for in a star she had in spades—ravishing beauty, natural talent, irresistible charm, and a fascinating life story. Due to the enormous power of her personality, she was an object of public fascination for the whole of her storied career. Her highly publicized private life was the stuff of tabloid legend, fraught with melodrama and inextricably linked to her work. Though she played many unforgettable, complex women on-screen, it was her public persona—"the Elizabeth Taylor who's famous, the one on celluloid"—that proved to be her most demanding role. She lived many lives, famously marrying eight times—twice to Richard Burton, her eleven-time costar with whom her legend is entwined. Upon the tragic death of her third husband, producer Mike Todd, and her controversial subsequent marriage to actor/singer/family man Eddie Fisher, she went from sympathetic widow to social pariah in the public eye. However, her favor was soon restored after a nearly fatal bout of pneumonia forced her to undergo an emergency tracheotomy. Of her tumultuous life, she said, "I am a survivor. I am a living example of what people can go through and survive."

Taylor had her breakout moment in *National Velvet* (1944) when she was just twelve years old. Born with a genetic mutation that gave her a double set of eyelashes, she appeared more mature than her child-star peers at MGM. As she came of age in the spotlight, she skipped the awkward adolescent phase and was thrust into a more grown-up public image. Despite her youth, she was outspoken and not afraid to stand up to Louis B. Mayer, whom she called the "absolute dictator of the studio." When he insulted her mother, who managed Taylor's early career, the spunky fifteen-year-old shot back, "You and your studio can go to hell!" She refused to apologize, and as she recalled, "nothing happened; I wasn't fired and the only reason was because I was in demand. I knew that. I already knew who I was."

Her confidence was warranted, evidenced by her meteoric ascent to stardom as she transitioned to adult roles. *Father of the Bride* (1950) was a box office hit, due in part to the publicity campaign tied to Taylor's wedding a month before the film's release. She delivered a multidimensional performance to critical acclaim in her next movie, *A Place in the Sun* (1951). Her success continued throughout the decade, which culminated in triumphant screen adaptations of the Tennessee Williams plays *Cat on a Hot Tin Roof* (1958) and *Suddenly, Last Summer* (1959). She won her first Oscar for her portrayal of Manhattan call girl Gloria Wandrous in *BUtterfield 8* (1960) and took her star power to new heights with the lavish epic *Cleopatra* (1963), for which she became the first actress to command a salary of one million dollars for a single film. She delivered another volcanic Academy

ALSO STARRING...

Award–winning performance in *Who's Afraid of Virginia Woolf?* (1966)—the apex of an estimable acting career. Her legacy as a talented actress with unfathomable star quality continues to have an enduring hold on the public imagination. Taylor is often considered the last true movie star—her rise to fame was one of the final gasps of a once-great studio system in decline. The arrival of television signaled a dramatic shift in the entertainment landscape and reshaped American celebrity culture in the second half of the twentieth century. Taylor provided a link to Hollywood's golden past and continues to live on as a symbol of its glory.

Elizabeth Taylor is photographed with a flirtatious grin by Frank Worth on the set of *Giant* (1956, Warner Brothers, dir. George Stevens). For the singularity of her beauty, she was perceived as a screen siren, but that was not her goal. She wrote in her memoir, "I do know I'm a movie star and I like being a woman. But as far as being thought of as a 'sex goddess,' I have never been concerned about that."

ALSO STARRING...

NOTES

LILLIAN GISH

p. 16 "who taught me it was more fun to work than to play."
Lillian Gish, *The Movies, Mr. Griffith & Me* (New York: Avon Books, 1969), v.

p. 17 "for the purely selfish reason . . ."
Gladys Hall, "'Lights!' Says Lillian!" *Motion Picture Magazine*, April–May 1920, 102.

p. 19 "It wasn't in style then . . ."
Gish, *The Movies, Mr. Griffith & Me*, 231.

p. 19 "Those of us who worked with Mr. Griffith . . ."
Gish, *The Movies, Mr. Griffith & Me*, 234.

p. 19 "It was a delicious scene, one of my really favorites."
Albin Krebs, "Lillian Gish, 99, a Movie Star Since Movies Began, Is Dead," *New York Times*, March 1, 1993, Section A, 1.

p. 23 "Acting is the most exacting work in the world. . . ."
Delight Evans, "The Girl on the Cover," *Photoplay*, December 1921, 39.

LOUISE BROOKS

p. 25 "if I was to create my dream woman . . ."
Louise Brooks, *Lulu in Hollywood: Expanded Edition* (Minneapolis: University of Minnesota Press, 2000), 10.

p. 26 "I learned to act from watching Martha Graham dance."
Kenneth Tynan, "The Girl in the Black Helmet," *New Yorker*, June 11, 1979.

p. 31 "In Hollywood, I was a pretty flibbertigibbet . . ."
Brooks, *Lulu in Hollywood*, 104–5.

p. 34 "It was clever of Pabst to know even before he met me . . ."
Tynan, "The Girl in the Black Helmet."

p. 37 "Louise has a European soul. . . . She belongs to Europe and the Europeans."
Cedric Belfrage, "Their European Souls: Some Stars' Spirits Flower Only Abroad," *Motion Picture Magazine*, February 1930, 96.

p. 38 "Someday, I thought, I would run away from Hollywood forever. . . ."
Brooks, *Lulu in Hollywood*, 21.

p. 39 "There is no Garbo! There is no Dietrich! There is only Louise Brooks!"
Roger Ebert, Film Review: *Pandora's Box* (1928), April 26, 1998.

p. 39 "born a loner, who was temporarily deflected from the hermit's path . . ."
Brooks, *Lulu in Hollywood*, 58.

ANNA MAY WONG

p. 43 "I considered all they said. . . ."
Graham Russell Gao Hodges, *Anna May Wong: From Laundryman's Daughter to Hollywood Legend*, 3rd ed. (Chicago: Chicago Review Press, 2023), 63.

p. 48 "My career has been all important to me. . . ."
Muriel Babcock, "She Doesn't Dare Love," *Movie Mirror*, March 1932, 112.

p. 50 "I do not see why I, at this stage of my career . . ."
Yunte Huang, *Daughter of the Dragon: Anna May Wong's Rendezvous with American History* (New York: Liveright Publishing, 2023), 180.

p. 51 "I had to be sure whether I was really playing a Chinese . . ."
Robert McIlwaine, "Third Beginning," *Modern Screen*, December 1937, 80.

CLAUDETTE COLBERT

p. 53 "I just went right onstage, and I learned by watching. . . ."
Eric Pacce, "Claudette Colbert, Unflappable Heroine of Screwball Comedies, Is Dead At 92," *New York Times*, July 31, 1996, Section D, 21.

p. 54 "I was bored with those roles, but because I happened to look like a lady . . ."
Michiko Kakutani, "Claudette Colbert Still Tells DeMille Stories," *New York Times*, November 16, 1979, Section C, 31.

p. 57 "DeMille's films were special . . ."
Kakutani, "Claudette Colbert Still Tells DeMille Stories."

p. 59 "everything that is being offered to me now is comedy. . . ."
Virginia Lane, "Claudette Colbert's New Code of Living," *Movie Classic*, August 1935, 29.

p. 60 "Hollywood was not my dream, you know. . . ."
Robert Berkvist, "To Claudette Colbert, Broadway Is Home," *New York Times*, December 3, 1978, Section D, 1.

p. 60 "I suppose . . . you might say that is really the height of my ambition . . ."
Max Breen, "She Wants to Be Loved," *Picturegoer Weekly*, March 1938, 11.

MARLENE DIETRICH

p. 63 "girl from a good family."
Marlene Dietrich, *Marlene* (Lexington: University Press of Kentucky, 2022), 3.

p. 64 "he shaped her appearance, highlighted her charm . . ."
Dietrich, *Marlene*, 46.

p. 64 "an ordinary, brazen, sexy and impetuous floozie."
Dietrich, *Marlene*, 64.

p. 64 "the most disreputable and most mythical place in the world."
Dietrich, *Marlene*, 84.

p. 66 "In my opinion I have always played 'dissolute young girls' ..."
Dietrich, *Marlene*, 57.

p. 67 "An aura of mysteriousness has never been my forte."
Dietrich, *Marlene*, 64.

p. 70 "vibrantly alive" / "freed from Josef von Sternberg's artistic bondage."
Frank S. Nugent, "A Delightful Comedy Romance Is 'Desire,' at the Paramount," *New York Times*, April 13, 1936.

p. 75 "I was born German, and I shall always remain German ..."
Dietrich, *Marlene*, 178.

p. 77 "My legs, always my legs! ..."
Dietrich, *Marlene*, 85

p. 77 "No Dior, no Dietrich!"
Jess Cartner-Morely, "Marlene Dietrich Is the Muse for Feminist Retelling of Dior's Story," *Guardian*, April 16, 2024, https://www.theguardian.com/fashion/2024/apr/16/marlene-dietrich-muse-feminist-retelling-dior-story.

p. 78 "I'm not an actress, I'm a personality."
Chloe Walker, "Marlene Dietrich: 10 Essential Films," *British Film Institute*, December 1, 2020, https://www.bfi.org.uk/lists/marlene-dietrich-10-essential-films.

p. 78 "My hair looked too dark on film."
Dietrich, *Marlene*, 59.

p. 78 "A floodlight was beamed on my hair from above ..."
Dietrich, *Marlene*, 59.

p. 78 "I've always been fascinated by the magical effect of cameras and light."
Dietrich, *Marlene*, 50.

p. 78 "The higher [the] key light is placed ..."
Dietrich, *Marlene*, 51.

p. 81 "I am sincere in my preference for men's clothes ..."
Rosalind Shaffer, "Marlene Dietrich Tells Why She Wears Men's Clothes!" *Motion Picture Magazine*, April 1933, 54.

p. 81 "After this incident, I resolutely refused to follow the studio's orders ..."
Dietrich, *Marlene*, 58.

p. 82 "I dress for the image.... Not for myself, not for the public, not for fashion, not for men...."
"Marlene Dietrich's Wardrobe Secrets," *Observer*, March 6, 1960.

p. 82 "assurance ... a kind of knowing that you are all right in every way ..."
Vanessa Thorpe, "Still Modern after All These Years ... Marlene Dietrich's Ageless Charisma," *Observer*, November 25, 2017.

MYRNA LOY

p. 86 "Talk about racism!"
Myrna Loy, *Being and Becoming: A Memoir* (Salisbury: Dean Street Press, 2021), 46.

p. 89 "solidified my exotic non-American image."
Loy, *Being and Becoming: A Memoir*, 45.

p. 89 "I recall little about that racist concoction."
Loy, *Being and Becoming: A Memoir*, 59.

p. 89 "the last straw"
Loy, *Being and Becoming: A Memoir*, 59.

p. 89 "first realization that I could make people laugh."
Loy, *Being and Becoming: A Memoir*, 58.

p. 89 "a new awareness of my abilities"
Loy, *Being and Becoming: A Memoir*, 58.

p. 90 "Get your chin up, kid. You've got the whole world ahead of you."
Loy, *Being and Becoming: A Memoir*, 56.

p. 92 "the film that finally *made* me."
Loy, *Being and Becoming: A Memoir*, 73.

p. 92 "From that very first scene, something curious passed between us ..."
Loy, *Being and Becoming: A Memoir*, 71.

p. 93 "I wanted what Bill was getting, that's all...."
Loy, *Being and Becoming: A Memoir*, 80.

KAY FRANCIS

p. 97 "seldom been given the right role to show what she can do."
Elsie Janis, "Class with a Capital KAY," *New Movie Magazine*, March 1934, 51.

p. 98 "I had a sudden feeling of tremendous self-confidence. I felt very indomitable...."
Margaret Reid, "Oklahoma Defies Broadway," *Picture Play Magazine*, November 1930, 55.

p. 98 "What is there in a [microphone] to scare you after you are used to 1,500 people?"
Leonard Hall, "Vamping with Sound," *Photoplay*, October 1929, 126.

p. 102 "that nameless something" / "in the manner of wearing clothes ..."
"That Nameless Something," *Picture Play Magazine*, November 1929, 54.

p. 102 "I want to graduate, eventually, from these siren things and play sophisticated leads."
Leonard Hall, "Just Three Years," *Photoplay*, October 1932, 48.

p. 105 "It is silly to be conscious of your height...."
Virginia T. Lane, "Kay Francis' Style Secrets," *Modern Screen*, December 1933, 92.

p. 105 "another tradition of tall girls she rebels at—low heels...."
Lane, "Kay Francis' Style Secrets," 93.

p. 105 "being handed a poor story with the idea that your name ..."
Malcolm Oettinger, "Is Stardom Worth It?" *Modern Screen*, May 1933, 47.

p. 106 "I can't wait to be forgotten."
S. R. Mook, "I Can't Wait to Be Forgotten," *Photoplay*, March 1939, 32.

p. 106 "I've done everything I set out to do ..."
Mook, "I Can't Wait to Be Forgotten," 72.

p. 106 "I think a woman is well dressed when she ..."
Samuel Richard Mook, "Let Kay Budget Your Wardrobe," *Picture Play Magazine*, January 1938, 42.

CAROLE LOMBARD

p. 109 "I found that individuality was more important . . ."
J. Eugene Chrisman, "Little Success Stories of the Stars,"
Hollywood Magazine, August 1934, 10.

p. 114 "that we bring to the screen the same qualities we bring to
living."
Gladys Hall, "Lombard—As She Sees Herself," *Motion
Picture Magazine*, November 1938, 68.

p. 114 "Because I don't believe it is a man's world . . ."
Hart Seymour, "Carole Lombard Tells: 'How I Live By a Man's
Code,'" *Photoplay*, September 1937, 13.

p. 117 "I buy good things but not a great many things. . . ."
Hall, "Lombard—As She Sees Herself," 68.

p. 117 "the most difficult part I ever played. Because Irene was . . ."
Hall, "Lombard—As She Sees Herself," 66.

p. 117 "Back of all comedy, there is tragedy . . ."
Hall, "Lombard—As She Sees Herself," 66.

p. 121 "Throw a bolt of material at Carole, and any way it hits her
she'll look great."
Larry Swindell, *Screwball: The Life of Carole Lombard* (New
York: William Morrow and Company, Inc., 1975) 112.

p. 122 "I *love* everything I do. I'm intensely interested . . ."
Hall, "Lombard—As She Sees Herself," 66.

p. 122 "With age there comes a richness that's *divine* . . ."
Hall, "Lombard—As She Sees Herself," 68.

BETTE DAVIS

p. 126 "I knew it was possible with my ambitions for acting . . ."
Bette Davis, *The Lonely Life* (New York: G. P. Putnam's Sons,
1962), 130.

p. 128 "The last stages of consumption, poverty, and neglect . . ."
Davis, *The Lonely Life*, 142.

p. 132 "I knew that, if I continued to appear in any more mediocre
pictures . . ."
Whitney Stine, *Mother Goddam: The Story of the Career of
Bette Davis* (New York: Hawthorn Books, Inc., 1974), 78.

p. 132 "In a way, my defeat was a victory. . . . In the long view . . ."
Davis, *The Lonely Life*, 170.

p. 135 "The cornerstone of my career in films was the power . . ."
Davis, *The Lonely Life*, 14.

BARBARA STANWYCK

p. 137 "depth of feeling: emotion, sensitiveness, fire, sincerity . . ."
William F. French, "Barbara Stanwyck—The Star They All
Want!" *Motion Picture Magazine*, December 1935, 34.

p. 141 "I'd give my soul for a chance at that."
Jerry Asher, "The Price She Paid for Stella Dallas," *Picture
Play*, December 1938, 45.

p. 141 "I think I can play the part—you think I can't play it . . ."
Asher, "The Price She Paid for Stella Dallas," 88.

p. 142 "Perhaps the most important thing is to be honest with
yourself . . ."
Barbara Stanwyck, "Barbara Stanwyck Thinks Fame Largely
Due to Luck," in *A Lost Lady* (Warner Brother Pressbook,
1934), 17.

p. 145 "I had played medium heavies . . . but never an out-and-out
killer."
Dan Callahan, *Barbara Stanwyck: The Miracle Woman*
(Jackson: University Press of Mississippi, 2013), 141.

p. 147 "From deep emotional tragedy to sparkling, brilliant
comedy . . ."
Paul Manning, "Barbara Stanwyck is 'A Real Gal' to Every-
one," *Exhibitor*, Studio Survey, SS-2.

IDA LUPINO

p. 150 "I am NOT a 'delectable ingénue.' I am NOT a 'dizzy little
thing.' . . ."
Gladys Hall, "The Loves of Lupino," *Motion Picture Maga-
zine*, October 1936, 37.

p. 153 "It was a chance I *had* to take. . . ."
S. R. Mook, "Lupino! Genius or Screwball?" *Screenland*,
December 1940, 92.

p. 153 "I *should* be a brunette—it's my natural coloring. . . ."
Elizabeth Wilson, "Watch Out, Bette Davis! Here Comes
Ida Lupino!" *Screenland*, January 1940, 66.

p. 154 "do pictures with poor bewildered people because that's what
we are."
William Donati, *Ida Lupino: A Biography* (Lexington:
University Press of Kentucky, 1996), 135.

p. 158 "I am 'mad,' they say. I am temperamental and dizzy and
disagreeable. . . ."
Hall, "The Loves of Lupino," 73.

VERONICA LAKE

p. 161 "Veronica Lake is a Hollywood creation."
Veronica Lake, *Veronica: The Autobiography of Veronica
Lake* (Salisbury: Dean Street Press, 2020), 1.

p. 162 "and my gimmick, my one featured feature was my hair . . ."
Lake, *Veronica: The Autobiography of Veronica Lake*, 24.

p. 165 "Not a bad break, you'll admit."
Lake, *Veronica: The Autobiography of Veronica Lake*, 33.

p. 165 "Guts, huh? My first role and I'm telling them I'm walk-
ing out."
Lake, *Veronica: The Autobiography of Veronica Lake*, 32.

p. 166 "It pleases me greatly to see this particular motion
picture . . ."
Lake, *Veronica: The Autobiography of Veronica Lake*, 69.

p. 166 "was right back in the low-cut gowns and wearing the sexy
hair."
Lake, *Veronica: The Autobiography of Veronica Lake*, 77.

p. 169 "I was laughing at everybody in all of my portraits. I never
took that stuff seriously."

Judy Klemesrud, "For Veronica Lake, the Past Is Something to Write About," *New York Times*, March 10, 1971, 38.

p. 169 "brainless little blonde sexpot"
Lake, *Veronica: The Autobiography of Veronica Lake*, 81.

p. 169 "big bones"
Lake, *Veronica: The Autobiography of Veronica Lake*, 82.

p. 170 "The world looks very different through *both* eyes."
Lake, *Veronica: The Autobiography of Veronica Lake*, 214.

KATHARINE HEPBURN

p. 173 "Hollywood tries to make each person into a set pattern. . . ."
Ruth Biery, "Katharine Hepburn Reveals Herself—for the First Time!" *Motion Picture Magazine*, February 1934, 68.

p. 173 "I wished I was a boy because I thought boys had all the fun."
Charlotte Chandler, *I Know Where I'm Going: Katharine Hepburn, A Personal Biography* (New York: Simon & Schuster, 2010), 29.

p. 173 "skinny and very strong and utterly fearless."
Katharine Hepburn, *Me: Stories of My Life* (New York: Knopf, 1991), 43.

p. 174 "was just full of the joy of life and opportunity . . ."
Hepburn, *Me: Stories of My Life*, 124.

p. 174 "began to feel for the first time like a real actress."
Hepburn, *Me: Stories of My Life*, 124.

p. 174 "Should I wear a different kind of clothes just because . . ."
Biery, "Katharine Hepburn Reveals Herself—for the First Time!" 68.

p. 175 "Kate wasn't someone you could mold easily, that you could control. . . ."
Charles Higham, *Kate: The Life of Katharine Hepburn* (New York: W. W. Norton & Company, 2004), 43.

p. 175 "She wore pants. So did I. We had a good time working together."
Hepburn, *Me: Stories of My Life*, 145.

p. 175 "I have not lived as a woman, I have lived as a man. . . ."
Katharine Hepburn, interview by Barbara Walters, *Interviews of a Lifetime*, 1981.

p. 176 "Go to the Martin Beck [Theatre] and see Katharine Hepburn . . ."
Hepburn, *Me: Stories of My Life*, 166.

p. 177 "a real disaster"
Hepburn, *Me: Stories of My Life*, 232.

p. 177 "career was at a low ebb"
Hepburn, *Me: Stories of My Life*, 236.

p. 177 "I'm not living my life for Hollywood or publicity, and I never will. . . ."
Biery, "Katharine Hepburn Reveals Herself—for the First Time!" 68.

p. 178 "I didn't have brains enough to be scared . . ."
Hepburn, *Me: Stories of My Life*, 239.

p. 178 "The script was a good one. Cary Grant was really wonderful in it. . . ."
Hepburn, *Me: Stories of My Life*, 238.

p. 179 "We just passed twenty-seven years together in what was to me absolute bliss."
Hepburn, *Me: Stories of My Life*, 396.

p. 181 "As for me, prizes are nothing. . . ."
Higham, *Kate: The Life of Katharine Hepburn*, 107.

p. 184 "You wish to be wholly sincere in your dealings . . ."
Jay Brien Chapman, "Why Katharine Hepburn Didn't Dare," *Screenland*, March 1936, 33.

p. 184 "I am very grateful to *The Philadelphia Story*. It gave me a lift when I needed it most."
Liza, "What's This about a New Hepburn?" *Screenland*, November 1940, 91.

p. 187 "The whole town of Hollywood isn't going to take myself away from me!"
Biery, "Katharine Hepburn Reveals Herself—for the First Time!" 69.

p. 188 "She has far too definite a personality to fit into just any clothes. . . ."
Carol Craig, "This Is Hepburn," *Movie Classic*, February 1936, 41.

LAUREN BACALL

p. 191 "She has the talent, the looks, and the audacity. . . ."
Barbara Flanley, "That New Girl!" *Screenland*, January 1945, 67.

p. 191 "Katharine Hepburn that afternoon made me glad to be alive . . ."
Lauren Bacall, *Lauren Bacall: By Myself* (New York: Alfred A. Knopf, 1979), 21.

p. 191 "I was bought for what I was, and I'm going to stay that way. There'll be no changes."
Flanley, "That New Girl!" 67.

p. 193 "on the right side – starting to curve at the corner of my eyebrow . . ."
Bacall, *Lauren Bacall: By Myself*, 82.

p. 194 "By the third or fourth take, I realized that one way to hold . . ."
Bacall, *Lauren Bacall: By Myself*, 94.

p. 197 "No one has ever written a romance better than we lived it."
Bacall, *Lauren Bacall: By Myself*, 129.

p. 197 "I think I've damn well earned the right to be judged on my own. . . ."
Tom Burke, "And Don't Call Her Bogey's Baby," *New York Times*, March 22, 1970, Section D, 24.

p. 198 "the best part I'd had in years."
Bacall, *Lauren Bacall: By Myself*, 205.

GLORIA GRAHAME

p. 202 "*who* the character was, *where* she was, *what* she was . . ."
Robert J. Lentz, *Gloria Grahame, Bad Girl of Film Noir: The Complete Career* (Jefferson: McFarland & Co., Inc., 2011), 48.

p. 207 "I dote on death scenes . . . because it is those scenes which linger . . ."
Vincent Curcio, *Suicide Blonde: The Life of Gloria Grahame* (New York: William Morrow & Co., 1989), 84.

p. 207 "She was born to be bad . . . to be kissed . . . to make trouble!"
Human Desire, directed by Fritz Lang (Columbia Pictures, 1954), poster.

ALSO STARRING . . .

Gloria Swanson

p. 211 "the most glittering goddess of Hollywood's golden youth"
Peter B. Flint, "Gloria Swanson Dies; 20's Film Idol," *New York Times*, April 5, 1983, Section D, 27.

p. 211 "Dressing is not a matter of general styles, only . . ."
Lois Shirley, "How to Adapt Screen Modes to Fit Your Personality," *Photoplay*, July 1931, 32.

p. 211 "I have studied the modern woman—she is my business."
Adela Rogers St. Johns, "The Confessions of a Modern Woman—as Told by Gloria Swanson," *Photoplay*, February 1922, 21.

p. 211 "together created perfect clothes for my character . . ."
Gloria Swanson, *Swanson on Swanson* (New York: Random House, 1980), 482.

p. 212 "the best thing I've ever done. Ever!"
Swanson, *Swanson on Swanson*, 322.

Miriam Hopkins

p. 215 "a rebel against life"
May Allison Quirk, "A Rebel Against Life," *Photoplay*, July 1933, 62.

p. 215 "You can't pigeon-hole the Hopkins person. She fits no mold."
Quirk, "A Rebel Against Life," 62.

p. 215 "she had achieved that state of blessedness in which . . ."
Quirk, "A Rebel Against Life," 62.

Norma Shearer

p. 216 "Not one of them ever successfully, consistently, progressively, artfully portrayed . . ."
Basil Lee, "The Real First Lady of Films," *Photoplay*, July 1934, 29.

p. 216 "a woman's idol. . . . She is what every woman thinks she might have been . . ."
Lee, "The Real First Lady of Films," 96.

p. 218 "Now I am myself. I am no longer trying to strike a pose, to attitudinize, to impress."
Gladys Hall, "Discoveries about Myself—As Told by Norma Shearer," *Motion Picture Magazine*, April 1930, 100.

Rosalind Russell

p. 219 "I am a gambler by nature, a rebel, an experimenter . . ."
Gladys Hall, "'Roz' in Shorthand," *Screenland*, November 1941, 33.

p. 220 "Each [producer] wants me to do the same part . . ."
James Carson, "The Rosalind Road to Successville," *Modern Screen*, April 1940, 28.

p. 220 "They not only bore me but I don't believe in them. . . ."
Hall, "'Roz' in Shorthand," 82.

Ingrid Bergman

p. 223 "I don't think I'm so important. But I think my acting is."
Hedda Hopper, "Ingrid Bergman Talks," *Modern Screen*, December 1948, 81.

p. 224 "Their power shocked me, and I thought it very wrong . . ."
Ingrid Bergman, *Ingrid Bergman: My Story* (New York: Delacorte Press, 1972), 131.

p. 224 "I have no regrets for what I have done. I only regret the things I haven't done."
Susan King, "Classic Hollywood: Retelling Ingrid Bergman's Life 'In Her Own Words' via Diaries, Home Movies," *Los Angeles Times*, December 5, 2015, https://www.latimes.com/entertainment/classichollywood/la-ca-mm-classic-hollywood-ingrid-bergman-in-her-own-words-20151206-story.html.

Elizabeth Taylor

p. 225 "the Elizabeth Taylor who's famous, the one on celluloid"
Elizabeth Taylor, *Elizabeth Taylor: An Informal Memoir* (New York, Avon Books, 1967), 199.

p. 225 "I am a survivor. I am a living example of what people can go through and survive."
Elizabeth Taylor, interview by Johnny Carson, *The Tonight Show*, NBC, February 21, 1992.

p. 225 "absolute dictator of the studio."
Taylor, *Elizabeth Taylor: An Informal Memoir*, 21.

p. 225 "You and your studio can go to hell!"
Ann Taylor Fleming, "Elizabeth Taylor: Act II," *Vogue*, October 1, 1987, 482.

p. 225 "nothing happened; I wasn't fired . . ."
Fleming, "Elizabeth Taylor: Act II," 482.

p. 226 "I do know I'm a movie star and I like being a woman. . . ."
Taylor, *Elizabeth Taylor: An Informal Memoir*, 202.

SELECTED BIBLIOGRAPHY

LILLIAN GISH

Affron, Charles. *Lillian Gish: Her Legend, Her Life*. Berkeley: University of California Press, 2002.

Gish, Lillian. *The Movies, Mr. Griffith & Me*. New York: Avon Books, 1969.

Sanders, Terry, dir. "Lillian Gish: The Actor's Life for Me." *American Masters* on PBS. Season 3, Episode 1, aired July 11, 1988.

LOUISE BROOKS

Brooks, Louise. *Lulu in Hollywood: Expanded Edition*. Minneapolis: University of Minnesota Press, 2000.

Jaccard, Roland, ed. *Louise Brooks: Portrait of an Anti-Star*. New York: New York Zoetrope, 1982.

Neely, Hugh Munro, dir. *Louise Brooks: Looking for Lulu*. Los Angeles: Timeline Films with Turner Classic Movies, 1998. YouTube. https://youtu.be/4F8GuNAu1Q4?si=Xd8XLRfM-MKIIVazf.

Paris, Barry. *Louise Brooks: A Biography*. Minneapolis: University of Minnesota Press, 2000.

ANNA MAY WONG

Hodges, Graham Russell Gao. *Anna May Wong: From Laundryman's Daughter to Hollywood Legend,* 3rd ed. Chicago: Chicago Review Press, 2023.

Huang, Yunte. *Daughter of the Dragon: Anna May Wong's Rendezvous with American History*. New York: Liveright, 2023.

Rocca, Mo. "Anna May Wong: Death of a Trailblazer." *Mobituaries with Mo Rocca*, February 7, 2020. Podcast produced by CBS News, 59:47. https://mobituaries.com/news/the-podcast/anna-may-wong-death-of-a-trailblazer/.

Salisbury, Katie Gee. *Not Your China Doll: The Wild and Shimmering Life of Anna May Wong*. New York: Dutton, 2024.

CLAUDETTE COLBERT

Custodio, Isabel. "Claudette Colbert, Screwball Comedy, and *It Happened One Night* | Best Actress 1935." Be Kind Rewind, March 31, 2023. YouTube video, 27:45. https://youtu.be/w9P6aquSqHw?si=VXPsU5jg4naMQVbx.

Dick, Bernard F. *Claudette Colbert: She Walked in Beauty*. Jackson: University Press of Mississippi, 2008.

MARLENE DIETRICH

Bach, Steven. *Marlene Dietrich: Life and Legend*. Minneapolis: University of Minnesota Press, 2011.

Chandler, Charlotte. *Marlene: Marlene Dietrich, A Personal Biography*. New York: Simon & Schuster, 2011.

Dickens, Homer. *The Films of Marlene Dietrich*. New York: Citadel Press, 1968.

Dietrich, Marlene. *Marlene*. Lexington: University Press of Kentucky, 2022.

———. *Marlene Dietrich's ABC*. New York: Doubleday, 1962.

Riva, Maria. *Marlene Dietrich*. New York: Alfred A. Knopf, 1993.

Schell, Maximillian, dir. *Marlene*. Munich: Bayerischer Rundfunk, 1984. Amazon Prime Video. https://www.amazon.com/Marlene-Annie-Albers/dp/B004D1EIC8?dplnkId=87d4c5db-bf02-44a6-8f2a-6e0a85876acf&nodl=1.

MYRNA LOY

Custodio, Isabel. "Why Myrna Loy Never Got an Oscar Nomination | Always Second Best Actress." Be Kind Rewind, April 26, 2022. YouTube video, 37:14. https://youtu.be/hY3B_sTrqeg?si=n-N8uUzWeCXbFeiAO.

Leider, Emily W. *Myrna Loy: The Only Good Girl in Hollywood*. Berkeley: University of California Press, 2011.

Loy, Myrna. *Being and Becoming: A Memoir*. Salisbury, England: Dean Street Press, 2021.

KAY FRANCIS

Kear, Lynn, and John Rossman. *Kay Francis: A Passionate Life and Career*. Jefferson, NC: McFarland & Company, 2006.

Longworth, Karina. "Follies of 1938, Chapter 2: Kay Francis, Pretty Poison." *You Must Remember This*, July 18, 2014. Podcast, 39:31. http://www.youmustrememberthispodcast.com/episodes/youmustrememberthispodcastblog/follies-of-1938-chapter-2-kay-francis-pretty.

CAROLE LOMBARD

Morgan, Michelle. *Carole Lombard: Twentieth-Century Star*. Stroud, England: History Press, 2016.

Ott, Frederick W. *The Films of Carole Lombard*. Secaucus, NJ: Citadel Press, 1972.

Swindell, Larry. *Screwball: The Life of Carole Lombard*. New York: William Morrow & Company, Inc., 1975.

BETTE DAVIS

Custodio, Isabel. "1936 | Bette Davis Wins a Consolation Oscar."
Be Kind Rewind, August 30, 2018. YouTube video, 11:15. https://
youtu.be/1aCgkHVUOgE?si=qA7Qoxvy7xZMJoQ8.

Davis, Bette. *The Lonely Life: An Autobiography.* New York: G. P.
Putnam Sons, 1962.

Davis, Bette, and Michael Herskowitz. *This 'n That.* New York:
Berkley Books, 1987.

Jones, Peter, dir. *Stardust: The Bette Davis Story.* Burbank, CA.:
Warner Home Video, 2006. DVD.

Sikov, Ed. *Dark Victory: The Life of Bette Davis.* New York: Henry
Holt & Co., 2007.

Stine, Whitney. *Mother Goddam: The Story of the Career of Bette
Davis.* New York: Hawthorn Books, 1974.

BARBARA STANWYCK

Callahan, Dan. *Barbara Stanwyck: The Miracle Woman.* Jackson:
University Press of Mississippi, 2012.

DiOrio, Al. *Barbara Stanwyck: A Biography.* New York: Coward-
McCann, 1983.

Russell, Catherine. *The Cinema of Barbara Stanwyck: Twenty-Six
Short Essays on a Working Star.* Urbana-Champaign: Univer-
sity of Illinois Press, 2023.

Wilson, Victoria. *A Life of Barbara Stanwyck: Steel-True,
1907–1940.* New York: Simon & Schuster, 2013.

IDA LUPINO

Custodio, Isabel. "Actresses Who Direct: Barbra Streisand and Ida
Lupino." Be Kind Rewind, October 28, 2020. YouTube video,
31:09. https://youtu.be/7AT5QInh-r4?si=sHU53Jzm_h7J3W7M.

Donati, William. *Ida Lupino: A Biography.* Lexington: University
Press of Kentucky, 1996.

Grisham, Therese, and Julie Grossman. *Ida Lupino, Director: Her
Art and Resilience in Times of Transition.* New Brunswick, NJ:
Rutgers University Press, 2017.

Seros, Alexandra. *Ida Lupino, Forgotten Auteur: From Film Noir to
the Director's Chair.* Austin: University of Texas Press, 2024.

VERONICA LAKE

Lake, Veronica, and Donald Bain. *Veronica: The Autobiography of
Veronica Lake.* Salisbury, England: Dean Street Press, 2020.

Lenburg, Jeff. *Peekaboo: The Story of Veronica Lake.* New York:
St. Martin's Press, 1983.

Longworth, Karina. "Veronica Lake (Dead Blondes Part 4)."
You Must Remember This, February 21, 2017. Podcast, 50:43.
http://www.youmustrememberthispodcast.com/
episodes/2017/2/20/veronica-lake-dead-blondes-episode-4.

KATHARINE HEPBURN

Berg, A. Scott. *Kate Remembered.* New York: Putnam Publishing
Group, 2003.

Brendel, Rieke, and Andrew Davies, dirs. *Katharine Hepburn:
The Great Kate.* Cologne, Germany: Florianfilm, 2014.

Chandler, Charlotte. *I Know Where I'm Going: Katharine Hep-
burn, A Personal Biography.* New York: Simon & Schuster, 2010.

Custodio, Isabel. "Politics and the Star Persona of Katharine
Hepburn." Be Kind Rewind, May 14, 2021. YouTube video, 27:50.
https://youtu.be/eAi8-vqslVU?si=qRtF4FgCFDigNNsp.

Edwards, Anne. *A Remarkable Woman: A Biography of Katharine
Hepburn.* New York: William Morrow & Company, 1985.

Hepburn, Katharine. *The Making of* The African Queen: *Or How
I Went to Africa with Bogart, Bacall, and Huston and Almost
Lost My Mind.* New York: Alfred A. Knopf, 1987.

———. *Me: Stories of My Life.* New York: Alfred A. Knopf, 1991.

Higham, Charles, *Kate: The Life of Katharine Hepburn.* New York:
W. W. Norton & Co., 2004.

Mann, William J. *Kate: The Woman Who Was Katharine Hep-
burn.* New York: Faber, 2006.

Tucker, Lorna, dir. *Call Me Kate.* Netflix, 2023. https://www.netflix.
com/title/81475700.

LAUREN BACALL

Bacall, Lauren. *Lauren Bacall: By Myself.* New York: Alfred A.
Knopf, 1979.

———. *Now.* New York: Alfred A. Knopf, 1994.

Longworth, Karina. "Bacall, After Bogart." *You Must Remember
This,* September 16, 2014. Podcast, 41:08. http://www.youmus-
trememberthispodcast.com/episodes/youmustrememberthis-
podcastblog/ymrt-14-bacall-after-bogart.

Mann, William J. *Bogie & Bacall: The Surprising True Story of
Hollywood's Greatest Love Affair.* New York: Harper, 2023.

GLORIA GRAHAME

Curcio, Vincent. *Suicide Blonde: The Life of Gloria Grahame.*
New York: William Morrow & Co., 1989.

Lentz, Robert J. *Gloria Grahame, Bad Girl of Film Noir: The Com-
plete Career.* Jefferson, NC: McFarland & Company, 2011.

Longworth, Karina. "MGM Stories Part 13: Gloria Grahame." *You
Must Remember This,* December 8, 2015. Podcast, 48:08. http://
www.youmustrememberthispodcast.com/episodes/youmus-
trememberthispodcastblog/2015/12/8/mgm-stories-part-thir-
teen-gloria-grahame.

ALSO STARRING . . .

Gloria Swanson

Shearer, Stephen Michael. *Gloria Swanson: The Ultimate Star.* New York: St. Martin's Press, 2013.

Swanson, Gloria. *Swanson on Swanson.* New York: Random House, 1980.

Miriam Hopkins

Ellenberger, Allan R. *Miriam Hopkins: Life and Films of a Hollywood Rebel.* Lexington: University Press of Kentucky, 2018.

Norma Shearer

Lambert, Gavin. *Norma Shearer: A Life.* New York: Alfred A. Knopf, 1990.

Quirk, Lawrence J. *Norma: The Story of Norma Shearer.* New York: St. Martin's Press, 1988.

Rosalind Russell

Dick, Bernard F. *Forever Mame: The Life of Rosalind Russell.* Jackson: University Press of Mississippi, 2006.

Russell, Rosalind. *Life Is a Banquet.* New York: Random House, 1977.

Ingrid Bergman

Bergman, Ingrid, and Alan Burgess. *Ingrid Bergman: My Story.* New York: Delacorte Press, 1980.

Chandler, Charlotte. *Ingrid: Ingrid Bergman, A Personal Biography.* New York: Simon & Schuster, 2007.

Rossellini, Isabella, and Lothar Schirmer, eds. *Ingrid Bergman: A Life in Pictures.* San Francisco: Chronicle Books, 2015.

Elizabeth Taylor

Brower, Kate Anderson. *Elizabeth Taylor: The Grit and Glamour of an Icon.* New York: Harper, 2022.

Taylor, Elizabeth. *Elizabeth Taylor: An Informal Memoir.* New York: Avon Books, 1967.

———. *Elizabeth Taylor Takes Off: On Weight Gain, Weight Loss, Self-Image, and Self-Esteem.* New York: G. P. Putnam's Sons, 1987.

INDEX OF NAMES AND FILMS

ABOUT THE AUTHORS

Ira M. Resnick started his impressive collection of movie posters and lobby cards while studying at New York University Film School, after which he embarked on a decade-long career as a professional photographer. He is the founder of the Motion Picture Arts Gallery, the first gallery devoted exclusively to the art of the movies, and the author of *Starstruck: Vintage Movie Posters from Classic Hollywood* and *The Seventies: A Photographic Journey* (both Abbeville). He is a trustee of the Film Society of Lincoln Center and former chairman of the board. He is also a trustee of City Center in New York City and the San Francisco Silent Film Festival. Resnick resides in New York with his wife, Paula, and two children.

Raissa Bretaña is a New York–based fashion historian who works as a writer, researcher, lecturer, and educator. She hosted a popular video series for *Glamour* in which she fact-checked historical costumes in film and television, and also appeared as a guest on *Follow the Thread*—a special programming series for Turner Classic Movies that explored the relationship between fashion and film. Bretaña received a BFA in Costume Design from Boston University and an MA in Fashion and Textile Studies from the Fashion Institute of Technology, where she has served as adjunct faculty in the History of Art department. She currently works at the Museum at FIT and continues to freelance as a consultant to costume designers for period film and television productions. Bretaña is the author of *Shoes* and the forthcoming *Fashion of the Gilded Age* (both Abbeville).

Jane Fonda is a two-time Oscar winner and an Emmy award–winning American actress and a political activist. She sits on the boards of V-Day: Until the Violence Stops, the Women's Media Center (which she cofounded in 2004), the Georgia Campaign for Adolescent Power & Potential, and Homeboy Industries. She lives in Los Angeles.

Photo Captions and Credits

Front cover: Photo of Marlene Dietrich for *Shanghai Express*, 1932 (detail). See page 71.

Back cover: Promotional photo of Katharine Hepburn, 1942 (detail). See page 182.

Page 2: Photo of Katharine Hepburn by George Hoyningen-Huene, c. 1939/40.

Page 4: Promotional photo of Carole Lombard, 1932

Page 6: Getty Images (Ron Galella)

Page 7: Getty Images (Steve Schapiro)

Page 240: Author photos by Rose Callahan.

Project editors: Lauren Orthey and Colette Laroya
Copy editor: Ashley Benning
Design: Misha Beletsky and Julia Sedykh
Production director: Louise Kurtz

First edition
10 9 8 7 6 5 4 3 2 1

ISBN 978-0-7892-1493-5

Library of Congress Cataloging-in-Publication Data available upon request

For bulk and premium sales and for text adoption procedures, write to Customer Service Manager, Abbeville Press, 655 Third Avenue, New York, NY 10017, or call 1-800-ARTBOOK.

Visit Abbeville Press online at www.abbeville.com.